MILES, ORNETTE, CECIL

MILES, ORNETTE, CECIL

Jazz Beyond Jazz

Howard Mandel

Routledge
Taylor & Francis Group

NEW YORK AND LONDON

First published 2008
by Routledge
711 Third Avenue, New York, NY 10017

Simultaneously published in the UK
by Routledge
2 Park Square, Milton Park, Abingdon, Oxon OX14 4RN

Routledge is an imprint of the Taylor & Francis Group, an informa
business

Typeset in Perpetua by Prepress Projects Ltd

Library of Congress Cataloging in Publication Data
A catalog record has been requested for this book

ISBN 10: 0-415-96714-7 (hbk)
ISBN 10: 0-203-93564-0 (ebk)
ISBN 13: 978-0-415-96714-3 (hbk)
ISBN 13: 978-0-203-93564-4 (ebk)

CONTENTS

EPIGRAMS

The really competent critic must be an empiricist. He must conduct his exploration with whatever means lie within the bounds of his personal limitation. He must produce his effects with whatever tools will work. If pills fail, he gets out his saw. If the saw won't cut, he seizes a club...

[T]his is almost exactly the function of a genuine critic of the arts. It is his business to provoke the reaction between the work of art and the spectator. The spectator, untutored, stands unmoved; he sees the work of art, but it fails to make any intelligible impression on him; if he were spontaneously sensitive to it, there would be no need for criticism. But now comes the critic with his catalysis. He makes the work of art live for the spectator; he makes the spectator live for the work of art. Out of the process comes understanding, appreciation, intelligent enjoyment – and that is precisely what the artist tried to produce.

<div align="right">H. L. Mencken, "Criticism Of Criticism Of Criticism" (1918)</div>

Picasso said once that he who created a thing is forced to make it ugly. In the effort to create the intensity and the struggle to create this intensity, the result always produces a certain ugliness, those who follow can make of this thing a beautiful thing because they know what they are doing, the thing having already been invented, but the inventor because he does not know what he is going to invent inevitably the thing he makes must have its ugliness.

A creator is not in advance of his generation but he is the first of his contemporaries to be conscious of what is happening to his generation.

<div align="right">Gertrude Stein, *Picasso* (1938)</div>

[T]he presence of Hip as a working philosophy in the sub-worlds of American life is probably due to jazz, and its knifelike entrance into culture, its subtle but so penetrating influence on an avant-garde generation.

Norman Mailer, "The White Negro," *Dissent* (1957)

Modern jazz has developed gradually from social music, and it still has a large popular wing that does not consider its music too serious to compromise.

A.B. Spellman, *Four Lives In The Bebop Business* (1967)

[T]o truly love the music you have to want in on this filthy mess as a way of life.

Gregory Tate, "The Electric Miles (Parts 1 and 2)," *Flyboy In The Buttermilk* (1983)

I appreciate the music, am deeply fond of much of it, but I was not driven to write about it simply from a nostalgic urge (the most sentimental and often misguided corruption of both the past and the present) to talk about a popular music with which I grew up. A hazard lurked, as real as the romanticization of personal memory, behind the allure of writing about something so closely associated with growing up, of being drawn to it simply because one is, naturally, drawn with pain and pleasure to one's childhood and adolescence. Something else, larger and more dispassionately demanding, was what had to be pursued here.

Gerald Early, *One Nation Under A Groove* (1995)

PREFACE

Way Out West

Greg Tate

We now know that what we call Western modernity is broadly derived from the mating, mingling and mangling of cultural traditions created on four continents – Europe, Africa, Asia and the Americas. One could be said to have much to tell us about the absurdity born of reason, one about the reason born of absurdity, one about all the ways science and myth can be seamlessly interpolated, socially, politically, culturally, spiritually.

From one will come Nietzsche, Kafka and Beckett. From one will come Robert Johnson, Ralph Ellison and Jean Paul Basquiat. From one will come Mizoguchi, Takemitsu and Miyake.

The difference between European and African histories of modernity is the difference between witnessing mass murder as a form of industry and mass murder as a form of spectacle. The difference between them is the difference between quantum mechanics and the blues, which may be no difference at all. And then there's the difference born of intentionally disrupting the status quo with dissonance. And then there's Miles Davis, Ornette Coleman and Cecil Taylor – the nominal subjects of this book, who dare to embrace the dissonance within themselves, a dissonance which the status quo defines as disruptive on account of being so black and blue, so architectonic and Zen, so European, African and Asian at the same time.

Miles, Ornette and Cecil – the three wise men of the late twentieth century's Black avant-garde. A triumvirate of iconoclasts around whom Howard Mandel has now drawn a line in the sand – if only because while this grouping now seems inevitable, even logical, it also begs questions of race, musical history, musical difference, mutual antipathy.

But Miles, Cecil and Ornette are hard figures not to bind together, if only because they each represent an idea of Black America as one capable of reconciling its insiders and its outsiders, its familiar faces and its alien ones, its traditionalists and its neophrenics, and of reasoning out the absurdity of how all those blue Blacks are so much less beloved than their blues. (Echoing the song by Roger Guenveur Smith that pondered, "Why does everybody love Black music but nobody loves Black people?")

This book is also about something else – about the education of a serious listener of African-American improvisational music, about how and why and wherefore it is that one becomes something known as a jazz critic. Telling their story is telling his own, a process that refers Mandel back to his boyhood, adolescence, young manhood and to major professional encounters with Miles, Ornette and Cecil – figures whose conversation illuminates their art and renders it even more mystifying. You come away from these conversations convinced of each man's conviction in the provocative directions his music took, its scientific and ritual grounding in the cultural and musical traditions that formed them, and equally certain that they've taken those traditions places that invite incomprehension, wonder and pitched debate.

In his final chapter Mandel addresses the question of whether the avant-garde is "done" in jazz. But his book de facto answers the real question – who could possibly come from jazz today who'd be more avant-garde, more of a Black and blue Outsider artist than Miles, Ornette and Cecil?

Put a gun to my head. Cleave the twentieth century in half. Force me to name two figures who sum up music in the twentieth century. I will have to give you four: Ellington and Monk from the Africans; Stravinsky and Cage from the Europeans. Ellington and Stravinsky teach us how to make small things big, Monk and Cage teach us how to make big things small and even how to make them not at all. Ellington is the one who first calculated how many kinds of blue there were. Monk realized how many different ways you could subdivide them, play with them, rhythmically, harmonically, melodically, timbrally. Miles Davis is the stepchild of Edward and Igor. Ornette Coleman the bastard child of Thelonious, Martins Luther and Luther King and Blind Willie Johnson. Cecil represents the supreme Africanization of Western symphonic music. Anything calling itself avant-garde in jazz would have to be all that and way more.

Now get that gun out of my face, pilgrim.

Musically speaking, twenty-first century popular music already belongs to Billie Holiday, Miles, James Brown, Ornette, Cage, Karlheinz Stockhausen, Cecil, Sun Ra, Sly Stone, Jimi Hendrix, George Clinton and King Tubby. If only because, like Monk and Cage, they all didn't just play the blues but played games with the blues, too. Reminding us of Clinton's dictum that "Everything good is nasty; nothing is good unless you play with it." (Of that lot, Ornette is The One for me and Mandel, though. Because he sounds like all the last century's blues, from the melancholic to the merry, and all the silence surrounding them. Because like Miles, Cecil and God, he don't change for nobody but he could play with any of those people without them having to change for him. Ornette is the avant-garde at its most ecumenical and democratic.)

Yet even given its current crisis of stasis or abject terror at scaling the peaks erected by Davis, Coleman and Taylor, jazz continues to be a source of great cultural

curiosity. Why does this music, an African-American music at that, and even more specifically the African-American jazz paradigm, still matter in this Information Age of ours? Because it continues to privilege self-determination and indeterminacy, insurgency and instability. Because it continues to privilege reason and absurdity. Because it continues to privilege industry and spectacle. Because it continues to privilege quantum mechanics and the blues. And because it continues to disrupt the status quo by being so Black and blue, so good and nasty to play with, so funky. And then again because jazz is what Miles, Ornette and Cecil have done as a way of life for over 50 years, against all the grains and odds imaginable. We need to be reminded, as Cecil tells Mandel, that empires are remembered more for their artists than their politicians, and in the case of our late-stage hypercapitalist empire, its techno-fads, militant fundamentalist plutocrats and professional gossipmongers.

I want: To return to this idea of mass murder as a form of industry and mass murder as a form of spectacle; to suggest that Schoenberg was composing elegies for the Holocaust before it happened and what was left of European humanism after the fact; to suggest Ornette Coleman was composing elegies for the Middle Passage, once described by Arthur Jafa as an 'Auschwitz on the water,' after the fact; and to suggest that Coleman was also composing requiems about the carnivalesque of lynching, and threnodies for the catafalque we've watched African-American culture reduced to in the age of bling, krunk and crack-nostalgia.

I need: To return to this idea of the jazz paradigm: to once again acknowledge that it is in a crisis of stasis. Because like the Harlan Ellison story, it has no mouth and yet it must scream.

I have to ask: So why are there no young Black jazz musicians – as in under 45 – with as immediately recognizable a voice as Miles, Ornette and Cecil? Or Arthur Blythe and Henry Threadgill and David Murray, for that matter? What happened in the 1980s that made identity anathema and technical facility a mask for soul? Why hasn't there been one new standard written in jazz in almost 30 years? Won't blame Wynton Marsalis again; he's merely symptomatic, not causal. It's not a condition of history, either. Because by contrast I can think of at least 30 rappers I'd recognize within two bars or less. I'd venture to say it's the distance traveled from a Black blues culture that used to demand a hint of personality from those who called themselves players.

Betty Carter once told me that in her day the girl in Cleveland who sounded like Sarah Vaughn stayed in Cleveland. The late Andrew Hill observed that the difference between his generation and the current one was that today's players came out of school with enough technique to play anybody's music, but those of his generation developed technique in order to play their own music.

Howard Mandel has done jazz discourse a major service by focusing on the musics of Davis, Coleman and Taylor. Because there is no music more difficult to shed

skin in for 50 years than jazz, or to continually grow new skin patterned as beauti-fully as that which has been discarded. Because we all need to be reminded that their unteachable, gutsy and rigorous desire to take irrational and absurd risks in the name of stamping jazz with a personal sonic signature is the only thing, as Miles relays to Mandel, that the current generation of jazz musicians owes to jazz history and the jazz tradition.

JAZZ BEYOND JAZZ –
THE AVANT-GARDE

You don't like it – but maybe you do. Maybe you can't help it: the sound sticks with you, and you find as you listen again – just out of curiosity, not because you like it – it still rings, odd but true. Yes, the music at first and second and often third exposure seems unlikely, laughable, disorienting, provocative. Yet you listen again.

The trumpet is ragged, fragile, fierce, cracking and crackling. The saxophone bays and probes, mourns and babbles. The piano is sheer madness, rumbling and chiming as it's swept and hammered high and low, finger-runs and forearm-clusters a blur some possessed performer throws down, churns up, explodes.

Probably more than one musician is simultaneously pumping his or her own energies in raucous accord, on who knows what instruments. The ensemble may well be grandiose, gritty and/or glitzy – loud, rhythmically complicated – at full-tilt raging almost beyond control or, grown quiet, desolate as a vacant lot past midnight.

The ensembles' tempers loom darkly, largely. They give fierce howls and wry twists to seemingly innocent sing-songs, disdain comforting harmony and enforce a beat that's physical but not simply steady, tight or diffuse or there's no telling which. The musicians don't blend sweetly together – they raise puzzling, dense, dissonant dins.

These sounds are bound to move you. Which way, though? Towards their source? Or away, to put it at a distance, escape it, turn it off?

This so-called music, in its disinclination to indulge simple pleasures, may resemble what you've gathered of contemporary Western classical-tradition composition; it might be atonal, attitudinal and hermetic, not facing the crowd, reputing common sense and – most infuriating of all! – not-so-subtly assuming its aesthetic superiority; presumptuous, self-righteous, elitist, too head-y for words. It's jazz of some sort, right? Then what's it got to do with old New Orleans, rags and blues, Roaring Twenties bounce, Swing Era tunefulness? With Billie, Ella and Sarah, Ellingtonian elegance, bebop, the precepts of the old school? It's not even cool. This noise must be that "free jazz" you've heard about. This is some crazy music,

abiding no rules, courting few niceties and taking no prisoners. This is jazz beyond jazz, also known as the avant-garde.

Though often associated with the 1960s, this movement actually dates from at least a decade earlier, and its seeds were present in jazz from the start. Free jazz in the early 1960s – when it became notorious enough to rate a nickname – was assumed to abjure hummable tune, flowing rhythm and audience-approved consonance to claim its status as a great-because-difficult art form, politically correct protest, expression privileged by its primal intensity and effect of catharsis. Jazz old fogeys claim this music killed jazz – if they don't think bebop had knocked it off already. It's the music to which several labels were affixed – the New Thing, Fire Music, Great Black Music, among more or less catchy others – but avant-garde stuck.

That French term originally had military significance, meaning forefront troops or advance corps, and, according to Roger Shattuck, it was initially applied by journalists to the artistic iconoclasts of turn-of-the-twentieth century Paris, exemplified by Alfred Jarry, Henry Rousseau, Erik Satie and Guillaume Apollinaire. In *The Banquet Years* (Anchor Books, 1961), Shattuck says the usage originally reflected intellectual France's absorption in the Dreyfus affair (a political scandal in which an innocent, rising young Jewish artillery officer was condemned to Devil's Island through anti-Semitic collusions), but as a categorical concept, "avant-garde" transcends any particular era.

I would argue that transcendence of time and place is the avant-garde's hallmark, that truly avant-garde work is not ahead of its time or in any way alien to its surroundings, but indelibly marks its time, is pertinent to *all* time, and illuminates social context, the circumstances surrounding its creation but also the perspective from which it's received. An artifact of the avant-garde, whenever it is considered following its initial emergence, recognition and celebration (which may occur, if at all, considerably after its first publication or issuance), lives both backward – as prior works are reconsidered in its lights – and forward, influencing innumerable future projects in countless ways forevermore.

Similarly, a document, replication, keepsake or even *mis*representation – whether via book, film or sound recording – of avant-garde activity may have powerful (and unintended) repercussions both near and far from the geographic and mental place of its birth. It may exert its influence as an exotic import arriving from a mythologized distance, or – for those who embrace it most fervently – be treated as a commonplace, familiar, intimate and sacred gesture like a daily prayer, a philosophy of life or a way of being.

In the present day we can date the birth of the jazz avant-garde to the birth of jazz itself, and propose that the entire jazz enterprise, originally and still essentially a product of urban black American culture (though there has never been much ethnically or racially exclusive about that culture) is avant-garde in and of itself.

However, in the first half of the twentieth century people who philosophized about such categories as the avant-garde were completely dismissive of jazz or anything else linked to popular, commerce-driven arts. It wasn't avant-garde, it wasn't art, it wasn't self-conscious cultural expression – it was only good for slumming.

A different view had been expressed earlier. Appreciation of America's vernacular musics as valuable was urged in the 1890s by Czech composer Antonin Dvorak during his tenure at New York's National Conservatory of Music. His advice led to some hybridization of European classical forms with elements derived from African-American spirituals, rhythmic syncopation and blues-inflected harmony, in early twentieth century works by Debussy, Stravinsky, Milhaud, Gershwin and Copland, among others. However, for the most part music created outside the cultural matrix acknowledged by America's most privileged class received seriously short shrift.

Prior to the 1950s, the dominant cultural elite of the U.S. assumed the musical avant-garde, as much as it thought of it at all, to be a movement related to European-born developments such as atonality and Arnold Schoenberg's 12-tone system. John Cage, among American composers claiming avant-garde status, as well as German-born theorist of the avant-garde Theodor Adorno, held disdainful if severely misinformed impressions of jazz, plus had no ear or heart for it.

Yet in retrospect Jelly Roll Morton's 1926 charts for his Red Hot Peppers easily stand as avant-garde; in terms of expansive, genre-defying concept and virtuosic realization, only a handful of chamber music or symphonic scores by Americans *or* Europeans in that era compare. Louis Armstrong became widely accepted as jazz's main man and America's most beloved representative almost immediately upon emerging as a name in the mid-1920s, so the avant-garde label doesn't quite fit, whereas Duke Ellington's compositions for his Cotton Club jungle band of 1927 were and are avant-garde, because they were so different from other music – even Jelly Roll's and Armstrong's.

And so on. Tenor saxophonist Coleman Hawkins can be dubbed avant-garde, as a cogent, virtuosic, original and uncompromising soloist in the 1930s who pioneered vast areas for other instrumentalists to explore and develop; his tenor saxophone contemporary Lester Young qualifies as avant-garde in light of the enormity of the alternative he proposed to Hawkins' prevailing mode. Pianist-composer Thelonious Monk was avant-garde despite the fact that he was a sideman for Hawkins, by the end of the '30s the most widely heralded jazz musician, not a struggling unknown; Monk, Charlie Parker, Dizzy Gillespie, Max Roach and their associates were avant-gardists, instigating the evolution – revolution? – of bebop.

But when the avant-garde term was first applied to jazz, it was affixed to the works of white players such as pianist Lennie Tristano, who recorded self-consciously unpremeditated small group improvisations in 1949, and Stan Kenton, whose 1947 Progressive Jazz Orchestra and 1949–51 Innovations in Modern Music Orchestra (43 pieces including strings and an enlarged wind section) showcased

complex scores drawing on twentieth century Western European ideas. With black jazz musicians such as pianist John Lewis of the Modern Jazz Quartet demonstrating affinities for Western European material and forms in the 1950s, composer and jazz historian Gunther Schuller coined the phrase "Third Stream" to cover the convergence of Western European classicism and jazz. In the mid-1960s the racial nuance governing the use of the term "avant-garde" changed again. This label became as shorthand for turbulent, form-breaking improvisations – also called free jazz, the new thing, black music – associated with social movements bespeaking freedom and liberty, particularly those promoting civil rights and black nationalism.

To cut through the conundrum of race confused with aesthetics, George Lewis, the Chicago-born, Association for the Advancement of Creative Musicians-bred improviser-trombonist, computer-music composer, installation artist and professor of music, in his comprehensive article "Improvised Music After 1950: Afrological and Eurological Perspectives" (*Black Music Research Journal*, Vol. 16, No. 1, 91–122. Spring, 1996) brings attention to Ortiz M. Walton's *Music: Black White & Blue* (1972). Walton recognizes African-American bebop innovators of the early 1940s as fundamentally contrarian – a trait frequently associated with the avant-garde – for having "posed potent challenges to Western notions of structure, form, communication, and expression."

Lewis conceives the terms "Eurological" and "Afrological" to identify contrasting musical belief systems and behaviors. He reports that white Eurological composers such as Cage – who began to employ improvisation ten years after black Afrological beboppers advanced that practice to prominence – may have been radical enough to critique and disassociate from the European-based classical tradition, but they did not break with those traditions so far as to identify with jazz musicians or otherwise bridge any Euro/Afro divide.

As Lewis construes his Afrological matrix, it is transnational and transethnic. Yes: jazz specifically sprung from those people Albert Murray calls "Omni-Americans" – whom I take as Americans who want to claim and/or partake of everything available and relevant to their present nationality, more than their racial or ethnic ancestry. Yes, they may also be or descend from white European immigrants, but "acquire basic American characteristics . . . part Negro and Indian." Add part Asian, part Middle Eastern, too. Omni-American culture is not to be defined by the skin tone, racial, religious or ancestral background of its adherents, but rather inferred from their values, practices and self-identification.

Jazz attracted Americans of Western, Eastern, Caribbean, Hispanic and every other descent as both creators and appreciators from birth. Pre-jazz American music of the minstrel show, the vaudeville stage, the brass band, the ragtime piano, work camps, taverns, brothels and tent meetings was a multi-culti thing, too. While jazz remains a gift from black America, fluidity is one of the chief features of its

design, and one of the most gratifying facts of its history is that by the twenty-first century it's become embraced as a music for and of the whole world.

New jazz styles, stars and stimuli have been acknowledged and accepted from abroad since the 1930s – gypsy guitarist Django Reinhardt, Machito and Mario Bauza among a large contingent of Cubans, pianists George Shearing and Marian McPartland from England, trombonist Albert Mangelsdorff and keyboardist Joe Zawinul among those from Austria and Germany, Swiss guitarist–harmonicat Toots Thielemans, Hungarian guitarist Gabor Szabo and Japanese pianist–composer– big band leader Toshiko Akiyoshi are some of its avatars. Since World War II jazz has spread rapidly; today jazz has footholds everywhere. Still, and any hype to the contrary, new jazz ideas are specially validated – and not just for the hard-core American jazz community, this being the whole *point* of the validation – when black American musicians respect and condone, adopt and adapt them.

Jazz is without question what George Lewis inclusively defines in his article as "Afrological" music, proceeding if not arising from premises radically contrary to the Eurological foundations of the music that preceded it, and making a great break from Africa, too. As such it is music that presupposed a new land, a collectively dreamed vision of what America might become. In that vision and in the practice of jazz, black as well as white musicians are free to adopt and adapt "Eurological" traditions – to which, as Americans, they have every right. In the early twenty-first century that vision has continued to take root. Personal observation suggests the audience for avant-garde jazz is thick with college-educated, arts-absorbed, socially engaged, and racially, ethnically and nationality-neutral quasi-bohemian jaded idealists.

As if in reaction to this self-selected Omni-American strain, though, some jazz musicians and followers have convened a confederacy that has given a stubbornly hard time to the three musicians who are the focus of this book: Miles Davis, following his plunge into electric amplification and what were deemed to be pop-music forms, and Ornette Coleman and Cecil Taylor, for venturing beyond the border lines of what was long regarded as jazz's staked out territory. As critic Stanley Crouch has mentioned, the adventurers, scouts and explorers of new frontiers sometimes don't come back. Crouch, among wary others, has suggested that dangers of failure and cultural betrayal lurk outside the basic jazz conventions of ballads, swing and blues, and that it may be best not to go there. One might fall off the edge of the jazz world.

But in the early twenty-first century, as during other eras of social stress and change, those who do dare to venture into the unknown, to press on where no one else has, to aim for far horizons, open new perspectives or simply leap into the cold, rough, onrushing waves of possibility deserve a modicum of regard. They are experimenters, researchers, pioneers, trailblazers, mapmakers, prophets and seers,

offering us impressions and maybe intelligence from the front, guiding us where we can only go: forward.

It's easy to dismiss any art form's avant-garde as wild and wooly, uncontained and uncontainable. In the jazz avant-garde from the 1950s and '60s to today, the music has been known to go on and on like a guest whose rants outstay his or her welcome, demanding attention to some rude, unrewarding, self-declared genius. Yet there are fans of long experience and discriminating (if not collectively agreed upon) taste who eagerly seek these sonic blasts as nourishing life-enhancements. As the initial shock of hearing Miles, Ornette and Cecil – or Albert Ayler, John Coltrane, John Zorn, members of the Association for the Advancement of Creative Musicians, the Spontaneous Music Ensemble, the Globe Unity Orchestra – wears off, you may find yourself among them.

You didn't like it – but maybe you did. Maybe you've come to hear it another way. Maybe the music excites you. Maybe you revel in the bold directions it takes, the imaginative speculations it spins, the heightened passions it conveys live and/or on record. Maybe you've already encountered this same energy level or something like avant-garde jazz's unflinching rigor and flagrant lyricism in inspired rock 'n' roll, rhythm 'n' blues, rap, trance, religious musics or indigenous sounds from some remote corner of the earth, in contemporary or historic classical composition. Maybe you're fascinated by the lines of empathy encircling these musicians, be they tangled, layered and knotty. Maybe you embrace the prickliness of its iconoclasm, the thrills of its leaps to extremes, its charms as the challengingly strange. Maybe you wonder about the people making these sounds. Who are they? Why do they do this? How did they arrive at it? Is anyone else listening?

Of course – many. You are not alone. No one grows up automatically attuned to the most foreign sounds around; the best we can hope for is ears and mind that perk up rather than close down when something unusual veers into range. If we're lucky, curiosity is the default setting of the senses, and if we're the least bit adventurous, we'll indulge inquisitiveness that seems to promise new delights. At least that's my own story.

I was born in 1950, and my early, immediate childhood experience of music was slight. I liked banging on my grandmother's baby grand, and recall that once as a tyke, hearing a sax spooling out a long line over the car radio, I imagined I could race along with it like following the bouncing ball during a cartoon sing-along. A little later novelty rhythm 'n' blues radio hits snagged me – "Alley Oop," "Charlie Brown" and "Duke Of Earl" remain with me still.

I had no idea while in grade school on Chicago's South Side that the urban blues flourished almost literally across nearby Stoney Island Avenue, and my discovery as a teenager of strange, dramatic music by members of the Association for the Advancement of Creative Musicians (AACM) in the neighborhoods around the University of Chicago was a surprise.

In my twenties, I was thrilled to be asked to write overnight reviews for the *Chicago Daily News*, and devoted myself to reporting on music, alerting general readers to what was new-as-in-news from music-makers around town. Five years of that fun gained me editing jobs at *Down Beat* and *Billboard*, and eventually *Guitar World*, *Ear* and *RhythmMusic* magazines – at each stop and with each freelance assignment for the *Village Voice*, the *Washington Post*, and international publications like *The Wire* and *Swing Journal*, I'd listen harder, seek out answers to my questions and trust that asking the musicians themselves might result in information that could contribute to a better understanding of, if not by itself illuminate, what was happening with noise, rhythm, funk, history, tonality – things of which neither you nor I are born expert.

Somewhere between 1966 and 1980 these endeavors became my career, and my predilections fixed my attentions on three magnetic poles. Miles Davis, Ornette Coleman and Cecil Taylor loomed over my listening like colossi. But rather than forbidding gatekeepers guarding against entry to exclusive lands beyond, they stood at trailheads leading into fertile, far-unfolding fields, regions of tests but also rewards, the experience of which could only increase my grasp. My pursuit of their musics became avid, and resulted eventually in opportunities for me to speak with each of them. The opportunities varied in direct relationship to their interests in revealing themselves, and consequently the sections on each of them that follow take different forms, with different tones.

I only spoke at length with Miles once – the entire interview is a full chapter, later on. I got to know Ornette better, encountering him often, interviewing him roughly every five years, and I offer one full tutorial in harmolodics besides excerpts of our talks amid analysis of his work and discussions of it by other musicians. In his audiences with me, Cecil has become more direct over time, but so many people complain that they just don't get his music that I've offered strategies on how to listen to it. Maybe these diverse approaches will confuse you, but maybe they add up to a unified view of jazz beyond jazz, as they're all mine.

Miles Davis, Ornette Coleman and Cecil Taylor are an internationally known triumvirate. They are three black Americans born within just a few years of each other although into distinctly different milieus. They are contemporaries but not collaborators, nor quite rivals. Each in their own personal ways have drawn on the vast treasures of arts and culture, popular and esoteric alike, combining Afrological and Eurological traditions in varying degrees to arrive at sounds animating the present and illuminating paths to the future.

They are individually revered icons to those who pursue alternatives to the vigorously promoted and overwhelmingly embraced corporately directed culture of America – the hit music, mainstream movies, commercial television and market-researched phenomena that have flooded us for half a century (maybe not coincidentally, just about when Miles, Ornette and Cecil edged out of sub-culture obscurity into a wider, if still cult-focused, spotlight). Miles, Ornette and Cecil have also been

the recipients of international honors, and Miles unusually earned fame and fortune in the commercial cultural marketplace, but overall their capital in the bazaar of consumable merchandise or eternal ideas remains undervalued. Consider:

- Miles – In mid-career, renowned as the most sophisticated tastemaker of modern music, he utilized new instruments and innovative recording-studio techniques to reach avid young audiences and re-ignite the already raging aesthetic of the 1960s. With a blast of insinuating trumpet and flash of street-tough attitude intimating pseudo-Satanic majesty, Miles fired up fusions of electronica and exoticism, street sass and rarified tenderness, psychedelic fantasia and spooky narrative. Conservatives claim the 20 final plugged-in years of Miles' career were a waste, yet his influence more than a decade after his death has not waned.

- Ornette – A Johnny B. Good/Mr. Natural font of humanistic musings, he has unleashed melodies of everyday joy, sorrow and psychological acuity with now acknowledged as classic small groups and a little condoned highly amplified octet – as well as with the Grateful Dead, the New York Philharmonic conducted by Kurt Masur and magician-tricksters from the hills of Joujouka, Morocco. An oracle in conversation as in music, Ornette upsets one commonplace after another to construct a unified field theory of music he's called "free jazz," "harmolodics" and "sound grammar," contending that humans seek unisons however dissonant their initial cries, and inevitably arrive at resolution by the end of their life-songs. Coleman is beloved by artists of all stripes, although critics have frequently dismissed his observations as mumbo jumbo. For decades caught between controversy and indifference, late in life he has been bedecked with awards.

- Cecil – The epicurean aristocrat of the piano, reviled by jazz's canon-makers as if he were the Marquis De Sade, he was raised as a child prodigy, given access to the African-American cultural elite and provided a proper New England Conservatory education. His incisive intelligence and uncompromised commitment to his concepts have resulted in a radical restructuring of his instrument, of composition, of solo and group improvisation, of performance practices and all standards applicable to musical command. Yet he's routinely overlooked, ignored or slighted by commentators in favor of lesser, ostensibly more marketable talents.

While groundbreaking musics of Miles, Ornette and Cecil have been praised by a global intelligentsia that refers to the artists by their first names alone, their genuinely avant-garde positions have been generally downplayed by establishment forces. Their mutual marginalization is evident, for instance, in the way their careers of innovation are given brief mention in documentarian Ken Burns' *Jazz*. This 19-hour television series – aired in 2001, commissioned by the U.S. Public Broadcasting

System, sponsored by General Motors with further funding from government agencies and major philanthropies – was afforded broader dissemination, including workshops in public grammar schools, than any other jazz history in any medium. Miles is lionized, then abandoned; Ornette and Cecil can be missed if you blink.

Why do Miles, Ornette and Cecil still rile defenders of convention when the works of other artists initially derided as avant-garde – Gershwin's "Rhapsody In Blue," Stravinsky's "Histoire du Soldat" and "Ebony Concerto" for Woody Herman, Tristano's "free" quartet experiments and Kenton's bombast, for example – are de-fanged and assimilated after much briefer periods of controversy? Will Miles, Ornette and Cecil's renegade ideas – various tagged as "trendy and dismal" (Crouch on later Miles), "an unmitigated bore" and "jiving'" (Andre Previn and Roy Eldridge, respectively, on emergent Ornette) and "bullshit" (Branford Marsalis on Cecil) – ever be tamed, and sometime later deemed tired? Is there something basic to their sounds and concepts that holds them ever removed from the grasp and taste of the general population, thus increasing their worth among those who seek antidotes to the status quo, rendering them high priests of an eternal avant-garde?

To be sure, Miles, Ornette and Cecil are American originals. They didn't record with each other, had only glancing social interactions and constitute no school. Very few musicians – tablaist Badal Roy, saxophonists John Coltrane and Dewey Redman, trumpeter Wallace Roney, drummers Edward Blackwell, Ronald Shannon Jackson, Elvin Jones and Max Roach – have collaborated with more than one of them. Miles, Ornette and Cecil have each instituted their own ideals, goals, structures, strategies and processes, and haven't even had all that much nice to say about one another (although few disparaging comments drop from Ornette's lips).

Still, these three independently and simultaneously revolutionized jazz beginning in the 1950s and continuing past today. They infuriated other jazz musicians such as Charles Mingus and Roach (in his first reactions to Ornette) who thought of themselves as glints of the cutting edge, even as they've inspired artists in other fields as disparate as film director Louis Malle, composer Leonard Bernstein, painter Robert Rauschenberg, novelist Thomas Pynchon, dancer Mikhail Baryshnikov, monologist Laurie Anderson and proto-punk rocker Lou Reed. They've come to be considered gods or gurus as well as devils and fools by competing contestants for the keys to cultural power.

Miles Davis was a star in near-constant transition, a moving target intent maybe from the moment of his precocious arrival as trumpeter to bebop instigator Charlie Parker on attaining the heights of his game. He established and sustained his primacy and became emblematic of the avant-garde by promoting the integrity of his personal sound, while relentlessly shaping (and being shaped by) backing bands he organized to contextualize it. At career start Miles was painfully aware of his technical limitations, but also canny about turning them into strengths. In his mid-1950s' breakthroughs as a leader he made the most of the atypical "vulnerability" of his

brass attack, and by 1959, when he recorded *Kind Of Blue*, he was so wise as to devise his own rules by which other musicians had to play.

Miles from his early midlife in the mid-1960s to his end relied on musicians of a younger generation to stretch his horizons, as he depended on composer–arranger Gil Evans to orchestrate his successful albums *Miles Ahead*, *Porgy And Bess* and *Sketches Of Spain*, on composer–producer Teo Macero to shepherd *In A Silent Way*, *Bitches Brew* and *On The Corner* to completion, on a bevy of protégés, flunkies, kinfolk and lovers to keep him going, but only on himself for the marrow of his music. In the later 1960s, refusing to resign his self-designated post as most influential instrumentalist of popular modernism, Miles embraced technological advances and social realignments, championing a stylistic shift that convened a coalition audience of listeners who identified with and eventually integrated distinct factions of America's so-called counterculture – a loose and voluntary amalgam that included anti-authoritarian and fashion-driven, disenfranchized and self-indulgent, hedonistic and militant, articulate and inchoate, Afro- and/or Latin-centric separatist and militantly liberal, pan-racial splinter groups.

In the mid-1970s, unable to counter these movements' spent trajectories and ridden with persistent health problems, he became depressed, drugged, unproductive and reclusive. Miles returned to action after five gloomy years almost despite the urging of Dr. George Butler, vice president of artists and repertoire for Columbia Records, his long-time company. The entreaties of Miles' 20-something nephew Vince Wilburn and the kid's friends may have been more effective than Butler's, as he could take the young men to represent a new consumer base eager for his return.

Miles in the 1980s was often derided for selling out, for trashy taste, for egregious showboating – but he continued to produce frankly instrumental pop music with a devil-may-care insouciance, and he never bothered to sound like anyone else. Few of Miles' latter albums are completely satisfying, but if he repeated himself in any way besides playing repertoire such as Cyndi Lauper's anthem "Time After Time" and Michael Jackson's "Human Nature" night after night it was only at the conclusion of his life, when, encouraged by Quincy Jones and an enormous paycheck, he revisited past touchstones at the 1991 Montreux Jazz Festival.

Prior to that, Miles' albums *Decoy* (1983), *Aura* (1985), *Tutu* (1986) and *Amandla* (1988) effectively introduced fresh approaches or consolidated his moves in unusual context. Burgeoning fresh talents (guitarist John Scofield, multi-instrumentalist/producer Marcus Miller, electric bassist Joseph "Foley" McCreary, reeds player Kenny Garrett) and some of his longtime associates (arranger Gil Evans, guitarist John McLaughlin, drummer Al Foster, actress Cicely Tyson) helped him re-invent himself. Even *doo-bop*, his unfinished last recording, retains his inimitable sound as he set to grappling with the idioms of rap and hip-hop like no other jazz artist has, even by 2007.

Miles' posthumously-released "complete" recordings – resplendent boxed sets of his classics, with out-takes and ephemera – are prized collectibles, maybe most of all to baby boomers who correlate their significant life experiences with earlier releases of the material and would, if they could, relive highs of years gone by. But his sound remains instantly identifiable, piquant and haunting, its thrills undiminished and aging well, no less remarkable despite ubiquity, appropriation or worship by mass-culture. Post-boppers and punks, funkateers and alt. rockers, gangstas and neo-soul stars all claim him as a progenitor.

Ornette Coleman – performer–composer and unbound thinker – is as compelling a figure as Miles, although of radically different background and temperament. Ornette's approach to life, his art and his career are of a piece, unique, but enacted as if each unprecedented step were entirely commonsensical if not inevitable. He can rightly state he's only been trying, all along, to freely, peacefully be who he is. He comports himself as gentlemanly, genuine, imaginative, assured in his views and uncommonly wise (or surpassing all understanding).

Ornette's singularity has been hailed and denounced in nearly equal measure since he first ventured beyond his "poorer than poor" home on the wrong side of the cattleyard railroad tracks of Fort Worth, Texas. He began his career as a honking soloist with black rhythm 'n' blues dance bands touring low-level venues throughout the southwest, but with mixed results: in 1949, for instance, he recorded a slew of original songs, but was fired by his band-boss and run out of town before he got to hear the playbacks (the tapes were never issued, and have not been found). Ornette's listeners have always had extreme reactions to his music, some being fascinated by his sound, others outraged by the notion he's putting them on. Impoverished, discouraged, strangely clad and unkemptly groomed during his 1950s' residency in Los Angeles, Ornette was ostracized even by musicians who might have been expected to be more prescient or progressive, and survived only through the efforts of his closest coterie.

When he arrived in New York City in 1959 to play a two-week gig at the Five Spot jazz club on the strength of his debut albums for the independent West Coast record label Contemporary and the good will of highly respected pianist John Lewis of the Modern Jazz Quartet, Ornette was feted as a genius by a predominantly white artistic elite while scoffed at by many of his black jazz elders and peers. Some of his supporters may have let themselves be dazzled by his superficial eccentricities, but surely others were genuinely excited by the vigor of his music, which dispensed with such presumed basics as regular chorus lengths, cyclical chord changes and strict requisites of "proper" intonation.

Neither approval nor disapproval stopped Ornette from disputing music as it had been; instead, he was motivated to ask ever bigger questions. Blessedly inner-directed, he instituted his own concerts, his own artists' house, his own record label and a fee structure he felt adequately paid him for his labors. Besides writing

sheaves of tunes that have by now established themselves as treasured jazz reper-toire, Ornette ventured into chamber and orchestra music, as early as his Town Hall concert of 1962 averring that no gulfs separate musical impulses by genre, and that jazz and classical music could also meld with rhythm 'n' blues.

Self-taught on saxophone, violin and trumpet as well as in composition, Ornette has allowed nothing to deter him from his quest of self-realization, and he's encour-aged collaborators to play equally free of a priori bonds – although not without meaning or discipline. His concerto grosso *Skies Of America*, debuted in 1971 and revived in Fort Worth, New York City, Verona and Japan in the 1990s, extends that mandate even further, to symphony conductors and instrumentalists.

Ornette has been lauded by critics and scholars, has received fellowships from the John Simon Guggenheim Foundation, the MacArthur Foundation and the Grateful Dead's Rex Foundation, has been honored by the government of France as well as with the Dorothy and Lillian Gish Prize, the Japanese Praemium Imperiale and, in 2007, both a Grammy for Lifetime Achievement and a Pulitzer Prize. Yet much of his music – including legendary meetings with native musicians of Morocco, Madagascar and China – has been created virtually in private, documented on per-sonally held recordings and remains unheard. He has vowed common cause with practices of shamans from non-Western cultures to produce states of transcendent consciousness, and reads up on advanced Western scientific discoveries, philoso-phy and metaphysical speculations. He has linked himself with such thinkers as mathematical cosmologist Buckminster Fuller and educator–spiritualist Rudolph Steiner. Ornette's ideas, musical and otherwise, may or may not strike one as useful, beautiful or true, but they are indisputably striking and his own.

Ornette has developed his overriding insights in acoustic quartets, trios, quin-tets, a double-quartet (on the album *Free Jazz*), chamber ensembles and orchestral settings, and also with his electro-acoustic band Prime Time, featuring electric gui-tars, basses, drums, Indian tablas and keyboards in orbit around the nucleus of his own performance. The efforts of this ensemble, first issued on the LP *Dancing In Your Head* in 1975, have confounded many of Ornette's earliest hard-won fans. Yet Prime Time has spun off at least two generations of acolytes who seem destined to continue the dissemination of Ornette's polyphonic, mind-stretching effects.

He is a self-reliant individualist in the approved American mode by virtue of his unbending commitment to his vision. He's tough, persistent, but not what any-one would call rugged; Ornette (like Miles and Cecil, too) expresses in his music vulnerability and the search for solace, elements of the blues, as well as the gifts of comprehension, empathy and celebration. He has inspired admirers and followers but no copycats, having established an example of being true to himself that pre-scribes others do likewise. The concepts he's called "harmolodics" or "sound gram-mar" may or may not gain traction, but Ornette's blues-inflected melodies and

harmonically liberated flights are established as marvels, compelling and wondrous, inimitable by design.

Cecil Taylor is perhaps the thorniest and most controversial of these three independent composing, improvising, ensemble-leading artists. Serious students of the piano and spontaneous improvisation regard him as one of the major re-definers of any expressive art to emerge in the past 50 years. His imposing and well-defended personality, however, has tended to ward off close study of him since the lengthy profile A.B. Spellman included in his 1966 book *Four Lives In The Bebop Business*, though some insights can be gleaned from the comprehensive annotation of the 11-CD boxed set *Cecil Taylor In Berlin '88* (FMP) by Steve Lake, Bert Noglik, Ekkehard Jost, H. Lukas Lindenmaier, Daniel Werts, Jost Gebers, photographer Dagmar Gebers and several musicians.

Cecil is not an easy man to get close to or portray. Most published interviews depict him as guarded, attitudinal and/or elusive. In my experience he has rambled. When asked about his history he starts with his mother's expectations, enforcement of rigorous practice and initiation of him into expansive worlds of art, then segues to his New England Conservatory studies and autodidactic initiatives, his cynicism regarding America's understanding and acceptance of African-American culture, his fledgling forays into jazz with swing-oriented players such as Hot Lips Page and Johnny Hodges, his gradual discovery of simpatico experimentalists including soprano saxophonist Steve Lacy, bassist Buell Neidlinger and saxophonist Archie Shepp. And he's just begun. His range is vast, encompassing knowledge of arcane interests and things as elemental as the forces of nature and organic processes.

He veers away from explaining anything about himself, deflecting self-exposure with witticism and obscurity. Only by listening closely, in sequence, to his early oeuvre can one discern how his music evolved in rather incremental steps from his not-quite-ripe yet nonetheless distinctive self-produced recording *Jazz Advance* through the surprisingly amiable quartet album *Looking Ahead* (co-led by vibraphonist Earl Griffiths) to disaffected variations of Cole Porter standards such as "Love For Sale" (from 1959) and Ellington's "Things Ain't What They Used To Be" (1961), to the flat-out improvisational drive of his trio at Denmark's Café Montmarte in 1963 and finally the intricate, unique ensemble works *Unit Structures* and *Conquistador*, recorded, respectively, in May and October of 1966.

Jazz has seldom witnessed a comparably total reconception, if not outright refutation, of its bedrock assumptions regarding melody, harmony, swing, instrumentation and orchestration as presented on those albums of Cecil's – neither has any other genre of music. At the time of their release, during the height of the civil rights era, his music was often disparaged as being more akin to contemporary European (read: white) composed music than to anything emerging from black Americans (whether black Americans were being better represented by Marvin Gaye – whom

Taylor admires – or Charles Mingus – whom he didn't much like – was seldom stipulated). Cecil himself abjured racial stereotypes, alluding to his Native American and Scots–Irish ancestors as well as his African-American ones, and crediting (white) Tristano and Dave Brubeck as well as (black) Ellington, Monk, Art Tatum, Bud Powell, Erroll Garner and Horace Silver as formative influences.

He ascertained, during overseas forays in the early 1960s, that foreign audiences were more receptive to his project than U.S. listeners (though he had packed houses at New York's Five Spot several years before); he subsequently inspired and eventually connected with an increasing circle of European-born and -based (though maybe not entirely Eurological) musicians who admire his galvanic energy and are unfazed by his bracing juxtapositions of assonance and dissonance. Still, Cecil's style asserts one of the irreducibly African-derived elements of African-American jazz – percussive, propulsive, imperious rhythm – as central to his art.

He has also dedicated himself to completely revamping how the piano is played, inventing a signature vocabulary that is louder, softer, faster, slower, more repetitive, less vernacular, more complicated and liable to rove farther afield than any other composer–improviser's in history. One might find precedents for Cecil's pianistic extrapolations in Scriabin's preludes (harmonically exploratory, technically demanding, but rather brief) and sonatas (wafting from secular serenity into the deeply mystic) and the first movement of Ives' *Concord Sonata* (dense, energized, contradictory, propulsive, then spinning off in a different direction entirely). But as a spontaneous rhapsodist, Cecil is peerless. Neither Keith Jarrett nor Fredric Rzewski, two of his contemporaries mining superficially comparable veins, can touch him. Cecil's music, whether he's playing alone, with loyal collaborators or unfamiliar but seasoned ensembles, is uncompromising, and to listeners who have found their ways to it, precipitously lyrical.

Cecil has had academic appointments at University of Wisconsin and Antioch College among other institutions, but it was the MacArthur Foundation grant he received in 1991 – not his international concertizing or vast catalog of recordings with musicians from Great Britain, Germany and Africa as well as the U.S. – that assured his financial security. Swing Era pianist–composer–arranger Mary Lou Williams, bebop drummer Max Roach and English expatriate Marian McPartland (as host of the National Public Radio series "Piano Jazz") are among the well-established musicians who've extended themselves toward Cecil, but he has suffered much shunning by conservative forces in jazz and contemporary concert music.

In spring 2007 he performed for the first time – on a bill with fellow MacArthur Award-winner but dissimilarly avant-garde saxophonist and composer John Zorn – under the auspices of Jazz at Lincoln Center, which its artistic director–trumpet star Wynton Marsalis calls "the house that swing built."

Since its inception in 1988, Marsalis' jazz center has skirted involvement with the avant-garde; no Miles-influenced electric jazz has ever been allowed, Ornette's mu-

sic has been performed by the Lincoln Center Jazz Orchestra, but Ornette himself has not been onstage, and Marsalis did not show up to welcome Cecil and Zorn on their two nights at his institution. Marsalis may or may not think Cecil swings, but the pianist has exerted direct and profound impact on a legion of other musicians, most of whom also stand firmly outside conservative and restrained jazz styles, and are rarely heard in mainstream venues.

Such a fate doesn't leave someone labeled avant-garde, like Taylor, Coleman or Davis, ahead of his or her time. That very concept is dubious; unless we believe in time travel or fortune telling, each human is *of* his or her own time, not "ahead" of it, however prophetic or visionary they may prove to be. If we cling to the admittedly debatable proposition that there's progress in human events and endeavors (maybe even if we don't), it can only be that the times – defined by the interests and attentions of the overall social, cultural and commercial milieu – have not always kept pace with an era's most significant activists. That does not indicate that the person with the new ideas is isolated because of his/her inventions and innovations. Few jazz musicians have been so much of their time as Miles, but he produced much for us to chew on in the future, too.

So the following pages are meant to illuminate the accomplishments and legacies of Miles, Ornette and Cecil, with concentration on aspects pertaining to the avant-garde, by referring to their lives, by quoting their words, by attending closely to their recordings and by relating some of my personal encounters with their arts. Critics can't actually remove their personal preferences and/or histories from their considerations; typically we mask our involvements by constructing arguments that pretend to be objective, distanced from the intimate and subjective perceptual experiences that result in our individual tastes. We all know, though we may deny it, that effort is a charade.

I hope my memories of introduction, revelation and connection to the musics of Miles, Ornette and Cecil are instructive, maybe reflective of the experiences of others coming into contact with these sounds. Maybe my stories will ground Miles', Ornette's and Cecil's musics in the years I've lived with them – 1960s to 2007. Maybe this strategy is unconventional, but as I put together this book, re-examining old reviews and articles (if I quote them extensively, the date of their composition or publication is cited), trying to weave thoughts that have retained some bit of relevance into an informative and readable flow, it became inescapable. There's nothing avant-garde in this decision; I'll just chance that it works. One thing I've learned from Miles, Ornette and Cecil is to plunge on past debilitating fears of failure. Maybe they never had such fears; certainly they let nothing stop them.

Miles, Ornette and Cecil provide many lessons besides that one to those of us in their sway. They've taught by example the importance of self-reliance, critical thinking applied to encrusted assumptions, belief in ourselves above others. Maybe, due to some advantage they've gained by confronting the world as their instincts

reveal it, the work they've done that's been called avant-garde will prevail. Maybe their so-called avant-garde points of view will win common currency and, eventually, dominance. Maybe their musics, so challenging in our day, will come to be taken for granted. Maybe their musics' precepts will in turn be challenged – and an insurgency against them as received opinion will be launched. Maybe the standards of what was once avant-garde will be exceeded or overturned; maybe the boundaries that stopped Miles, Ornette and Cecil, hardly perceptible at this time when we remain awed that they've created as freely as they have, will be breached. If that happens and the musics' fires burn out, they will be old news, avant-garde no more.

But until then, Miles, Ornette and Cecil, individually and all together, should be celebrated for having given us tunes, tones, timbres and trends that contribute to the whirl of present and future soundtracks. These three are among the enduring avant-gardists – artists whose works still amaze and confound us – from all eras and cultures in the world not quite past, still within reach. The basic materials from which their avant-gardes have been created are, in any event, available to everyone.

Story to the point: On a cloudy, chilly day early in 2006, walking on Bleeker Street in Greenwich Village, I found myself a couple of steps behind a slightly bent, older man – Ornette Coleman. With one or two strides I caught up and said hello, as I've done every chance I've gotten since first meeting him 30 years ago, but this time I had the sense I'd interrupted his reverie.

"Howard," he smiled in recognition after a moment, then asked directly, "do you play every day?"

"I play a flute almost every morning," I answered, shy to admit my pleasure. I'd taken up flute at 16, having had piano lessons since age 10, and I studied electronic music at Syracuse University in a well-equipped Moog studio. But I don't brag about it, and Ornette didn't know it. "What I've been more involved in is writing about you for an upcoming book. About you and Miles and Cecil – how you all were working around the same places, during roughly the same time period, but each came up with such different musics."

"Ah, yes," he said, sagely, "isn't that something? We each came up with our own music – and all using the same notes."

MILES DAVIS, DIRECTIONS

Miles, Chicago Jazz Festival, 1990 ©1990 Marc PoKempner.

Me and Miles – un-cool confessions[1]

I first met Miles in my buddy Bob Seigel's basement rec room in 1965. Red Garland, Oscar Pettiford and Philly Joe Jones helped with the introduction. Bob's dad was a psychologist who listened to some jazz, and had given his son *In The Beginning*, Miles' quartet album of 1954, which my pal passed on to me after we listened to side two while playing Monopoly and I told him how much I liked it. He didn't think it was so great.

We were 14, and I had very definite ideas about music – I'd recently lost my first girlfriend to the plague of Beatles popularity. Carol was all caught up in the "Yeah, yeah, yeahs," which I, an adolescent philistine, sneered at for being less accomplished than trumpeter Donald Byrd's *A New Perspective*, her father's copy of which we'd listened to while playing ping-pong in her basement. She started dating a guy who took orders at a Chinese take-out place, as I learned when I'd gone there to pick up dinner for my family one night. When she made it official, I went to see another of my pals, Allen, who was adept at picking out songs by the Beatles, the Rolling Stones, the Lovin' Spoonful and the Animals on his family's piano. We sang to soothe my laments for a while, then I went home. If I'd had it, I would have slipped Miles' *Kind Of Blue* on the stereo.

But I didn't, so I probably listened to the radio. These were the days of Motown, Aretha Franklin's Atlantic hits and Dionne Warwick's sweet singing. Or I listened to Herbie Mann's "Comin' Home Baby," from *At The Village Gate*, or Ramsey Lewis' "The In Crowd." I liked the pulsing bass and windy flute on Mann's record, and Lewis' casually bluesy piano playing gave me another taste of those sounds I heard passing through the black neighborhood on the other side of the commercial boulevard from where I lived on Chicago's South Side. Besides, "The In Crowd," recorded live with the clink of glasses and listener's oohs and aahs, was all about a smart set, and I longed to be part of one some day. Pudgy, pimpled and a notorious wise-ass, I figured I stood a very slight chance. Still, I was proud enough to an-nounce, not suppress, my unpopular tastes.

I was sure, for one thing, that the Beatles were a passing fad. My parents enjoyed Broadway show music, and it wasn't until *Revolver* that I was convinced Lennon, McCartney and Harrison were worth considering as songwriters alongside Rodgers and Hammerstein, Lerner and Lowe, George and Ira Gershwin, Cole Porter and Frank Loesser. Anybody could sing "Yeah, yeah, yeah" – Allen and I proved that. Most early Beatles tunes were mere ditties. I didn't recognize their bright spirit as anything special or enduring. Real, composed music – like the stuff the passionate Russians Tchaikovsky and Rachmaninoff wrote – was something else. And improvis-ing melody must certainly be an art.

That's where I was when I found *In The Beginning*. Garland opened "A Gal In Calico" with luminous block chords that caught and held me – I can still hear them in my mind whenever I want, remembering them as handfuls of pearls pulled from the sand and rinsed clean in the pianist's palms. Ramsey Lewis was pretty sloppy – even I could approximate on piano his blue notes and rhythm. But Garland's touch was understated, elegant and far beyond my limited abilities. I instantly as-sociated him with sophistication.

Then Miles' trumpet entered, mid-range, voice-like, not burnished and bouncy as I expected trumpets to be from the omnipresent examples of Herb Alpert's Tijuana Brass. Self-aware and earnest, pockmarked but classy, honest as my movie

hero Bogart, Miles seemed quite admirably manly. With his horn, he drew a portrait of and possibly for an initially shy but soon merry and daring girl, playing with careful deliberation, as though if he didn't sketch her correctly she'd bolt. Warming to his solo, he swung more easily, as if confident he'd won her admiration – maybe with the gliss he tossed off at the end of his first chorus, or the double- and triple-tongued notes with which he pricked one's attention on the ninth bar of his third time through.

Miles didn't press, though. His finishing touch – even, suggestive intervals he proposed as he smoothly turned the tune back to Garland – was cool and deferential. Hey! Maybe this was how to speak to girls! I could learn something from Miles!

And he took me places I'd vaguely imagined with his next number, "Night In Tunisia." Drummer Philly Joe shook something – a reptile clinked its armored tail. Bassist Pettiford asked an oblique question, then asked it again. Getting no answer, he wove his query into a pattern as a rug-maker hides a significant figure in an elaborate design. Now Miles replied, with nasal half notes. Jones clanged his cymbal's bell. Garland fell into sync with him, and Miles unfurled a wondrous melody.

I wasn't sure where Tunisia was – although I knew enough to be able to picture a mezzuzzin's tower over a walled desert village, set against a midnight blue sky, star-lit and crescent-mooned. I could feel dust rising from unpaved streets, smell strange spices and exotic incense. Didn't know this was Dizzy's song, occasion of Bird's most convoluted flight, a bebop anthem – only that Miles sped me towards adventure down a path that seemed to offer entry to mysterious nightspots in all but forbidden sectors of my city, to views from the ramparts of North African fortresses, to intensely vivid images from overheated regions of my own mind.

I indulged my imagination. I was already addicted to strange books and old movies. I was too young to be admitted to places in Chicago where jazz was played – the frustration of standing in bitter cold outside the Plugged Nickel in December of 1965, unable to hear note one from Miles' band! – so collecting records was the obvious route. I shopped the cut-out bins with exaggerated discrimination, having little money, not knowing what I liked. Some stores let me listen to selections before I bought them, and I found that Miles didn't always move me. *Miles In Europe* sounded thin, pinched, hurried. *Miles Smiles* was slick, with a whoosh I couldn't really appreciate, although I liked the melodies – Wayne Shorter's "Footprints," Eddie Harris' "Freedom Jazz Dance" and Jimmy Heath's "Gingerbread Boy," especially.

I believe I bought *Kind Of Blue* as soon as I heard it. Here was poise, lyricism, delicate shadings of emotion that a sensitive kid like me was relieved to learn could be shared by grown men. I'd heard the blues – on my sixteenth birthday I'd wandered into the Jazz Record Mart, operating base of Delmark Records, where for the next five years I'd hang out – but never blues like these that sounded so profound. They mirrored, validated, amplified and romanticized my feelings. I might have been a

blue kind of guy, but not like these musicians, who knew how to live with these feelings, and even how to express them.

I learned all that record by heart, listening constantly to it and followed Miles' sidemen: alto saxophonist Cannonball Adderley and pianist Bill Evans to *Know What I Mean?*; tenor saxophonist John Coltrane to *Live At Birdland* and *Impressions*. *Impressions* led me to alto saxist–bass clarinetist–flutist Eric Dolphy (and *Out To Lunch*), Dolphy to bassist–composer Charles Mingus (*Mingus Presents Mingus*), Mingus somehow to pre-Rahsaan Roland Kirk, a positively monstrous reeds and winds player (*Rip, Rig & Panic*). I thought only *I* knew about pianist Herbie Hancock's *Maiden Voyage* and *Empyrean Isles* – great albums to make out to (oh yeah, I'd found a steady girl-friend). Blue Note promotional LPs were on sale – I picked up the two volumes of pianist Thelonious Monk playing his weird catchy compositions, vaunted saxo-phonist Ornette Coleman's trio *At The Golden Circle*, and pianist Cecil Taylor's *Unit Structures*.

Much of this music was way over my head at first; maybe that's why I liked it. I could listen over and over, be sure there was more to this jazz than I could understand, and stimulate all my senses in the attempt. My self-affiliation with this avant-garde seemed to give me one up on my contemporaries who dictated the unofficial high school dress code and mysterious social hierarchy (as I traveled in a mostly Reformed and very moderately Conservative Jewish circle, my peers were not particularly athletic, but the ones who intimidated me projected a sense of being at physical ease with themselves as I seldom was). Even the budding bohos, I thought, the kids who slink around in all black, aren't hip to *this*, I'd console myself, alone in my room. Though maybe I could turn them on to it . . .

I was lonely because by then my parents had moved our family to the suburbs, and I'd been separated from my longtime friends. When I got my driver's license I'd attend concerts on the University of Chicago campus, nearer to my old stomping grounds. Some were presented by a famed student-run folk society, but I sought out those produced by the Association for the Advancement of Creative Musicians (AACM), a loose if decidedly African-American community – not a strict collec-tive – of intense musicians allied around aesthetic principles I could only guess at. Its members played original music, often with costumed dancers, poetry or related visual arts on display. They experimented with free expression in structured frame-works, mixed in musical bits from the blues, brass bands, cartoons, the circus, the classics and standards and noise, too. Their shows were full of surprises.

By now I was resigned to the quality of some rock music, especially if it was in any way strange. I grudgingly liked a few things the Beatles did, and warped electric bands from San Francisco – Quicksilver Messenger Service, the Jefferson Airplane, Big Brother and the Holding Company with Janis Joplin – and streetcorner-tough blues by Junior Wells and Buddy Guy. Also Jimi Hendrix and Frank Zappa's Mothers of Invention. At the Record Mart, I overheard musicians who dropped by speak of

politics, drugs, "freedom," travel, work. I began to read *Down Beat*. Where did Miles fit in?

Well, he was a star. I realized that, though I maintained personal, private claims to his sensibility. Miles was more popular and commercially successful than other innovators I'd become interested in, such as Ornette Coleman and Cecil Taylor. Though Coltrane was deeply involved in what I read was called the New Thing, Miles scoffed at it and pursued his own music with his latest band of improvisers. Some of them were familiar to me from Blue Note albums, but Hancock, Shorter, bassist Ron Carter and drummer Tony Williams sounded different on Columbia Records behind Miles: secondary to their leader, chained to short tracks, their resonance compressed. I still enjoyed Miles' horn, biting or muted, but couldn't make his way coincide with my nascent aesthetic theory. So while I plunged into the energy of 1960s free jazz, I set Miles aside. Until I got a chance to hear him live.

It was fall 1969, I was home from college on vacation, and he was booked into Chicago's Civic Opera House, at least five balconies tall and the stage a city block from the last row on the main floor. Wherever my tickets said my seat was, I managed to sneak into the orchestra and find an empty place on the aisle soon after the concert began, probably because lots of people left. I can't date the performance precisely by record releases – for reasons to become clear later, what he was playing was not what his records represented, anyway. Without doubt this was a new Miles.

Chick Corea and Keith Jarrett both played keyboards from opposite sides of the stage. Jack DeJohnette was drumming. It was either Steve Grossman on soprano and tenor saxes or Gary Bartz playing alto and soprano – I can't pin down which – initially standing almost off in the wings (perhaps to hear himself?) and eventually elbowing out from behind the others to the stage's lip. Dave Holland played upright bass and maybe electric, too. Airto curled around his cuica, rubbing the inside of the small wood barrel with some sort of flat pick to get a persistent screech. There was no guitarist. Still, the stage was crowded with amplifiers and stacks of speakers, as at a rock show. The musicians weren't in a row facing front but scattered a few feet from each other, in their own spaces around a sort of hollow, maybe the better to reach their dials, keep the electric cords straight or maintain sight lines for eye contact.

Miles stood antennae thin and vibrant, as I recall, one shoulder raised, torso in three-quarters profile, looming though he was small, as if straining on tip toe – horn rampant and focus of all. His sound was louder, more confusing and forceful than anything I'd heard in concert from Cream, the Doors, the Mothers, Hendrix or Sly and the Family Stone. He played a lot of ripping, snorting runs using wah-wah pedal – so his feet must have been pumping – smears and phrases of jaggedly different lengths, aggressive blasts shot over our ears, past our comprehension – missiles aimed at targets we couldn't imagine. It was hard to distinguish foreground

or background, hard to think anything Miles played was "melody," hard to sense the others' providing supporting parts or perceive any underlying structure. The house mix was maybe part of the problem. Sound – warped, distorted, fuzzy-edged, searing sounds – seemed to bounce off every surface of the hall. Likely whoever was mixing had never had to balance a similarly constituted ensemble, or encountered one like it, either.

I strained to pick out something familiar – a melodic riff, a collective rhythm. Whether due to the Opera House's acoustics, the embryonic nature of Miles' music or my own inexperience, it seemed mostly like chaos. I wasn't turned off at all – I was delighted! The power from the stage washed over me, and I felt justified in my unspoken allegiance to Miles. He was as furious as saxophonists Archie Shepp and Pharoah Sanders and leader of the ragtag Intergalactic Myth Science Arkestra Sun Ra about racism, the war in Vietnam, the constraints on progress, the hypocrisy of America, the nature of the universe. He, too, was an adventurer, an iconoclast, a revolutionary!

I bought *In A Silent Way*, and was privately elated that it was mellow, textured for romancing, oh yeah, and listening to potted, too – in the groove like *Kind Of Blue*. I bought *Bitches Brew*, and was less impressed by Miles' reliance on ostinatos – anything over a repeated figure will sound coherent, I thought. (Stoned, I realized there was a lot more than simply repetition in the roiling undercurrents and wild reefs at *Brew*'s bottom.) I also heard Miles live twice more – at the Ann Arbor Blues and Jazz Festival, and at my college, Syracuse University. Both performances were thrills. Miles gave my ears a feast, and I was devout, once again. Miles would always be worth hearing, I decided.

Jazz-rock, per se, was not my style. Rockers who improvised a la jazz (in the Blues Project, for instance, or Blood, Sweat and Tears, Jethro Tull and the Flock – not Eric Clapton with Jack Bruce and Ginger Baker in Cream, though: in my self-invented categorization, that was the blues) mostly struck me as wimpy, pretentious or showy, working in mundane contexts and without much interaction. Jazz men (few active jazz women except Carla Bley interested me at the time) went electric, I suspected (thinking of Eddie Harris, John Klemmer and Herbie Mann) either to sell out or to slum.

I was into AACM artists such as Anthony Braxton and the Art Ensemble of Chicago who were known only in my hometown, and Ornette's hootenanny-like album *Friends And Neighbors* – but Miles stood up to all of them, facing rock crowds *At The Fillmore*, hitting hard on *Live-Evil*. Folk music was precious; Miles was raw. Rock 'n' roll went country; Miles shot into space. *Jack Johnson* was audacious – and guitarist John McLaughlin, also blazing in Tony Williams' Lifetime and his own Mahavishnu Orchestra, was incomparable. Miles continued to feature soloists whom he inspired beyond their presumed limits. I think I was propelled by the whoosh of his jet stream when I graduated into the job market, first working for a tiny salary at

the Record Mart, then for a significant raise as a copy clerk at the *Chicago Daily News* and advancement into writing overnight music reviews.

Contrary to my momentum and much to my dismay, my preferred culture, aka the counter-culture, petered out in the mid-'70s. We got out of Vietnam and got rid of Nixon but the peace and love energies seemed to deflate. The AACM and Black Artists Group (BAG) musicians from St. Louis remained active, but who paid any attention? Disco was on the rise. I loved *On The Corner*, Miles' unprecedented release, percussive like nothing else in his catalog, anticipating both the hip-hop and rap rhythms of the future, racing past the steady-pulse "minimalist" composers whose return to tonality became a new Big Thing. I was in the right place at the right time, knowing the right people to start freelancing for *Down Beat*. I'll never forget composer Steve Reich's reaction when I slipped *On The Corner* into his Blindfold Test (no information in advance on what was being played): "Fantastic! – the sleigh bells, clapping, wah-wah pedals, pots and pans and overproduction – it's a good session with Miles Davis!"

My girlfriend Chris was one of the few women I've known who really liked electric Miles after *In A Silent Way*; most of them were put off by his macho posturing, his increasingly shrill and slurred trumpeting, his affinity for heavy metal guitars. But then she left. I was kind of blue again. My people were missing in action. Where were Ornette, Cecil, the principals of the Jazz Composers Orchestra? Freedom was replaced by over-fed fusion, and Miles seemed to implode like a sun that's burned itself out. *Agharta*, his live album from Japan, was a roar without dynamic fluctuations, and his *Get Up With It* was a two-record set that I didn't feel cohered. Then Miles was quiet, too.

From the mid- to late '70s, I regrouped. Got a new girlfriend, and suffered *our* storms. Applied myself as a professional to editing a jazz magazine and writing informed criticism, which meant study of jazz history. I started attending the annual New Orleans Jazz and Heritage Festival, and also stumbled upon Miles' earlier achievements. I gained some perspective.

From *Birth Of The Cool* I learned that Miles had always looked further than the formulas to make music that was modern, not a day behind anyone else. Nor was he scared of arrangements – this man had Juilliard training, at least briefly, and would use it when it suited him. He'd grown up middle class or better, and worked well with white musicians. I discounted his anti-white statements as so much image building, though I wondered at their necessity.

Listening to Miles with Charlie "Yardbird" Parker, Jackie McLean, Horace Silver, Sonny Rollins and others, I learned he'd come up in the tradition, with a birthright and something to prove. He was accepted with little question when he first hit the scene – St. Louis, his birthplace, was a font of trumpeters from the era of Mississippi River boats to the rise of Lester Bowie – but he struggled to arrive at his own sound, rather than striving to run at the top of the horn in the manner

instigated by Dizzy Gillespie. Consequently, no trumpeter had developed a more immediately recognizable instrumental voice than Miles.

After throwing off heroin, Miles had started nearly from scratch to rebuild his musical reputation. Little had I realized *In The Beginning* was a comeback album, a collection of tracks that signaled the formation of Miles' band-to-be, nor had I known earlier that *Kind Of Blue* was the culmination of Miles' search for ensemble balance, documented in his run-up albums such as *'Round Midnight* and *Milestones*. Miles luxuriated in the orchestral arrangements Gil Evans created for him – at last, I pretentiously opined, romance without mush – and *Miles Ahead*, *Porgy And Bess*, *Sketches Of Spain* were all new to me. I listened to more Gil Evans, marveling at his subtle touch. Just how did he link Hendrix and Miles?

During Miles' late '70s retirement, Columbia Records and I, together, caught up on music he'd made since the late 1950s that the label hadn't issued. These productions became as valuable to me as *Chronicle*, his complete Prestige recordings of 1951–56 in LP boxed set form, including classic tracks released as *Cookin'*, *Relaxin'*, *Workin'* and *Steamin'*, on which he introduced John Coltrane, perhaps his greatest protégé, as well as *In The Beginning*. *Big Fun* is the most consistent double-record set of Miles' Columbia scraps – in McLaughlin, prominent throughout it, Miles had a rock-heroic/jazz-devoted collaborator with ostentatious chops, rare imagination and noble passion. There were also tracks on *Directions* and *Circle In The Round*, though, which filled in gaps and clarified Miles' steps towards his apocalyptic mid-'70s concert recordings, rampages that went uninterrupted for the length of an LP side and picked up from the point they'd broken off when you turned the vinyl over, released at the time in Japan only (why was that?) as *Dark Magus* and *Pangaea*.

Of course, at *Down Beat* we were always speculating about whether Miles would return to public performance, and how. No one could have guessed that three young men – Robert Irving III, Vince Wilburn and Randy Hall – would simply walk into our offices one afternoon and announce themselves as Miles' new band, with a tape to prove it.

To me, *The Man With The Horn* – the eventual result of what they played us that day – was most welcome. Miles scaled back from 40-minute onslaughts to four-minute tunes, but was hard-assed as ever; he made tart heads out of the merest nothing – did he have any lip left? – and got over on the radio. If reedman Bill Evans (no relation to MD's former pianist of the same name) and guitarist Mike Stern, unheralded players who turned up on the album, were fresh recruits, Miles would whip them into shape. Stripped down to basics, he was pushing on, strong.

I pulled up stakes in Chicago and relocated, chasing my rocky romance, looking for new employment, to Washington, D.C. The change wasn't easy, in fact I moved again in six months, to New York City, but I stayed tuned to Miles, and each of his comeback albums got better. With every performance I caught he appeared healthier, more assured, playing longer and taking more chances. Guitarist John

Scofield became more than a foil for Miles; he provided pieces designed to highlight and challenge Miles' strengths, and to please the crowd without condescending to it.

By fall of 1982, when I sublet an apartment in Manhattan, Miles was accepted again as the archetypal jazz charismatic, and with good reason: no one was so dramatically compelling onstage. I read Ian Carr's biography of the man, and it didn't do justice to the force of his scowl, or his command of both live and studio situations. *Decoy* struck me as the most distinctive, far-reaching album any instrumentalist had assembled from popular electronics and open-ended structures since, well, *On The Corner*; wickedly detailed, unclassifiably moody, and on side two, uninhibitedly stomping, it proved Miles could still mount previously unconquered summits. *You're Under Arrest*, *Decoy*'s follow-up, I thought was a trifle. But not a dull one.

In spring of 1985 I saw Miles perform during the New Orleans Jazz and Heritage festival on the same bill as heavily promoted would-be-trumpet-king Wynton Marsalis. I thought Miles was killing. So he wanted to be a pop star? Why not inject some baaad jazz into commercial music? So he'd left Columbia for Warner Bros Records? Now Miles had two record companies working for him, as Columbia had enough unissued tapes of his music on its shelves to trickle out into the beginning of a new century.

In Wynton's wake, the opinion that Miles was a canny trendsetter but an uneven trumpeter became prevalent. Damn, I'd never denigrate his skill with a horn. His clams, substitutions and ellipses all sounded right; he could confound me, and I'd just want to hear him again. In the mid-'80s I heard Miles play to a pier on the Hudson River packed with a youngish party audience, and he caused the disparate elements of a newly constituted band – bluesy tenor saxist Bob Berg, maniacally fast guitarist Stern and an untested rhythm section – to bond. Once I asked Miles, over the phone, "What will you be remembered for?" and he responded in his unmistakable harsh whisper, "My sound." He wasn't modest, or wrong.

On a couple of occasions I got close to Miles. The first time was at a New York City exhibition of his art works – and he seemed comfortable, draped in modernly cut Japanese garments, peering up at his own spindly figures on the walls, mixing with the crowd. Once I was interviewing Foley, Miles' lead bass guitarist, for a *Down Beat* article and he brought me to a rehearsal hall where the band was assembled; eventually Miles stalked in, sunglassed and boosted on platform shoes, hair-weave jelled, beefy white body guards at his flanks, utterly imperious, not fit to be approached.

And once I touched Miles – after the Black Music Association held an evening-long "Tribute To An American Legend" in his honor at Radio City Music Hall, with jazz players and pop musicians performing Miles-related material, and of course Miles himself – who could pay better tribute? – with his band. A post-concert reception for the honoree and some 300 with-it guests started well past midnight in

Miles at an exhibition of his drawings and paintings, circa 1988, New York City © *1988 Lona Foote.*

a lavishly appointed midtown nightclub. Miles entered regally, walking steady with a cane and his wife, actress Cicely Tyson, on his arm. I reached forth and tugged his sleeve gently. It felt like a brave move. He looked me straight in the eye.

"It's been a pleasure," I mumbled.

His gaze widened. He smiled just a little, acknowledging his due. I grinned and Miles nodded, benignly.

New directions

Miles was avant-garde – stubbornly, maybe defiantly, self-consciously, sometimes awkwardly distinctive and daring – almost from the start. Maybe from birth, based on genetics or childhood imprinting, since he grew from a familial lineage (as detailed in John Szwed's biography *So What*) distinguished by ambition, accomplishment and prosperity. There may be no agreement on the recipe that produces such a personality, but Miles certainly had the disposition.

Not that Miles was obviously either prodigy or rebel when he received a trumpet from his father for his thirteenth birthday. His first biographers, Jack Chambers (in *Milestones: The Music And Times Of Miles Davis*) and Ian Carr (*Miles Davis: A Biography*), as well as many contemporaneous record reviewers and annotators, cast his early work as technically and conceptually limited, the hesitant efforts of an uncertain youth overwhelmed by the company of his heroes Charlie Parker and Dizzy Gillespie,

founding alto saxophonist and trumpeter of the technically advanced World War II-era jazz breakthrough bebop. I disagree, finding something special to be heard in all but the earliest date of Miles' almost 50-year recording career.

There's not much of Miles to be discerned from his contributions to the formulaic numbers – "That's The Stuff You Gotta Watch," "Pointless Mama Blues," "Deep Sea Blues" and "Bring It On Home" – sung by Rubberlegs Williams in April 1945 for Savoy Records. Williams was an unimpressive vocalist copping what he could from Fats Waller (who had died little more than a year before) and blues shouter Wynonie Harris. Tenor saxophonist and clarinetist Herbie Fields, a white up-and-comer who, like Miles, was at the time enrolled in the Juilliard School of Music, played the bulk of the tunes' solos and audible fills, drawing on both the relaxed phraseology of Lester Young and the then-invigorating energy of rhythm 'n' blues honkers and screamers. Miles, age 18, was afforded a couple of brief moments, but was mostly relegated (jazz historian Phil Schaap avers Miles relegated himself) to indifferent obbligati recorded in the distant background.

Miles' more salient debut was his appearance at Charlie Parker's recording session for Savoy Records on the afternoon of November 26, 1945, with drummer Max Roach, pianist Bud Powell and bassist Curly Russell; Gillespie was there, too. This studio date was the first to truly represent what Parker and Gillespie had wrought, mostly in after-hours jam sessions with Thelonious Monk, among others, in Harlem nightclubs. The musicians and producer Teddy Reig approximated the ambiance of those jams by turning the studio into a party with liquor, drugs and privileged hangers-on.

Miles' best effort of the day, two choruses on the issued version of "Now's The Time" (designated "Original Take #4" on the late 1950s compilation of all the session's tracks and out-takes titled *The Charlie Parker Story*, from Savoy Jazz) brought him to the attention of modern jazz fans upon its release, although it's far from his most brilliant, complete or mature statement. Indeed, *Down Beat* reviewer John Mehegan, as reprinted in the Savoy release's liner notes, called it "lugubrious, un-swinging, no ideas," and proposed, based on the swifter, more confident tone of the muted trumpet solo of the tune recorded next, "Thriving On A Riff," that Gillespie had taken over the trumpet chair. Mehegan speculatively attributes what he calls the "Martian piano" solo on the track to Miles, but uncredited pianist Sadik Hakim later said it was his.

Mehegan also identified Miles as nothing but a Gillespie wannabe: "The trumpet man, whoever the misled kid is, plays Gillespie in the same manner as a majority of kids who copy their idol do – with most of the faults, lack of order and meaning, the complete adherence to technical acrobatics," he wrote. These comments and others like them may be considered knee-jerk first reactions to something or someone previously unknown. Parker and Gillespie were already recognized by jazz fans as young Turks leading an aesthetic coup, but a "misled kid" could be, maybe should be, put down before he misled others.

As for "lugubrious" – there is indeed a somewhat self-conscious weightiness to Miles' solo. Unswinging? Well, Miles blows his piece with deliberation, not shooting off fast from the get-go; he hews to the band's pulse while holding back slightly so as to gain attention and build suspense. No ideas? That just seems wrong: Miles follows Parker's well-articulated, bouncing and bounding yet blue declaration of the titular call – whether to members and potential recruits of the still-underground black pride movement ("Now is the time for all good men to come to the aid of the party") or proponents of post-War existentialism – with his own very different kind of cadence, and modernist, possibly conservatory-influenced, compositional content.

"If Parker's solos on these blues show him to possess a grand and complex rhythmic sensibility articulated with an often anguished tone," writes Szwed, "Davis is his opposite: muted, choosing only a few notes, worrying the small details, playing against the harmonic structure, playing against the blues, even playing against Parker." Szwed goes on to cite writer Ralph Ellison's idea of a "cruel contradiction" implicit in jazz: "the individual finding personal identity both against and within the group."

That sense of being at once of and without the group can be applied to Miles at many moments of his career. In "Now's The Time" his melodic extension is a strange one that does not explicitly restate the tune's riff, but moves during the first

Charlie Parker with sax, and Miles ©William P. Gottlieb/Ira and Leonore S. Gershwin Fund Collection, Music Division, Library of Congress.

chorus with equal measure up and out and down and in. The emotional connotation is reflection, maybe indecision, maybe sadness. Miles is in no hurry; unlike Gillespie, who typically stuffed many quick notes in a phrase, Miles searches for the perfect telling tone, one slightly oblique from the established harmony (as in this case, feinting at both minor and major variants of the key), while giving his notes roughly equal rhythmic value. That aspect of his career concept is already clear— this is where he establishes it.

Miles also abjured Gillespie's signature interest in the horn's highest register, although in his second chorus he became more of a clarion, moving into the upper octave. He ended his piece with a quiet reiteration, like a man who has struggled with a question, come to a useful conclusion and reasserts it for his own peace of mind. Miles has the chops to match his intent; the modesty of that intent may be due to his apprentice status, rather than weak technique.

Does that seem like a lot of import to assign to a 45-second-long solo? But 78 rpm records were never more than three and a half minutes, and "Now's The Time" was one of those shots heard 'round the world. As trumpeter Red Rodney, a later sideman to Parker, is quoted by Chambers, "The first time we really ever heard Miles was on that . . . it was a new sound . . . it was a young guy that didn't play the trumpet very well, but had discovered a whole new way of treating it and playing it."

Miles' supposed lack of confidence was banished and his technical proficiency much improved by August 14, 1947, when he first recorded as a leader – it's clear from the music and circumstance of the recording itself. This time it was Miles who hired Parker (to play tenor sax, which he did rarely, rather than alto) and Roach, as well as Nelson Boyd on bass and pianist John Lewis, who became mastermind of the classicist Modern Jazz Quartet and, as we'll see, a key proponent of advanced jazz art.

What's notable about this project, because unusual for the rough-and-tumble boppers of the later 1940s (and maybe or maybe not avant-garde), was the amount of preparation Miles put into it. He wrote charts for new compositions, including "Sippin' At Bells," a blues which he complicated with many more chords – 18 by Szwed's count! – than is typical of the form, which usually needs only three. He scheduled two rehearsals for the combo, and persuaded Parker to practice on the tenor, the deeper horn with which he'd begun professional life but had abandoned years prior to Miles' recording. As others have mentioned, Parker's use of tenor on this date made for a less bright, warmer and mellower front-line blend.

According to a Columbia Records press release of 1957 promoting excerpts from an interview of Miles conducted by his producer George Avakian, "You don't learn to play the blues. You just play. I don't even think about harmony . . . I used to change things because I wanted to hear them – substitute progressions and things. Now I have better taste."

The assertion that simpler blues represented better taste voices Miles' preference for unvarnished over polished experience. The impulse to refine or elaborate upon ideas that have essential power in their fundamental forms is not wrong or bad, but it does not relate to the primal characteristics of breakthroughs generally associated with the avant-garde concept or, by likely inevitability, its realizations (cf. Gertrude Stein, who concurred with Picasso that "ugliness" was inseparable from the experience and result of invention, new creation, birth). In other words, one can only refine or beautify an idea once it's been stated – and the avant-garde is more often about unearthing a gem of thought that's not previously seen the light of day than about bringing the precious nugget to a fine sheen.

A decade before Miles vowed he was after unprocessed rather than prettified ore, Parker and Lewis handled with ease the harmonic complexity he wanted to hear on the first recordings under his own name, and as Szwed suggests, "*this* [might be called] the beginnings of cool jazz." The cool school, which Miles is credited with founding in league with the coterie including baritone saxist/composer Gerry Mulligan, alto saxist Lee Konitz, composer John Carisi and French horn player (later Pulitzer Prize-winning composer, New England Conservatory president and jazz historian) Gunther Schuller who gathered at Gil Evans' one-room apartment off the nightlife concourse 52nd Street, first went public as a nonet with one gig as an intermission band spelling the Count Basie Orchestra for two weeks in 1948. This group recorded three sessions over 1949–50, collected for LP release in '57 as, famously, *The Birth Of The Cool* (Capitol/EMI).

The "little big band" nuances of the nonet's charts were arguably avant-garde in and of themselves, but of a somewhat different order than what the main bop instrumentalists were discovering for each other and hipster audiences in their after-hours jams, loose studio dates for independent labels and major initiatives such as Dizzy Gillespie's Big Band. Evans, with his arrangements of Parker compositions "Donna Lee" and "Anthropology" (aka "Thriving On A Riff") was extending the temperamentally subdued repertoire of the elegant Claude Thornhill Orchestra into harmonically advanced territory. His economical deployment in the nonet of trumpet, tuba, trombone, French horn, baritone and alto saxes, piano, bass and drums successfully wedded the intimacy and flexibility of combo jazz with the timbral depths available from larger ensembles.

This back-and-forth of smaller and larger groups was of vital practical use to working jazz musicians in the late 1940s, when the big bands that had been the staple of the pre-war Swing Era were fighting what proved to be inevitable decline. New costs of travel and accommodations, as well as America's changing preferences in leisure time activities – the dark psychological and social states reflected in post-war fiction such as Norman Mailer's *The Naked And The Dead*, Hollywood film noirs and Broadway plays like Tennessee Williams' *A Streetcar Named Desire*, and also the stay-at-home tendencies that the new medium of television, a 13-station national

network launched in 1947, would soon encourage – all affected the commerce and contents of musical presentation.

In 1947 no less a star than Louis Armstrong dispensed with his big band to organize a six-person All-Stars (seven, with singer Velma Middleton) that would be his performance vehicle for the rest of his life. Jimmie Lunceford, director of one of the most popular dance bands, died. Stan Kenton disbanded his 18-man ensemble in spring (then organized a concert-oriented 20-piece Progressive Jazz Orchestra in the summer). Duke Ellington and his Orchestra performed the penultimate of seven almost annual concerts at Carnegie Hall, in which he had introduced his most elaborate works (including January 1943's "Black, Brown And Beige," December 1947's "Liberian Suite" and flirtatiously atonal "The Clothed Woman," November 1948's unveiling of Billy Strayhorn's "Lush Life" and his own "The Tattooed Bride"). Basie let go of his big band, though he reassembled it occasionally until giving up in 1950 (reconvening in 1952). The film biography *The Fabulous Dorseys* was released, fictionalizing the career of swing band-leading brothers Jimmy and Tommy, but they too had quit the road by the end of 1947.

Some bandleaders attempted to adjust to the social and musical changes: Benny Goodman assembled what would be his last big band in order to address elements of the bebop style. Woody Herman, inaugurating his "Second Herd," had a hit with "Early Autumn," tightly harmonized by composer Ralph Burns for the bop-fluent "Four Brothers" sax section (tenors Al Cohn, Stan Getz and Zoot Sims, plus baritone Serge Chaloff). Starting in mid-1946, Gillespie devoted enormous effort to maintaining his determinedly avant-garde big band (theme song: "Things To Come"), spotlighting the hottest young soloists, crossover singer Ella Fitzgerald, the irresistible Afro-Cuban rhythms of conguero Chano Pozo and composer–arrangers including Mario Bauza, Tadd Dameron, Chico O'Farrill and George Russell.

But American couples going out for an evening together didn't support the new big bands as they had patronized the swing units. Bop challenged them with melodies that sped by faster than many feet could move, and seemingly unsingable lines full of what sounded like deliberate dissonance. Gillespie toured Scandinavia with his big band and was hailed for daring artistry, yet jobs in the U.S. were too scarce to meet weekly payrolls.

As it seems to always, American culture exhibited severely conflicting and simultaneously crossover tendencies. White singers including Bing Crosby, Frank Sinatra, Peggy Lee, Dinah Shore, Doris Day, Judy Garland, Perry Como and Tony Bennett were having their heydays – so were black singers Ella Fitzgerald, Billie Holiday, Dinah Washington, Sarah Vaughan, Billie Eckstine and Nat "King" Cole. All reached national audiences, differentiated perhaps by race, ethnic or religious backgrounds and places of residence, but essentially the same radio-listening, dancehall, club or concert-going and record-buying public.

In the classical world, Charles Ives, the New England insurance magnate who

had written his maverick music in seclusion, won the Pulitzer Prize for his *Symphony No. 3* (which he had composed in 1911); in country music, the rowdy young singer-songwriter Hank Williams had his first radio hit with "Move It On Over." Louis Jordan, a father of rhythm 'n' blues and progenitor of rock 'n' roll called the King of the Jukebox, came out of the battle of the bands milieu of New York's Savoy Ballroom to parlay his comic jazz songs into enormous and widespread popularity; Swing Era vibraphonist Lionel Hampton also pioneered r&b and rock, fronting a bluesy, blaring big band that performed for zoot-suited Lindy-Hoppers and G.I. Bill college crowds.

Doo-wop, another stylistic precursor of rhythm 'n' blues and rock 'n' roll, was being sung by ad hoc male groups on neighborhood streetcorners of the bigger Northern cities, while Alan Jay Lerner and Frederick Lowe scored a Broadway success with *Brigadoon*, about a Scottish town that appears out of the mists once every hundred years.

Of course there were larger social forces on the march too: an incipient civil rights movement and rise of labor unions fueled hope of new economic mobility for black Americans (though Congress passed the Taft-Hartley act restricting union activities). Jackie Robinson integrated major league baseball in the summer of 1947 – a year before President Harry Truman signed an executive order desegregating the U.S. military. An event of lesser impact that yet signaled the end of a cultural era: New Orleans trumpeter Bunk Johnson, the hero of jazz's purist wing – the "moldy figs" – cut his final recording in December of 1947, satisfying his longstanding ambition to interpret Scott Joplin rags.

In the late '40s, Miles Davis had respect if not outright enthusiasm for early jazz, and by extension Johnson's straightforward style. Although Miles was caught in a controversy, named a "new star" in the 1947 Esquire jazz yearbook but signing a letter of protest with Armstrong, Ellington, Holiday, Fitzgerald and other black jazz stars protesting the edition's apparent Jim Crow bias, he made a point of telling Pat Harris in an interview published in the *Down Beat* issue of January 27, 1950, "I don't like to hear someone put down Dixieland. You've got to start way back there before you can play bop. You've got to have a foundation."

Miles' presupposition of the value of the past in creating a future is common among jazz musicians and other artists who appropriate elements of their predecessors' accomplishments for their own purposes. Such appropriation is, of course, central to any notion of progress or linear evolution in artistic styles, natural to any field that proceeds on the basis of technical (if not technological) innovations, or is taught via oral or master–apprentice processes. However, as philosopher Peter Büger proposes in *Theory Of The Avant-Garde* (1974),

[I]t is in the historical avant-garde movements that the totality of artistic means becomes available as means. Up to this period in the development of art, the

use of artistic means had been limited by the period style, an already existing canon of permissible procedures, an infringement of which was acceptable only within certain bounds . . . It is, on the other hand, a distinguishing feature of the historical avant-garde movements that they did not develop a style. There is no such thing as a dadaist or a surrealist style. What did happen is that these movements liquidated the possibility of a period style when they raised to a principle the availability of the artistic means of past periods. Not until there is universal availability does the category of artistic means become a general one.

Miles assumed by 1947 that he was well beyond the technical and aesthetic stage represented by Bunk Johnson's New Orleans foundation, but he did not jettison the basics in his reach for originality or the sublime. He had dropped out of Juilliard in 1945 due to disinterest in its course of study and enthrallment with (if not declared commitment to) the values implicit in jazz — chief among them its fundamentally African-American identity, individualism, ongoing exploration and spontaneous creativity, as his attendance at jazz clubs, pursuit of nascent bebop, introduction to pop recording and affinity with Bird and Diz attest. He demonstrated little use for the repertoire and instrumental practices attached to Western classical music, but he did not scorn the artistic aspirations promoted by high culture and the conservatory — he prepped for his debut album as a good conservatory student should. In the first flush of professionalism, Miles tried to reconcile two goals that weren't to him in obvious conflict: to make it new, and to do it right.

(However, Miles did not devote himself only to those pursuits: he also developed a drug habit that demanded significant energy and money to support. Though transgressive, heroin addiction should not be considered emblematic or adjunct to the avant-garde. Actually, those who got involved with heroin in the late '40s indulged in something of a herd mentality, with jazz players reporting themselves drawn to use partly to emulate the lifestyle, hence aim for the brilliance, of Charlie Parker.

The euphoria or sense of impregnable well-being that heroin reputedly fosters is often ignored in discussions of epidemics of its abuse, and Miles is certainly one of a jazz legion who entertained addiction voluntarily, even recreationally. It often seems that the majority of the era's musicians on a quest similar to his volunteered to carry the burden of heroin addiction as a golfer embraces his handicap, to even out the playing field by admitting to having inordinate talent. But if musicians thought themselves more brilliant when using the drug because their self-awareness or sensory perceptions were subjectively "intensified" — a word the poet Coleridge coined to described opium's effects — heroin in objective reality as likely distorted, diffused and/or drained aesthetic concentrations.

Maybe the opiate slows one's sense of passing time, so that discrete notes in a fast series may each exist for the user who plays them more distinctly, and upcoming gestures can be rendered more emphatically. Maybe sonic characteristics such as

volume, timbre, attack and decay may seem more vivid to those under the drug's spell. This is Szwed's opinion:

> (H)eroin narrowed the emotional and visual fields to only the moment. It gave a crystalline vision of the music, slowing the music down as well, stopping and holding up to the light those beautiful bop melodies that otherwise could fly by so fast that they left nothing but vapor trails.

Those who know say heroin users quickly become inured to the drug's high, and seek higher doses to attain it, or else learn to maintain a steady dosage level to stave off the ill effects of withdrawal. It may be argued that some specific qualities of the music Miles made during his first period of drug abuse would have been different had he not been using, but we cannot know how.

One admirable certainty of this period is the fortitude Miles demonstrated in breaking heroin's hold without the support of substitute medication, when he isolated himself at his father's farm for two weeks in 1953. As Szwed relates, he had experienced this method before, when his father had him incarcerated for two weeks in a nearby jail to accomplish the same purpose around Christmas, 1951. Novelist Nelson Algren described the pain of his protagonist Frankie Machine's cold turkey withdrawal in *The Man With The Golden Arm* (1949), the first winner of the National Book Award: "[H]is own entrails were tearing at his throat and his very bones were twisting. He heard his own voice crying as shrill as a wounded tomcat's down the icy corridors of his anguish." Miles' endurance of something comparable reminds us that there may be effetes in the avant-garde, but there are seldom weaklings. Then again, he had weaknesses; the first "cure" he endured didn't end Miles' heroin use, and the second one didn't quite either. Szwed writes that Miles "felt that he was gradually weaned away from heroin because of [the] poor quality" available in Detroit, where he was living, in late summer of 1954).

All jazz can fairly be considered alternative, if not avant-garde, in relation to bal-lyhooed Western culture as the core concept of improvised solos relating to bluesy harmonies unfolding over propulsive rhythms challenges historically established, European-generated compositional practices. Yet there is little likelihood anyone listening 50 years later to Miles on "Now's The Time," or to his first session as a leader, or to *The Birth Of The Cool* album or to any other of his records of the 1950s – whether small group sessions with the leading instrumentalists of the decade, or large ensemble set pieces arranged by Gil Evans, or even *Kind Of Blue*, canonized as his masterpiece – will take the music as radical, inaccessible or off-putting.

For one thing, these examples sport at least superficially generic surfaces and structures (there are a couple of exceptions, as collected in *Chronicle*, the compilation of Miles' sessions for Prestige: He was prominent in altoist Konitz's sextet on March 1951, essaying two compositions by George Russell – "Odejnar," based on

a motif that resembles a serial tone row, and "Ezz-Thetic," with Miles' second line deliberately oblique to Konitz's – in company with other Lennie Tristano associates guitarist Billy Bauer, bassist Arnold Fishkin and pianist Sal Mosca, plus Max Roach on drums). Secondly, most jazz listeners have long ago heard and accepted the artists' main substantive moves in more inspired array. Then, too, "Now's The Time," despite digital remastering, has a primitive audio image, so it sounds old-fashioned; paradoxically the audio images of *The Birth Of The Cool* and *Kind Of Blue* have been rendered so contemporaneous – as if they were recorded in the digital rather than analog electronics age – as to be relatively unremarkable.

However, the music Parker and Miles improvise and the drum strokes with which Roach accompanies them, the coolly witty nonet blends, Miles' loneliness pitted against Coltrane's forthrightness, Adderley's bounce, pianist Evans' impressionism, the rhythm teams' stalwartness, all this retains immediacy. And the innovators' ideas – Parker's abstracted bluesiness, Miles' compositional deliberations, Roach's unpredictable, emphatic accents, small groups sounding like bigger ones, successions of contrasting solos – have been adopted so unanimously by musicians in their wake that they're taken for granted. We must recall that these musical concepts have not always been with us, that they have a traceable source.

Yet these concepts are identifiably avant-garde because they transcend period style, serving as cornerstones upon which a palatial future has been constructed. In contrast, the advanced style of Gillespie's futuristic (however commercially stymied) big band and the deft format strictures of *The Birth Of The Cool* nonet's charts seem to seek period favor. They do not break from forms; they seek to *further* forms to which they fervently subscribe. Their most unusual content is nonetheless clothed in familiar drapery: Afro-Cuban music had been a ballroom staple in the U.S. since a craze for the song "The Peanut Vendor" in the early 1930s, and *The Cool* was tailored after Thornhill's politesse. The innovations, in each case, are crafted by adept artisans to appeal to general audiences (even though these particular efforts didn't immediately catch hold). Although they include substantively progressive elements, these efforts are also consolidating, if not rear guard, actions.

The apparently conflicting aspects of *The Birth Of The Cool* have been debated since the music's initial airing. Composer–arranger Tadd Dameron, a black man who wrote charts in the 1940s for Lunceford and Basie (the Count considered them "too far out" to record, according to the *New Grove Dictionary Of Jazz*), vocalists Billy Eckstine and Sarah Vaughan, Gillespie and Coleman Hawkins, appraised " 'Boplicity' one of the best small-group sounds I've heard." Miles had composed it for the nonet under his mother's maiden name, and Gil Evans had scored it. Bandleader–composer–arranger Elliot Lawrence, who among other credits played piano on Woody Herman's 1958 recording of Stravinsky's "Ebony Concerto," hailed *The Cool* recordings as "those great Miles Davis sides," according to Miles biographer Ian Carr. Carr mentions that "even Chicago traditionalist Eddie Condon murmured approval" of *The Cool*.

Contrarily, critic Stanley Crouch, in a survey of Davis' career published in 1990 in *The New Republic*, denounces the charts as "little more than primers for television writing." To Crouch, they are evidence that "Davis . . . was not above the academic temptation of Western music," and demonstrations of "another failed attempt to marry jazz to European devices."

This judgment is arguable; in the same article, Crouch scolds "the critical establishment" for ignoring Ellington's "The Tattooed Bride," and being "unable to determine the difference between a popular but insignificant trend and a fresh contribution to the art," though it was less jazz critics than jazz musicians – black ones like the MJQ's John Lewis and West Coast orchestra leaders Benny Carter and Gerald Wilson as well as white ones such as Gerry Mulligan, Chet Baker and Shorty Rogers – who promulgated what Crouch denigrates as "soft sound, the uses of polyphony that were far from idiomatic, the nearly coy understatement, the lines that had little internal propulsion." That such pale music, masquerading as jazz, was adapted for television, in Crouch's view, attests to its sell-out qualities.

In reference to the avant-garde concept, there is no "right" about this, though I hear the music Miles Davis made in the 1950s as mostly progressive, i.e. developmental, rather than breakaway or breakthrough. However inspired the tracks he cut with Monk, Horace Silver, Rollins, McLean, Jimmy Heath, *et al.* on Blue Note and Prestige Records, they represent consolidation and some taming of the bebop revolution into a post-bop formula. Though *Kind Of Blue* is now widely regarded as the font of a modal jazz that breaks faith with the strictly cyclical chord progressions and substitutions/extensions of bebop harmony, the album's genius is in a formal simplicity capable of encompassing the very different if invariably rigorous harmonic extrapolations of pianist Evans and saxophonists Coltrane and Adderley, as well as Miles' concentrated melodicism.

The most unprecedented yet arguably prophetic project Miles embraced in the 1950s is one he may never have intended to be heard as a record at all. In December 1957 he conducted a four hour recording session with a French based quartet (including American expatriate drummer Kenny Clarke) for the soundtrack to Louis Malle's thriller *Ascension pour l'echafaud* (released in the U.S. as *Frantic*, but more descriptively titled *Elevator To The Gallows*).

Of 16 completed takes, most of 10 were used in the film – drenched, in the soundtrack mix, with extra atmospheric echo. Novelist–critic Boris Vian wrote in 1957 that Jeanne Moreau, the movie's femme fatale, had drinks with the musicians, producers and technicians when they gathered for the night-time session in the Poste Parisien studio, helping to create a relaxed mood. Malle screened continuous loops of scenes for which he wanted music, while Miles improvised with considerable poise on a few phrases he'd sketched out in his hotel room the week before.

"All the musicians were concentrating hard, since I guess they were aware that they were taking part in something exceptional" soundtrack producer Marcel

Romano, who later supervised jazz scores similarly contrived by Kenny Dorham and Art Blakey, said in an interview published in liner notes in 1988.

"[Miles] knew exactly what he wanted," the date's bassist Pierre Michelot recalled in a separate interview that same year, "and he also knew what he wanted from us, which is very much to his credit." Yet the demands Miles made on his contracted players were not extraordinary in terms of their technical facilities; instead, he instructed them to chance a simplified and unusually open-ended structure.

"What was typical of this session was the absence of a specific theme" Michelot continued.

> This was new for the period, especially with the soundtrack of a film . . . Save for one piece ('Sur l'autoroute'), based on the chords of "Sweet Georgia Brown," we only had the most succinct guidance from Miles. In fact, he just asked us to play two chords – D minor and C 7 – with four bars each, ad lib. That was new, too – the pieces weren't written to a specific length.

Malle, who gave non-musical directions, asked that the music be in counterpoint to the image rather than stick closely to it, which allowed him to eventually assign pieces to different episodes than the ones for which they'd originally been created. Although tenor saxophonist Barney Wilen has a few understated solo moments, it is Miles' trumpet that provides running commentary on the noir plot's fatalistic turns and the yearning, guilt, restless worry, brief release, flirtation, isolation and claustrophobia that affect Malle's murderous lovers.

The soundtrack to *Ascenseur pour l'échafaud*, re-issued in 1988 by Polygram-Fontana – with all out-takes in order of actual recording, stripped of post-production reverb as well as the way it was edited, mixed and sequenced for the film – offers some fleeting pleasures in and of itself. Miles' uptempo horn as unleashed on the tracks "Dîner au Motel," and "Sur L'Autoroute" is choice. However, music made for movies is necessarily subservient to a director's cut, and all the tracks finally selected for use in the film are brief; only two last as long as four minutes. There is little stretching out, although Miles succeeds in substantiating his skeletal ideas. He had prepared well for this exercise. Still, it was his flexibility and spontaneity in response to Malle's imagery that carried the day.

For instance, the third take of what Miles called "Nuit Sur Les Champs-Élysées," with which Malle opened his film (as "Générique" on the soundtrack), begins with the trumpeter's bravura unaccompanied introduction – a touch that doesn't occur on unused takes one and two. On take four of "Nuit," occurring in the middle of the soundtrack as "Florence sur les Champs-Élsées," the trumpet spouts the same theme, altered, in a fragmented acapella intro, and the rest of the track proceeds at a less sodden, almost jaunty pace.

Similarly, take one of what Miles called "Assassinat" is a slow, minute and a half

long solo by bassist Michelot, who accelerates when Clarke enters on cymbals for the track's final 30 seconds. In the soundtrack this is "Visite du Vigile," placed at the film's anti-climax, when Moreau awaits her lover whom the viewer knows has been arrested.

On "Assassinat" take two, Miles plays softly, as if hemmed in by the insistent bass throb and all but imperceptible minor chords of the piano; Malle repurposed this track, as "Julien dans l'ascenseur," for the central episode presenting a murderer caught while trying to escape the scene of his crime. Take three precedes two and one on the soundtrack; it's called "L'assassinat de Carala," and evokes suspense – will this murder occur, or not? – through Miles' gradual increase of volume and Clarke's edgy cymbal washes behind him.

Two attempts at a morose "Final" were discarded in favor of an initially bolder third take, titled "Chez Le Photographe du Motel" and placed at the very end of the movie. Miles inserted his Harmon mute halfway through this piece. The first, open horn section may underscore the audience's shock at the plot's last twist. The second, muted ending reprises the bittersweet bleakness of much that's come before.

Romano remembered Miles saying the session had been satisfying, but also that "he did tell me he had no intention of repeating the experience." In fact, recording this soundtrack was an experience that served Miles quite well, and forecast a way he would work in the future, more than once.

The notion of shifting between two chords during pieces improvised without specification of length foreshadows the shifting between two modes that pianist Evans and Miles devised two years later for fellow soloists Coltrane and Adderley on "So What" of *Kind Of Blue*. It is a commonplace of jazz criticism to note that Miles plunged even further into open forms in subsequent albums, culminating in his extended, electrically charged performances of the mid-1970s (*Pangea*, *Dark Magus*, *Agharta*, *Black Beauty*), but the *Ascenseur* soundtrack was his first such foray.

The cyclical repetition of motifs, like the looping of scenes Malle had prepared for Miles to watch while recording, became a tactic Miles and producer Teo Macero tapped on the epic title track of 1969's *Bitches Brew* – which is drenched in studio-processed reverb and other special effects so that an audible echo results – and "Great Expectations," recorded around the same time, though not issued until 1974 (on *Big Fun*, compiling some unreleased recordings from '69 through '72). Looping occurs in Miles' oeuvre prior to that, in 1967's "Circle In The Round," and was notoriously edited by Macero into *In A Silent Way* (1969).

The periodic recurrence of themes, in whole or part, is a prevalent feature of several pieces Wayne Shorter wrote for Miles' early '60s quintet also comprising Herbie Hancock, Ron Carter and Tony Williams. "Footsteps," "Orbits" and "Dolores" on *Miles Smiles* (October 1966) cycle motifs or shards thereof through their performance in a manner not directly tied to strictly repeated chord progres-

sions. Miles was obviously conscious of this structural innovation; the title of his one composition on *Miles Smiles* was "Circle."

Miles would contribute to soundtracks again, jamming with John McLaughlin for the little-seen documentary *A Tribute To Jack Johnson* (1970), adding his trumpet parts over Marcus Miller's studio contrivances for *Siesta* (1987) and virtually phoning in snippets for the Jack Nitzsche score to *The Hot Spot* (1990), which matched him with blues guitarists Taj Mahal, John Lee Hooker and Roy Rogers (it's unlikely they recorded together, in person). Did Miles record while he was watching? According to John Szwed, he took the boxing-film assignment ultra-seriously, but would he have bothered to view Ellen Barkin and Gabriel Byrne in the surreal shaggy dog story, or Don Johnson and bimbos in the over-heated Miami neo-noir? He probably paid more attention to *Dingo* (released in 1992) as he starred in it.

Paris clearly meant something special to Miles. During his first visit there in 1949, at age 23, he'd been hailed for his personal bebop trumpet style, so different from Dizzy Gillespie's. He was pleased to find that Parisians did not reflexively exhibit racial prejudice. He had one of his most romantic and memorable love affairs with bohemian actress Juliette Greco. He was accepted by a crowd of artists and intellectuals including Pablo Picasso (according to Miles' autobiography), Simone de Beauvoir and Albert Camus (according to Eric Nisenson in *Round About Midnight: A Portrait of Miles Davis*), and Jean-Paul Sartre (the autobiography, Nisenson and Szwed), with whom he became friends. In the 1950 *Down Beat* interview with Pat Harris he mused, "What I would like to do is to spend eight months in Paris and four [in New York City]. Eight months a year where you're accepted for what you can do, and four months here because – well, it's hard to leave all this."

Szwed recounts in *So What* that years later in Paris, Miles "ran into the French pianist René Urtreger, and as they passed each other, he whispered in René's ear, 'Freedom!'" Paris was also the site of his 1991 career reunion concert, at which a little more than a month before his death he essentially said goodbye to such of his significant collaborators as McLean, Shorter, Hancock, Chick Corea and Joe Zawinul, John McLaughlin and John Scofield, saxophonist Bill Evans, Dave Holland and Al Foster.

As a crucial character in his one movie performance in the French–Australian production *Dingo*, Miles indulged in a bit of self-mythologizing by appearing as a Paris-based American expatriate trumpeter who changes the life of an Australian boy when his band's airplane touches down to refuel at a remote station in the outback. Miles' signature song on the *Dingo* soundtrack, co-composed by Michel Legrand, is an achingly spare Harmon-muted trumpet theme, built on an interval not unlike the one he introduced on *Ascenseur*'s "Nuit Sur Les Champs Élysées."

Miles' music of 1963 through 1967 with the Hancock–Carter–Williams rhythm section and saxophonists George Coleman, Sam Rivers or, finally, Shorter, has already been the subject of much insightful, detailed study. Chambers is superb on the round up, development and productivity of this group, one of the prime models of modern jazz interaction, which created much beautiful, sophisticated music out of the daring, mastery, intelligence and intuitive play of its members. The accomplishments of this, Miles' "second great quintet" (the first being his 1955–58 Coltrane, Red Garland, Paul Chambers, Philly Joe Jones group) might easily be taken as avant-garde, though they have seldom been considered so, in part because Miles disdained any such association.

As Chambers writes of Miles circa 1962, "He piloted his new quintet through a period of growth and change that was internal to the group rather than directed at the changing tastes of the world beyond jazz music." Referring to the second quintet's album recorded in October 1966, Chambers notes, "(T)he music on *Miles Smiles* is hardly less accessible to bop-bred listeners than Davis's earlier work" and "For the listener, the music presents both the conventional and the unexpected not by moving between one pole and the other but by straddling both poles."

Straddling these poles, which maybe also represents the contrasting imperatives of commercial viability and creative impulse, seems to have become Miles' default stance, one he assumed successfully though maybe uneasily, too, and out of some internal necessity. From the release of *'Round Midnight*, Miles' debut on Columbia Records, through his collaborations with Gil Evans and large ensemble and past his earliest experiments with Hancock on electric piano – like "Stuff," recorded in May 1968, released on *Miles In The Sky* – Miles was busy maintaining his position as the leader of the progressive mainstream of contemporary jazz. Gerald Early writes in "The Art of the Muscle: Miles Davis as American Knight and American Knave" (the first essay of *Miles Davis and American Culture*, a catalog edited by Early in accompaniment of the Missouri Historical Society's museum exhibition of Miles' paintings, published by Missouri Historical Society Press in 2001):

> The major, overarching context that, I think, explains him better than most is that he came of age when jazz music ceased to be a popular commercial music. Thus, he was faced with the dilemma of trying to make a living, of being something of a personality, in a music that had a dwindling audience and lacked the cultural and artistic presence it once had. He was enormously inventive, snappishly opportunistic, yet surprisingly principled in the simple act of making a living in a dying art, that is, dying as an art form with a large audience.

Miles was committed to jazz, as both a living art form and an enduring tradition – remember Bunk Johnson? If he perceived the music as endangered, I think he meant to save it by keeping it ever fresh. But his primary commitment was cer-

tainly to himself, and he would do everything in service of both jazz and himself to remain at jazz's fore. So when he expressed caustic criticism of a self-identified though doctrinally diffused jazz alternative, nominally "the avant-garde," he may indeed have been distancing himself from the people and attitudes associated with (and risking marginalization by) the designation. But he was not deaf or immune to musical and extra-musical developments that qualified as avant-garde, in and of themselves. Changes were coming, and he was all for change, if not for all these other agents of it.

The music of Ornette Coleman, introduced to New York City through a lengthy booking of his quartet featuring trumpeter Don Cherry, bassist Charlie Haden and drummer Edward Blackwell at the Five Spot in 1959, was much publicized and debated in subsequent years as a revolutionary new form, "free jazz," and documented by nine albums recorded for Atlantic Records from May '59 through March '61. Through the rest of the '60s Ornette, a soft-spoken man from across the Cow Town railroad tracks of Fort Worth, Texas, purveyed his engaging if idiosyncratic ideas from label to label, changing personnel and always writing new repertoire, producing his own projects when necessary, separate from, though neither disdainful nor disinterested in, jazz players who claimed to have come through "the tradition" — that is, swing bands influenced by Ellington, Basie and Fletcher Henderson to small groups inspired by Parker, Gillespie and their bebop cohort.

Pianist Cecil Taylor, a hyper-educated, inquisitive man with intractable concepts and technique that was his alone, had arrived in New York from studies at the New England Conservatory in Boston in the early '50s. He recorded his debut album, *Jazz Advance*, in 1954; had a six-week stint at the Five Spot in 1956, and after his 1957 performance at the Newport Jazz Festival (favorably reviewed in *The New Yorker* by Whitney Balliett) had been reserved a place at the new music table, but responded with an attitude rather like Groucho Marx's: "I'd never join a club that would have me."

Sun Ra, the keyboardist/composer/arranger/cult-leader born and raised in Alabama and reaching artistic maturity in Chicago, moved to New York in 1961 to calmly conduct his Intergalactic Arkestra, with such soloists as John Gilmore, Marshall Allen, Danny Davis and Pat Patrick, in varieties of outrageous disquiet that he announced he'd brought with him from outer space. Tenor saxophonist Albert Ayler, from Cleveland to New York in 1963 via the U.S. Army and Europe, practiced a yowling, fiercely ecstatic and fractious jazz derived from folk songs, gospel, rhythm 'n' blues and marching band selections.

Soprano saxophonist Steve Lacy and trombonist Roswell Rudd had reached unusual musical conclusions by playing traditional (not "dixieland," though sometimes called that) jazz while studying the harmonically quirky compositions of the one-and-only, eternally avant-garde composer–pianist Thelonious Monk, and the equally deft but much lesser known composer–pianist Herbie Nichols. Pianist

Paul Bley had been a supporter of Ornette Coleman's in Los Angeles; on the East Coast he recorded songs of his then-wife, Carla Bley, and helped stage the October Revolution concert series with trumpeter Bill Dixon (one of Cecil Taylor's collaborators). Bassist–bandleader Charles Mingus, having established himself at the center of New York jazz life in 1951 had, since the '55 performance of his orchestral work "Half-Mast Inhibition," pushed the niceties and ambitions of jazz composition with a large circle of collaborators, including multi-reedists Rahsaan Roland Kirk and Eric Dolphy, pianist Jaki Byard and drummer Dannie Richmond.

The spiritual quest and technical achievements of Miles' former sideman Coltrane, who had also been stirred by working with Monk, had encouraged a circle of reeds players – including Ayler, Rivers, Kirk, Dolphy, Rollins, Archie Shepp and Pharoah Sanders – to explore the extremities of their instruments, imaginations and physical powers with extended, oblique or slight obvious reference to the standards of virtuosity and common forms that had preceded. Miles respected Monk, Coltrane and Rollins, but had few positive comments, at least as conveyed in Leonard Feather's *Down Beat* Blindfold Tests of 1964 and 1968, about the rest of New York City's avant-garde.

Outside of New York, Chicago's Association for the Advancement of Creative Musicians (founded in 1965) promoted principles of experimentation, originality and instrumental virtuosity that produced artists as diverse as pianist Muhal Richard Abrams (a protégé of the popular and investigatory saxophonist Eddie Harris, who contributed "Freedom Jazz Dance" to Miles' mid-'60s repertoire), Fred Anderson (tenor sax), Anthony Braxton (alto sax), and the original members of the Art Ensemble of Chicago (Lester Bowie, trumpet; Joseph Jarman, reeds, winds and poetry; Roscoe Mitchell, reeds, winds and percussion; Malachi Favors, bass; and drummer Philip Wilson, who left the AEC to tour with the jazziest edition of the Paul Butterfield Blues Band).

Other AACM members included Pete Cosey, the electric guitarist who worked as a session man for Chess Records, the era's predominant blues label, and toured with Miles in the heat of the mid-'70s; trumpeter Wadada Leo Smith, who created the most convincing Miles tribute recordings with guitarist Henry Kaiser in the early 2000s; violinist and composer Leroy Jenkins; keyboardist Amina Claudine Myers, and reeds and winds player Henry Threadgill, a composer and ensemble leader initially known from the trio Air, later making his mark with big little bands of mixed instrumentation (such as his seven-person "Sextett"). The AACM's kin-like Black Artists Group in St. Louis convened saxophonists Julius Hemphill, Oliver Lake and Hamiett Bluiett – who eventually formed the World Saxophone Quartet with Oakland-born and raised David Murray. In Los Angeles, pianist–composer Horace Tapscott established the Pan Afrikan Peoples Arkestra in 1961, an ensemble that in 1963 became the performance arm of the Underground Musicians Association (UGMA). Also in L.A., clarinetist John Carter, originally from Ornette Coleman's

hometown Fort Worth, formed the New Art Jazz Ensemble with Ornette's friend and sometimes trumpeter Bobby Bradford.

Avant-garde jazz had taken root outside the U.S. too. In 1962 Albert Ayler was scandalizing and intriguing the Scandinavian jazz scene. By 1964 German Albert Mangelsdorff was producing multiphonics (two sounds at once) on his trombone in quartet with saxophonist Heinz Sauer. That year Dutch pianist Misha Mengleberg and drummer Han Bennink accompanied Eric Dolphy on his *Last Date*. British free improvisers instituted The Spontaneous Music Ensemble at the end of 1965.

Jazz was hardly the only art then exploding with avant-garde concepts, energies and invention: all forms in all media seemed to be comparably in ferment. Avant-garde "serious" music by white Americans was epitomized by John Cage's set (including dancer Merce Cunningham, painter Robert Rauschenberg and pianist David Tudor) performing multi-media works. Cage was also a teacher of Allan Kaplow, whose "happenings" – non-narrative but theatrically contrived public performances – were comparable to, though different from, events staged by members of the Fluxus group. They were conceptualists and language–action artists who organized loosely in 1962 with associates in Germany and Japan as well as New York City, where cellist Charlotte Moorman, eventually notorious for concertizing bare-breasted, held her first Avant-Garde Festival in 1963, and her friend Korean-born Nam June Paik began electronically modifying televisions.

In 1962 composer Morton Subotnick and electrical engineer Don Buchla embarked on building what Subotnick called a "black box that would be a palette for composers in their homes . . . like an analog computer . . . a collection of modules of voltage-controlled envelope generators [that] had sequencers in it." Composer LaMonte Young instituted The Theater of Eternal Music in 1964 to experiment with music of extreme duration, sometimes with the participation of Terry Riley, whose 1964 composition "In C" situated cells of simple melodic material against each other in an expansive, communitarian manner, to be played by any collection of instruments, over unspecified duration. Steve Reich's earliest phase piece "Come Out," based on a tape-looped slice of a young black man's statement to police, was realized at Columbia Princeton Music Center in 1966, foreshadowing his distinguished career; Philip Glass explored related matters, including music of long duration but limited or static harmonies following his first U.S. concert in November, 1968. Karlheinz Stockhausen, from his base in Cologne, had gained an international reputation for his abstract music employing electronics and sound filters; in 1969 he would instigate "Sept journées, die sieben tagen," or "Seven Days," comprising 14 pieces of "musique intuitive . . . to be listened to purely as abstract sound patterns and arrangements" (according to Stockhausen Week artistic director Diego Masson), performed by an octet including jazz improvisers Michel Portal (reeds) and J.F. Jenny-Clark (bass).

Most of this Eurological avant-garde music avoided specific socio-political

content. But jazz did not ignore the most significant social movement of the era, the struggle for civil and personal rights for all Americans, and it was also reflected in and/or affected most of the other literary, performing, popular and media arts. In 1962 African-American James Baldwin – a friend of Miles Davis – had published his novel *Another Country*, which depicts, in its first chapters, the suicide of a bi-sexual black jazz musician. In '63, African-American Amiri Baraka (then known as Leroi Jones), published *Blues People: Negro Music In White America*, an invaluable and provocative analysis of the roots and outreach of jazz, and advanced his reputation as a provocative poet and playwright. The most ground-breaking literature of the Beat writers had been published in the late '50s (William Burroughs' *Naked Lunch* in '59) , but in '61 Henry Miller's *Tropic of Cancer* was on trial in the U.S., charged with being pornographic. From 1961 until his death in 1966, comedian and satirist Lenny Bruce was overwhelmed with legal actions involving obscenity charges; he also riffed in his routines on the hypocrisies of American race relations.

During these years, African-Americans emerged as masters of modern dance: Alvin Ailey, Katherine Dunham (who had established herself some 20 years before, but was selected in 1965 by President Lyndon Johnson to serve as a technical ad-visor and cultural ambassador to West Africa), Rod Rodgers and Judith Jamison were prominent movers and shakers. Conventional commercial entertainments also demonstrated cognizance of social change: Broadway theater flirted with non-tra-ditional casting in 1964 by starring Sammy Davis Jr. in a musical version of Clifford Odets' "Golden Boy," originally about a young Italian man conflicted over his gifts as a violinist and a boxer (echoing Al Jolson's *The Jazz Singer*, which ushered in talking pictures with a story about a Jewish rabbi's son caught between his desires to be a cantor or a black-faced vaudevillian minstrel). In '64 the Academy Award for Best Actor went to Sydney Poitier, the first African-American recipient, for his portrayal in *Lilies In The Field* of an unemployed construction worker who almost single-handedly saves an order of East German Catholic nuns relocated in Arizona from going without a church. In 1965 Bill Cosby, the comedian who in 1981 hosted Miles' third marriage (to actress Cicely Tyson) in his home, became the first black American with a lead role on television, as a tennis pro-espionage agent in the weekly series *I Spy*.

In American popular music, the primary field from the nation's inception in which whites, blacks, Native Americans, people of Hispanic ancestry and indeed im-migrants from everywhere had met and maybe bonded, change was the order of the day. The nascent mass music market for teenagers, sparked by black rhythm 'n' blues hits like Joe Turner's "Shake, Rattle and Roll" of 1954, had suffered a grievous blow when Elvis Presley was inducted into the Army in 1957, and his rockabilly-roll did not recover substantially upon his return to civilian life in '60. Country-bred music retained its audience – in part by slicking itself up as the new "countrypolitan" sound out of Nashville – but urban music such as Brill Building pop, the upbeat soul

stirrings of Sam Cooke, show tunes and film-TV themes, as well as jazz from New York and L.A., the Chicago blues, New Orleans' Caribbean-inflected rumba-boogie, and r&b out of St. Louis, Memphis, Houston and Detroit prevailed.

Singer Joan Baez had experienced a professional breakthrough at the 1959 Newport Folk Festival and folk music had become white American college students' soundtrack of choice, though its historical legacy was obscured by the dilutions of such acts as the Kingston Trio and Peter, Paul and Mary. In reaction (though maybe it wasn't evident at the time), *The Freewheelin' Bob Dylan*, that songster's second album, was well received upon its release in 1963.

So were such escapist alternatives as the Beach Boys' California-summer anthems "Surfin' USA" and "Be True To Your School," the Brazilian bossa nova smash "The Girl From Ipanema" (as recorded by guitarist–singer Joao Gilberto with his companion Astrud offering an impromptu chorus in English and saxophonist Stan Getz supplying obbligato), and the first singles of the Beatles, Rolling Stones and Dave Clark Five – advance troops of pop music's British Invasion (which soon generated renewed interest in black Americans' blues, but at first was just fodder for teenie-boppers).

The mid-'60s was also the heyday of Ray Charles (who won his first Grammy in '63), James Brown (immortalized by his 1962 album *Live At The Apollo*, furthered by "Papa's Got A Brand New Bag" in '65) and Motown (by 1964, the largest independent record company in the U.S., producing hit after hit by Martha and the Vandellas, the Temptations, the Supremes, the Four Tops, Marvin Gaye and "Little" Stevie Wonder, among others). In 1966 Aretha Franklin left Columbia Records, which had given her wishy-washy material, for Atlantic Records, which helped her become the Queen of Soul. Latin-black styles were huge, too – the boogaloo was a dance and music craze, its Spanish Harlem-born beat popularized by Mongo Santamaria's recording of Herbie Hancock's composition "Watermelon Man" and subsequently finding its way into jazz albums, particularly those produced on the Blue Note label.

Initially artists producing these works, even and maybe especially those involved with commercial pop, embraced their identification as outsiders. The white singers and bands could claim this status by virtue of their youth, though at the end of the '60s they had apparently formed the new mainstream. But prior to that sea change, pop–rock–folk–soul musicians as well as elite composers, choreographers, visual artists, writers, filmmakers and jazz musicians proclaimed their distance from mainstream society with pride. A vast contingent of artists and audiences posed themselves as critics and dropouts if not outlaws of a flawed society, accepting as little as possible in terms of compromise, and that much only to survive and be subversive. As the mid-1960s' protests, assassinations, foreign war, urban riots, sexual freedoms, drug use and consciousness-altering activities like meditation escalated, American society seemed on the brink of a cultural revolution. The avant-garde leads cultural revolutions – by definition.

Miles was well aware of the scenes swirling around and beyond him (and so were his multi-dimensional band members: Williams avid about new pop–rock–soul styles, Hancock having studied electrical engineering, Carter with an advanced music conservatory degree, Shorter a devotee of comic books and movies). As the already-crowned prince of hip, Miles had little reason in the early to mid-'60s for making a further point of his place amid mavericks and renegades. He was a black American jazz musician – wasn't that enough? He defended his social, commercial and artistic positions by plunging ahead with his own program, never allying with musical forces that couldn't or wouldn't boast direct ties to the bebop past he'd partaken of – and never going back to bebop, either. His status as a first-rank recording star, an urbane sophisticate and trendsetter was secure; his music was as de rigueur for would-be playboys as bullfight posters and Italian tailoring, for bohemians as beards and Beat poetry, for upwardly mobile black males as admiration for boxer Sugar Ray Robinson (admiration Miles shared) and other self-possessed, accomplished brothers.

The new jazz avant-garde didn't identify him as a target of rebellion, but neither did it champion him as a comrade-in-arms. Miles wouldn't let them; he held them off. "I thought Ornette was playing more than Don [Cherry] was," Miles said in his *Autobiography*. "But I didn't see or hear anything in their playing that was revolutionary, and I said so."

> What they were doing back in the beginning was just being spontaneous in their playing, playing "free form," bouncing off of what each other was doing. That's cool, but it had been done before, only they were doing it with no kind of form or structures, and that's the thing that was important about what they did, not their playing.

Miles was particularly hard on Cherry, saying, "Anyone can tell that guy's not a trumpet player it's just notes that come out, and every note he plays he looks serious about, and people will go for that, especially white people." Cherry, good-natured though he was, could have been hurt by this comment, as he considered Miles one of his trumpet heroes, along with Harry "Sweets" Edison and Chet Baker, all of whom predicated his dry, vibratoless tone and willingness to sound soft, sweet, coy, playful rather than brash and brassy. But in a 1989 interview, Cherry seemed more bemused by Miles' behavior than put off by his barbs. He remembered Miles coming to hear Ornette's quartet at the Five Spot, and sitting in.

"He [Davis] wanted to try the pocket trumpet and he played practically all night," Cherry said, referring to the unusual, compact instrument he preferred. "After I played, Miles said, 'You're the only mother I know who stops his solo right at the bridge.' Then he started doing it."

Miles evidently admired Cherry's melodicism more than he was always willing to admit – "Don Cherry I like," he told Feather in '64, after listening to him on a recording of "You Are My Lucky Star" in Rollins' quartet. Miles was not one to generously praise other musicians tilling in or near his fields, not predisposed to make an effort over particularly fine distinctions, nor particularly interested in verifying information he might offer as statements of fact. "I think Cecil Taylor came on the scene around the same time that Ornette did," Miles continued in his *Autobiography* (though he must have known Cecil had already by '59 been in New York several years).

> He was doing on piano what Ornette and Don were doing with two horns. I felt the same way about him that I felt about them. He was classically trained and could play the piano technically, but I just didn't like his approach. It was just a lot of notes being played for notes' sake; somebody showing off how much technique he had.

Ornette and Cherry were seldom, in the late '50s or any other era, accused of showing off bounteous technique – to the contrary, they were derided for flaunting their perceived technical limitations and accused of deliberately instituting a kind of primitive chaos. Cecil, during that same period, was obscure and severely underemployed; although hailed by a few established critics (notably, Balliett and Nat Hentoff, who had met the pianist in the late 1940s in Boston), he suffered the derision of most of the East Coast jazz elite and core African-American audience for "not swinging" and incorporating far too much "classical training."

Nothing of the sort could be charged against Miles or the members of his quintet. Shorter, Hancock and Carter had – like Miles – come up through the respected jazz ranks. Williams, while undeniably young, loud (he used particularly heavy sticks) and excitingly irrepressible, had been schooled in jazz from childhood by his saxophonist father, tutored by Boston's famed drum teacher Alan Dawson, mentored by tenor saxophonist Sam Rivers (whom Williams persuaded Miles to hire briefly before Shorter took over band's the tenor sax chair), blessed by Blakey and Roach and playing professionally by age 15.

Miles and his men from 1964 to 1968 were jazz musicians' jazz musicians. They lived up to the popular image of hard-living night trawlers (Shorter's biographer Michelle Mercer reports that a hostess of their after-hours hangs remembered the era as "days of lines and noses"), and they represented the pinnacle of elegant knowingness expected of the elite. Miles' quintet pushed the boundaries of jazz in a manner that clearly flowed from mastery of technique and tradition, as did Coltrane and Rollins and in his own way, Monk, rather than attacking its parameters from an odd angle or seeming to discard them entirely, as Ornette, Cecil, Sun Ra

and Ayler were thought to do. Both sets of adventurers defied the status quo, but Miles' quintet played well-paying jazz clubs and summer jazz festivals, while those musicians labeled avant-gardists were usually found on the fringe.

Miles pursued the new strategically, introducing original material, often written by his band members, in studio recordings rather than practicing it on the gig in preparation of its documentation. From the first of these recordings, jazz conservatives heard them as a challenge. As Szwed discovered, *E.S.P.*, issued in '65, was reviewed for *Down Beat* by trumpeter Kenny Dorham, who was worried "that this group was edging toward the jazz avant-garde," and concluded, "It's not for me." Dorham was not merely closed-minded; Hancock had accompanied him on Blue Note albums, and Dorham had recorded, albeit uncomfortably, with Coltrane and Cecil Taylor in '58 (*Hard-Driving Jazz*, re-issued as *Coltrane Time*).

In the quintet's albums, Miles experimented with compositional elements such as ostinato (repeating) bass lines (which he had previously used to good effect on "So What") and cyclical (rather than linear) lead themes laid loosely over aggressive rhythm section parts. In performances, Davis' quintet still played his long-established repertoire in something close to the usual head–solo–solo–solo–head out format, but within that basic format, the entire ensemble was nimble, expansive and ultimately unlimited by formal restraints. If Miles was relying on his book of standards to hold onto his dependable fan base, he didn't intend the old songs to rein in his quintet.

As everyone lending a casual listen to the quintet realizes, Tony Williams' input was vast, his rhythmic "orchestrations" (to use Chamber's word) every bit as galvanizing as Miles' sense of melodic lyricism and emotional mood. But he was splendidly matched: Hancock and Shorter were pleased to take liberties with such tunes as "My Funny Valentine," "If I Were A Bell" and "So What," cognizant of the freedoms broached by players associated with the nominal avant-garde, though they voiced no allegiance to it, either. Hancock, Shorter, Carter and Williams, often teaming together on their individually brilliant albums of the period, demonstrated plenty of freedom, including the freedom to not pledge allegiance to the cult of "free." As artists they assumed the rights employed by all others in their field of operations, so on such of their recordings as *Spring* and *Lifetime*, *Empyrean Isles* and *Maiden Voyage*, *Ju-Ju* and *Speak No Evil* – even without Miles – they swept as a current breaking off from the mainstream, if not cutting a whole new course.

Miles adapted his trumpet vocabulary to some of the less conventional, more fragmented impulses of his impetuous younger sidemen. One of his new gestures was a streaking downward run, hardly articulated – a rip or dash, an ejaculation, an exclamation point, a curse, a gasp, all at once.

Hear the quintet's open interpretations of Miles' staples recorded during two frigid Chicago nights at the Plugged Nickel in December 1965. Each piece is subjected to spontaneous revisions of the leader's typical renderings, and the revisions

themselves are dramatically transformed throughout the course of the two nights' seven sets. At each pass time is newly elasticized, harmonies extended, melodies altered beyond their recognizable shapes. The warhorses of Miles' songbook became little more than launching pads from which the band takes off on far-flung improvisations. The band seems to comprise five co-equals, rather than a leader and sidemen.

Still, it operates within some limits jettisoned by those fomenting free jazz. Miles called his approach "controlled freedom." All improvisations went forth from known materials. The horns mostly played sequentially or with a bit of overlap, but seldom sustained simultaneous interaction or counterpoint. Williams might change tempo or even time signature mid-piece, or drop sudden accentuating bombs (as Kenny Clarke had done at the beginnings of bebop) or extended explosive phrases, but his rhythms still tended to flow from the lingua franca ching-ching-a-ling. The music was collectively "free" to the extent that the musicians listened closely to each other and responded with unique rapport and, yes, I'd say they achieve coordinated freedom of flight equal to any musicians of that day. Yet essentially Miles' men downplay the notion of revolt – they're not working against him or against the legacy he represented, after all. Though in *Footprints*, her Shorter bio, Mercer tells of them conspiring to play at the Plugged Nickel against expectations, the recorded document has them sounding like they'd agreed to plunge on down the path sanctioned by their leader.

During this period Americans were excited by Martin Luther King and Malcolm X, black nationalism and the Black Panthers, yet the Miles Davis Quintet was undemonstrative regarding those issues. Miles played benefits for civil rights organizations, but made no more overt show of his politics than to insist that images of African-American women, including his very attractive wife Frances and, later, Cicely Tyson, appear on his album covers, rather than a picture of a white model. He didn't need to wave flags higher than that. Hipsters knew where Miles stood; others could assume what they would.

The idea was that Miles, Shorter, Hancock, Carter and Williams, like the white avant-garde and contrary to perceived imperatives of the day, made music for music's sake, instead of to promote a social or political agenda, from a sense of protest or in pursuit of spiritual transcendence. They were out to realize the potentials of principles Miles had helped his elders and peers outline and define during the two preceding decades of his career. Miles' second great quintet, at its greatest, played fearlessly at the very edge of possibility, but always from the inside, stretching out. Miles, Shorter, Hancock, Carter and Williams might have reached an impasse, clinging to the fundamentals of a once daredevil but now endangered art.

In 1968 Miles had accrued several good reasons to re-evaluate his career and tinker with its direction. He was 42 years old and one of the world's most powerful

(acclaimed *and* influential) musicians, able to cajole or finagle unusual concessions from promoters and extra monies from his record label, the sole jazz veteran retained by Columbia Records when Clive Davis, its new president, took command. But Miles had also suffered personal wounds – altercations with the police among other hard characters, recurring physical ills for which he was heavily medicated, failures of his marriages and feints at parenting (now he was a grandparent!), and a relapse into recreational drug use (not of heroin but cocaine, and liquor, of course). Some of these problems were self-inflicted, some unavoidable. The biggest challenge he faced was inevitable: aging. He neither could nor would escape change and the times, nor is there much sign in his life that he would want to (or thought escape into security, much less fixity, was possible).

If his quintet had accomplished an extraordinary level of sophistication, flexibility and fluidity, it was nonetheless lagging in album sales and media attention, lapped by lesser musicians tapping more potent trends. There is no need to detail how rock 'n' roll – post-Elvis and rockabilly, white British and American youths appropriating black urban blues, neo-folk bards turning to electric instruments and blunt opposition to the established generation – affected the stalwarts of jazz. Let it be that a decade's changes shook their world and threatened to bury them.

Miles wouldn't be buried; he would catch up. One taboo almost all of jazz society honored was a ban on loud electric instruments, though rock music ran on their charge. High volume delivered music better to larger audiences, of course, but often at the expense of nuance. It's unlikely Miles simply decided he liked music loud, but easily believable that he recognized the capabilities of new and improved amplifying gear to address potential audiences, and he probably realized, in the wake of Bob Dylan's turn to electricity at the 1965 Newport Folk Festival, the publicity his adoption of electronics would provoke. He may have been tickled by the prospect of doing exactly the opposite of what would be expected of him, or he might have decided, seeing the size of the crowds drawn to electric soul, blues and rock bands that if you can't beat 'em, join 'em. Anyway, why not use the newest tools and best toys to play the greatest music in the land? Give electricity, much in the air, a try.

The guitar itself was held in low regard by many jazz purists. Lonnie Johnson and Eddie Lang had brought the instrument to jazz settings in the 1920s, Eddie Durham and Django Reinhardt had advanced its appeal and properties in the mid-'30s, bluesman T-Bone Walker and Charlie Christian had proved the electric guitar could find itself a place as a solo voice, respectively in Cab Calloway's and Benny Goodman's bands. Yet in modern jazz it was rare. Despite the appearance of some dozen talented and accomplished jazz guitarists – Tiny Grimes, Barney Kessel, Oscar Moore, Tal Farlow, Herb Ellis, Kenny Burrell, Jim Hall and Joe Pass among them – the stringed instrument was seldom integrated as an important voice in horn-based groups, most often found in rhythm 'n' blues-drenched organ trios.

In the '60s, Wes Montgomery ruled among jazz guitarists for his plummy sound,

fast and imaginative octave-doubling lines, thick chords and rhythmic momentum. Grant Green, who generally limited himself to bluesy single-note melody variants, was prominent as a Blue Note session leader and sideman. *The New Boss Guitar Of George Benson With The Brother Jack McDuff Quartet* introduced another Montgomery-inspired contender in 1964. But it was in rock 'n' roll that the guitar had become king, and out of rock a new breed of jazz guitarist emerged.[1]

Larry Coryell, having started to record with drummer Chico Hamilton in 1964, was the first guitarist celebrated for straddling rock and jazz. He was "without question the most inventive and original guitarist to appear since Charlie Christian," as *The New Yorker*'s august critic Whitney Balliett was quoted on Coryell's debut as a leader, *Lady Coryell* (Vanguard Records). That same year Coryell formed the Free Spirits quartet, which boasted jazz pretensions and rock energies – hence, jazz-rock.

The Free Spirits had a saxophonist–flutist, Jim Pepper, who despite his greater capabilities played mostly backgrounds on vamps and banal chord changes, and a very fluid drummer in Bob Moses, who could swing though the Spirits didn't ask him to. The band, bassist Chris Hills and rhythm guitarist Chip Baker cut one album – *Out Of Sight And Sound* – which was badly recorded, drenched in reverb, devoid of interesting melodies and marred by terrible singing. In 1967, though, Coryell began to work with vibist Gary Burton's quartet; their albums *Duster*, with bassist Steve Swallow and drummer Roy Haynes, and *Lofty Fake Anagram*, with Swallow and Bob Moses were (and remain) fresh and energetic, if not rock productions by any stretch of definition.

They feature no singers, no songs built on single, emphatic beats, no realistic intentions that they should be danced to, and despite suitable album cover imagery (a yellow storm blowing over a field, long-haired young musicians in fringed jackets and black sweaters, an exotic illustration on a death theme) they invariably value and showcase instrumental virtuosity of an earnest, adult nature. No rocker would create something like them or claim comparable music as their own (until, maybe, Frank Zappa on "The Eric Dolphy Memorial Barbeque" on *Weasels Ripped My Flesh* and Captain Beefheart instrumentals like "One Red Rose That I Mean" on *Lick My Decals Off Baby*, both from 1970).

For his first sessions with a guitarist, in early December 1967, Miles called upon Joe Beck, a 22-year-old studio session player – a white kid – who had replaced Coryell in Chico Hamilton's band, and had started to work with Gil Evans. He'd also previously recorded with Hancock and Carter. Subsequently Beck had a long and varied career, but beyond two more minor tracks, he never worked with Miles again.

Miles has been quoted saying that he'd been influenced by bluesman Muddy Waters and soulman James Brown, and he likely *was* impressed by the substantial successes of those enduringly popular, indeed fundamental African-American urban

musicians. He could well have studied the instrumentation of their ensembles and naturally felt akin to their expression. Paul Tingen in *Miles Beyond: The Electric Explorations of Miles Davis, 1967–1991*, makes a cogent argument for considering Miles "as primarily a blues player who moved into jazz and then into jazz-rock, rather than a jazz player who was influenced by the blues." Miles re-affirmed, verbally and musically throughout his career that he felt imbued with the blues.

Indeed, Miles may have heard of, if not actually heard, Waters and other Mississippi Delta-inflected bluesmen during his East St. Louis youth – Waters lived in larger St. Louis during 1940, when Miles was 14 (St. Louisian Chuck Berry, the same age as Miles, was gigging locally during his teens). Blues was the hue of the city, its name famous worldwide via W.C. Handy's "St. Louis Blues" recorded by Bessie Smith, Louis Armstrong and Earl Hines (who backed by his ultra-hip orchestra had a 1940 hit "Boogie Woogie on St. Louis Blues").

Miles claimed in his autobiography: "I used to listen to Muddy Waters in Chicago down on 33rd and Michigan every Monday when he played there and I would be in town," to gig or to visit his sister from the mid-'50s to the mid-'60s. In that decade the blues – especially that of Waters and his country-born but citified circle – was providing omni-Americans and Europeans, too, with the juice of their rock 'n' pop revolution (an example: psychedelic bluesman Jimi Hendrix's debut album *Are You Experienced?* was released upon the U.S. in fall '67). But there is no reference in Miles' first preserved recording featuring an electric guitar to the grit Waters and Jimmy Rogers exhibited at taverns and after-hours joints in the early '50s and in their Chess Records classics (first released in LP rather than singles format in 1965), to the pronounced lead lines or stinging fills Buddy Guy deployed in Water's band live and on record in the earlier '60s, or to the urgently tight and insistent rhythms at the core of Brown and his JBs, who had scored one of independent souldom's greatest triumphs with his self-produced *Live At The Apollo* album of 1962. Neither was there an explosion of distortion, feedback and swashbuckling melody as Hendrix's trio deployed. Miles' first recorded meeting with electric guitar is more tentative, almost tenderly so.

On "Circle In The Round" Joe Beck plays a simple, throbbing figure that repeats itself in an unhurried if not lazy way at midtempo and midregister, while Miles solos at length on open horn, and Shorter more briefly, twice, on tenor. There's not much blues about the horns' sketchy theme, a braiding of phrases like silk scarves twisting together. Hancock on celeste adds glistening effects and some suggestive melodies that are not developed, remaining understated and elusive. Williams, beneath them all, supplies a dazzling variety of dynamic motifs, building intensities that are jarringly deflated by several obvious edits. Those moments come as a surprise, but they are accepted as readily as hard-cuts in an action movie.

When first issued in 1980 as the title track of a compilation of Miles' out-takes, "Circle In The Round" was 26 minutes long, taking up an entire side of an LP; a

version available from iTunes in 2007 is seven minutes longer, but not very different (Stan Tonkel, a Columbia engineer, is credited with editing the briefer version, from the 33 minutes Teo Macero had prepared). Like most of Miles' recordings held from release for a significant period after their event, this piece is not one of his primary statements, being of interest mainly to those of us trying to trace the steps of his evolution, and suffered a drubbing (if not dismissal) by most Miles' commentators. Miles dissed Beck's undulations in his autobiography, saying that he was relieved, guitaristically, by his next draftee on the instrument, George Benson, though Benson's efforts on "Paraphernalia" (from *Miles In The Sky*, recorded in January 1968) are uncharacteristically, uncomfortably provisional, and Miles used Benson only twice more to slight benefit. Szwed says Miles asked Benson to join his band, but the invitation was declined.

Beck's estimation of his own work was dismal; he told George Coles, author of *The Last Miles*, "There was nothing I could contribute. The sessions were patently unsuccessful." Harsh self-judgment. Beck supplied what was asked for; if he lacked the confidence on that occasion to offer anything else, or even realize he could, he nonetheless supplied Miles with a basis from which to proceed. "Circle In The Round" annotator James Issacs called Beck's part "gimbri-like," referring to a Moroccan lute that looks like a cigar-box and broom handle guitar; the figure recalls to me the pluckings of the douss'n guni, a light, soft West African hunter's harp that Don Cherry used in his late '80s Multikulti band. With its rolling repetition situated between bass and piano, and its deliberate subversion of the raging lines the instrument delivers in most outings, Beck's electric guitar introduces a layer of sinuous continuity that presages Miles' upcoming *In A Silent Way* and *Bitches Brew*. Maybe "Circle In The Round" failed to meet Miles' great expectations, but it's fun enough to listen to, and prefigured the shape of Miles' brand new bag.

In 1967, few performers outside the Western classical realm issued uninterrupted album-side-length works. To do so was to make a statement, as if length itself signaled seriousness of purpose.

Duke Ellington's 45-minute "Black, Brown and Beige" premiered at his annual Carnegie Hall concert in January 1943, was the first jazz suite, comprising seven sections in what its composer called a "tonal parallel to the history of the American Negro," but it received negative reviews, and he never presented it in completion again. He continued to work in long forms ("Such Sweet Thunder," "Nutcracker Suite," "A Drum Is A Woman," the Sacred Concerts, "Latin American Suite," "New Orleans Suite," "Toga Brava," "Far East Suite"), but these were mainly assemblages of separate pieces linked by topic. Sonny Rollins recorded "The Freedom Suite," a 19-minute trio improvisation, in 1958, taking up an LP side; Ornette Coleman recorded *Free Jazz*, a full album for "double quartet" improvising free of restrictions but with touchstone passages and a prepared sequence of showcasing episodes, in

1960; John Coltrane's *A Love Supreme*, recorded in 1964, was a four-movement suite. Coltrane also segued through linked movements in his sweeping *Meditations* (1965), and filled both sides of an LP with the highest-energy blowing of his extended clique on *Ascension* (1965). Cecil Taylor's *Conquistador*, recorded in October '66, had an 18-minute title track and 19:30 piece for its second side.

In pop-rock, sidelong or album-length works had gained even more cachet. The Beatles' epochal suite-like *Sgt. Pepper's Lonely Hearts Club Band* was issued in the U.S. in summer 1967; it was still a series of songs loosely linked by narrative concerns and special sound effects, but my, what good press it got. The Jefferson Airplane's *After Bathing At Baxter's*, released in December '67, also boasted an overall structure for the album and was more daringly experimental, with a 90-second musique concrete-like collage ("A Small Package Of Value Will Come To You Shortly") and a 9-minute instrumental, "Spare Chaynge" that builds from spacey, intermittent noises into a tense, ultimately triumphant jam by guitarist Jorma Kaukonen, electric bassist Jack Casady and drummer Spencer Dryden – a rare example of genuinely jazzed rock, analogous to Cream's 16-minute version of Charlie Patton/Willie Dixon/Howlin' Wolf's "Spoonful" live from the Fillmore on *Wheels Of Fire* and Jimi Hendrix's 15-minute blues "Voodoo Chile" on *Electric Ladyland*, both released in 1968. Quicksilver Messenger Service stretched Bo Diddley's "Who Do You Love?" into a 20-minute side in spring 1969 (on *Happy Trails*). The Paul Butterfield Blues Band had been there first, in '66, with "East-West," a 13-minute modal-blues workout reputedly inspired by Indian classical sitarist Ravi Shankar.

"Circle In The Round" tops those few recordings in length and flow-through. Had it been issued when it was recorded, it might have trumped the jazz examples for audience accessibility – it is very easy listening – and the rock outings for sonic variety (no such extended productions came out of black pop/soul music until George Clinton's Parliament-Funkadelic mid-1970s raveups, though James Brown was famous for the unpausing relentlessness of his performances). But it wasn't issued when recorded. Most of Miles' experimental recordings of that period – finally collected in *The Complete In A Silent Way*, a boxed-set released in 2001 – were not marketed; rather, they were snuck out.

Maybe that was Miles' intent; maybe he wasn't satisfied with the takes, he truly considered them experimental in nature and experiential at that, sending his players up a path but not worth publicizing as steps on the way. Starting with *Filles de Kilimanjaro*, "Directions in Music by Miles Davis" had been imprinted on his album covers, and his charisma was based on how singularly recognizable and inimitable his personal, ensemble and conceptual stamps were. Maybe he felt the held-back tracks weren't really indicative of his directions, or hadn't arrived at his destinations.

Teo Macero, as Miles' producer, might have concurred, and not bothered to present the music to Columbia brass rather than have it rejected, Miles' sessions shut down, the creative font stilled at its source. Maybe Macero, a recorded alto

saxophonist and composer in his own right with jazz, symphonic and third stream experience, didn't like these tracks himself; maybe he wasn't willing to commit to them the taxing close work of razor editing he'd begun to employ on Miles' raw material. Maybe he had no feeling for these particular pieces. Or maybe Macero was protecting Miles from the opinions of Columbia Records executives, though it's telling that people in such positions might then have been so incurious about what their demanding jazz star was working on that they didn't listen for themselves. Maybe their minds were elsewhere, absorbed by Columbia's rock albums experiencing unprecedented sales. Maybe the record company guys heard this music and thought it so far out, so way beyond them, that they declined to release it.

Miles annotator Bob Belden contends that Miles himself rejected "Circle," disappointed in it ("He wanted a sitar-like drone, and he got a studio musician's version of a sitar-like drone instead," Belden said in a 2006 phone interview), that Macero would have acceded to Miles' decision, and that Columbia execs probably never received test reels from Miles' sessions. Whatever the reason, as a result Miles' avid fans at the time could not know where he was going. *The Complete In A Silent Way* documents successive stages of Miles' development, clarifying his process by including the tracks withheld for 35 years. Would there have been a market for these works in 1968?

Devotees were buying Miles' albums twice a year then, spending time between releases debating their virtues. *Sorcerer* and *Nefertiti* were released in '67; *Miles In The Sky* and *Filles de Kilimanjaro* were prepared for '68. Miles' fans tended to be avid; maybe they could have handled more. That the music was not issued, even though Miles was in fiscal debt to Columbia Records and the label eager for his next product, suggests that *someone* felt it was too avant-garde to garner significant sales or critical support. Ironic, as Macero's memos note Columbia's interest in the prospect of Miles and Gil Evans recording music derived from the Lerner and Lowe's Broadway fairytale *Camelot* and the film version of *Dr. Doolittle*. Imagine: "Miles talks to the animals."

That surely would have been taking the trumpeter's appeal to "youth" too far and off course, but Miles definitely had something youthful in mind. Like his record company, he was quite cognizant of the baby boomer audience, 200,000 of whom gathered in June 1967, to cheer new headliners – Janis Joplin, Ravi Shankar, Buffalo Springfield, as well as South African trumpeter Hugh Masekela, Chicago blues-and-ballads singer Lou Rawls, soulman Otis Redding and the Jimi Hendrix Experience in its Stateside premiere – at the Monterey Pop Festival. It was the height of the summer of love. Miles was not immune to the attractions of youth or love.

In February 1968 he divorced his wife Frances, ended (well, suspended) his affair with Cicely Tyson and acquired a new girlfriend, 23-year-old Betty Mabry, a bright sprite from New York City's funky-chic scene. Miles was not the first middle-aged man to want a lover half his age, not the first to find one and to follow her

guidance through a thorough makeover. As an artist embodying the haut romantic myth, he could be expected to draw fuel from his lovelife for his music. Maybe his albums of this era can be interpreted without too much exaggeration (or insistence) as tracing the arc of his *amours fou*.

Belden's liner notes to *The Complete In A Silent Way* boxed-set are definitive explications of the music and the music-related business surrounding its creation. The box sensibly starts with tracks from the LP *Filles de Kilimanjaro* (recorded in January '69, released with Betty Mabry's image on its cover), and ends with the as-issued LP version of *In A Silent Way* (recorded in February and issued in July '69, with a cover depiction of turtlenecked Miles). Between these poles are 92 minutes of hitherto unreleased music by Miles with old sidemen Hancock, Shorter and Williams, and new ones Chick Corea, Dave Holland, Keith Jarrett, John McLaughlin and Joe Zawinul, comprising previously unheard full takes and the two "rehearsals" that were eventually cut into the side-long pieces "Shhh/Peaceful" and "In A Silent Way/It's About That Time." The music in the box is sequenced by session.

Given the beginnings of Miles' electric career – from "Stuff" on *Miles In The Sky*, which is Herbie Hancock's debut recording on the electric Fender Rhodes piano and continuing with the same album's "Paraphernalia," wherein George Benson gets jumpy – there are few surprises in the so-called new material. The best of these early vamp, rhythm and buzz shufflings, notably "Mademoiselle Mabry" and "Frelon Brun" from *Filles*, are well known. Of what's never been issued before "The Ghetto Walk," at 26 minutes, is the big deal, but on first listenings interest in it waxes and wanes. It's based on a peculiarly dated boogaloo, and conjures attitudes kin to 1970s blaxploitation flicks. There are some fine moments when electric guitarist McLaughlin gets with Miles just right. The unissued "Splash," "Splashdown," "Early Minor" and "The Ghetto Walk" will excite the most excitable, but are essentially warm-ups for what's to come.

Which starts immediately upon Zawinul's single organ pitch opening "Shhh/Peaceful" with a note of suspense, alone for three seconds, that mood briefly heightened when McLaughlin plucks two low notes. In the track's sixth second, a whole new sound cuts in, a burbling concoction of Corea's Fender Rhodes chords, Hancock's gospel/blues-redolent figures, Zawinul's sustaining organ, Holland's throbbing bass and Williams' wrist-driven, half-open high-hat, spilling forth in unhurried abundance, anticipating Miles' entrance.

The trumpet hasn't been heard for the first 100 seconds of the track; when Miles comes in his sound is incomparably compelling, lazy yet purposeful, flush, captivating. His melody, seemingly as spontaneous as one's facial expressions during a tete á tete, unfurls effortlessly with lustrous tone, through the others' interlaced yet independent strains. When at two minutes and 43 seconds Miles emits a squeak, a tweak, it is obviously deliberate; so is the tenderness of tone with which he follows it. He is without question leading, surprisingly upbeat and at a moderately brisk

pace, but the entire ensemble sound supports his easy, opulent, sweepingly seduc-
tive invitation. Gerald Early writes:

> Jazz was searching for a role in the culture after World War II, and it tried sev-
> eral possibilities: as mood music (that combined pseudo, middle-brow intel-
> lectualism with its function as background noise for mating) . . . as soundtrack
> for gritty, neorealistic crime cinema . . . as experimental neoclassical music . . .
> as politics in the form of agit/prop aesthetic.

Which role did *In A Silent Way* fit? Without doubt: mood music for mating. Not
"background noise," thank you very much, Mr. Early. Why should this function be
disparaged, as music is an enhancement to love, and sexual love need not be put
down as base, like animal husbandry? Why not celebrate an erotic masterpiece, if
the construct of one was the music creator's aim, and he succeeded? *In A Silent Way*
strikes me as proudly and profoundly amatory: a backdrop, yes: an audio tapestry, a
beguilement, a lover's gift, maybe, a lapidary reflection and recollection, the erotic
sonata for sensualists, and yes, maybe sybarites. *In A Silent Way* is not as oceanic
as *Bitches Brew* or as rapacious as *Live-Evil*, as spiky as *On The Corner* or as druggy as
"Guinevere," but it is the key initial document of Miles' electric departure, and if it
was inspired by or serves Eros, does that disqualify it from the seriousness afforded
music with historical, political or spiritual points to make? If so, how foolishly pre-
tentious of the disqualifiers.

(And oh, what delight to have heard that music live, though Miles never ever
performed it with the same cast, that way. His brief stabs at doing so, renditions
of "It's About That Time" for instance, captured on a bootleg recording from the
university town Ann Arbor, Michigan, in 1970, or the DVD *Miles Electric: A Different
Kind Of Blue*, his thrilling set at that same year's Isle of Wight festival – issued in
2004 by Eagle Eye Media – hardly allude to the sweet sex play for which the original
might have been/can be a soundtrack. On second thought, best to have this music
only as a recording. The imposition of live musicians – isn't there a movie scene
of blindfolded violinists hired to perform for some Casanova's seduction dinner? –
upon private, personal intimacies would render the intimacies gross and the music
absurd. *In A Silent Way* was personal, private music – not Miles' larger-scale pop-
cum "social music" comin' round the bend.)

And as it is, there's maybe nothing so well tempered in Miles' entire electric
oeuvre as "Shhh/Peaceful," except "In A Silent Way/It's About That Time," on
the original LP's flip side. Turn it over, someone would always say. And again. And
again. Both sides of IASW unveil themselves sensuously, layer after layer, at tempos
conveying the luxury of love, the urgency of lust and the languor of satiation. The
theme of "In A Silent Way," originally written by Zawinul as a reverie on his Austrian
childhood, is refashioned by McLaughlin and the keyboardists – without doubt at

Miles' direction – to float like an opium dream or reverie of post-coital repose. Again the trumpet's entrance is delayed, for more than two minutes, at which point it affects a soft, sad quality, like murmurings conceding depletion and contentment. After about two minutes of that, "It's About That Time" asserts itself in a manner much more strenuous, as if intent upon revival.

The opening four-minute episode is reprised in its entirety after 12 minutes, two-thirds of the way through the 18-minute LP side constructed in the recording studio by producer Macero, a piece which eminent jazz critics (esteemed Martin Williams then of the Smithsonian Institution chief among them) and Miles' straigh-tahead jazz fan base may have spurned but college-age music freaks and others with the requisite hipness quotient embraced virtually unquestioned. There were no reports of buyers returning *In A Silent Way* to retail outlets because they felt shortchanged by the repetition of its main sequence. Odd though it might have been first time to hear exactly the same music roll forth at the end of side one as at the beginning, the complete return of "In A Silent Way" it was less cause for complaint than delivery of satisfaction.

There was no precedent for the recapitulation, unless one allows all Western Europe music's history with sonata form. In jazz, Count Basie's orchestra one-more-timing the flag-waving out-chorus of "April In Paris" might be some kind of a reference, but an oblique one, not like Miles repeating his gorgeous call over a bur-bling stream of beguiling timbres, crisscross thematic tangents and pulsing rhythm. Basie's tune came to an irresistible climax, and repeated it over and over; Miles' piece was more like a mobius strip, begun at one spot and returning to that spot with a twist. Or: Heraclites said, you can't step in the same river twice, to which Zeno responded, You can't step in the *same* river *once*. Miles and Teo proved them both right. "In A Silent Way" was different when it began from when it ended, by virtue of all that happened in between, and "In A Silent Way/It's About That Time" still seems different in the listening, as one's attentions find different details to fix on and enjoy with each repetition.

Let us not scorn Miles for indulging his satyrism, which many men might aspire to themselves. Scorn is pointless and useless, anyway: no shame ever stuck to Miles, who on the contrary bragged in his autobiography about his most offensive mi-sogyny, boasted of pimping and smugly tossed off gruesome anecdotes about beating his wives and lovers. His macho reputation and seductiveness, initially assumed and projected upon him by his public but self-publicized in his autobiography, was the envy of such rivals as writer Norman Mailer (who married a woman whom Miles had squired) and the archetype for would-be gangstas, to every sensitive guy and self-respecting gal's dismay. But there is no violence implicit in "In A Silent Way/It's About That Time" or "Shhh/Peaceful." Rather than take him to task for what he did, consider what it was, how he did it, why it matters.

Creating an erotic sonata was one thing – and is only one way to see his achieve-

ment. Another, guitarist Carlos Santana suggests in an interview on the Isle of Wight DVD, is to hear "In A Silent Way" and "Shhh/Peaceful" as sonic balms during an era of much civil unrest. Interest in meditative music, which traded narrative drama for peaceful (relatively static) ambiance, was at a height then, with composers Glass, Riley, Reich, and Young, Eastern European avant-gardists such as Gyorgy Ligeti and Iannis Xenakis and Indian raga virtuosi and gurus, too, promoting experience as flowing forth or rather unfolding from nominally limited or "minimal" materials in a timeless suspension, the best contemplation, perception and absorption of which rewarded significant patience.

More happened in Miles' pieces – he expected generative collaboration from his fellow performers, for instance, which Glass and Reich did not require of their ensemble members – but *In A Silent Way* may also be thought of as a return to the laid-back, artfully distanced, arguably dispassionate cool, after his '60s quintet had explored untrammeled improvisation that was comparably hot, especially in live performances such as those captured at the Plugged Nickel. Miles' live performances following from *In A Silent Way*, as seen on *A Different Kind Of Blue* and a series of some half-dozen semi-bootlegged videos of his performances in Tanglewood, Paris, Vienna, Newport, Montreux, Japan and Berlin, 1970–73, are hot, too: strenuous, loud, fierce, all participants engaged as in deadly serious teamwork. Or maybe references to the hot–cool spectrum no longer illuminate Miles' music, which from '68 until his death often presents a paradoxical integration of temperaments, so that it's hard to tell if the aura of a performance is steam evaporating from a wicked simmer, a vicious boil or frost rising from dry ice.

Miles' in-studio recording practices by then seem to have become entirely off-hand, his preparations scant or last minute. He phoned Zawinul back minutes after having summoned him to the *In A Silent Way* session to add that he should bring along some compositions. But the impression is deceptive. It's not that Miles was being shoddy or didn't care; rather, he trusted himself and his musicians in and of the moment. According to Bob Belden:

> After *E.S.P.* Miles was recording as Coltrane had started doing in 1961, going into the studio to do a session, rather than to make an album. Tracks accumulated in this manner, and when there was enough for a record, they'd put one out. He didn't have a plan going in for an album called *Nefertiti*, an album called *Sorcerer*. They just went in and recorded. That's why those takes [from those sessions] dribbled out over the years in *Circle In The Round*, *Big Fun*, *Get Up With It*. There was no musical plan for them to begin with. There was no preconception of an album with cover art and everything. For *Bitches Brew*, yes, but that was in 1970, when all the stuff started really happening in the studio.

Or maybe the foundation of Miles' confidence in his sidemen wasn't so much trust in them as faith in his own alpha-male domination. He obtained the results he wanted, after all, not with direct and explicit instructions, but with subtle messages, silent body language and the use of psychological leverage. Belden:

> Larry Young was supposed to be the organ player for *In A Silent Way*, but when Tony Williams saw him, he kept Young out of there – that's why Zawinul played organ, when he was just there to provide some songs. When Tony saw McLaughlin and Larry Young there, he went 'Oh, no!' That was his band, Lifetime, that he was trying to get signed, and he saw Miles was about to take it over. He got Larry Young out of there, and that's why Tony played the way he did on the session [the famously unwavering, unvarying cymbal figure] and why it was the last time he played a note with Miles.

If whim, happenstance and personal manipulations determined a session's resultant raw material, post-recording production was done with after-the-fact deliberation, not heat-of-the-moment reaction, and much reliance on a producer (Macero) to fix it in the mix, cut and paste. This method of Miles' was to be adopted for commercial projects across genres and has been employed in all the decades since.

Furthermore, his embrace of the latest developments in musical instruments, not only electric pianos and guitars but also all their modifying add-ons from wah-wah pedals to ring modulators, filters, synthesized patches, etc., was daring then. Electronic music had been the nearly exclusive preserve of avant-garde composers (and pop-jazz guitarist Les Paul) prior to the deployment of drum machines under lame tunes that fed the fad for disco in the late '70s, subsequent harder-core techno and eventually loopy electronica. But soon after *In A Silent Way* was issued, having the latest gear became a must for pop bands wanting to make a splash, like Emerson Lake and Palmer, the British "progressive rock" trio born in July 1970 who were the first to tour with a Moog synthesizer, and The Who with guitarist Pete Townsend, inspired by Terry Riley's 1967 album *Rainbow In Curved Air*, driving a Lowry organ through an Arp synth for the opening flourish/underlying bed of "Baba O'Riley" on *Who's Next* in 1971.

It should not be overlooked, though, that Miles devised how to enfold new items into his band's palette for expansive musical purposes and didn't trot them out merely to snare musical naifs and tech-heads with their novelty, then shift back to conventional instrumentation for the body of a piece. Proof to that point is the complication of overall sound Miles instituted by having three keyboardists playing simultaneously, together, throughout *In A Silent Way*, where one would previously have been expected to handle the job. Three grand pianos wouldn't have given him the same beds – their buzz of electricity and fuzziness of tone was what he wanted. And that Hancock, Corea and Zawinul could offer, spontaneously, contrasting parts

that nonetheless sustained some connective link was another accomplishment Miles affected – evidently with little more than complete confidence in his cohort's e.s.p., or his collaborators' eagerness to supply him with what they thought he wanted, even/especially if that required going farther from their own baselines than usual.

Each player was ambitious in his own right, after all. Hancock, Zawinul, Corea, McLaughlin and Williams were each on the verge of beginning their own bands, and eager to stretch to fulfill what they thought were his requests, preferences, demands, for a variety of psychic rewards. If Miles was of a mind to record a valentine for his sweetheart, they must have picked up on that mood to help create it; if he were urging calm consideration in the face of social unrest, they'd get behind that, too. They were there for him as only some legendary groups of jazz musicians have been for their leaders, and among themselves. Jelly Roll Morton's Red Hot Peppers, Louis Armstrong's Hot five and seven, Ellington's early orchestra, Basie's All-American rhythm section, Parker with Gillespie and Roach, Roach with Clifford Brown and Sonny Rollins, Blakey's Messengers, Mingus with Dannie Richmond and Eric Dolphy and Jaki Byard, pianist Bill Evans' classic trio, John Coltrane's quartet, Ornette Coleman's *This Is Our Music* quartet (plus Dewey Redman), the Art Ensemble of Chicago, Steve Lacy's 1970s–80s groups, Anthony Braxton with rhythm section comprising Marilyn Crispell, Mark Dresser and Gerry Hemingway, and Cecil Taylor's units with trumpeter Bill Dixon as well as alto saxophonist Jimmy Lyons, come to mind.

The commanding, grandiose, dyspeptic, cynical, hardening and fearsome Miles was not far behind the mellow, love-struck one, as suggested by the sequence of his (mostly) studio albums released in the wake of *In A Silent Way*. If *In A Silent Way* can be characterized as the in-love album, *Bitches Brew* might be the falling-out storm, *Live-Evil* the regrouping project, *A Tribute To Jack Johnson* the fighter-alone statement, *On The Corner* the race-man declaration, *Big Fun* the recapitulation compilation and *Get Up With It* representative of his intensifying midlife crisis and confrontation of mortality (by virtue of its centerpiece, "He Loved Him Madly," Miles' 32-minute dirge in reaction to Duke Ellington's death). His in-concert recordings from 1970 to his 1975 retirement, including *Live At The Fillmore East*, *In Concert* (aka *Live At The Philharmonic*), *Agharta* and those initially withheld from release (*It's About That Time*, *The Complete Cellar Door Sessions*), bootlegged (*Double Image*, *Lennie's On The Turnpike*) or initially issued only in Japan (*Dark Magus*, *Black Beauty*, *Pangaea*) also document his relentless experimentation and musical development.

Glimpses of Miles in transition fascinate. His Shorter–Corea–Holland–DeJohnette lineup's performance at the July 1969 Festival de Juan Pins in Antibes, from an album issued by Japanese Sony, demonstrates both the gap between and lines linking Miles' past and present repertoire. He sandwiched long-time staples of his book – "Milestones," "Footprints" and "Round About Midnight" – between the new opening number "Directions," as yet unrecorded "Miles Runs The Voodoo

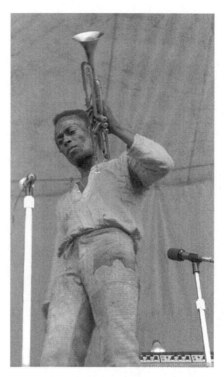

Miles Davis, 1970, New York City ©Jack Vartoogian/FrontRow Photos.

Down," "It's About That Time" and updated "Sanctuary" (to which he adds "The Theme," which he'd first recorded in 1955, as a ten-second coda). The listening experience is quickening but not jarring. Had the recording been released nearer to its occurrence, it might have reassured (or refuted) skeptics by demonstrating that Miles and band *could*, if they wanted to, segue without pause from unprecedented voodoo to the straightahead hardbop he'd exemplified in the musical incarnation he was abandoning, the old skin he shed.

Miles born again – to some as a brilliantly inspired Dr. Jekyll, to others a monstrously electrified Mr. Hyde – announced himself in the juggernaut *Bitches Brew*, conceived as a much more public album ("social music" being his neologism of the early '80s) than *In A Silent Way*. *Bitches Brew* is a project of pronounced ambitions, in varying degree personal, profit-oriented and political. Having arrived with *In A Silent Way* at a musical restructuring he could get behind by issuing rather than holding back for later exploitation, with at least the tacit encouragement of Columbia Records' Clive Davis to go after the burgeoning young white rock/pop consumer market and with visions of those enthused mass audiences in his head, Miles pulled out all stops in the creation of a purposely challenging, inescapably provocative double album that changed the course of jazz and much else. Its success – im-

mediate upon its release, and measurable on many levels, must have validated to its author how he himself should proceed. And he was not alone: all *Bitches Brew*'s players productively pursued parallel paths for years to come, launched by Miles' direction.

One of the money shots in Ken Burns' multi-part video history *Jazz* is of Miles standing in the wings at the Newport Jazz Festival in July of '69, absorbed as soul-rock instigator Sly Stone whips a crowd of thousands higher and higher. Upon second viewing, one notices that Burns does not really substantiate any such moment, but creates the myth of it by juxtaposing a still photo of Miles with actual footage of Sly. The depiction is almost too good to disallow merely on the basis of its fictionalization – like if it didn't happen, it should have.

Even without the counsel of Betty Mabry or Clive Davis, Miles would have known that the much-heralded youth culture – teens, 20- and 30-year-olds, increasingly alienated from prevailing norms by the Vietnam war and attendant military draft, full of themselves due to the convergence of their baby boom demographic bulge, rampant hormonal energies, advances in birth control, availability of psychedelics and media attentions – were stoked for musical fulfillment, eager for something big. If he could capture their attention he would simultaneously claim his primacy among American musicians, reaffirm his status in Columbia's catalog and assemble a new order, a Miles nation. Miles was not without ego; he might rule. He would sense that. It was no coincidence that Miles' recording sessions for *Bitches Brew* began the day after the Woodstock music festival, apotheosis of the '60s counterculture.

Woodstock was a genuinely momentous event. Has there been in the world's history another so ballyhooed "three days of peace and music" (as its poster, print ads, subsequent album and documentary movie advertised it), public caucus of half a million-some mostly young and privileged people, which propelled them into lifelong self-mythologizing, reinforced by a corporate entertainment industry seeking to exploit that weekend forevermore? Woodstock compares to what other happening? It is unique in the history of pop culture and the avant-garde in America, at the very least, as an occasion at which genuinely experimental, anti-conventional and assumption-challenging music was heard and adopted by a representative mass audience as an essential expression of the social-political moment. Of course, it wasn't Miles who delivered.

Not to underestimate the leveling effects of mass intoxication on sensual inhibition and perceptual defenses, but the Woodstock festival's Saturday lineup, starting shortly after noon, offered enough to attune even the squarest ears to the sweep of expressive, expansive, highly energized, rhythmically driven, guitar-drenched music. The sequence of acts from about 3 p.m. on was Santana, Canned Heat, Mountain – wailing guitarists purveying San Francisco-Hispanic-tinged blues, popularizations of traditional country blues and super-amplified blues; singer Janis Joplin's six-piece r&b horn band (with only guitarist Sam Andrews retained from Big Brother and

the Holding Company, which had begot her), Sly and the Family Stone in the peak performance (starting at 1:30 a.m.) of their self-described "psychedelic soul," the adventurously spacey Grateful Dead, the bluesy redneck swamp-rock of Creedence Clearwater Revival, and determined-to-impress guitarist Pete Townsend leading UK standard-bearers The Who. Sunday began (at 8 a.m.) with the acidly pointed Jefferson Airplane, included The Band and Blood, Sweat and Tears, and was topped by vocalists Crosby, Stills, Nash and Young. The Paul Butterfield Blues Band kicked off Monday morning, followed by the jokey revivalists Sha-Na-Na.

Jimi Hendrix insisted on being last act at the festival, starting around 9 a.m. Monday morning. He performed after the attending multitude had dwindled to an estimated 80,000, his solo guitar, feedback and effects-laden postmodern expressionist de/re-construction of "The Star-Spangled Banner" being the climax of a two-hour set (his longest ever). There are no other events in the annals of the United States out of which anything comparably avant-garde has directly, fully and enduringly captured the attention and imagination of the body populace. In three minutes and 45 seconds Hendrix calmly took up the national anthem, proclaimed its glory and shredded its hypocrisy, let its power ring forth and exposed its corruption, conjured a tone poem of destruction, misery and death fogged by false piety and returned the nation's theme song to us, its citizenry, daring us to honor it. After a moment's pause (as shown in *Woodstock*, the nearly four-hour film documentary), Hendrix leavened the seriousness of his statement by plunging into "Purple Haze," his signature hit in the States.

There was no "jazz" at Woodstock; sitarist Ravi Shankar's was the only all-instrumental ensemble – and Miles would hire a sitarist for his next studio session (November '69). But less than 24 hours after Hendrix unfurled his tour de force, Miles went to work on his masterpiece. The session call was for 10 a.m., Tuesday, August 19, with Macero and Tonkel in the control booth at the Columbia studios. Miles' key collaborators – Shorter, Zawinul, Corea, McLaughlin, Holland, DeJohnette – were joined by bassist Harvey Brooks (née Goldstein), a recently hired Columbia producer who had jammed with Hendrix, recorded with Bob Dylan, the Doors and the Electric Flag; multi-reedist Bennie Maupin, restricted to bass clarinet; Larry Young, who Miles had wanted on *In A Silent Way*, delegated to electric piano; drummer Lenny White; multi-percussionist Don Alias, and Jumma Santos, aka Jim Riley, a guest of Alias' who Miles told to pick up a shaker. It was a big band, and Miles made music with it that might have retained his adventurous committed fans, yes, but wanted, too, the rock, pop and soul listeners who might have thought instrumental jazz – or call it what you want to, what Miles had always played and what he continued to play – passé.

According to Dr. George Butler, self-described as a "neophyte producer" at Blue Note Records in '69 who moved on to run Columbia's jazz department in the '70s:

Though *In A Silent Way* fueled the fusion movement with its repetitive electronic trancelike beat, it did not generate the heavy sales anticipated; this goal was realized by . . . *Bitches Brew*, a heavily electronic rock creation that sold in excess of half a million copies. This recording needless to say made [Miles] an immediate superstar for a vast new audience of young rock fans who had never focused any attention on jazz in any form.

At the date itself Miles exercised the prerogatives of a rock star. He ignored his own rule against allowing lovers to attend sessions by having Betty Mabry there and, according to Szwed, aimed his trumpet at her as he played his first notes of his title track. "Bitches Brew" was a take-off (says Szwed) of a tune Mabry had sung on a demo Miles had produced for her two months earlier. The title itself was profane enough to ruffle the more staid suits at Columbia and, particularly when paired with the luridly surreal exoticism of Mati Klarwein's painting for the album's double-spread cover, to entice the anti-authoritarian pseudo-revolutionaries whose rhetoric upbraided the war in Southeast Asia, President Richard Nixon, assistant to the President for national security affairs Henry Kissinger, racism, capitalism, imperialism, uptightness and old fogeyism in general.

Miles briefly quoted the tune "Spinning Wheel," then a radio hit for Columbia's vaunted Blood Sweat and Tears, but the track "Bitches Brew" has its hook in its repeating bass line, and its point in the rhythmically declamatory phrase Miles works over starting at the ten minute 30 second mark. At several junctures he deploys a nagging echo (Macero-devised tape-delay), and there's a rubato (out-of-rhythm) introductory and concluding episode that he punctuates with a fierce, up-ripping shriek.

"Pharaoh's Dance," Zawinul's theme positioned to open the album, recalls *In A Silent Way* with its multiple subdued keyboards, intertwining basses and guitar, loose hi-hat figure and the awaited entrance (delayed two and a half minutes) of Miles. He is initially low-key, glancing – and after less than half a minute takes a half-minute respite, during which Corea, particularly of the three keyboardists, proposes an attractive alternative melodic path. But when Miles returns he insinuates a row of tones at a discordant remove from Corea's suggestions or any other portion of the set-up, and emphatically reiterates it. Miles treats his chosen pitches in a succession of phrases laid suspensefully over (through?) the band rather as composer Arnold Schoenberg dictated a note set should be managed in early twentieth century serial music, using inversions and reversals, but with the additions of silence and attitude – articulated attack – as elements of momentum. He ratchets up tension and the keyboards, drums (including congas), wisps of sax and guitar fall in behind. The bass clarinet surges on Miles' heels; he leaves the ensemble to discourse without him.

There's a faux end/new start at eight minutes in – almost the halfway point

— when the multitude quiets, and Miles reasserts his declaration, rephrasing it, expanding on it, so everyone rallies: Maupin overblowing his bass clarinet into its forced high register, Shorter slipping along on soprano, McLaughlin answering his cries, Young sparring with McLaughlin, Corea chiming in with asides. Intensity is built from the bottom up, from the density of the bass players' contributions and DeJohnette's beats. This episode climaxes and quiets; a bass keeps throbbing and the players add themselves over it gradually, keyboards first, then McLaughlin, Maupin and Shorter. Then Miles returns as lord of the realm. "Pharaoh's Dance" offers a vision of angular Egyptian figures like hieroglyphics etched on the walls of the pyramids sprung to sudden life.

I describe both "Pharaoh's Dance" and "Bitches Brew" — 20 and almost 27 minutes long, respectively, each originally taking up an entire side of the bombastic two-LP album — as if they were organic ensemble performances, improvised in the traditional "live" jazz way, because that's how they spilled forth as the vinyl spun, but that's not how the works were created. These pieces, as Tingen details in *Miles Beyond* (crediting Enrico Merlin's research, Lenny White's memories and Teo Macero's testimony) were post-session constructs that Macero stitched together and processed through work that deserves to be regarded as composition. As Tingen quotes Macero:

> I had carte blanche to work with the material . . . take all those tapes back to the editing room, listen to them and say: 'This is a good little piece here, this matches with that, put this here,' etc., and then add all the effects, the electronics, the delays and overlays . . . Take it back and re-edit it — front to back, back to front, and the middle somewhere else . . I'd send it to Miles and ask: 'How do you like it?' And he used to say, 'That's fine' or 'That's Ok' or 'I thought you'd do that.' . . . He never saw the work that had to be done on those tapes. I'd have to work on those tapes for four or five weeks to make them sound right.

Macero's involvement in the final shape of these tracks, also earlier and later ones and hence the revolution Miles wrought, is not in dispute, but it should be stressed that as imaginatively as he served the recorded material, he did not pen, play or otherwise originate it. Miles' willingness to hand over his fragmentary formulations to his producer for finishing is consistent with his creative relationship with Gil Evans and his expectation that sidemen could be depended on to give what he wanted, even if he didn't specify what that might be.

Delegation of such chores toward the completion of an artistic product superficially contradicts conventional notions of the artist's personal responsibility for his ultimate output. The processes of all music-making, though, and maybe jazz especially, have always been collaborative, and the development of advanced record-

ing studio techniques promoted adjuncts such as sound engineers and producers to more interactive roles. Miles' reliance on Macero wasn't an abdication of his artistic control; his assertion on the album covers that the music issued from his direction was no idle boast (though *Bitches Brew* was the last album on which he'd assert it; in the early '80s on *Star People* he would claim authorship of "All Drawings, Color Concepts, and Basic Attitudes"). The music of *Bitches Brew* sounds like Miles', not like Macero's, judging from such of the latter's recordings as *The Eclectic Side Of Teo Macero* (Teo Records, 2000), *Black Knight* (Teo Records, 2003) and *Impressions Of Miles Davis* (2005, Traditional Crossroads). Macero's music is worth hearing – he is a skilled and sometimes adventurous orchestrator, has a strong sense of drama and a phonebook full of contact numbers for prime soloists. His *Impressions* employs tropes Miles introduced and/or exploited before, during and after their association, but only approximates music Macero might have wished Miles had made.

Miles used every dimension of his talents, and whoever else's he could commandeer, in music that perpetrates powerful moods – delicate lyricism, snappy wit, captivating romance, penetrating anger, brooding skepticism, churlish glamour and victorious grandeur among them. He had gut eagerness to seize the time, the place and the people at hand, to squeeze something personally meaningful out of them. His fearless grappling with whatever he might just happen to stir up is the spirit animating *Bitches Brew*. He didn't get those qualities from Macero or any other of the admittedly ingenious, innovative and maybe even irreplaceable collaborators he employed in the creation of his art. He had those qualities in himself.

Prior to the recording of *Bitches Brew* Miles' concerts had become increasingly wild. An unauthorized and insufficiently annotated *Double Image* CD (Moon Records, Milan) captures his quintet with Shorter, Corea, Holland and DeJohnette in October 1969 (according to Miles researcher Peter Losin). The band's music is extraordinarily free in form, though framed by themes and devices that, when Miles decides to impose them, offer firm hold to his players and auditors alike.

The bountiful 81 minutes, split between two performances, is unusual for featuring Miles' trumpet on only three minutes of the 34-minute title track (Zawinul's composition) and approximately 16 minutes of the 44-minute rendition of "Gemini" (initial title for "Bitches Brew"). The generous space afforded the rest of the ensemble is amazing for the unrestricted improvisation Corea instigates, shifting the songs' variations, instrumental textures and group dynamics from nice ideas to rich uproar to suppressed but evident energy. In accord and inspired, Shorter rains a torrent of ideas on both soprano and tenor saxes; Holland and DeJohnette are also thoroughly engaged.

Miles, according to Corea (quoted by Tingen) "used to listen intently from the side of the stage, and . . . sometimes he'd take his trumpet and join us in 'outer space' for a moment. But otherwise his role was always to bring back a focal point

of melody in the group." Left to their own devices, Corea, Shorter, Holland and DeJohnette anticipate the short-lived, dynamically quicksilver but almost entirely acoustic Circle quartet Corea and Holland (he used an electric bass sparely in it) formed in September '70 with drummer Barry Altshul and multi-reeds player Anthony Braxton.

Shorter left Miles in March '70, prior to the April release of *Bitches Brew*. Their last night together, at New York City's Fillmore East opening for Country Joe and the Fish (best known for their anti-war "Fish Cheer" aka "I Feel Like I'm Fixin' To Die" with its melody from Louis Armstrong's "Muskrat Ramble"), was recorded by Columbia, but not issued until 2001. If I'd had *It's About That Time* I might have been better prepared for my first experience of Miles live and electric at the Civic Opera House.

Consider: Four of the tracks that completed *Bitches Brew* — "Spanish Key" and "John McLaughlin," "Miles Runs The Voodoo Down" and "Sanctuary," paired two-to-a-side on the package's second LP — were not as elaborate studio efforts and post-recording productions as "Bitches Brew" and "Pharaoh's Dance." The four-minute episode named for and after the British guitarist was the tail end of a section originally recorded for the "Bitches Brew" track, and Miles had introduced the other three pieces during his earlier summer '69 tour. At the August *Bitches Brew* sessions Miles' expanded personnel built upon what his core group, the touring band, had already mastered. The tracks of *Bitches Brew* share sonic consistency as a vast expanse of airs, squalls and countercurrents, thick and murky bass activities, linear and chord accompaniments and bounteous rhythmic details from two traps kits, congas and other hand percussion. All the instrumentalists — core group members and ringers together — constituted a new world symphony.

By contrast, *It's About That Time* features only Miles' touring band, his A team. Fade in at the distorted start the first of two 45-minute sets *It's About That Time* presents, and right out front there are Miles' sneers and Shorter's amens, Corea's raunchy electric clusters, Airto's shattering cuica, DeJohnette's chastening drums and Holland's running electric bass. A portentous bass cue signals the ensemble to snap to for the blaring head of "Directions," by Zawinul, in the band's book already for a year, and Miles zooms out like a jet from a hangar into the sky, banking obliquely, loop-de-looping, showing off. He sounds free, as if he's just been freed, not as at the *Bitches Brew* sessions where he's responsible for captaining a large, weighty orchestra. "Spanish Key," Shorter's "Masqualero," "It's About That Time" from *In A Silent Way*, "Miles Runs the Voodoo Down" and a theme called "Willie Nelson" all get the same treatment on *It's About That Time* — themes dashed through then discarded as each instrumentalist stakes his battle stance in fluid space, an individual post to hold despite clashing fluxations. The electric piano's buzzy overtones and wavering intonation blunt niceties of pitch, but lend sparkling crunch to the overall sound.

Davis himself is full of confidence, chops and daring far beyond the other famed

trumpeters of the day, including Dizzy Gillespie, Don Cherry and Freddie Hubbard. Shorter roars on tenor with a heft that compares favorably to even such of his models as Coltrane or Sonny Rollins, and runs head, pulse and heart beyond what Archie Shepp, Pharoah Sanders, Sam Rivers and Albert Ayler, champions of the same horn, were then blowing at full force (and amidst lesser volume). Shorter always played better with Miles than with anyone else, including Art Blakey's Jazz Messengers, Weather Report, Herbie Hancock in the mid-'70s V.S.O.P. quintet or otherwise, and the bands he himself has led since his resurgence dating from the mid-1990s. Here he used huge gusts of breath to power momentous melodic variations of a substance equal to but quite different from Miles' piercing blasts. This music starts *out*, and heads farther out. The band's unity, swagger and propulsion is, very macho, slap hands, all grins.

It's About That Time demonstrates where Miles went from the *Bitches Brew* studio, out to flaunt his findings before hippie crowds come to the Fillmores East and West to hear bands that spoke to their inherent tastes: laconic Country Joe, the psychedelicist and smooth blues popularizer Steve Miller, the neo-rural singer–songwriter Neil Young, the big-voiced princess Laura Nyro. Opening for such "stars," why would Miles compromise? Why should he not present his music in overdrive, create with unrestrained fervor, blow away the constraints on some little minds? Miles, prior to *It's About That Time*, had only seen audiences of rock-hall size in relatively staid concerts and jazz fests; those contexts had not yet provided him with audiences virtually by declaration open to radical messages conveyed via music. Other bands on the Fillmore circuit – Zappa's Mothers of Invention, say, or the Dead or Pink Floyd– may have had ambitions to explode music's previously assumed limits. Of them all, Hendrix was the one who stood out, demonstrating what could be done by regenerating African-American blues, rooting flagrant pop in rhythmic and oral traditions and making it new with technology, extravagance, virtuosity and charisma.

Hendrix died of careless intoxication at age 27 in September 1970. He'd been quoted in *Melody Maker* in March 1969 saying if Miles and Rahsaan Roland Kirk would jam, "it's almost worth dying, just for the funeral." There was no such jam, but Miles attended the funeral in the company of his current lady friend and also Betty Mabry, whom he had divorced, accusing her, among other things, of having had an affair with the man they mourned. Other guitarist–singers may have been more musically daring, more virtuosic, sophisticated and as hard or harder rocking – McLaughlin, with Miles' encouragement, was one worthy rival. But no one else combined all Hendrix's skills – compelling singer, imaginative songwriter, innovative instrumentalist, dazzling soloist – while credibly embodying all his roles – soulman, revolutionary and incendiary showman. Hendrix's legacy has proved indelible. At the 2007 Superbowl, the American pro-football spectacular that annually accounts for the largest U.S. television viewing audience of any program and is broadcast to 200 countries around the world, pop–soul–funk–rock singer–songwriter–guitarist

Prince entertained at half-time with musical pyrotechnics and physical gyrations directly traceable to Hendrix in his prime.

By autumn 1970 Sly Stone had begun a downward spiral involving band defections, missed gigs and aberrant behavior, reportedly spurred by his excessive drug use. James Brown was busy recording albums of jazz standards, pop ballads and Christmas songs as well as his own intense African-American funk; posters advertised his "1970 World Tour," but he performed mostly in black "chitlin circuit" venues. Stevie Wonder was still "Little" Stevie, under the thumb of Motown Records; that label's focus had shifted to pre-pubescent Michael Jackson of the Jackson Five, from the Four Tops and Temptations to diva Dianna Ross, from hometown Detroit to Los Angeles and the movie business. Aretha Franklin was between releases of *This Girl's In Love With You*, filled with covers of songs by white rockers, and *Young, Gifted And Black*, a ringing affirmation of her personal identity.

Of leading black American musicians who had demonstrated the crossover appeal of their vital new sounds to unbound young audiences, that left only Miles. *Bitches Brew* was embraced by mainstream record buyers — it hit number 85 on the Billboard Top LPs sales chart, one notch below the bubble-gum radio hits collected in *The Best Of Tommy James And The Shondells*, one click better than Barbra Streisand's *Funny Girl* movie soundtrack (top classical LPs number one and two were Walter Carlos' synthesized *Switched-On Bach* and *The Well-Tempered Synthesizer*, number three the *2001: A Space Odyssey* film soundtrack comprising avant-garde works by Gyorgy Ligeti with "Thus Sprach Zarathustra" and "The Blue Danube" waltz).

Miles saw his opportunities and seized them. He became enormously productive over the next five years — and though he would be accused by old school critics and fans of selling out jazz in favor of commercially viable music, he did no such thing. He worked with the elements used by the most popular, financially successful musicians in the world, yes — in the largest, poshest venues he could fill in the world, too. But his music brooked little compromise. It became less like everything commonplace as it became twice and thrice distilled. It remained unremittingly spontaneous, intuitively directed, fervent, experimental and evolutionary. For all his trouble, Miles didn't instantly get rock-star rich. His efforts did lead him to rock-star burn out, though, and an extended retreat to dark privacy.

Miles missed Woodstock, but he presented a 38-minute set without pause or spoken words on August 29, 1970 at the United Kingdom version of the generational gathering, the Isle of Wight Festival (audience estimate 600,000, according to the *Guinness Book Of World Records*) with a reconstituted band: Gary Bartz now on reeds, Jarrett joining Corea on keyboards, Brazilian Airto Moreira deploying his personal collection of hand percussion instruments, Holland still on electric bass and DeJohnette, drums. The DVD *A Different Kind Of Blue* is invaluable for showing their entire performance, filmed by cameras onstage.

Lean Miles, wearing a light orange jacket over an orange knit shirt and rhine-

stone-encrusted blue jeans, plays his horn unmuted and without wah-wah pedal, a fine sweat eventually dripping down from his trimmed natural haircut, his cheeks sometimes bulging like his old friend Gillespie's as he pushes air through his horn. His eyes are fixed on the trumpet's stem between its mouthpiece and finger valves, but he may not be seeing much of anything. He starts blowing aggressively over a simple vamp that soon arrives at the zig-zag theme of "Directions"; he slows down to pave the way into "Bitches Brew," encourages his ensemble in rushes of tempos and passages of suspended time through "Miles Runs The Voodoo Down," alludes to "It's About That Time," ends with the lick of "The Theme" and a salute with his horn to the crowd, walking off as the band simmers down but returning to glance out over the appreciative ovation (Carlos Santana says the set was a triumph), to grin and wave again.

This footage is particularly handy for its demonstration of the warp and woof woven by the rhythm section. Moriera's percussion colors, the propulsive counter-themes created by Jarrett and Corea, the mutual attentions of Holland and DeJohnette and the entire band's instant responses to Miles' every gesture remain as nowhere else to see and hear. This video provides a glimpse, too, of what was to come when Corea and Holland left Miles' fold. In December '70, the week before Christmas, he played four nights, all recorded by Columbia, with Bartz, Moreira and DeJohnette, Jarrett alone on Fender Rhodes and Holland replaced by 19-year-old professional soul-band bassist Michael Henderson.

On the last night of that gig guitarist McLaughlin sat in, and excerpts of those sets appeared on *Live–Evil*, the record released as the follow-up to *Bitches Brew*. It was another two-LP album illustrated with Mati Klarwein paintings (though the por-trayed pregnant African draped in flowing red and the stern, jowly, pasty-skinned, big-haired blond ogre, nastily suggesting albino Brazilian musician Hermeto Pascoal who contributed to the album, were less attractive than the fantasies attached to *Bitches Brew*). It was an uneven production. Seventy-five minutes from the Cellar Door crew (six CDs representing their December D.C. gig in unedited form were finally released in a boxed-set in 2005) bookend four tracks totaling 16 minutes from two studio sessions with two different groups.

There are obvious mistakes and omissions in the credits of *Live-Evil*. Who plays flute on "What I Say"? From the breathy sound of it, Pascoal. Where is the "electric sitar"? Not heard on this album. The music itself ranges from whip-driven Cellar Door performances like "Sivad" and "Inamorata" to the inconclusive short tracks "Little Church," (on which Pascoal whistles the line Miles plays, as if teaching it to him, and Jarrett lurks below, on organ), "Nem Um Talvez" (Pascoal vocalizing softly, again in unison with Miles' trumpet; Ron Carter delicately strokes his acoustic bass, there's soft organ and disassociated hand drumming) and "Selim" (more of the same). An almost 6-minute medley of "Gemini" — *almost* "Bitches Brew" — and "Double Image," recorded in studio in February '70, pits Miles enunciating his line

slowly against a bevy of extreme effects: McLaughlin's harsh chopping and suddenly plummeting guitar, a whine in the dog-whistle upper register (from the organ?), irregular bursts of percussion and unpredictable, undeveloped keyboard flurries.

The album coasted to a decent reception on the popularity of *Bitches Brew*, but if Miles, Macero, Columbia or audiences won over by *Bitches Brew* had higher hopes for *Live-Evil*, they were almost certainly confounded. Crime novelist George Pelacanos, who is scrupulous in his use of music to flesh out his sociologically credible characters, draws on *Live-Evil*'s eventual mainstream reputation for his 2006 book *The Night Gardener*; it symbolizes murderous perversity. In truth the music isn't evil, awful or bad – just not as deliberate, together, structurally astonishing and full of affirmative discovery as *In A Silent Way* and *Bitches Brew*. The same can be said of *Black Beauty: Miles Davis At Fillmore West*, recorded in April 1970 with Steve Grossman the recent replacement for Wayne Shorter on soprano sax in the Corea–Holland–DeJohnette–Moreira lineup; *Miles At Fillmore: Live At The Fillmore East*, recorded in June '70 with Grossman, Corea and Jarrett, Holland, DeJohnette and Moreira; and even *A Tribute To Jack Johnson*, from studio jams recorded in April and November '70, with McLaughlin, Grossman, Herbie Hancock, drummer Billy Cobham and bassist Michael Henderson.

In each case, Miles and company devote significant energies to their performances, and listeners are rewarded with genuine thrills as the musicians arrive as one at previously unimagined crystallizations of spontaneously improvised music. Miles in all of these (except maybe *Jack Johnson*, which has a delectably casual quality though Macero severely edited and processed the original material that went into it; unedited and previously unreleased tracks from the sessions were boxed as *The Complete* in 2003) seems to have tightened his control of the bands, though there are no obvious fetters on any of the players and each strives to outdo the others as well as themselves. But the major musical breakthroughs have already been made.

The pieces on these albums do not represent retrenchment. Each of them attempts forays into new territory. They respectively incorporate Pascoal's melodies, Macero's editing of an overabundance of performance tape down to a size that could be construed as representing the concert experience and a pugnacious fling at instrumental hard rock, trumpet and guitar toughing it out side by side (without singers, hummable refrains or other repeatable forms, and at 25 minutes a track, unlike any rock before or since, of course).

The main feat, however, has been accomplished. A new, infinitely more commodious soundscape has been established – one that accommodates many more noises and sounds than ever before. Where real-time throwdowns and music that never could be played in real time but, through studio manipulations, is etched forever as if it had, can indeed co-exist. Most of Miles' and company's subsequent expeditions don't light out in surprising new tangents, but detail, consolidate, colonize and maybe even settle territory already won.

A caution against analysis that is too ahistorical: in 1970 much of Miles' potential audience had not yet been exposed to electric keyboards as played by Hancock, Corea, Jarrett and Zawinul, to McLaughlin's post-rock/blues electric guitar, to the hard-hit but polyrhythmic playing of Tony Williams and Jack DeJohnette, the voracious saxophonics of Shorter, Bartz, Grossman and soon Dave Liebman, or for that matter Miles' own recently invigorated, sharpened and piercing force. Dissemination, acclamation and acceptance of edgy jazz–rock–fusion wasn't instantaneous, unimpeded or total.

The music filtered out through burgeoning FM radio stations that had gained popularity in the late '60s with alternative programming to the typically three-minute hits played on commercial AM frequencies. It didn't take long – maybe just months – for Miles' music to begin registering widely. But whoever stumbled on *Live-Evil*, *At Fillmore* or *Jack Johnson* without having already heard *In A Silent Way*, *Bitches Brew* or any of a few other albums first would surely have wondered where this music had come from and what it meant to be about.

True, fans back then raced to record stores upon learning that new albums by their heroes were available, and many recordings by Miles' compatriots were forthcoming. Zawinul had persuaded Shorter to co-found Weather Report with him. Hancock had released *Fat Albert Rotunda*, a merrily accessible soundtrack for an animated children's TV show hosted by comedian Bill Cosby, but his more challenging Mwandishi sextet debut was in the offing. Tony Williams' Lifetime with McLaughlin and Larry Young had issued the two-LP *Emergency!* in May '69 (four months after *In A Silent Way* came out); it was largely shunned by jazzers and rockers both, due in part to the drummer's vocalizing. After Lifetime's second album, *Turn It Over* (recorded in July 1970, released in December 1970) with bassist and singer Jack Bruce, formerly of the rock supertrio Cream, McLaughlin left the band, but he engaged in a flurry of recording activity that resulted in his albums *Devotion*, *Where Fortune Smiles* and *My Goal's Beyond*, *Spaces* with Larry Coryell and Corea, *Moto Grosso Feio* with Shorter, a project with reeds player Joe Farrell and another with bassist Miroslav Vitous (the third Weather Report co-founder) – all issued in 1970.

Depending on listeners' personal preferences and receptivity, any of these albums as much as Miles' *Live-Evil*, *At Fillmore* and *Jack Johnson* might have appealed as emanations of the avant-garde. They all contained, in varying degrees, breakaways from jazz and/or rock/blues/rhythm 'n' blues/soul music conventions, and took advantage of newly opened musical vistas. But these and most of Miles' other anomalous recordings from '68 through '74 (eventually released on the compilations *Big Fun*, *Directions*, *Circle In The Round* and *Get Up With It!*) in which he tinkered with personnel and instrumentation, structural elements including but not limited to song forms, the latest gear and influences from locales such as India and Caribbean islands, were solidifications of his breakthroughs, not new breakthroughs of comparable music-art-life-changing scope. The music Miles made from '70 onward

continued to refine and recombine ingredients of his new music recipe, ingredients he'd used in his *old* new music, too. Those ingredients – blues, balladic feel, major and minor tonalities, earthy rhythms, uncommon voicings, unusual timbres, attentions to dynamics – didn't get stale if he mixed them fresh, in sync with the present.

It is unfair of anyone to demand that the next idea an artist realizes must be as complete or universal as the last one. Musical revelations didn't simply dawn on Miles – he worked for them. One of most admirable things about Miles is how hard he worked, touring and recording in the early '70s and after his return to action in 1981, too, with as much or more persistence as top echelon commercial bands whose members were maybe 20, 30, 40 years younger – despite the frequent debilitating illnesses, physical pain, hospitalizations and continuous medication (legally prescribed and otherwise) that bedeviled him.

In *Miles Beyond*, Paul Tingen postulates that Miles was engaged in a creative process involving two imperatives: transcend and include. His notion is that Miles proceeded by steps, methodically but also instinctively testing ideas out of public sight (primarily in recording studios, since he called few rehearsals), before acknowledging having accomplished his intentions and approving their commercial release. Having actualized an idea to his satisfaction, says Tingen, he moved on from it, but always carried it along. The musical investigations Miles conducted from the time of, say, his quintet's recordings at the Plugged Nickel up to *In A Silent Way* were indicative of his process – adding elements (electric piano, electric guitar, multiple keyboards) and subtracting them (acoustic piano, cyclical chord progressions, swing feel from the drums) until he arrived at wholly new configurations in which his horn could regale listeners with new kinds of phrases in a new voice leading to new formulations of possible beauty but irrefutable aesthetic cohesion, hence truth.

Miles continued his additive and subtractive processes as if trying to get to bedrock, or alchemize the irreducible essence of making music live. He did away with chord progressions entirely, anchoring his outpourings and those of his fellow soloists on very simple repeated bass lines, and he discarded preconceived melodies beyond the fewest possible cells of notes from which he could spin variations as long as his imagination and his air supply (per phrase) would allow. He didn't connect successive phrases of tunes into a narrative so much as lance scalar runs upwards or downwards, skipping steps at his caprice, extending the time value of a given note, stopping in dead silence when he wished, spitting out or slurring a pitch, kinking the line, each phrase an object in itself. His tongue and lips did the work, his fingers on the valves skittering – his involvement seemed more physical than meditated, more impulsive than pre-planned as a way to tell a musical tale. He increased rhythmic propulsion by multiplying the number of his drummers, percussionists and comping sidemen, subdividing units of the beat so as to be able to start and stop phrases wherever he wanted without losing underlying propulsion and to take inspiration from any of a multitude of percussive accents.

Melodic elaboration based on fixed scales but without harmonic movement, in conjunction with complicated rhythm accompaniment, resembles the surface design of classical Indian music. However, that ancient Indian music (both northern and southern, Carnatic styles) prizes delicacies of intonation that were lost at the high volumes of amplification (and probably at the strenuous expenditure of physical energy) Miles employed to project to the large performance spaces that were his principal venues in the mid-'70s. The hard rock and heavy metal bands then in their heyday were his competition for bookings in huge auditoriums, arenas and festival sites. Subtlety was not their strong suit, sheer power and big amps were (satirized in *This Is Spinal Tap*, the 1984 mockumentary, by a scene in which guitarist Nigel Tufnel – actor Christopher Guest – shows off equipment that can be dialed up past 10 for "that extra push over the cliff . . . one louder . . . to 11!").

Although Miles exploited bent notes – akin to blue notes – and smears, especially with the wah-wah pedal attached to his trumpet, pitch nuances were seldom discernable as important to any conventional sense of melody in the midst of the noise levels and timbral distortions produced by the percussion players (Ndugu Leon Chancler, Billy Cobham, James Mtume Forman, Al Foster, Badal Roy) and guitarists (Pete Cosey, Reggie Lucas, Dominique Gaumont) he took on the road. That was much less true when Miles and Shorter had played overlapping and twined melody lines in his mid-'60s acoustic quintet – subtle shifts of intonation and emphasis could make more difference then as interpretive variants of a given theme, even though Tony Williams played loudly. Now Miles' bent notes and tonally warped lines were meant as signals, flares, flashpoints, intimations in themselves – gestures rousing up or tamping down the bands' responses, and the audiences'. Miles found resolution for those bends and warps, of course, in the tonal center.

Given the superficially static yet internally complicated sound field, the hyperactive rhythm, harmonic reductions and microtonal fluctuations Miles imposed on many of his early to mid-'70s performances, I would nominate two more studio creations from Miles' pre-retirement as distinctly significant steps arriving at previously untried realms and deserving recognition as landmarks of the avant-garde. One is the album *On The Corner*, the other "He Loved Him Madly," a half-hour dirge recorded within a month of Duke Ellington's death in 1974 and the key piece of *Get Up With It*, Miles' last release before his retirement, an album inflated to two-LP size with studio tracks from several previous years. *On The Corner* and "He Loved Him Madly" could hardly sound more different, one being a snappy, down 'n' dirty evocation of the urban street, the other a plaintive and ethereal requiem.

On The Corner, Miles most extraordinarily rhythm-charged album, was recorded in June and July 1972 and released the same year. The musicians involved went unidentified on the original packaging – Miles claimed this was an anti-critic, anti-jazz nerd move – which was graced by two cartoonish scenes by Corky McCoy. He drew black urban characters: a militant whose black beret had a button reading "FREE ME"; two hand-slapping pals with Afros, one of whose t-shirts read "VOTE

MILES"; a short fellow showing his empty pockets to a tall, conspicuously under-dressed lady; a pimp in a purple suit and yellow broad-brimmed hat pointing her out to another fellow carrying a portable radio; and a chap with arched eyebrows, wearing very tight blue jeans, taking in these others with an amused attitude. In the flip side of this image, the militant, a button saying "SOUL" pinned to his black jacket, held an electric chord running to a green trumpet. The short guy now carried a stack of books and the tall, under-dressed lady seemed to be by his side. The pimp, the Afro'd "VOTE MILES" fellow, the eyebrowed figure and another mini-skirted woman all stood under large printed letters: Off. At the top of the front cover in the same type: On.

McCoy's characters presumably represented the black audience Miles sought. His rhetoric at the time often portrayed white musicians as successful because of their race, his own success limited because of his blackness and his record com-pany's disinterest in marketing his music either as it did white musicians' or ag-gressively to black audiences. These points have some merit – the 1970 U.S. census reported Americans of African descent as 11 per cent of the total population. White audiences did overwhelmingly buy white musicians' recordings, though they bought black musicians' recordings (specifically, Miles') too. Black music listeners certainly bought music by whites. White and black buyers were not separate, but neither were they numerically equal.

John Lennon (with Yoko Ono), Paul McCartney (introducing his post-Beatles band Wings), George Harrison (producing *The Concert For Bangla Desh*), the Rolling Stones (issuing *Exile On Main Street*, one of their strongest albums), Eric Clapton (as Derek and the Dominos), Paul Simon, Led Zeppelin, Don McLean, the Beach Boys, the Eagles, the Allman Brothers, Joni Mitchell, Neil Young, Elton John, Ry Cooder, Carole King, Carly Simon, Lou Reed, Jethro Tull, David Bowie, the Nitty Gritty Dirt Band, Bette Midler and Seals and Croft were riding high, as were Miles' former pia-nist Bill Evans and recent protégés Corea and McLaughlin (though not at the level of the singers, songwriters and pop–rock bands). Black musicians Stevie Wonder, Curtis Mayfield, Isaac Hayes, The O'Jays, Harold Melvin and the Blue Notes, Roberta Flack with Donny Hathaway, Bill Withers, Al Green, the Temptations, Miles' former pianist-protégé Hancock, ex-sidemen Cannonball Adderley and George Benson were also doing pretty well (though the instrumentalists not as well as the singer–songwriter–popsters).

Miles' frequently attributed musical qualities to racial or ethnic origins, and al-luded to white racism or entitlement with self-righteous disdain, deservedly enough. But Miles' unilateral statements about race and ethnicity should always be taken with a soupçon of salt; his actions demonstrated his comprehension and negotiation of myriad complications. Throughout his career he often employed white sidemen and worked with white producers, often raising the ire of black critics. The early

'70s was a period in which he suffered just such disfavor from writers like militant African-American musician and educator Bill Cole, ostensibly for taking on pop music trappings.

In a *Down Beat* review following Miles' 1971 gig at Wesleyan University in Middletown, Connecticut, Cole asked:

> How does [Miles' set] compare to the vigorous black music being playing in 1971? I'm sorry, but it just doesn't make it! . . . As quiet as it is kept, the members of this band play so well that they almost disguise the fact that what they think they're playing ain't really happening. I think an artist's concept of music gets pretty warped when he must use gimmicks and theater to articulate it.

Cole detailed the clothes Miles, Bartz, DeJohnette wore, the band's unspoken interpersonal relationships ("a definite communion") and interaction with the audience ("like osmosis . . . most of the audience felt they were participating"); these elements presumably supported his contention that "as theater [this concert] was a magnificent spectacle." However, he disdained the music itself, including Miles' repertoire ("the same tunes played over and over again"), Miles "fix[ing] a drummer of DeJohnette's dimension into rudimentary patterns," Bartz's playing of "1940s, early '50s stuff" and Miles' trumpeting "one outburst after another. He is essentially playing the same line with different accentuations. The amplifier is another bad, sad trick." Cole went on to publish *Miles Davis: A Musical Biography* in 1974, and updated it in 1994.

Paradoxically, brickbats such as Cole's as well as Miles' own critique of the music business's pro-white bias became more pointed due to Miles' financial and cross-racial successes following from *Bitches Brew*. Similarly, the early '70s witnessed considerable turmoil about issues surrounding race despite some measurable progress by African-Americans in greater U.S. culture and society. In 1972 black mayors were elected for the first time in Newark, New Jersey, Los Angeles, Atlanta and Detroit. The Reverend Jesse Jackson founded his Operation PUSH community organization in Chicago, Congresswoman Shirley Chisholm mounted a campaign for the Democratic Presidential nomination and 15 members of the U.S. House of Representations and Senate formed the Congressional Black Caucus. The passage of the Equal Employment Opportunity Act outlawed job discrimination at the Federal level on the basis of race, and the heinous Tuskegee Syphilis experiment that the U.S. Public Health Service had conducted for 40 years, observing black men in late stages of the disease, was brought to a long overdue end.

In 1972 gospel singer Mahalia Jackson, who had been prominent in the civil rights struggle, attracted a white audience and dreamed of building a non-denominational place of worship, died and 40,000 people trooped past her open coffin at a church

on Chicago's South Side. In Manhattan, rock 'n' soul keyboardist Billy Preston became the first black headliner at Radio City Music Hall. Incumbent President Richard M. Nixon was re-elected in a landslide over the Democratic peace candidate Senator George McGovern, although the one and only reigning trumpeter had recorded a track for *On The Corner* promoting his own minority party candidacy: "Vote For Miles."

There was a precedent for this jest: in 1963 Dizzy Gillespie had launched a "Dizzy for President" campaign at the Monterey Jazz Festival with vocalese master Jon Hendrix (no relation to Jimi) singing, "You want to make government a bale of fun? – Vote Dizzy, vote Dizzy" to the tune of Gillespie's jocular "Salt Peanuts." Gillespie's explanation of his run was still applicable nine years later: "Anybody coulda made a better President than the ones we had in those times, dilly-dallying about protecting blacks in their exercise of their civil rights and carrying on secret wars against people around the world," he had then opined. But nothing of bebop is retained in *On The Corner*.

On The Corner opens with what seems on first encounter an undifferentiated clatter of percussion, a distorted guitar strum – you'd hardly call it a chord – reverberating repeatedly like a tin can kicked against a dumpster in a distant alley, the presentiment of melody instruments far off but coming closer, one stick slapping a half-opened hi-hat, another hitting a cowbell every so often, a bump of electric bass, a slithering lick of guitar, an oil slick-like effusion erupting now and then – oh, that's Miles' sneering through a mute! – a soprano sax adding a serpentine squiggle, but everything so mashed close together in the mix it's nearly impossible to get a handle on what you're supposed to hear.

The title track segues after the soprano attempts a soft landing three minutes into "New York Girl" – there was a cue line in the vinyl, but no other sense of transition (on headphones you might notice a hitch of half-a-beat). What's a girl got to do with the wicked guitar solo that pivots on a sharply articulated phrase, same pitch throughout, like a telegraph key punched 16 times fast and then distortion, pitch rearing like a horse on hind legs, and whooping! – the percussion roiling the while? Foggy layers shift beneath this; they must be from keyboards.

At some point (after just a minute and a half) "New York Girl" has become "Thinkin' One Thing And Doin' Another," but again, there's neither pause nor ostensible difference between the tracks. Sounds rebound as if mirrors are reflecting them; an electric piano (or some similar ax) trills at impossible speed. The density then dissipates, leaving vacancy for Miles' wah-wah horn to fill – but a high whine flies through, frogs burp just aside him, rusty springs sprong, a deep tub is thumped, the guitar sniggles, the implacable bass keeps bubblin'.

"Vote For Miles" has another guitar passage, with different percussion sounds (but a lot of the same ones, too), wah-wah trumpet in the background, soprano sax surging to the fore. One is hard-pressed to define a theme or melody within the morass, and there may be no harmonic movement but there is plenty of harmonic

contrast. Dave Liebman, who played soprano on the album, tells the story of being called to the session unexpectedly – never having played with Miles – while at a medical appointment, and hurrying so fast he abandoned his car unparked near the studio; when he arrived he entered the room where the music was going on full blast, and was given no instructions, not so much as a key to play in, just told to blow, which he did, memorably. "Vote for Miles" quiets after seven minutes to reveal tabla player Badal Roy at the bottom of everything, and a sitar, played by Colin Walcott, is droning on, intersecting with the keyboard whine.

"Black Satin" uses many of the same percussion elements and a weird whistling before breaking into syncopated handclaps and sleigh bells, and a genuine tune – a simple one, but still cause for amazement – played in unison by Miles, the whistling device and impossible-to-identify others. A portion of this mix seems to run backwards – but the trumpet carries on as does some burbling keyboard, Michael Henderson's bass, of course – and in another dramatic shift, tabla and sitar and rusty springs, expiring.

"One And One" has a sinuous tenor sax thread that unreels as if wound from left to right stereo channels, while the bass has stooped lower, the sleigh bells are back and keyboards (maybe multiples of them) dither in the background. Is Miles blowing a cautionary tone, peering over the saxophonist's shoulder? There's the suspense one feels on an empty, unfamiliar street at night, with a foreboding of being followed, being jumped. "Helen Butte" employs the same conceits, for 16 minutes; "Mr. Freedom X" starts with maybe log drums or water drum against tabla and bass, then traps kick in and the same nagging whistle theme threatens to return once more – but spaceship bleeps seem to hold it at bay. It never comes back. That's ok, we remember that hook like we bit into it, hidden in gummy candy.

On The Corner was and remains gloriously confrontational. There were no liner notes explaining it, no explicit or implicit justification; maybe you'd like it, maybe you wouldn't, maybe you'd try it again. I loved the sound upon its first impact. The album must have called to me when it was unpacked and put in the display window of my local record store because I ran right out, saw it, bought it, ran back to my dorm room, slipped it on. It was so dramatically different – its sonic qualities, I mean, without precedent. I heard some resemblances to Indonesian gamelan, if one of those percussion orchestras were to have taken up residence in a New York City subway and been mixed down to a distorted blare through a Pignose amp (small portable powerhouses, introduced to the commercial market in 1973). This was the one Miles album which mindless hedonists with sufficient stamina actually could dance to, I thought. But I was evidently in the minority, liking it or thinking its dance potential mattered.

Every publication's critic drubbed the album, with one important exception: Robert Palmer of *Rolling Stone* and the *New York Times*. Maybe a generation divide was activated; Palmer was 27, and few of Miles' fans that age had attained comparable influence as professional critics by that time. It was older jazz writers, still

empowered at most newspapers and magazines, who loudly cast their votes "No!". They felt Miles had gone too far. Miles had issued an insult. Miles must finally, here as they had not been able to do before, be denied.

"I had started thinking about building a new audience for the future," Miles states in his autobiography. "I had already gotten a lot of young white people to come to my concerts after *Bitches Brew* and so I thought it would be good if I could get all these young people [black and white] together listening to my music and digging the groove."

If you've got all those kids, who needs their elders? They couldn't dig him? Well, the negative critics weren't hip to processed electronic music. They dismissed state-of-the-art studio wizardry as impure, compared with unmediated live improvisation. They couldn't make out the instrumentation much less the personnel or the internal workings of *On The Corner*; they heard in it a refutation of everything beloved of jazz – its elegance, its finesse, its prized tradition – and a crass appeal to low common denominations. They saw that same strata of consumers lining up to see blaxploitation movies (*Shaft*, of 1971, directed by black American renaissance man Gordon Parks, sparked the genre) in which black heroes, be they lone wolf private eyes or independent drug dealers, won against stuffy bureaucrats, crooked cops and organized crime kingpins – older white men like the critics themselves!

At the time of this writing Bob Belden is preparing a Columbia album purporting to be the complete *On The Corner*, and beware of what you wish for. We may find out that album, which has become a cult item adored by rappers, hip-hoppers, DJs and avant-gardists of many other stripes (cf. Steve Reich's comment when I played it for him during a *Down Beat* Blindfold Test), was concocted out of only five minutes of multi-channel music, jiggered and flopsied every which way (no we won't; Belden says there are several hours of master tapes, stop-and-start efforts eventually stitched together). We may learn that the story Szwed relates of British cellist Paul Buckmaster's eight-week stay as Miles' houseguest, during which he promoted J.S. Bach's *Cello Suite No. 1*, Karlheinz Stockhausen's "Mixture," "Gruppen" and "Telemusik," and a binary, on-off theory of reality to his host is a sham (no we won't; in my book, Szwed is a very credible historian).

Miles said in his autobiography, "I had begun to realize that some of the things Ornette Coleman had said about things being played three or four ways, independently of each other, were true because Bach had also composed that way." He approved of Stockhausen's (and Buckmaster's) "use of rhythm and space."

But even if he were jivin', if he thought Stockhausen's maneuvers to disassociate the music he ended up with from the music played by the musicians he'd enlisted was a joke worth repeating, if Miles went forth with *On The Corner* to see how dumb people could be, what we'd buy, what we'd swallow, I wouldn't give a damn. It's outrageously energizing music. It leaves no room for boredom. It goes over the top,

and hangs out there like no other. It stimulates my thinking – or confounds it – and makes me move in ways I like on every listening. It never stands still, or lets me, either. Other commentators have voiced similar, if sometimes conflicted, responses.

Rock critic Lester Bangs in 1981 described *On The Corner* as an "environmental record" of "alienation so extreme that we could only grow into it . . . as time caught up with us and we caught up with Miles." Phil Freeman, in his 2006 volume *Running The Voodoo Down: The Electric Music Of Miles Davis*, writes, "Sure, it's a dead end, artistically," and then credits its influence on late '70s-early '80s disco-punk, its anticipation of "some of the more avant-garde hip-hop, and also drum 'n' bass," while also warning it has "no elements of the blues and very little rock. Its jagged funk, Afro-Indian rhythms and electronic noise formed a cocktail that was unique and unrepeatable."

Ok folks, call it what you want to. No one creation embodies all dimensions of any genre, movement or categorization that is by definition anti-formulaic. But as no one but a jazz musician with the background, insight and originality of Miles (no one, that is, but Miles) could have/ever has come up with anything like *On The Corner*, which is inclusive of and also transcends genre/movement/categorization, I call it jazz and avant-garde too.

"He Loved Him Madly" is equally qualified, though as bleak as *On The Corner* is fecund. An ethereal gloom is cast from the very start by the organist – who must be Miles, though no organ is listed in the album's annotation, no organ player credited – one of the three guitarists (Cosey, Lucas and Gaumont), and anonymously disembodied intermittent snare drum rolls. The effect is of emptiness. Gothic in its chill, this requiem for the greatest jazz composer to imprint his music on the world, created by a man who admits to being abject with loss in the composition's title as he never admitted to elsewhere, is not a New Orleans marching band-and-burial society traipse to the cemetery, followed by riotous ragging of "Didn't he ramble?" and an everyone-invited second line celebration. It begins more like sound effects appropriate to a Beckett play.

Through a torturous trek of heavy-gauge guitar noodling, out-of-sync tattoos, and an inexplicable sonic shifts (at 6:22 and 9:25 seconds) the music arrives at some definitive harmonic resolve at 10:12. At 10:28 there is an obvious rend, or edit – it must have been intentionally so – leading to the drums establishing regular metric ticking, as if cueing the pace of a cortege, and congas supplying deeper percussive accents. Liebman's alto flute enters at 12:45 in the middle of its range, and intones a series of unhurried, sylvan phrases, leaving copious space between them. The bass plays virtually sub-audio tones, also sparingly.

Miles enters on trumpet at 16:08, sounding achingly bereft. His solo, employing digital delay for an echo effect and limited wah-wah that intensifies the sobbing sound, continues for four minutes. There is no explicit tune, only the expression of

grief and loneliness amid a dour ambiance. The elements gain a fullness and more actively stated pulse prior to a last organ swirl, guitar lines and a cut-off ending on an upbeat – as if to say the end comes and life continues.

Miles had bought a 78rpm record of Ellington's "Mr. JB Blues," a feature for and about bassist Jimmy Blanton, when he was nine years old. He had performed on bills with Ellington, had played and praised Ellington's work for writer Alex Haley during their meetings that resulted in Miles being the subject of the first *Playboy* magazine interview. He'd said in a *Down Beat* Blindfold Test "I think all musicians should get together on a certain day and get down on their knees and thank Duke." Little has been published about the relationship of Miles and Duke, but it was reciprocal enough for Ellington to send Miles a personalized Christmas card.

Miles had suffered a heart attack while on tour in Brazil just before he learned of Ellington's death. He recorded "He Loved Him Madly" a month later, maybe fixed on thoughts of his own end (his burial plot at Woodlawn Cemetery neighbors Ellington's). It was the last studio work he committed before choosing to take his leave. Miles continued to gig for another year, including an early 1975 tour of Japan during which he had pneumonia. That trip resulted in the last of his live recordings for six years, issued as two double-LP albums, *Agharta* and *Pangaea*, representing complete afternoon and evening concerts from a single February day in Osaka.

Throughout both, Cosey solos at the farthest reaches of psychedelic guitarism, way beyond clichés or conventions, tossing off lines with barbs that could only have been twisted by wire cutters, employing strange tunings and corrosive timbres; Lucas hangs with him, adding emphasis besides playing rhythm. In *Agharta*, especially, Miles, freed by a pickup on his horn from a stationary stance at a microphone, rails from the vortex of their sound, matching the guitarists for wah-wahs and whines, feedback and reverberating cries, smears, stabs and extended staccato runs. Sonny Fortune, Liebman's replacement, emits a siren's roar of evenly articulated, solidly formed notes on alto sax, his lungs a bellows, and the rhythm by Mtume and Foster is near-constant.

Liner notes for the 1976 release recommended listening to this aural apocalypse at highest possible volume, but cranking it up to 11 risked the crush of its aural density (maybe more so when it was first available than ages and Miles later; when released, nothing comparable to *Agharta* had been heard on his records, the previous live Miles concert in U.S. circulation being from 18 months earlier, September '73, *Live At Philharmonic Hall*, with a lineup including electric sitar and only one guitarist). *Pangaea*, unissued in the U.S. until 1991 but available as an import from Japan before that, comprises two evening sets – on the album titled "Zimbabwe" and "Gondwana." The latter piece was the day's anti-climax, with flute, water-drum and koto casting a ghostly quiet, like the calm following a firestorm. Miles' trumpet hung over all like a specter surveying the scorched earth.

That might have been the last we heard from him. Suffering illnesses and surgeries – bleeding ulcers, larynx nodes, hip replacement, more pneumonia, leg infections, diabetes, insomnia, impotence – and further deaths of old friends (jazz journalist Ralph J. Gleason, Cannonball Adderley, Gene Ammons, Bill Evans, Charles Mingus), Miles burrowed into reclusiveness, more and different drugs, booze, compulsive cigarette smoking, bad eating habits and worse company, dirty sex, televisions never turned off, crazy telephone calls, financial disregard, fits of violence and mindless self-neglect. See Eric Nisenson's *Round About Midnight: A Portrait of Miles Davis* for harrowing details. "For the first time, the music in his head stopped," Szwed speculates. But in1980, after five years of such dissipation, Miles was coaxed back to action by a musical crew including his nephew Vincent Wilburn, Jr., a drummer, and the attentions of actress Cicely Tyson, among others.

The fact of Miles' re-emergence was remarkable, but the music he offered was denigrated by many critics and fans at the time – always held to his previous high standard – and not much more appreciated since. Old accusations that he was a sell-out re-emerged in his wake, dampening if not drowning out the cheers of his loyalists and promotion by his record company of his comeback.

Maybe he attempted too quick a return, though what would returning mean to him if not at least the restoration – nay, upgrading! – of his prior position? He recorded and released both *The Man With The Horn* and *We Want Miles* before he'd fully regained his trumpet technique, if not his attitude.

Of *The Man*, a studio album contrived of several sessions, released in 1981, I

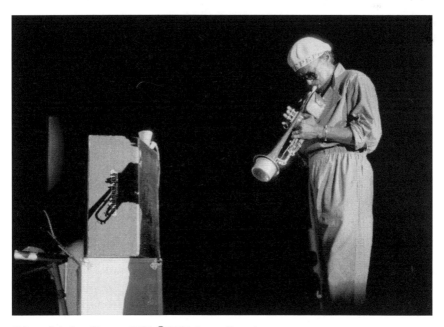

Miles and shadow, Chicago, 1990 ©*1990 Lauren Deutsch.*

wrote for the *Illinois Entertainer*, "Miles slinks back to the thick of it . . . He turns 'Shout' into a murderous radio hit . . . There's space filled with tension that only Miles' snarling lip and mewing whimpers will release."

I reviewed *We Want*, a compilation of concert recordings, in 1982 for *Down Beat*: "The trumpeter has reached the point where his art and mass popularity have a chance to meet . . . He isn't [anymore] smashing atoms; he's twisting nursery taunts like 'Jean Pierre' into deadly hooks."

He didn't pick up his music where he'd left it. He ventured forth with a less multi-layered, still loud but not so thick sound. He had dialed down his intensity, and returned to several conventions, including old-fashioned song form and typical small jazz group instrumental hierarchies. The band was amplified but its music not much processed. A barer style had become the period's pop–rock norm. "His new boys [tenor saxophonist Bill Evans, not related to the pianist, and guitarist Mike Stern] take this phase seriously (as they'd better)," my *DB* review continued, "and their faith adds quite a bit of credibility to Miles' current music. As they believe, so do we."

Star People, a studio session released in 1983, was an improvement: "Miles seeks to assert his mastery of the time-honored blues and demonstrate the maturation of his iconoclastic electric ensemble," I enthused in *Down Beat*, awarding it four-and-a-half stars, just short of "masterpiece" rating. In retrospect I can say it wasn't quite worth that, but there were plenty of critics eager to accuse Miles of coasting, as in the early '70s they'd accused him of betraying jazz entirely, and I meant to assert his relevance because I'd missed his presence, which bore an effect on the rest of jazz, maybe as much as his sound.

Disco had in the later half of the '70s exerted a particularly detrimental influence on the average intelligence of pop music. That fad's simplistic and never-developed melodic hooks, formulaic rhythms, novelty lyrics and functional dancefloor populism (see *Saturday Night Fever*, but know the classic BeeGees' soundtrack is far superior to the run of disco hits) flourished in reaction to the socially, politically and aesthetically idealized (however misguided or ridiculously inflated) efforts of the best of the Woodstock Generation. Disco music in its "substance" (or lack of) was damning to other popular forms, and upon its commercial collapse disco damaged the record business, which didn't regain momentum until public excitement over a new consumable format, the CD, was stimulated in 1982.

Miles' earliest '80s work was sometimes derided as "disco" (though it wasn't even close) and could be mocked as flamboyant in the context of anti-virtuosic punk and back-to-basics new wave. Flamboyant '70s progressive rock and star-studded jazz fusion had all but collapsed under the weight of their pretensions. Come at from another direction, Miles' earliest '80s recordings seemed undernourished relative to the era's posh black pop productions and pale compared to George Clinton's Parliament-Funkadelic boogie raves. I had reservations about Miles' music then,

but extended it the benefit of my doubts, and felt justified when encountering his ensemble at Chicago's Auditorium Theater, as I reported in *Down Beat*:

> His band, half confident and half scared shitless into playing way beyond their previous suspected abilities, is right with him. Miles starts as scheduled, takes the briefest intermission, and has a ball.
>
> Savoring the freedom he's afforded by the cordless mike attached to his trumpet, Davis paces into the speaker's path to stir up feedback, wanders into the wings to blow a note right in the face of Cicely Tyson (toward whom he's been mugging kisses), and glances meaningfully at his band: they instantly change time. Playing open horn or with a mute stuffed into its brass throat, Miles mews and whimpers, then shoots a fearless, unimaginable line of melody, jagged but to his mark.
>
> [He's] trim in a tight white jacket, splash of red bandanna falling from a pocket, designer jeans, sun-visor shading his black face . . . (W)hen the rhythms surge from the stage, when the band stops short, turns as a unit and plunges on at his casual hand signals, or a soloist strains to really say something that might win an approving nod from the Master Blaster . . . no one's thinking of the past.
>
> Miles himself, of course, is the controlling eye. He curls, on his feet, into a self-protective crouch, trumpet bell merely inches from the floor – the better to hear his own tone? He lets loose giant bursts which, far from being mistakes, blur what one thinks of as correct choices and force one to reconsider melody, harmony and the organization of sound. Songs built on simple themes, ten notes or less, which have no strict chorus structure, depend for their climactic peaks on Miles' immediate reflexes and his band's quick response. Miles builds on an upstart rhythm, inspired by black pop – reggae, rhythm 'n' blues or Baptist church or the African dance – using everything that's come before. Much of it, after all, has already been his.
>
> There is rock and roll in Stern's background; he worked with Blood Sweat & Tears from '76 to '78. But he studied at Berklee, the jazz school, too, and reels off octaves like Wes Montgomery's, can feed a soloist challenging chords and has a sense of his own solo's shape. He's admittedly unsure, but open-eared and learning quickly. Sometimes he goes faster and farther than is wise; then he depends on Davis to bring him back within reach of the motifs.
>
> Saxist Evans, too, is stretching. Miles plays a solo, describing a tonal center here, referring to a pause there, toying with an oblique variation and arriving somehow at a release. Evans starts where Davis stops, trying to fill in the blanks – 'You mean like this, boss? And this, here, like so? Gee, or this way? I can barely manage it . . . – or could I try this with that? Should I stand over here? Will it help if I –'

'Nah, candy sucker, nice try, but like this', Miles shows him, strength renewed.

Miles chooses his sidemen from recommendations and by instinct. He's not looking for star chops – they're taken for granted. At least their potential. He seems to favor some heedless quality, whether it's tinged by Stern's uncertainty, Evans's earnestness or percussionist Mino Cinelu's willingness to roll with his hand drums in the center of the stage, naked chest muscles gleaming. With Al Foster, Miles has direct communication, so the dynamics may vary, the accents change, but the pulse continues.

This may not be his greatest band, but its members help Miles make something happen that should have happened long ago. His new, freely formed music is emerging, somewhat menacing, certainly powerful, and it's getting heard. The audience isn't put off, FM radio and record buyers are taking up Miles' offer – so he's confronted the business, and can still feed his muse.

At the Auditorium, there was a lingering echo of raw aural splendor, and a crowd's ovation.

There were, in 1983, new jazz artists vying for that ovation. Replacements at the front included the avant-gutbucket (a phrase coined by *New York Times'* critic Jon Pareles) bunch gathered around tenor saxophonist David Murray and his cornet-ist–composer friend Lawrence Douglas "Butch" Morris, including cornetist Olu Dara, altoist–composer Julius Hemphill and baritone saxist Hamiet Bluiett among others; avant-gardely scientific alto saxophonist Anthony Braxton; the go-for-it George Adams–Don Pullen Quartet (veterans of the late Charles Mingus' bands); thoughtful pïanist Anthony Davis (unrelated to Miles) with several other impro-visers emerging from New Haven, Connecticut; the dissonant, clangorous and compound-complex free-funk of bands such as Ornette Coleman's Prime Time, Ronald Shannon Jackson's Decoding Society, trombonist Joseph Bowie's Defunkt, harmolodic guitarist James Blood Ulmer's trio, alto saxist Oliver Lake's Jump Up! and reedist Henry Threadgill's seven-person Sextett.

The Art Ensemble of Chicago had signed with ECM Records, insuring it the highest international profile of any AACM-identified band; AEC trumpeter Lester Bowie spun off side projects. The World Saxophone Quartet, comprising the afore-mentioned Murray, Hemphill, Bluiett and Lake, was also well-regarded and active in Europe besides the U.S. A circle of white musicians informed by jazz but de-voted to it only in varying degrees – including John Zorn, LaDonna Smith, Elliott Sharp, Tim Berne, Herb Robertson, the brothers Wayne and Bill Horvitz, Bobby Previte, Shelley Hirsch, Zeena Parkins, Phillip Johnston and Joel Forrester of the Microscopic Septet, trombonist Jim Staley and David Weinstein of the performance loft Roulette, vocalist David Moss and guitarist Bill Frisell – were becoming known as downtown (New York) experimentalists, collagists and improvisers.

Of course, many of Miles' electric sidemen had advanced their own musics

throughout the '70s – Hancock, Corea, McLaughlin, Jarrett, Bartz, DeJohnette and Holland having established themselves through a multitude of projects and recordings, Shorter and Zawinul's Weather Report (with electric bassist Jaco Pastorius) almost having run its course. Their various ensembles – Hancock's Mwandishi, Headhunters and V.S.O.P.; Corea's Circle, acoustic and electric editions of Return to Forever, special assemblages for particular records and tours, and his Elektric Band; McLaughlin's Mahavishnu Orchestra and Shakti; Jarrett's duets with DeJohnette, his American and European quartets, his solo piano concerts; Bartz's Ntu Troop; DeJohnette's Compost, Directions and Special Editions, Holland's quintets and trio with Sam Rivers – had become headline acts at international jazz fests and for major record labels, as had bands led by or including Tony Williams, Ron Carter and Dave Liebman, due in part to exposure they'd received and contacts they'd made through Miles' previous projects.

Alto saxophonist Steve Coleman would unveil the M-BASE Collective, loosely convening singer Cassandra Wilson, alto saxophonist Greg Osby, trombonist Robin Eubanks, guitarists Kelvyn Bell and David Gilmore, bassist Lonnie Plaxico, keyboardists Geri Allen and James Weidman, drummers Mark Gilmore and Marvin "Smitty" Smith among early others, around 1984. A nascent neo-conservative modernist jazz movement, arguably begun by Miles' former '60s sidemen Shorter, Hancock, Carter and Williams, who toured and recorded with trumpeter Freddie Hubbard as V.S.O.P., had also flourished. Starting around 1982 an incoming class of musicians were dubbed "the young lions," unofficially fronted by 21-year-old New Orleans-born trumpeter Wynton Marsalis, who owed more than a little to Miles' pre-electric style.

These forces had surfaced while Miles was away. None of them could claim his status as an icon of the jazz past. His longtime followers had repledged allegiance, but if he didn't maintain his penchant for change and identification with the present, newcomers separately or together might steal his thunder. Such threats kindled Miles' competitiveness. Having recaptured (with considerable help from Cicely Tyson, whom he'd married on Thanksgiving Day, 1981) focus, strength and desire, if not perfect health, Miles recorded *Decoy* in summer 1983 – an album in which he again made forward-bound music.

The title track begins with a thick electric bass line and a menacing rattle. A triangle or cowbell starts jingling (and will continue for the next eight and a half minutes, right through an odd, mid-track fade) while the drummer claps his closed hi-hat and punches his toms and snare. There's a flash of searing brass – trumpet and soprano sax mixed together? – then Davis slips in. Only a moment has elapsed – no delayed entrance here. Miles' trumpet is unmistakably central, extemporizing with coy and confident playfulness, unlike any of his musical moods in a decade. There is no overt anger, portentousness, desperation and self-conscious sweat. He has revived spirit and chops.

Guitarist John Scofield's instrument is modishly distorted to twang like a Slinky; Robert Irving III's keyboards mixed in the background suggest cloud fields moving independently, and after three discursive eight-bar choruses Miles announces his theme, a simple riff, in unison with soprano saxophonist Branford Marsalis – Miles even interjects quick, tight figures between the riff's repetitions. The drums rock steady, the bass (by Darryl "the Munch" Jones, who in 1991 took over bass duties in the Rolling Stones) syncopates the dance, the synth takes flight as if off to the stars and Marsalis blows a fetchingly off-center, very entertaining solo. At just over six minutes everything but the triangle drops out for almost three seconds, and Scofield returns to solo nimbly over the light, intriguing polyrhythms (Foster, drums; Cinelu, percussion). Marsalis reprises the theme and his solo's high points to a fade out on the bass, keyboards and ear candy (special effects). It reads as if straightforward, but "Decoy" sounds like one of the most eccentric songs any major-label jazz performer would release with any assumption of commercial potential and – surprise! – actual fulfillment of that hope.

At age 58 Miles gambled on the most up-to-date sonic equipment and designs to achieve his ambitions. He aimed for record sales, radio play and music television (which had been introduced by the MTV cable network in 1981, with expansion to New York and Los Angeles in '83). Having been impressed by keyboardist Hancock's recent hit single "Rockit" (produced by electric bassist Bill Laswell), Miles might have suspected that neither his "Decoy" title track nor "Code M.D.," the piece most in line with prevailing urban contemporary radio formats, *nor* the processed concert excerpts "What It Is" and "That's What Happened," would assuredly appeal to the new kids, slackers and hip-hoppers. But those tracks might – and did – win him exposure, which was half the battle. The "Decoy" promotional video did better than just get on the tube – it became the standard of MTV-approved jazz.

Like *The Man With The Horn* and *Star People*, *Decoy* comprised mostly shortish tunes, with only a slow blues ("That's Right") clocking more than ten minutes, and Marsalis' solo on the eight-minute 30-second title piece edited out of the video. But unlike Miles' previous '80s records, *Decoy* was quite weird and driving.

"Robot 415," just over a minute long, was like an interlude for a science fiction film, Miles playing oddly muted (and maybe doubled) trumpet over contrary synthesizer motion, electric drums and Cinelu's percussion; it fades out just as he starts to blow. The entire band is back for "Code M.D.," a soulful strut in which Miles regally delays his entrance until the last quarter. "Freaky Deaky," named in comedian Richard Pryor's honor, features more of the man without his horn: Miles' single-note line on organ-like synth climbs like a vine over a running bass figure, Scofield's guitar comments to the side. These elements do not resolve at the end of "Freaky Deaky" so much as evaporate.

Miles' devil-may-care smirk and pride in his bright idiom are evident on the like-

live tracks that originally filled side two of *Decoy*. Jones' thumb-plucking, Scofield's precise yet down 'n' dirty lead and Foster's swift, light drums lead Miles to perform the impossible – a duet with himself – on "What It Is," drawn from performance tapes from the Montreal Jazz Festival, and (obviously) overdubbed. "That's Right" is Miles' thoroughly convincing mid-tempo blues; he easily reaches high notes and realizes luxurious, imaginative statements on his three-and-a-half minute solo. "That's What Happened," also from the band's Montreal set, is fast, hot fun – splashy, flashy jazz-funk, indebted to Scofield, who served Miles as support, extension and alter-ego better than any guitarist since McLaughlin.

At the start of Miles' comeback, the hipoisie couldn't decide if he had returned as a self-parody or for real. *Decoy* should have convinced them of the latter. Further evidence was available, watching him deal with celebrity as to the manner born. His new band was hampered when booked to perform on tightly-timed network TV, but an unfortunate musical appearance on *Saturday Night Live* or David Sanborn's *Night Music* would be redeemed by Miles the late night talk show guest, as when he unabashedly flirted with actress Sigourney Weaver, who he sat next to on David Letterman's couch, demonstrating how he'd spit peas as a kid to improve his embouchure. Miles gained credibility every time he curled a lip in public instead of making nice.

In summer of 1984 I interviewed Miles over the phone from an office in *Down Beat*'s Chicago headquarters. Miles spoke from his home in Los Angeles, and our conversation was routed through Columbia Records' New York offices (either so it could be monitored or to keep his Malibu phone number private. Or both). Four years back at public performance and in the spotlight after his five-year self-imposed seclusion, Miles was eager to redefine his role in American culture, positioning himself as the pacesetter of self-described "social music."

Talkin', playin', BSn'[1]

"I don't mind talking if people are listenin'," Miles Dewey Davis told me by phone with an audible shrug. Just then, Miles' audience – unique in jazz for having endured and evolved over 35 years, across generations and diverse socio-economic classes, geo-political divisions, ethnicities, races and attitudes – *was* again listening and arguing about his new directions in music.

Decoy, his most recent Columbia album, was topping jazz sales charts and getting MTV play as a four-minute video. In it, his solitary, sepia-tinted, fedora-bedecked, scarred-lip image seemed to brood and glare at some unseen object. Alone but immersed in burbling sound, he wielded his trumpet to spew psychedelic twists of animated color to the title track's well-defined beat and contrary, ostensibly self-willed accompaniment. John Scofield's fingers wringing his guitar's neck were the only other music-makers the promo clip showed.

"Just don't ask me no bullshit," Miles warned in a hoarse husky growl, unmistakable as his Harmon mute sound. "I don't want to be compared to any white musician."

Who could compare? The only standard to hold Miles to was what he'd created himself. Was he playing ballads as tenderly, tentatively, tenaciously, tersely as he had during the 1950s and early '60s? Consider his frequent concert renditions of pop singer Cyndi Lauper's "Time After Time." Did he strip familiar songs to their essences, then fill them with provocative nuance? Well, he eked out an awfully slow "New Blues" (aka "That's Right," aka "Star People"). Could he recognize fresh talent, and direct it through groundbreaking forays? He had recently promoted guitarists Scofield and Mike Stern, saxists Bill Evans, Branford Marsalis and Bob Berg, studio-adept keyboardist Robert Irving III, multi-instrumentalist/composer–producer Marcus Miller, bassist Darryl Jones, drummers Al Foster, Vince Wilburn and Ricky Wellman and percussionist Minu Cinelu.

When and why – or was there ever? – a time when people stopped listening to Miles?

"I don't know," muttered The Voice. "But I was bored, myself. I was bored with the business end of it; that's always been terrible. You know, if you don't watch your money and have somebody who knows how to invest it, somebody'll steal you blind. Now, Columbia pays me very well, Columbia's doin' a good job on all its artists, especially me comin' back. But we still have to ask 'em for money time and again. You know what I mean?"

Yes, *but*: Miles had some options. His instantly recognizable, signifyin' face and lean meanness were perfect for product endorsements (he'd be featured in ads for Gap khakis, Apple computers, Honda motor scooters) and bit parts in movie and TV shows (Bill Murray's *Scrooged*, *Miami Vice*, a key character in *Dingo*). In promotional video clips distributed by Columbia Records, Miles painted elongated stick figures (which would eventually be hung in gallery shows and acquired for thousands by collectors of his ephemera), reclined in the white-upholstered living room of his Manhattan penthouse and quite comfortably, often ingenuously, responded to an off-screen interlocutor's questions however he decided to, on topic or not.

Miles had never liked the press much, though he'd had mutually beneficial relationships with such top jazz journalists as Leonard Feather and Ralph Gleason. He had granted interviews rarely, but modified that practice upon his return. New publicity was deemed necessary, so I was getting my turn. As always regarding Miles, I mostly listened. He was happy to lead.

"The more we play – the more *I* play – the more I can perceive what we can do in concert," he asserted. "What we *should* do. Then by playing a lot of concerts you can change the music. You get tired of hearing it, yourself. So the more we work, the more things change. The tempos change, we don't play songs in the same order and little things that happen that are great, we leave them in."

Yeah, so how come his set has turned so predictable?

"'Cause I tape all the concerts, so I can hear what we can use and what we can't, what we both like – the people and the band, the players."

Could these tapes be released?

"Yeah, they can be released, a lot of them. And the good stuff, I take it off if it's good, and use it. We used a lot of in-person stuff on *Decoy*.

"I've found, like a lot of other guys, I guess, that studio music sucks," Miles said in a confidential tone. "If I listen to [a tape from a concert] I can tell the good parts, and it has to be the same tempo, that's why I have to be so hard on drummers. I can be tied up [playing with complete concentration], and the drummer drops the tempo and I can feel it. A lot of stuff we don't use 'cause the tempos vary – that's why a lot of guys today play over a drum machine [or "click track"]. A lot of drummers get upset about that but you have to do that if you're gonna make a decent record in the studio. If you can get something live and something from the studio and put them both together, you can balance that all out. So you combine the two and the record comes out pretty good.

"I know that I can't make an album any more without playing something live, puttin' something live on it. 'Cause that other shit is just dull, man. I mean, you can't get no feelin', you know. There ain't nothing happening in the studio," he complained. "I just got through recording 'Time After Time,' and I don't play it but once a night, but [in the studio] we had to sit there and do it over and over. I had to do that on *Porgy And Bess*, and I swore I'd never do it again. It's not the retakes, it's the feeling you put in it. A musician in the studio, they don't have any feeling. Maybe if it's the first time, if they play something for the first time, but after that . . . Maybe you feel lucky and you get it the second time, too. After that it's just a job.

"I mean, you can't say 'I love you' twice. You have to say it when you feel it. And when I play a ballad, more than anything else, it's all me."

Whatever Miles did, he put all of himself into it. The *Decoy* video imagery and his visual art replicated his sensibility. His autobiography, written with Quincy Troupe, reveled in tales he told about himself, including – especially – those revealing his dark side. His raging uptempo numbers on *Decoy*, driven by Scofield, proved he still had the musical stuff, though he said they took a lot out of him.

"When I get through with a concert, I've lost about three pounds," he mentioned. "I swim about an hour a day, in the pool. I practice every day. Got to do that – you don't practice, you can't play nothin'. Scales, mostly – trumpet stuff. Long tones are the best. If I can play a low F sharp, loud and clear, then I know my tone is there. I had to work real hard to get that tone back when I came back; it took me two years to get it right. Now that it's back, I'm gonna keep it."

How important is tone to Miles?

"If you don't have a pleasant sound you can't play any melody. And my head is full of melodies," he answered.

Yet "I play what *we* can play," said Miles, "not *me*. I never play what I *can* play; I'm always playin' *over* what I can play. I'm always tempted to play something difficult, and usually it's a ballad, you know – the rest of the stuff is easy – but my love for ballads gets me in trouble. Well, not trouble . . . it's just that you have to have a good tone, a workin' tone, or else you're gonna think the ballad sounds bad. My love for singers makes me play like that on trumpet.

"Now, on 'Time After Time,' it's the song [that inspires him]. There are some songs that belong to certain people – they're just made for you. I've met guys who've had pieces for me, too."

He was speaking of pieces of music tailored specifically for him or provided for his alterations, by musicians: during the 1960s such "guys" as Wayne Shorter and Joe Zawinul; in the early '80s Robert Irving III, credited with "Decoy" itself and the album's spooky, radio-suitable processional "Code M.D." and co-credit with Miles for the trio snippet "Robot 415." Scofield had proved to be another one, on *Decoy* and onstage an invaluable ally, though the trumpeter scoffed of Sco' flat out, "He always overplays."

"I've told him," Miles sighed, " 'When you get through playin' what you know, *then* play somethin'. Nobody wants to hear you practice onstage. Practice at home.' You can't tell that to everybody. I don't tell that to John *every* time he does it – just when he gets on my nerves."

What did Miles tell bassist Darryl Jones?

"I give him a line to play, but I don't ask him for anything. If he plays too much of somethin' I don't like, I tell him. I stop him. What I'm trying to get him to do now is not resolve anything. I told him, 'After you play the tonic, there's nothing else to play. So *don't* play it.'

"Endings just drag me," Miles remarked when I recalled a trick he'd deployed at a New York Kool Jazz fest concert. Towards the end of a tune ringing feedback seemed to seep from some amplifier. Irving, Scofield and Jones all appeared mystified, and the drone kept on until they had dropped into silence. Then Miles simply dialed out the whine he'd summoned from his own bank of keyboards.

"I'm not playing with them when I do that," he insisted. "I just like to continue on to the next number. When we stop abruptly sometimes? After you've heard it all, if you play things long as we play 'em, they [the sidemen] don't mind stoppin' like that.

"We're getting away from chords," he continued. "Chords, they just get in the way. If I give Bobby [Irving] a chord, it's the *sound* I want – and I tell him that the sound can go anywhere. When you take a sound, it only sounds wrong if you don't resolve it to somethin' else. I mean, the next chord *makes* the first one; it tells on the first chord, the first sound. If you hit somethin' that sounds like a discord to everybody in the world, you can straighten it out with the next chord. So, we don't play chords. That is, we play 'em, but they're not . . . chord-chords."

Miles' notion of *sounds* for chords and his revolt against conventional, predictable resolutions seemed similar to ideas identified with both Ornette Coleman and Cecil Taylor. I asked if by abandoning strict adherence to chord structure, one can get a lot further, and if that was where he was going.

"Yeah. Otherwise, there's nothin' happenin'. Like, where's Wynton Marsalis? Wynton's a brilliant musician, but that whole school – they don't know anything about theory. 'Cause if they did, they wouldn't be sayin' what they say, and doin' what they do."

Trumpeter Marsalis had emerged from drummer Art Blakey's Jazz Messengers just two years before to record with Miles' '60s rhythm section, to win Grammy Awards in 1983 for both his jazz and his classical records, to sign a vaunted, long-term deal with Columbia Records and to disparage Miles' post-1967 ways. Marsalis had gained a prominence in the American culture debates asserting "traditional" jazz values (reliance on acoustic instruments and swing, mastery of chordal harmony, expulsion of rock/pop/funk/electric elements) against Miles' iconoclastic and relatively populist path. Marsalis dominated many jazz conversations, but I hadn't brought him up. Why had Miles?

"The only thing that makes Art Blakey's band sound good is Art. They're energetic musicians, yeah, but it's the same structure that we used to play years ago, and it's too demanding on you. You have to play the same thing [repeatedly]. If you play a pattern of fourths or parallel fifths or half-step chords and all that stuff, nobody's gonna sound different on that – everyone sounds the same. Why do you think Herbie [Hancock] don't want to play that anymore? He'd rather hear scratch music," Miles said, referring to Hancock's "Rockit" from his 1983 album *Future Shock*, which featured a turntablist with the moniker Grand Mixer D. St. "I'd rather hear somebody fall on the piano than to play [Blakey's hardbop style]. That newness will give you something – more so than all the clichés you've heard from this record, that tape. The only way you can get away from that is by being very selfish."

Selfish?

"Selfish. I mean: Don't listen. You don't listen to a trumpet player for what he's doin', you listen for the sound, to his sound. You don't listen to Herbie for how he's playin' the piano, you listen for what the whole thing does. You know what I'm sayin'? You don't have to play 'The Flight Of The Bumblebee' to prove to another trumpet player that you're a good trumpet player. Everybody can do that. The way you change and help music is by tryin' to invent new ways to play, if you're gonna ad lib and be what they call a jazz musician.

"I myself couldn't copy anybody. An *approach* I could copy, but I wouldn't want to copy the whole thing," Miles maintained, appalled that anyone would, so to speak, play-giarize.

"Listen," he went on, "I would love to play like Dizzy, or Buck Clayton, or, you know, all those trumpeters who I heard who I liked. But I couldn't do it. Roy

Eldridge – I couldn't play like that. I tried. I tried to play like Harry James – I couldn't do that."

When had he realized this inability?

"When I played 'Flight Of The Bumblebee' [a Rimsky-Korsakov orchestral interlude requiring considerable breathing, arguing and anger control, popularized by trumpeter Harry James in a 1940 rendition and to be recorded by Marsalis in 1990] and thought 'What the fuck am I playin' this for?' I was about 14. 'Carnival Of Venice' [another standard of brass repertoire, aka "My Hat, It Has Three Corners"] – I said, 'Damn, what is all this?'"

But most young musicians coming up look for guidance, and want to –

"Have an idol? Yeah," he anticipated me. "You can see how difficult it is, because you have so many records. When I was comin' up I had three records. I had Pres [Lester Young] playin' 'Sometimes I'm Happy', Art Tatum's 'Get Happy', Duke's 'Mr. JB Blues.' And my mother loved Louis Jordan. Billy Eckstine and Dizzy. Coleman Hawkins playin' 'Woody 'n' You.' That was about it. I thought everybody in the world, all the good trumpet players, played like Dizzy; when I got to New York I found out things are different, you have to go your own way, you can't copy anybody. You know, just because you play a flatted fifth doesn't mean somebody's gonna hire you," he snorted derisively.

What *would* Miles tell a youngster seeking advice?

"They have to get their own sound. Then, notes go with your sound. It's like a color. My color – I'm black, brown, with a little red-orange in my skin. Red looks good on me. You have to do the same with music. If you have a tone, you play notes to match your sound, your tone, if you're gonna make it pleasin' to yourself – and then you can please somebody else with it."

And composing for your band, or working things out with them live, you keep in mind *their* notes, as Duke Ellington did?

"Right, that's right. Yeah. You know what they can do. John and the rest, these are very talented musicians. If you play every night, and somebody does somethin', you remember that. If it's not somethin' we did ten minutes ago, I say, 'Well, here it is, down on this tape – you can hear it again. You know what to do.' But your sound has to match what you think – not what somebody else thinks. Nobody can make like me, know what I mean? Louis [Miles pronounces it "Louie" as the French do, and as Armstrong said it himself] was the one you could copy, he was the easiest. You can't play like Dizzy."

What could one copy from Armstrong?

"The sound, the tone. I like the tone of Pres, of Louis and Buck Clayton and Ray Nance. That low register sound, I hear that."

Many older listeners don't hear the connection between your electric style and earlier improvised music.

"Who cares? I mean, you go from 1984 on up, not from 1903."

But you wouldn't rule out an acoustic project, would you?

"No, I wouldn't mind. If the *place* was alright. You know, people have said I turn my back [on the audience, as an insult], but it's not like that. Onstage, there's always a spot that will register more for the horn player. When I was playin' with [trombonist] J.J. Johnson, he used to say, 'I'll give you $10 if you let me sit in your spot tonight', 'cause if it's a good spot for brass, that's what happens. But I would play acoustic with a nice guitar player, or a nice pianist like Keith or Herbie or Chick or George Duke, and record like that. It would be great. Not in Carnegie Hall – because the symphony, they got 70 guys all playin' one note [so the sound is clear]. They need some speakers in there.

"I think you can play acoustic [advantageously], always did. I used to have big arguments with Dave Holland and Chick about electric pianos and stuff – but how many years ago was that? And you can see what happened."

What happened was electric instruments became commonplace. Did Miles look forward to further adventures into high tech, of the sort Hancock had repeatedly assayed?

"Yeah, that knocks me out. Because I know Herbie so well – he's like what people call a genius, he's something else. But Keith, Chick, they're all crazy like that, they play so much there ain't nothin' left for them to do but funk with somethin' else. Herbie *has* to play with different things, because he's done everything else.

"Yeah, give somebody some kind of goose, give 'em just a little kick," Miles urged. "You owe that to music. A lot of guys are wearin' clean shirts, and drivin' new cars from copyin' me. They have jobs. But they owe Dizzy somethin', and Louis and people like that for what they did that was great. Why not try to do something yourself? Even if for nothin' else but the fans' sake, 'cause they done heard all this stuff. You don't play anything they haven't heard – it just comes out different. And everybody wants a new sandwich. Whatcha gonna put on a hamburger next? You know?

"Now, if we don't play some blues in front of a black audience ain't nothin' gonna happen, and I'm black, so that's what we're gonna play; if I was Chinese, we'd be playin' somethin' else. I still play the Harmon mute, yeah; I take the middle out of it. I'm not usin' wah-wahs or any of that, not this season. You know what I do, though? I play chords on the piano and play [trumpet] on top of the synthesizer.

"Hey, talk about prejudice, dig this: The synthesizer sound for trumpet is a white trumpet player's sound. Not my sound, not Louis' sound, or Dizzy's sound – a white trumpet sound! It is! And the only way I can play it is to play *over* it with my trumpet. To me, they should get Snooky Young or one of them good first trumpet players and have him record to put his sound on the synthesizer. I'd love that – or *my* sound. I have an Emulator [an early sampler, marketed by E-mu Systems in 1981]

that Willie Nelson gave me, and I could put my sound on that. I might just do it. Or get Snooky to let me record him."

Could Miles always tell the difference between a black and white player through their sounds?

"I don't know, man — there are a lot of good white players out there now. Used to be a white trumpet player couldn't play above a high C [two octaves above a piano's middle C]. Now they can do everything. But when I was at Juilliard, that white trumpet sound, that's what you used when you played concerts. You don't put that stuff on synthesizers for social music. They [synth/sampler manufacturers] have to get that sound together. You should have a choice on a synthesizer between a black and white sound.

"See, it's a problem because they [white trumpeters] can't lose that schoolin'. Wynton has told me sometimes he thinks things he plays sound too white. I told him, 'Don't worry about it', because he's a good player, and it ain't gonna be *that* white. He's sayin' that in order to play those strict phrases with the symphony orchestra you have to play like *them*, 'cause they can't play with *us*."

When Miles played with Gil Evans' orchestra in the late 1950s and early '60s, didn't the orchestra match Miles' sound?

"Gil loves my sound, and my sound fits because I love his arrangements, like those for Claude Thornhill — I loved that *pure* sound. But when you mix, when you integrate a band, it sounds different. You can tell when a rock band has a black rhythm section. It can hold the groove a little longer. And groups like Earth, Wind & Fire — they could mix a couple white trumpeters in there, use 'em right."

What else had Miles been digging? The Jimi Hendrix-derivative black rock auteur Prince?

"Yeah, I heard Prince. You know, it's easy to write in between a crack, like in a song," Miles advised, slighting Prince's reputation as a composer–performer wunderkind. "If you sing, it's easy to fill a phrase. But to fill up 32 bars for 15 minutes [as a jazz improviser is supposed to], you've got to admire a person for doing that. For what Prince's doing, filling his own backgrounds in, it's great — but only for a few minutes. I like to listen to groups like Earth Wind & Fire, Prince, Michael Jackson, Ashford and Simpson. They only have a couple of bars in which to do it, and they make the best of it. But if they had to do it for 32 bars for half an hour they couldn't do it, because they're not groomed that way.

"Me, I'm basically a quarter horse. You know how a thoroughbred runs a mile? A quarterhorse runs a quarter mile. I think it's easier to do what Prince and them, and Quincy [Jones], too, do — fill in those cracks [improvise phrases during breaks in the melody], write like that. Playin' — if you let it flow, if you can stand it, long tunes are alright. If you feel irritable when a take's going on, that means somethin's wrong, so you have to stop it. *Bitches Brew* and all that [long performances] turned

out great, because I let it flow for a while, but there were also cues, and the musi-
cians knew what to do."

Miles, what do you want to be remembered for?

"My sound," he hissed without hesitation.

That makes sense. One more question. Since you came back, which of your
songs or albums do you think is best?

"Best? That's a big word."

And comparisons are odious. No one compares with Miles.

Later and after

If Miles, in his mid-fifties in 1984, didn't flaunt the fire he had in his mid-forties
in 1970-'75, he nonetheless spent the rest of his life – seven years – inventively
and with stubborn energy weaving instrumental jazz and pop to his own design. He
recorded voluminously and toured the world, selling out big concerts and packing
smaller clubs, playing spooky electric keyboards as well as his unmistakable trum-
pet, leading young and talented, deliberately fashioned if not obviously fashionable
bands.

He employed, schooled and sometimes mentored a couple of dozen younger mu-
sicians, including (besides those previously mentioned) trumpeter Wallace Roney,
saxophonists Bob Berg, Kenny Garrett, Rick Margitza and Gary Thomas, keyboard-
ists Kei Akagi, John Beasley, Joey DeFrancesco, Adam Holzman, Deron Johnson
and Bernard Wright, violinist Michal Urbaniak, guitarists Jean-Paul Bourelly, Bobby
Broom, Hiram Bullock, Robben Ford, Earl Klugh, Dewayne "Blackbyrd" McKnight
and Billy "Spaceman" Patterson; bassists Felton Crews, Cornelius Mims, Benny
Rietveld and Richard Patterson; his own son Erin Davis among percussionists John
Bingham (also a guitarist, who created a kit comprising electronic drums, sam-
pler and octopads), Rudy Bird, Mino Cinelu, Paulino da Costa, Marilyn Mazur and
Munyungo Jackson, and drummers Al Foster, Omar Hakim, Ricky Wellman and
Vince Wilburn, his nephew. All deserve a mention, though they haven't all flour-
ished as Miles' alumni.

Miles also collaborated with George Duke, Easy Mo Bee, Flavor Flav, Quincy Jones,
Shirley Horn, Robert Irving III, Chaka Khan, Michel Legrand, Palle Mikkelborg
and the Danish Radio Big Band, John McLaughlin, Jack Nitzsche, Prince, David
Sanborn, Sting, Joe Sample, the band Scritti Politti, the Italian "superstar singer"
Adelmo "Zucchero" Fornaciari, Italian keyboardist–composer Paolo Rustichelli and
Tommy LiPuma, producer and chief of Warner Bros' jazz division. Miles was crucial
to three movie soundtracks and did other incidental work for advertisements, film
and TV. He participated in at least four fully videotaped concerts, *Live In Montreal*
(recorded in 1985) and *Live In Munich* (1988, both these two on Pioneer Artists),

Miles In Paris (1989) and, with Quincy Jones conducting the combined Gil Evans Orchestra and George Gruntz Concert Jazz Band, *Live At Montreux* (July, 1991; both these issued by Warner Reprise Video).

From 1981 until July '91, Miles recorded nine ambitious studio albums. *Tutu*, his debut for Warner Bros with which he'd contracted after 25 years with Columbia Records, was released in fall of 1986 and was validated with a Grammy award; in it he imperiously celebrated himself, thanks to the devotions of Marcus Miller. *Amandla*, his followup also produced by Miller, was a softer, breezier endeavor; *doo-bop*, which Bob Belden has called "Miles' last gasp," was released posthumously – both of them won Grammys, too.

Miles enjoyed, just before he died, two completely different career retrospectives. Two days after he headlined the Quincy Jones-initiated recreation of Gil Evans' 30 to 40-year-old arrangements for *Birth Of The Cool*, *Miles Ahead*, *Porgy And Bess* and *Sketches Of Spain*, Miles presided over a jam of friends from his past – including alto saxophonist Jackie McLean, Wayne Shorter, Herbie Hancock, Chick Corea, Joe Zawinul, Dave Holland and John Scofield and John McLaughlin – at the JVC Festival in Paris.

Throughout his musical life Miles developed unique repertoire with a sound – *le mot juste*, the only one that covers all dimensions – inimitably his own. It was the aural imprint of his speech, his trumpet lines and keyboard clusters, the moods he conveyed, the myth he projected and his larger concepts. He applied this sound to every circumstance.

One of his most telling modes of signification involved his appropriations of popisms and repurposing of them to his own specifications. It was a strategy he'd honed while coming up playing themes by Charlie Parker, Eddie Vinson, Dizzy Gillespie, Thelonious Monk, Gerry Mulligan, Richard Rodgers, Frank Loesser, George Gershwin, pianist Bill Evans, Wayne Shorter and Joe Zawinul, among others. Compare his versions with the original hit renditions of Cyndi Lauper's "Time After Time," Michael Jackson's winsome "Human Nature," Cameo's "In The Night," the Toto ballad "Don't Stop Me Now" and Scritti Politti's "Perfect Day," for what he kept of '80s vernacular songs and how he transformed those retentions to suit his musings.

Even when he didn't tamper much with the source renditions, Miles' trumpet was always more piquant, articulate, funnier, beckoning and biting than the voices of the pop singers, and the electronic settings realized by his bandmembers subject to his approval were typically more vibrant and sleeker than the original arrangements. His dip into hits of the moment as an alternative to reliance on the hits of the past anticipated the ad hoc "new standards" project that has found the likes of Herbie Hancock, Michael Brecker, Roy Hargrove, Don Byron and the Bad Plus proposing various post-Woodstock pop songs as potentially benefiting from jazz interpretation, hoping they'd not incidentally benefit jazz right back.

Among Miles '80s stand-alone projects was the overtly "avant-garde" album *Aura*, in which he soloed over a 27-piece orchestra (with second soloist John McLaughlin) in Denmark in 1984. Commissioned to celebrate Miles' acceptance of that year's prestigious Sonning Music Award, composer Palle Mikkelborg used a somewhat contrived plan to generate his thematic material, but the music is . . . interesting. For instance, on "Orange," the fourth of the ten sections named for colors, McLaughlin and Miles spin out acidic funkifications of a tone row expressed intermittently, like an exclamation point, by a chiming orchestral gesture reminiscent of the proto-electric keyboard Ondes-Martinot prominent in Olivier Messiaen's *Turangalîla-Symphonie* (Messiaen was a previous Sonning Award honoree). It sounds grandiose, but squeaky clean. Against this, Miles' trumpet and McLaughlin's guitar seem lifted out of *On The Corner*, the rich, mad, scrappy, contentious context of the early '70s left behind.

Miles made one record that's legendary for not having been released – "lost" is what George Cole calls it in his well-researched book *The Last Miles* (The University of Michigan Press, 2005). Miles' "Rubberband" sessions reportedly resulted in a full album of material co-produced by Randy Hall and Zane Giles at the same time and maybe as an alternative (though not to Hall and Giles' knowledge) to *Tutu*. It has been promised for release and withdrawn several times by Warner Bros. Maybe it remains unissued for the same reason it was passed over when completed: LiPuma, at least, didn't think it suitable for the unveiling of Warner's jazz trophy stolen away from Columbia Records. A rubberband, while amusingly elastic, was too disposable, commonplace and funky. Why not craft a more imposing monument, more like . . . *Tutu*?

Also: the "artist" known as Prince, Miles' partner in a collaborative flirtation, likely refuses to let Warner Bros, his former company, profit from his tunes recorded for what was to be *Rubberband*. Too bad – when snippets from the Rubberband sessions were last tentatively offered as part of a Warner Bros four-CD boxed set called *The Last Word* scheduled for release on its Rhino sub-label in 2002, I received an advance copy, and four previously unissued tracks – "Maze" and "Digg That" from summer '85 sessions, plus "Rubber Band" and "See I See" from October '85 to January '86 sessions – are jauntily idiomatic, Miles riffing mostly on open horn merry as an old rogue in pleasureland.

Though removed by then from common life and the real world, as happens to American celebrities, Miles protested apartheid in 1985 and supported Amnesty International in '86, reviewed and renewed his blues, and established templates for the use of new electronic instruments and studio procedures to project his unique personality in all possible forms. The great modern jazz trumpeter had become a peerless artist; comparing him to Picasso became commonplace. It was audacious, maybe even avant-garde, for a jazz musician to live as large as the most collectible painter of the twentieth century, as it was unheard of for a jazz musician to entertain

his muse for 40 years without domesticating her and to do it in public, always with an eye to *epate le bourgoisie*. Miles was identified internationally with what's high-charged, what's wicked and what's next, up to his death in September 1991 and on to this day.

One might assume, judging from the general press reaction to most of Miles' mid-'80s albums, that by then he had purged his fan base of seekers of the new *or* the old, of conservatives *or* progressives. Nothing he did was taken completely seriously, at least not in the U.S., by people who thought themselves on culture's cutting edge – beboppers or re-boppers, new wavers, punk rockers, contemporary composers, multi-culturalists or any other elite arts types typical of the Me Decade, though (or because) these listeners would be younger brothers and sisters of his ardent '70s listeners.

Tutu caused some stir, but fell between the cracks of smooth jazz and pop anthems then garnering radio play. It was too weird and hard-edged for the former, maybe too grandiose for the latter. Citizens during Ronald Reagan's presidency wanted their prejudices confirmed and egos stroked; *Tutu*, from its close up cover portrait of Miles by famed fashion photographer Irving Penn to its offhand appropriation – er, veneration – of the name of anti-apartheid South African bishop Desmond Tutu, winner of the 1984 Nobel Peace Prize, seemed a self-celebration, virtually coronating Miles. As the seer Mel Brooks mentioned first in his epic 1981 film *History Of The World Part 1*, "It's good to be king," and Miles surely agreed. But did he have to lord it over the rest of us?

Contrary to accepted opinion, when Miles secured his comeback circa 1983 as a headliner on the global festival circuit, he was hardly more docile or less extreme than when he'd left it. *The Complete Miles Davis At Montreux 1973–1991*, a boxed set of 20 CDs superbly recorded at an upscale Swiss jazz festival that took the term "jazz" broadly, sets the matter straight. After two discs featuring Miles' pre-retirement Liebman–Cosey–Lucas band, the 18 further discs document Miles almost annually from summer '83 through '91. At Montreux at least, Miles was determined to make a point of his elan vital, to demonstrate his relevance. And so he does. Up to his July 1991 appearance in the Quincy Jones extravaganza in which Wallace Roney stood by to blow in his stead when needed, Miles dependably imbued his sets with masterful pronouncements and ripping slurs, muted, microtonal cries, lippy attacks and lunges after evanescent melody that bespeak genuine engagement.

Miles' crafty revisions of the pop tunes, the hand-tooled charts by Marcus Miller of "Tutu," "Amandla," "Hannibal" and "Mr. Pastorius," Scofield's "What It Is," McLaughlin's "Pacific Express," Zawinul's "In A Silent Way" and his own "Jean-Pierre" took strength in the compositions' modular qualities. Instrumental parts of these pieces stand on their own and could be played by anyone. When expanded upon by Miles with Scofield, Foley, Berg or Garrett, their dynamics matched by synth colorist Irving and highly creative Kei Akagi, squatty-roo bassist Jones, sim-

Miles and lead bassist Foley, Chicago, 1990 © 1990 Marc PoKempner.

mering Foster or lighter, faster Wellman, the licks and patterns usually added up at least to nervy entertainment.

Marcus Miller had specifically designed Miles' comeback repertoire to exploit new studio production possibilities and techniques, particularly those involving overdubbing and electronic rhythm equipment. He hit his mark, especially in regard to the deployment of decorative effects that have been adopted and repeated, though often diluted and to less heady purpose, in subsequent pop product. But Miles brilliantly adapted those studio contrivances for use in his live shows in vast venues. On such stages his strutting and posing, the weight of his attitudes and the pride evoked by his keyboard-enriched, big band-imitative anthems achieved proper scale. The riffs and voicings of "Code M.D." or "Maze" or "Heavy Metal" might have seemed much-too-much to minimalists and proto-punks then, but even their foolish displays are welcome now, in contrast to minimalists' deliberate reductions and punks' ostentatious inabilities. Miles wasn't trying to create a canon of sentimental songs (though he did that, too) with his ostinato bass lines, electro-throbbing rhythms and brief, hummable bits, so as much as he meant to establish a street-savvy, pan-global and well-capitalized slanguage, right for the present and maybe the future.

What was *always* compelling, live most of all, was his personal line, variously wary, bold, romantic, wry, base and candid. His trumpet pulls one up and out, and then inward. His phrases are hastily brushed but excite vivid response. He emits blunt commands, full-bodied declarations and squelched whispers; he exploits such tried-and-true effects as dramatic stop times, breaks, duets with players drawn from the

101

larger ensemble – moves dating back to Jelly Roll Morton and King Joe Oliver. Miles' trumpet pierces the stratospheric high register he seldom reached for when young, and also delves to the bottom of its range. His ensembles are seldom as puffed up as Quincy Jones' huge ensemble; Miles led his regular, tour-worthy Garrett–Foley sextet at its gig in Nice on July 17, '91 (also included in the *Complete Montreux* box), nine days after Jones's circus, 70 days before his death, and he *burned*.

Miles' music at Montreux was free from impositions other than his own, and finely calibrated for precise results. He had vast ambitions. His "directions in music" were exotically intoxicating, his rhythms hypnotic and contagious, his moods languid and/or crisp, with scant decline. Miles spewed forth all-but-irresistible hooks, tales and sinkers (conclusions); he was so charismatic that his audiences followed him even into excesses and cul-de-sacs. But he arrived at much more transporting music live in concert or on his '80s studio albums than he did dull dead ends.

For the best of very late Miles, hear "High Speed Chase" on *doo-bop*, the widely dissed but also Grammy-winning album completed by rapper Easy Mo Bee shortly after Miles' demise. Set aside preconceptions about hip-hop, or forewarnings of its co-option of jazz musicians such as trumpeter Donald Byrd, organist Lonnie Liston Smith and guitarist Grant Green: here's a sharp uptempo track of syncopated stereo whistles, bells, traffic noise and vibes couching Miles' distinctive skitterings. Never mind that his part was lifted from an earlier, unrelated session and supporting sounds meticulously shaped around him – the concoction comes alive. Miles squirts out phrases that in themselves could be expanded into complete songs. He plays muted but deftly, using only a sample of his available power to negotiate the chase's quirky course, as he might have reined a sports car in a bit from its upper limit. He liked to drive fast, and as this track was designed post-facto to fit what he did, the impression, naturally, is that he aces it with ease. There are other choice cuts on *doo-bop*, Mo Bee's dumb raps notwithstanding – check out "Mystery," "Sonya" and "Duke Booty," too.

Though Miles' last touring bands featured Garrett's cogent alto sax, lead bassist Foley's rock–blues extrapolations, advanced keyboard deployment by Akagi and Adam Holzman, polyrhythms aplenty from the drummers and percussionists, he never took them into the studio or authorized concert tapes' audio release. Why not? The posthumously released *Live Around The World* provides a clue. His chops sometimes gave out – he's truly weak on the album's rendition of "Time After Time," and sometimes a tired quality overcomes the band. Also, he was regularly hectored to impersonate himself – which he did not avoid doing for Jones *Live At Montreux*, Legrand on *Dingo* (though "Paris Walking II" is worthwhile and "The Jam Session" a knockout), and Nitzsche's filmic blues pastiche *The Hot Spot*. Instead of recording his band – and letting Warner Bros profit from a disadvantageous deal that had shorn him of royalties on new copyrights, Miles pursued musical whims when and where he wanted to. No one forced him to record "Capri," a

sophisticated/smoochy ballad, as he did on Paolo Rustichelli's album of the same name; that was Miles' choice.

Not to be hagiographic: Miles made some music that can be deemed cheesy, but that's usually because popularizers grabbed and cheapened it. Herb Alpert, Mark Isham, Jon Hassell, Nils Petter Molvaer and Chris Botti are among the trumpeters who've glommed onto an aspect of Miles' music and run with it. Miles himself wasn't above employing pop conventions to convey his human nature to jazz-lite listeners who might be moved by heavier music if it reached them. But the best of his late output remains timely, durable and full of surprises, distant in form and content from the American songbook and fake book standards interpreted, composed and recomposed by Miles decades and gigabytes ago, further yet from the most popular jazz of the same years.

For example, these records topped Billboard's jazz and contemporary sales charts in 1991: Harry Connick Jr.'s *We Are In Love*, Joe Sample's *Ashes To Ashes*, Shirley Horn's *You Won't Forget Me*, the Crusader's *Healing The Wounds*, Natalie Cole's *Unforgettable*, Dianne Schuur's *Pure Schuur*, Maceo Parker's *Roots Revisited*, Gerald Albright's *Dream Come True*, Dianne Reeves' *I Remember*, the Yellow Jackets' *Greenhouse*, Marcus Roberts' *Alone With Three Giants* and Wynton Marsalis' *Standard Time, Volume 2*. This list contains five albums of vocalists singing '40s and '50s standards, three by smooth jazz advocates (Joe Sample being the keyboardist in the Crusaders, a pop–soul–jazz band born in 1961; *Healing The Wounds* was its last recording), one by James Brown's r&b-steeped alto saxophonist, one by an electric fusion band and two by dyed-in-the-wool straightahead acoustic preservationists. Miles' offshoots were represented by Kenny Garrett's *African Exchange Student* and Chick Corea's *Akoustic Band*, numbers 14 and 16, respectively of top-selling jazz CDs.

Yes, Miles fancied himself from the '70s on as an unrepentant gangsta; before that he'd portrayed more the isolated existentialist. There is little reason to think he was not truly vain, harsh, cryptic and decadent, the very opposite of the good-humored and gregarious image Louis Armstrong projected as a jazz star and figurehead, the image both Dizzy Gillespie and Wynton Marsalis adapted only slightly. Still, Miles shed brilliant light from his angle, highlighting individualism with his idiosyncrasies, casting a long shadow with every tilt of his trumpet.

At 1 a.m. the night after Miles died – September 28, 1991, at St. John's Hospital and Health Center in Santa Monica, California, where he'd been in a coma for four weeks following a stroke – trumpeter Jerry Gonzalez was blowing a fair homage to Miles' distinctive sound at Bradley's, Manhattan's late night jazz devotees' hangout. The long bar was full of drinkers, and it was smoky; the background chatter was constant, though some listeners sat staring at their drinks, alone with the music. Trumpeter Donald Byrd was present, among other musicians. It was guitarist Kevin

Eubanks' gig, with pianist Kirk Lightsey and bassist Rufus Reid; Gonzalez, always a Miles admirer, was sitting in to mark his regret and respects.

They improvised at a quick tempo on "Footprints," Wayne Shorter's deceptively simple tune from *Miles Smiles*, Gonzalez approximating Miles' burnished, bruised and burnt-edged tone. Eubanks repeated a concentrated, rhythmically rolling figure, honing it to his private sense of perfection. Lightsey accompanied prettily, and not obsessively – with complementary phrases, silence and space, and contrasting chords. Reid, a former Chicagoan who had anchored many a post-bop modernist and directed a jazz education program at William Paterson College of Rutgers University in New Jersey, walked a steady bass. Miles was dead. Long live Miles.

"It's the end of a jazz age," keyboardist and arranger Gil Goldstein told me a few days later. He was about to go onstage at the club Sweet Basil with the Miles Evans band – led by Gil Evans' son Miles – which had backed Miles Davis at the Quincy Jones-conducted concert the past July. Goldstein had prepared Gil Evans' crumbling old charts for that never-expected event.

"Really," said Goldstein, "if Miles is not here, who else is here still from the beginning? I mean, every style he played became a genre. Even the things everybody hated, that the musicians said were bull, now they're all styles. *Everything* he did became a classic."

There *were* surviving jazz musicians who predated Miles' entry into the modern jazz era: Gillespie, for one, as well as Miles' friend and trumpet mentor from adolescence Clark Terry, his first important employer Billy Eckstine, Swing Era trumpet heroes Harry "Sweets" Edison and Buck Clayton, '40s and '50s colleagues including Art Blakey, Max Roach, Milt Jackson, J. J. Johnson and Sonny Rollins. Doc Cheatham (b. 1905) remained of the brass players whose careers had begun in the Roaring Twenties; of trumpeters among Miles' closer contemporaries, Don Cherry, Bill Dixon, Art Farmer, Freddie Hubbard, Kenny Wheeler, 15-years-younger Lester Bowie, Olu Dara, Butch Morris and Lew Soloff, Italian Enrico Rava, Cuban Arturo Sandoval, Russian Valerie Ponamerov and Japanese Terumasa Hino as well as Wynton Marsalis, Jon Faddis and Terrence Blanchard were left to either embrace or otherwise grapple with his model.

"Miles' sound entered into whatever he played," said alto saxophonist Jackie McLean on the phone from his home in Hartford, Connecticut. McLean was 16 years old when he'd recorded a session now regarded as a classic with Miles in 1951. "I didn't love all the things he did in later years with his fusion bands, but as long as *he* was playing he captured that tone, and the music was his. I admired that, and wanted it – a real personal sound, a sound people could recognize in just a couple of notes as *mine*."

"To me, his fusion wasn't serious enough or deep enough," McLean continued, citing the orthodox position on Miles' development of music distant from that with which he'd begun. "Miles played a very technical, traditional music before 1969,

following Ellington and all the great masters. Then, for fame or money or something – I'm sure *not* because of his musical tastes – he decided to go this other way. But you've got to give him credit: he's the one who set up this whole marriage between rock 'n' roll or rhythm 'n' blues and traditional jazz. He opened up a whole market for people who play something heavier than 'Here comes Char-lie' four chord rock."

Jack DeJohnette, who Miles had hired away from his gig with Jackie McLean to join his electric band from 1969 to 1972, sat in a Grammercy Park hotel room, his voice heavy after a call on the phone from alto saxophonist Kenny Garrett. He turned from their commiserating conversation to speak of Miles' pace of innovation. "Miles was just doing what he heard at the time," DeJohnette said. "Some people keep up with it, and others either don't like it or fall behind. But Miles was always moving with his time."

Chick Corea, who had worked with DeJohnette in Miles band (and who I spoke with months after Miles' death), agreed: "Miles put the cap on a certain style of acoustic jazz music with Herbie and Ron and Tony and Wayne, and then he let the world of changing harmonies go, started going into vamps and jungle music, primitive rhythms and abstract melodies. The years we were on tour ['68 to '71] the sets I played in would be one improvisation from beginning to end with a few little cues from Miles to change the tempo or the key. Every tune we played was in this incredible abstract form; the meat of the rendition was a free improvisation."

"Miles' solos are really interesting to look at on music paper, because there's nothing to them," Corea said. "There's this one track on *Miles And Monk At Newport,* with Coltrane and the sextet, which is one of my favorite live Miles performances. They do a version of 'Straight, No Chaser', an F blues, and his solo on it, four choruses or so, is totally marvelous, simply a masterpiece. I've listened to it over and over again, and once for a lark I transcribed it, wrote it down.

"On a Coltrane solo or a Charlie Parker solo, you can string the notes out and see all these phrases and harmonic ideas, patterns, all kinds of things. Miles doesn't use patterns. He doesn't string notes out. It's weird. Without the expression, without the feeling he put in it, there's nothing there.

"They [Columbia] never released any live stuff from his band I was in; it was too far out, I think. There's not much you could say about this music or do with it, other than observe what was there. There weren't any particularly memorable melodies or songs. But I remember a searching energy and spirit of improvisation. There was never a studio version of the music we played, either."

Teo Macero, Miles' producer from *Kind Of Blue* in '59 through *Star People* in '83, regretted dozens of lost chances to capture Miles' music and notions for projects gone awry. "CBS didn't want live albums of Miles," he said by phone. "Some executive would always want him to go back to a quartet setting, or do another *Sketches Of Spain* – not that they liked that when it was recorded. I used to tell them, 'He's a

great artist. You can't screw around with a great artist, you've got to encourage him to move forward.' He should have done something with the London Philharmonic. He and Gil wanted to do something together again.

"Miles changed every five years, whenever he got a new girlfriend. I thought *Jack Johnson* was a step in the right direction. I wanted to put out a record every month by Miles. I wanted to take a sound truck on the road with the band and record everything they did. But I didn't control the pursestrings, and I had to fight [Columbia Records'] stupidity every day.

"As documentation, there are cassettes that Miles gave me, recorded on the road, and takes that are still in the can at Columbia or here in my place, which are important parts of his legacy. He paid his dues, but his was a typical artist's life. The work is not recognized until they're gone. I can't believe that still goes on."

From his apartment in the Manhattan artists' coop building Westbeth, John Scofield, Miles' guitarist from 1981 to 1983, said the trumpeter was always true to himself. "What I learned from him was that he went with his feelings of the moment. You have to learn to trust your own human instrument, to read what's supposed to happen. That for me is the great message of Miles.

"We would play in huge venues to thousands of people, and he was able to reach those people and have them love the music. They loved it because of a feeling that came from his trumpet playing and the mood of the musicians around him. He was able to convey that to us in unspoken ways, and create a mood through music – right there on the spot, not the same mood as the night before, different, but picking up on a certain thing."

"The first thing I learned from Miles was about being true to yourself," multi-instrumentalist, composer–producer Marcus Miller said in accord with Scofield, in yet another phone call. "Here was a guy who was acclaimed and criticized, and nothing that was ever said to him made him change what he felt he had to do. That's very important for a musician to learn, because you can be so easily swayed by people who have nothing to do with what you're about. They only know what you've already done; they have no idea of your goals.

"You've heard people say, when their parents have died, they finally feel like adults? Even if they're in their 50s? That now they're really on their own? Musically, I feel that way about Miles. I'm on my own now. This is it. Figure out what to do and do it. Right now I'm working on an instrumental record of my own."

Miles fathers creativity, still. What's genuinely avant-garde is generative – and music that derives and expands on Miles' has been issued since his death at an unflagging rate. Among the best recordings paying homage have been tenor saxophonist Joe Henderson's *So Near, So Far*, featuring Scofield, Dave Holland and Al Foster; singer Cassandra Wilson's *Travelin' Miles*, with her original lyrics to "Tutu" and "Miles Runs The Voodoo Down" as well as "Blue In Green" and soloists including Holland, Pat Metheny, Regina Carter and Stefon Harris; and trumpeter Wadada

Leo Smith and guitarist Henry Kaiser's three volumes titled *Yo Miles!* with soloists including Greg Osby, Tom Coster, John Tchicai, the Rova Sax Quartet, tablaist Zakir Hussain, drummer Steve Smith, bassist Michael Manring, guitarist Elliott Sharp and keyboardist John Medeski.

A Bitchin' Brew, Fusion For Miles is an electric guitar tribute featuring Mike Stern, Bill Frisell, Bill Connors, Pat Martino and Bireli Lagrene among the plectarists' and soprano saxophonist Dave Liebman. Trumpeter Tim Hagans plays "High Speed Chase," "Spanish Key," "What It Is" and "Nefertiti" on *Electrifying Miles* with Finland's UMO Jazz Orchestra conducted by Eero Koivistoinen. Children Of On The Corner – Sonny Fortune, Ndugu Chancler, Badal Roy, Michael Henderson, guitarist Barry Finnerty and pianist Michael Wolff – issued a powerful album called *Rebirth*. Producer Bill Laswell has had his way with Miles' material, editing and remixing it on *Panthalassa* volumes one and two.

Such projects have not exhausted the possibilities, some of which were only hinted at, others inspiringly realized, at a memorable event in March 2001, the year Miles would have been 75. More than 200 players of all ages performed in 28 ensembles at Symphony Space, a thousand-seat Manhattan hall, over the span of a 13-hour, nationally broadcast and web-streamed concert marathon called "Wall-to-Wall Miles." There were renditions of Miles' music from every stage of his career, presented non-chronologically and with no attempt at slavish recreation, but rather an imperative to make the music their own guiding musicians who'd grown up as his fans and were inspired to play with something like the sensitivity, intensity and daring he embodied.

The first band, the Voodoo Down Orchestra directed by drummer Bobby Previte, went on at noon and dove into *Bitches Brew*; the last, hitting past midnight, was trumpeter Wallace Roney's quintet with former Miles sidemen bassist Buster Williams and drummer Lenny White. Earlier Roney had captured Miles' stark, lyrical, vulnerable and exploratory side performing Gil Evans' *Sketches Of Spain* with Maria Schneider conducting her orchestra.

Trumpeters including Olu Dara, Dave Douglas, Jon Faddis, Russell Gunn, Graham Haynes, Tim Hagans, Tom Harrell, Eddie Henderson, Ingrid Jensen, Jimmy Owens, Terrell Stafford and James Zollar, saxophonists including Bob Belden, Michael Blake, Paquito D'Rivera, Claire Daly, Antonio Hart, Joe Lovano, David Sanchez, Gary Thomas, Bobby Watson and Miguel Zenon, trombonist Ray Anderson, clarinetist Don Byron, guitarists including Pete Cosey (in from Chicago) and his champion Vernon Reid, bassists Ben Allison, Cameron Brown and Melvin Gibbs, keyboardists Uri Caine, Marc Cary, Adam Holzman, Vijay Iyer and Mulgrew Miller, drummers including Jimmy Cobb (who played on *Kind Of Blue*), Victor Lewis, Idris Muhammad and Jeff "Tain" Watts, conguero Milton Cardona, DJ Logic, African kora player Mamadou Diabate and balafonist Famoro Diabate were among those who performed in unusual combos.

There were many unexpected highlights. Soprano saxophonist Jane Ira Bloom suggested the mysteries of outer space (she had been commissioned by the NASA Arts Program in 1989) through her version of "Solar," which Miles recorded in 1954. Trumpeter Steven Bernstein's Sex Mob, joined by guitarist Frisell, performed "Selim" and "Little Church" from *Live-Evil* with attention to detail that brought the full house to a breathless hush. Trumpeter Frank London and keyboardist Anthony Coleman, playing a pump organ, made sense of "He Loved Him Madly." The Campbell Brothers, three preachers from a gospel church in upstate New York, performed sweetly swinging renditions of Davis favorites "All Blues," "Someday My Prince Will Come" and "Summertime" on lap steel and Steinberger electric guitars. Vocalist Nora York segued from a dramatic introduction of Jimi Hendrix's "I Don't Live Today" to a wordless approximation of Miles' "So What" solo. Melba Joyce sang soulfully, with three student hornplayers, all women, supplying powerful brass breaks.

No admission was charged to attend Wall-to-Wall Miles; audience members were expected to wander in and out during the long day, as they'd done at previous Wall-to-Wall tribute concerts, annual since 1978, which had honored J.S. Bach, Igor Stravinsky, George Gershwin, Richard Rodgers, Ravel and Debussy, Stephen Sondheim, John Cage and others. But a lot of listeners found seats early and stayed. Though it was a dreary, cold and wet day, a long line of people hoping to get inside formed on Broadway and around the block. The mood was festive, the listeners seemed absorbed. After 13 hours of Miles' music, I was raring to hear more – not of the familiar or soothing, but of the exhilarating exploration of a wild, wide-open frontier.

ORNETTE COLEMAN, QUESTIONS AND CONJECTURES

Ornette Coleman at the World Trade Center, 1984, New York City © 1984 Lona Foote.

Ornette I've met

When I first met Ornette in summer of 1978 I sat in a chair not an arm's length from him in the New York offices of Artists House Records, facing him eye to eye, and held a microphone from my Sony Walkman Pro tape recorder to within about two inches from his lips to catch every word he said for nearly three hours. His words seemed that important. I wanted to capture every nuance, the better to study what he said.

I felt I was in sync with Ornette's music – his most recent album was *Dancing In Your Head*, equal to Miles' *On The Corner* in urgency and complication, among other attractions, but unlike it, too. Imagine if instead of snaking through the hurly-burly of *On The Corner* Miles had soared over it, dominating his street scene with compulsive melodic variations; that's how I heard Ornette in *Dancing*. And it wasn't simply his rush of phrases that grabbed my attention, but the entire sphere of sound he'd been able to conjure, unlike other "music" in its projection of both nearly total chaos but basic cohesion. I figured there must be an organizing principle to anything so anarchic that doesn't fly apart, and sensed some wisdom available from whoever directed such freedom (acknowledging the paradox of controlled liberty). I wanted to know what this was all about.

I'd scored a coup by getting an appointment to interview him for a *Down Beat* cover article, as he had a reputation for reticence, and had not been featured much in the jazz press since I'd first heard of him about ten years before. I'd listened to what I thought was a lot of his music already, starting with The Ornette Coleman Trio *At The Golden Circle, Volume Two*, which I'd found in my favorite sample bin at an Evanston record store when I was still in high school. I thought I'd come some way in listening since then.

That record had been a puzzle. I'd put it on a few times and been unmoved. It began with "Snowflakes And Sunshine" on which Ornette sort of played violin. There was no single-note line, just a choked cluster of strings, harshly bowed.

Was it jazz, or what? Was that violin playing, or random sawing? A bassist bowed lines of his own under the violin's. Then there was a very brief trumpet solo – and who was playing that? No trumpeter was listed in the credits, only "Ornette Coleman, alto sax; David Izenzon, bass; Charles Moffett, drums." On the album cover Izenzon was the squat white guy in a black overcoat, white fedora and dark glasses; Ornette, center, wore a belted white trench coat and black high-lid hat; Moffett leaned against him in dark coat, hat, white shirt and dark tie. The three huddled close before a field of snow covered tree trunks.

Back to their music: more bass bowing that seemed to have little to do with the drums underneath. A moment more trumpet. A break for the drums. More bowing, by the violinist, I guessed. Not bowing like a cellist's, purposefully etching a line – this was more like fiddle-scratching. No reference to any melody, just nervous spasms, as far as I could tell.

Serious but not studiously formal energy was evident – maybe three different energies from the three players, unconnected. At least I didn't hear any connection; the three just seemed all *there*. Maybe they were listening to each other and themselves, responding instantaneously with an unusual array of sounds. I thought if I was sitting in a room where this was happening it would feel pretty big. The liner note writer, Ludvig Rasmusson, claimed the appearance of Ornette Coleman at the Golden Circle in Stockholm, Sweden, was "one of the great cultural events this fall." What was the competition?

The trumpeter came on again, blowing strangled cries that seemed to require considerable effort. Another drum episode, simultaneously swinging and march-like. More violin screeching and the piece reached a sudden halt. The crowd in the Golden Circle clapped. Enter Ornette Coleman on alto sax.

His sax on "Morning Song" wasn't as forced as the trumpet on "Snowflakes," but didn't it wander? I was impatient with slow tempos then.

He played slowly, stretching out just a few notes in each phrase, demonstrating nothing like the rapacity of such players as John Coltrane and Pharoah Sanders, the sardonic, ironic bluster of Archie Shepp, the exuberant strength of Sonny Rollins – I hadn't yet heard Albert Ayler – or the hurdle-leaping-to-a-bop beat of Eric Dolphy, the surprising anachronisms of Marion Brown in *Three For Shepp*. Well, maybe Ornette had something like all of them, because these musicians sounded like a school, a community, men (no women?) in concert with each other. But Ornette had qualities all his own, too, unique and hard to specify.

"The Riddle" was faster – uh, where was the theme? Was there no theme? The trio seemed insouciant but ad hoc, tossed together, conventional in format, compared to some of the conceptually self-conscious AACM ensembles I'd heard. Ornette played in meter – with internal swing, actually – even when the tempo or meter under (around?) him changed. He played more notes on "The Riddle" – squalling, forceful phrases, fast as Charlie Parker's but differently twisted, as if wrestling out of constraints or blurting secrets, unable to suppress something almost too personal to say. Ornette's alto sax sound also seemed to be loud as a holler and grainy, garrulous – not sleek, smooth and effortless like Sonny Stitt's or bounding though solid like Cannonball Adderley's.

"Antiques" was mournful, and a fetching melody – abandoned after Ornette had hardly established it. The bassist gave the performance some lift. I could hear a tune trying to emerge from Ornette's irregular lines, but then he turned in another direction, playing softer, veering off in a way I couldn't follow. I put the album on the shelf, figuring I wasn't ready yet, didn't understand.

When did I get it? Not sure. Ornette snuck up on me. Reams had been written about him in the early '60s, by the hilarious novelist Thomas Pynchon (as McClintic Sphere in *V.*,[1] published in 1963), by gossipy newspaper columnist Dorothy Kilgallen, by sober Martin Williams of the Smithsonian Institution and jazz journalist Nat Hentoff (who partnered to edit the literate *Jazz Review*), by composer–conductor–French hornist–Third Stream theorist Gunther Schuller, biographer A.B. Spellman (who'd actually talked to Ornette – see *Four Lives In The Bebop Business*), Leroi Jones (*Blues People*), Valerie Wilmer (*As Serious As Your Life*). I read all that. In both journalism and fiction Ornette represented purity of vision and refreshing directness, as if he were a Johnny B. Good sax-slinger, noble savage, bluesman as spaceman, Mr. Deeds come to jazz-town – and cool, too. Some commentators admired his idealism; others, more cynical, laughed at him. Ornette saw the world his way, and persevered to make it so.

His detractors included jazz elders who shrugged him off as beyond sense, a fool, nut or charlatan, but other musicians I admired disagreed. Roscoe Mitchell of the Art Ensemble had named one of his compositions on *Sound*, his debut album, "Ornette," maybe more as an acknowledgement than due to compositional references or similarities – Mitchell's "Ornette," starting with its earth-churning solos by Kalaparusha Maurice McIntyre and including long, witty passages by Lester Bowie, was more severe, compressed and distended than Ornette, who simply flowed.

Ornette's sound grew on me gradually. I hardly noticed it happening, but eventually I heard the music he'd recorded as meaningful, the information he cast shedding light on intangible but nonetheless real things: feelings, nuances of relationships, psychological states, motes in the air, qualities of time. I suspected I projected a lot of the meaning I perceived onto his sounds, but maybe not – his sounds gave rise to notions I came up with no other time, listening to no other source. What I was perceiving seemed like a gift, so I didn't think about whether or how it was really happening; Ornette played his music without seeming to worry about it overmuch, after all, and I noticed he got those around him to do the same. It seemed natural that musicians who were *good* musicians – *musical* musicians, who hadn't sacrificed innate musical impulses to the grind of making a living or any other struggle – could

Ornette, 1982, Chicago, ©*1982 Lauren Deutsch.*

112

and should be able to do just that: *play*. Anybody, really, could do it if we listened to each other. That is the basic idea about music, isn't it? Music is to be *played*.

My most actively music-oriented friends agreed. Jim Baker, a pianist–violinist–guitarist–improviser,[2] sometimes brought his Wurlitzer electric piano to my family's suburban living room for not entirely aimless after-school jam sessions. The top of his Wurlitzer opened, and Baker could adjust thin metal tines to retune the instrument, which had some fuzzy timbres and rewarded a firm if not necessarily hard attack. He knew something about Ornette and introduced "Broadway Blues," which I thought of as a skipping theme, to our small book of tunes attempted more than once (others were Keith Jarrett's "Sorcery" from Charles Lloyd's *Forest Flower*, "Night In Tunisia" and a blowout of The Doors' "Light My Fire").

Charlie Doherty, our drummer and later a *Down Beat* editor, liked Ornette's tunes, his alto playing and Cherry's pocket trumpet and, especially, drummer Edward Blackwell. We three agreed that Blackwell had winning control, melodiousness and bounce in his beat. I played flute enthusiastically though not well, under the spell of Herbie Mann, Rahsaan Roland Kirk and Jeremy Steig. We were pretty lame, just high-school kids fooling around. We didn't usually have a bassist; if we could find one, we'd want him to be like Charlie Haden, who was the glue holding Ornette, Cherry and Blackwell together, unless they had some other centripetal force . . .

Captain Beefheart, among our favorite outrageous rockers, was said to be in awe of Ornette, and I could see/hear it – Beefheart's *Magic Man* album had a long track on which he played wild, hortatory soprano saxophone. But Beefheart was more mad and literary than Ornette, putting his odd metaphors and rude insights into macho lyrics, setting them against slamming blues tropes, making ugly beauty out of hyper-informed primitivism. Ornette didn't seem to have so much to prove. He had the blues, existentially. He just *was*.

I bought *The Avant Garde*, an album pairing sainted saxophonist Coltrane with trumpeter Cherry, whose suite-like albums *Complete Communion* and *Symphony For Improvisers* I loved – besides what he played as Ornette's right hand man. Cherry and Coltrane calmly assayed three Ornette tunes – "The Invisible," "Focus On Sanity" and "The Blessing" – an original "Cherryco," and Monk's "Bemsha Swing," all with beautiful details and more distinctive, shapely melodic forms than other contemporary music genres seemed able to muster. Which raised more general questions: Why were jazz compositions so disregarded? Why was jazz so undervalued?

Evidence of that undervaluation cropped up in unexpected places. My flute teacher had asked that I bring her records of flutists I listened to, but week after week my worn copy of Eric Dolphy's *Out To Lunch* remained on a mantle where she'd placed it when I'd handed it over, and though I'd pointed out that Dolphy's composition "Gazzeloni" was a tribute to an acclaimed Italian flutist, she never found the time to listen. I took it back. I'd listen to *Out To Lunch* or Coltrane's *Impressions* (also with Dolphy) or *The Avant Garde* repeatedly, for hours. This music

wasn't "avant-garde" in terms of being difficult or antagonistic – just interesting, exciting and mind-expanding. I didn't know that *The Avant Garde* had waited six years between its recording and release. If I'd known I wouldn't have understood why.

I hadn't then heard Ornette's recordings from the West Coast on Contemporary Records, but I knew their exclamatory titles, *Something Else!!!!* and *Tomorrow Is The Question!* I'd picked up that he no longer played with pianists (though he'd recorded with Walter Norris and evidently influenced Paul Bley, who played Ornette's "Ramblin'" on his trio album *Mr. Joy*). I heard his breakthrough East Coast recording *This Is Our Music*, its cover a photo of four skinny musicians looking anywhere but straight ahead. His other titles were also bold in their claims: *The Shape Of Jazz To Come*, *Change Of The Century*.

As a teenager I was amused by the audacity. Was he being funny? Or wishful? How could a jazz musician dare to declare he'd found the way? As a teenager, I could only doubt the slogans and as a teenager I could only hope what they proclaimed was true. What if it *was* as Ornette seemed to be saying? What if you could just play without thinking about hewing to certain notes instead of others, about playing them "right," about staying in lockstep with others in an ensemble, in approved intonation, in harmony, in key? What if playing music was like playing catch – collective catch, managing innumerable balls in the air, multi-ball baseball or soccer, pinball or marbles?

Of course, you ought to be able to play the notes you *meant* to, to have mastered your skills, to understand your thoughts clearly so as to be able to realize them – jazz should be more than venting. Sometime I began to hear how well Ornette played the saxophone, how he did things with it no one else could. Maybe the revelation came from his album *Friends And Neighbors*, which had gatefold photos of Ornette standing near a pool table with Anthony Braxton and Leroy Jenkins, AACM members in exile from Chicago, its tracks including a sing-along and one song, "Long Time No See," I liked so much I learned it – tricky to get in the fingers but, once captured, the notes rolled forth. Maybe it was *Crisis*, a poorly recorded concert at New York University's student union but with Cherry and Dewey Redman both and Haden's testimonial "Song For Che." Ornette's ideas, the specific melodic shards he enunciated with conviction though they might be posed in an alien tongue, were utterly compelling. Whatever he was saying, I knew he meant it and it made sense. What was its content?

I didn't buy Ornette's Town Hall recording on ESP of "Dedication to Poets and Writers" live from a 1962 New York concert when I saw it at the Jazz Record Mart; I wondered why he would record with classical string instruments for a label that looked – considering its cheap black and white printing and back cover plug for the invented language Esperanto – like it was run from a grungy backroom. But I'd become an Ornette freak. There was some charm about him and his scratchy

chamber music I couldn't deny. Well, sometimes I could – *The Empty Foxhole* or *Ornette At 12*, featuring his very young son Denardo on drums instead of Blackwell, were hard to abide.

Then I heard *Free Jazz* – designed with a glossy cover cut to frame "White Light" a Museum of Modern Art-certified Jackson Pollack painting, its layers of splatters suggesting how the music inside was spontaneously created as a "collective improvisation by the Ornette Coleman Double Quartet." Eight musicians in free-for-all suggested an athletic competition. The personnel could break into oppositional forces: Ornette vs. Dolphy (playing bass clarinet), Cherry vs. Freddie Hubbard (playing hard and brashly), Haden and Scott LaFaro (playing ultra-technically), Blackwell and Billy Higgins (Blackwell focused on tom-toms, Higgins on cymbals). But they were all friends, right? Might they work together to make free – and what would that mean? – music?

Free Jazz is a rare feat and noisy joy, its crosshatched strains of melody, blends and rhythms laying out manifold webs of interaction, modulation, harmonization and agreeable rather than competitive correspondence. All the soloists – meaning all eight musicians, as everyone plays all the time with equal fervor, attentive to the same instructions – are game for the unorthodox workout, if not simply inspired. More predetermination went into the music than was understood at the time (despite Martin Williams' informative liner notes). The musicians arrived at predetermined posts – not due to predictably cycling chord changes, but by some sort of arranged cues; there were brief themes, pivot-points and/or structural sketches for when each horn player might step some bit forward from the collective, what turns which bassists would take, when the drummers would get some space. Follow any one thread as it heads into a tangle; the music is buoyant, not angry or even emotionally heated, though neither is it cool; it's played with full intentionality and I think enjoyment by musicians secure in their personal sensibilities. Maybe it seemed to them, in 1960, like an unusual experiment – but a bold manifesto of the avant-garde?

Dolphy, for instance, when compared to Ornette was a conservative experimentalist, as were Hubbard and LaFaro. I'd heard Dolphy brilliantly play "free jazz" like that on *Free Jazz* on *Mingus Presents Mingus*, untethered by chordal instruments (guitar or piano), with trumpeter Ted Curson spinning off him as Cherry did off Ornette, Mingus and drummer Dannie Richmond anchoring the improvisations rather as Haden and Blackwell did, though adding in their own distinct vibe. I hadn't yet heard the theory that every jazz fan constructs his or her own history, dependent upon when one first hears an album with a new idea – I heard *Mingus Presents Mingus*, recorded six months after *Free Jazz*, before I heard *Free Jazz*, so I transposed which came first with which I found first.

Dolphy had recorded dramatic, expansive live sets with trumpeter Booker Little (and Blackwell at the drums) and with Coltrane's magnificent quartet, and

an ambitious studio session titled *The Quest* with pianist Mal Waldron and Texas tenor saxophonist Booker Ervin, and duets with Miles' bassist Ron Carter; he'd recorded with Carter on cello; he played standard clarinet besides alto sax, flute and bass clarinet, employing enviable traditional technique. He'd emerged with West Coast drummer Chico Hamilton, was featured practicing in the film *Jazz On A Summer's Day* from the Newport Jazz Festival, was also an adherent of Gunther Schuller's Third Stream, studied Indian music, played Latin jazz, improvised with smart Europeans (pianist Misha Mengelberg and drummer Han Bennink on his final album *Last Date*) as well as fresh Americans (trumpeter Woody Shaw, reedists Sonny Simmons, Prince Lasha, Clifford Jordan, vibist Bobby Hutcherson, drummer Tony Williams), not to mention his fiery "Impressions" solo aside John Coltrane and Stravinskian arrangements for Trane's *Africa-Brass*. Dolphy died mysteriously, tragically, young. He'd won my allegiance before Ornette.

The nice thing about music, though, in contrast with athletics, is that one needn't choose exclusive sides, we're free to listen to everyone, everything. I bonded with Ornette's music most decisively the day I arrived in San Francisco with Steve Ganis, a fellow Syracuse University journalist, to take up a work semester internship at *Not Man Apart*, newsletter of the environmental organization Friends of the Earth. We'd driven his Saab cross-country, stopping overnight with family, friends and even strangers. It was late January 1972, before commercially recorded cassette tapes were widely available, way before the advent of the CD, so we'd been listening to the car radio across America. We got to sunny, brisk San Francisco around noon with a map to the apartment of a former Syracuse art student named Alan who had agreed to put us up while we looked for a rental.

He was still in classes, though, so we circled through North Beach, the neighborhood we knew from legends of the 1950s–'60s Beat scene, and stopped at Tower Records, anchor store of a new retail chain. Right by the door was a stack freshly unpacked of Coleman's hot-off-the-presses LP *Science Fiction*. Its cover boasted a rainbow over a cityscape. We grabbed it right away, along with the Grateful Dead's "skulls and roses" double live album, also just released. Then we proceeded to Alan-the-artist's pad.

Alan greeted us, helped us get luggage into his spacious place, then left. Ganis and I were still roaring with momentum like Kerouac and Cassidy just off the transcontinental highway, but there was nobody to entertain with our stories other than ourselves, so we retired to a spare room, which like all rooms occupied by college students in 1972 had its own stereo. I tore the plastic wrapper off *Science Fiction* and laid side one on the turntable. It opened with Asha Puthli singing: "I've waited all my life, for you . . . ". We could not have imagined her voice or the music's effect.

She was articulating perfectly, flaunting her vast range with conspicuous grace, luxuriating in her fullness of tone and interpreting the song not as a pop diva, hippie chick or soul temptress, but as a mature woman.[3] Horns sobbed – alto and trumpet

– behind her, while bass and drums rustled independently, adding unsettled drama more than rhythm. Ganis and I, both I think, relaxed at last, having arrived at our destination, and continued listening entranced through the three other tunes on that side – including the memorable theme of "Law Years" – in companionable silence. After 20 minutes, we flipped the album over. Asha Puthli began this side, too, moaning "What Reason Could I Give?" We sat mutely, still, amazed at this song – a jazz ballad, swathed in vocal grace and nuanced coloration, reveling in sonic possibilities that were obvious enough but had the air of being unknown, untouched, only now discovered. The LP ended with a baby's cry and poet David Henderson bespeaking a text, filtered through electronics, with lengthy pauses, while Coleman's band blew independently of those elements, low in the mix, part of a collage that seemed superficial after the sublimity come before.

The needle in the turntable's arm lifted automatically; the arm retracted to its rest. Ganis glanced at me and won my everlasting respect, asking, "Again?" Sure, yes. So we replayed the first side, reviewing Ornette's vision of future jazz.

That night, or perhaps the next, Alan took us to a jam session at the San Francisco Institute of the Arts where he studied painting, Ganis played rhythm guitar while I brought out my alto saxophone, which I'd been playing badly but enthusiastically for two years. I played as willfully like Ornette as I could manage, affecting a gutterly growl, committing to my errant cracks and clams. I listened to the others – Alan on piano, Ganis, an electric bassist and a drummer. I couldn't be sure of staying in tune, much less in the generally agreed upon key. I could not reliably perform my most imaginative and immediate ideas, nor affect the group sound as I imagined I wanted to. Yet this "style" or manner, which I can't say I stole from Ornette because my fingers, lungs and mind weren't up to stealing so much as just trying to imitate him, seemed like the most completely natural way to play. We didn't play scores or call tunes. We had tunes in common – for spare change, Ganis and I would end up busking at Fisherman's Wharf, where I'd blow flute behind his singing and strumming on the Beatles' "I've Just Seen A Face" and the Dead's "Friend Of The Devil." But this was a chance to just play, so why bother?

From then on I thought of myself as one of Ornette's disciples. I admired his playfulness and spontaneity, shared by Izenzon, Moffett, Cherry, Redman, Haden, Blackwell and Higgins. Did a band have to know much more than a quick head in order to improvise at enlivening length? Not by my lights. One only had to listen with the best of intentions to the other players and respond just as purely of heart with music from within.

So who was Ornette, before me at the Artists House office in 1978? Smaller than I'd expected, light but not fragile, maybe wiry or limber but strong like bamboo. His facial features seemed sculpted less for symmetry than complement. His lips were full and brow wide, his eyes protected by surrounding bone structure. He spoke in an octave like the alto sax's midrange, with a reediness that sometimes slipped into a lisp.

117

His voice took me by surprise at first, but like his face's planes and ridges came to seem not askew but fit to his character. His eyes were slightly hooded but did not evade direct gaze: he glanced and saw past surfaces quickly, then he'd look away. Maybe his ears worked the same way, taking in all sounds as part of a continuous but seldom consciously identified musical stream. Ornette had proved to be one American artist devoted to upending a priori concepts, challenging conventions, assumptions, accepted practice and maybe logic in the name of individualistic idealism. As a result of his inquiries he re-shaped, at the very least, longstanding hierarchies applied to sound.

And I hadn't anticipated how Ornette loved to speak! He talked at length – as if playing an extended solo – always interested in what he might himself discover, glad of the possibility he'd stumble upon a fresh idea. He spoke as someone asking questions of himself, not answering someone else's; the effect was between a monologue and Socratic instruction. He also got at concepts using common words in unusual order, to break down the presumptions of the words themselves – as in this quote about the efficacy of the language we spoke:

> I think the English language in America is really the street language. It's not the ancestral language of all the people. I know myself, I don't speak any other language fluently, but there are many English words that you can use that another person wouldn't understand. Also, it's hard to describe something musically just using a noun, more than the *contents* of it.

Or this one, an effort to convey his theory of harmolodics in a nutshell:

> [I]f you're playing a melody and you don't have everything in your mind that you can do with that note — what some people call improvising, which I now call the harmolodic theory and method, which has to do with using the melody, the harmony and the rhythm all equal I find that it's much easier when a person can take a melody, do what they want to do with the melody, then bring his expression to yours, then combine that for a greater expression . . . [T]he people who I have worked with, they know how to do that.

I followed his thoughts as best I could, but it was sometimes like being in a maze constructed to confound logic with wisdom earned through experience, tracing a pathway intuitively true to life rather than pursuing the guidance of unexamined clichés. When I interrupted Ornette with earnest questions, hoping he would clarify specific points, he took my inquiries as invitations to propose many more possibilities or shoot off at further tangents.

One statement led to another, but not in any linguistically linear way. Each idea comprised common, simple words co-joined in newly minted syntax. The rear-

rangement required my closest attentions; I tried to follow Ornette's ideas by thinking in his terms, which was unusually stimulating. I'd had a similar experience in college listening to media theorist Marshall McLuhan, but McLuhan had worn a smirk, as if he'd enjoyed messing with students' heads. If my university professors offered odd ideas, they were typically couched in ordinary speech. Ornette's propositions conjured a skewed yet comprehensible universe of relationships and equivalencies. His language usage might recall comedienne Gracie Allen's, but he speculated on core questions about music and creativity, the values of originality and individuality, the integrity of each individual and exceptionality of each moment of life. He also put me in mind of the fictional Mexican shaman Don Juan conjured by Carlos Castaneda. I felt myself aligning with Ornette throughout our talk, and was exhilarated by the unexpected empathy, not alarmed, and not at all wary of being seduced by malapropisms or mysticism.

Ornette lectured, sort of Socratically, with questions; we took no breaks, and didn't even have water for refreshment. Occasionally I tried to steer the conversation to gain clarification or expansion of some point, usually without success. Or with complete success – as Ornette said towards the end of our appointment, "See Howard, you didn't need to ask me all this. You could have written the interview by yourself." By which I took it he meant that I'd understood him and would have come to the same conclusions if I'd asked myself the same questions I'd asked him.

This assertion was astonishing. I've read since he's said the same to others, but why should that bother me? If we'd hit on universals, they would hold true for other interviewers' too. Still, the idea that any writer could think like his subject and triumph to the point of being able to fully imagine his discourse was unsupportable, however much I was flattered by the notion. The idea that I had comprehended what Ornette said so well – or that he thought I had, that he thought we were of like mind – was also astounding.

I was excited after the interview but befuddled. I didn't know what I had on tape – I'd been too busy trying to follow Ornette's curlicued talk to securely keep track of it. I was eager to get back to my office and transcribe the two 90-minute cassettes I'd made. Then I would know what Ornette had said.

It didn't work that way. It was my practice to transcribe every word of a taped interview, concentrating on the intonation and emphasis of the subject's language. This would help me get inside a subject's speech patterns, and help me structure my article. For several days I listened to everything Ornette said, often again and again, typing a single spaced transcript of about 25 pages, maybe 25,000 words. Yet I couldn't always make out what he had meant.

His statements had a slalom shape, heading off in one direction and in the middle of a sentence turning the opposite way. His next sentence would leap from the end of the previous one's conclusion, even if they were diametrically opposed.

119

Had he stated one opinion, or its opposite? Was he allowing each side of a question its own validity – or questioning both and thus accepting neither? I could take no single statement at face value, though I'd sat listening while he'd said everything. No one had played with the tape. Coleman used language like a wizard. I thought he'd mesmerized me with verbal sleight-of-hand, or summoned visions that evaporated, dreamlike, when he was no longer there to avow them.

That interview, printed in *Down Beat* at the full length of nearly 5000 words that I submitted, forms the next chapter, followed by excerpts from the other interviews I've held with Ornette at roughly five-year intervals. After that first interview, I discovered Ornette's symphonic *Skies Of America*, first recorded by Columbia Records in 1971. In 1984 I heard it performed by the Fort Worth Symphony conducted by John Giordano on the occasion of the opening of Caravan of Dreams, a performance complex built in downtown Fort Worth, Ornette's hometown, by the scion of the wealthy local Bass family. I stayed in Fort Worth for most of a week, hanging out with Ornette and his band Prime Time when guitarists Bern Nix and Charlie Ellerbee and electric bassist Jamaaladeen Tacuma were its core. Film-maker Shirley Clarke shot footage of this Ornette set-down, of a breakfast discussion he submitted to with me and *New York Times* critic John Rockwell, his rehearsals and performances and the Caravan entourage in ragtag costumes and exaggerated makeup running through Fort Worth's streets to make it more of a circus. Her movie *Ornette: Made In America* may be most famous for the segment wherein Ornette says that he once sought to be castrated because sexuality was the cause of so much trouble, but a doctor convinced him to have a circumcision, a "symbolic castration" instead.

I followed Ornette around during the mid-'80s when Prime Time was often booked into prestigious venues to celebrate momentous events, and left their audiences as often perplexed as fulfilled. Prime Time, usually comprising two electric guitarists, two basses, two trap drummers or one and Indian tabla player Badal Roy with Ornette at the center, tended to confound professional and civilian listeners alike. I thought of it as modeled on an atom, Ornette being the nucleus, the bands' members so many electrons orbiting about him on their own dizzying paths.

I saw and heard Denardo Coleman, Prime Time drummer, mature and take over management of his father's career. I met James Jordan, Ornette's cousin, sometimes producer and advisor, who worked as director of the New York State Council on the Arts music program; he commissioned me to produce brief radio features about jazz artists (including Dewey Redman) touring under NYSCA auspices. I came to read and meet and hear Jayne Cortez, Ornette's ex-wife, Denardo's mother, a declamatory poet who fronted Firespitters, her own band with her son and other members of Prime Time. I read John Litweiler's biography, *Ornette Coleman: A Harmolodic Life*.

I watched Ornette in rehearsals (which he video-taped, when equipment was available) at his lofts and in recording studios, and witnessed many of his perfor-

mances – including the San Francisco Jazz Festival concert at which he invited a team of body piercers to serve as an entr'acte. I've spoken with Ornette whenever I've seen him, in musical contexts or otherwise, and he's always been generous, warm and forthcoming to me, if sometimes gnomic.

I've attended his after-concert gatherings, where he offhandedly spent many of the dollars he'd received for playing – renting out the entirety of an upscale Indian restaurant around the corner from Carnegie Hall and feeding upwards of 200 people, for example. I've been to a couple of his birthday parties: at the Harmolodics studio in Harlem, which turned into a giant jam session, and at Joe's Pub in the Public Theater, where Ornette greeted each acquaintance with a personalized Zen koan (he looked at me happily and said, "Howard, it *is* worthwhile to be a good person," which I've seldom doubted) but was pleased to hear.

I attended ceremonies where he was honored with medals from France and from the Lillian and Dorothy Gish Foundation. I shook his hand backstage and was hugged in return before he performed with old friends clarinetist Alvin Batiste and pianist Ellis Marsalis at the New Orleans Jazz and Heritage Festival of 2003; he wasn't always warmly received in New Orleans, but that time he was welcomed like a long-gone son, and there's nothing Ornette likes more than being appreciated, accepted. I've heard rocker Lou Reed and performance artist Laurie Anderson play with him; also pianist Geri Allen and her trumpeter husband Wallace Roney; Cherry, Haden and Higgins on the same stage with Prime Time, and Ornette and Prime Time improvising while maestro Kurt Masur conducted the New York Philharmonic through his *Skies*.

Ornette always leaves me feeling upbeat, healed and relieved, and I was never more convinced of the smug ignorance of an editor than when the dean of rock critics at the *Village Voice* met my suggestion of an interview with Ornette by saying, "Everyone knows he's only good for blowing his saxophone." Little in my experience was further from the truth. I was pissed when an associate editor at *Tower Pulse!* affixed snarky headlines and captions to my respectful story about Ornette's ambitious Prime Time album *Tone Dialing*, imposing a sarcastic tone on the article.

I've often avoided asking Ornette anything of substance when we've met in casual circumstance, not wanting to risk getting a meaningful answer that I couldn't take down by pen or capture on tape and study later, when I had time to cogitate on it. I don't think my partiality to Ornette invalidates my analysis of his music; I've listened to it so closely and scrupulously because I *am* a fan. I've made many suppositions about what Ornette has meant by his music and his methods, and have received nothing but positive feedback about that from him or any of the dozen-some musicians who have been in his bands. I became friendly with Don Cherry, and spent a day with Edward Blackwell when he was gravely ill, and have written about Haden, Nix, Tacuma, guitarist James "Blood" Ulmer, drummer Ronald

Shannon Jackson, singers Asha Puthli and Mari Okuba,[4] and two editions of Prime Time. Maybe they've shined me on. Once, Dewey Redman expressed skepticism about my inquiries.

"Did he tell you about harmolodics?" Redman asked, mischievously. "I've been hearing about harmolodics for 20 years, and still haven't figured it out." Cherry gave me the best explanation of Coleman's theories I've heard (quoted further on). Denardo talked to me plainly about his father's way of working. Nix despaired of understanding what he was doing in Ornette's band, with Ornette's music, but he acknowledged Ornette's magnetism and magic, too. Tacuma was an unfailingly live wire. Guitarist Pat Metheny, who recorded *Song X*, one of the most successful collaborations with Ornette instigated by someone else, offered a contrary opinion about Ornette's spontaneity and range. I've met tablaist Badal Roy, who also played with Miles Davis, and pianist David Bryant, who never got to do all he wanted to in Prime Time, Prime Time guitarists Chris Rosenberg and Ken Wessel, bassist Greg Cohen of his Sound Grammar quartet, conservatory-educated musicians who consider themselves Ornette protégés such as oboist Joseph Celli, and jazz players in his thrall including pianist Joanne Brackeen and saxophonist Michael Marcus.

They – we – and thousands more all add up to a constituency for Ornette that doesn't inhibit or constrict him. He is a moving, changing figure who won't look backwards. He resists talk of illness or human limitations, though not death. He sees correspondences, not differences, though he draws some fine distinctions. He's camera-shy, though photogenic and given to wearing flashy performance clothes. He habitually invites people whom he knows only slightly or has just met to come up to his loft to hang out – and he means it.

Ornette has lived in Manhattan since the '60s with few luxuries, though he has been financially rewarded for his works by the John Simon Guggenheim Foundation, the Japanese Imperiale Award, a MacArthur Foundation grant, the Gish Award and, in 2007, a Pulitzer Prize, ostensibly for his album *Sound Grammar*. For a time, he resided in a drafty, empty school building in Manhattan's drug-and-poverty-infested Lower East Side that he'd bought at public auction, planning to turn it into a community culture center for multi-media arts. I visited there once; he was surrounded by paintings he'd been given or collected but had never hung on the walls. He was driven from that home by toughs who broke into it and hit him on the head with a hammer.

Ornette was undeterred, as he has been for all his creative life. In the 1960s, when I was just discovering his music, he refused to play unless he was compensated equally with better-established mainstream musicians, or controlled the occasion himself, which sometimes ended in disaster. Since the '80s Ornette has more graciously been paid the fees he's requested, and has been accommodated in his visions of multi-dimensional performances, which is good for his fans because he loves to

play, especially to play as he never has before, and the extra dimensions add grandeur, though they are seldom essential.

Ornette never coasts in performance, doesn't demure and plays everything he knows. When he performs "Lonely Woman," one of his earliest compositions and one which his auditors of relatively traditional leanings are likely to remember 40 years after its debut, he inevitably digs into his experience to evoke an anguished heart (I've heard it was originally titled "Angry Woman," and portrayed someone he warned would become very lonely if she persisted in her anger). He does not presume to be a mystery, however obscure his pronouncements seem to be even to some who should know better. And he's a seeker, not a shaman, eager to discover but never so arrogant as to profess having special powers. He will volunteer, however, that when he was a child he wanted to be a physician and he settled for making music because he believes music can heal too.

So who is Ornette? A slight figure with a wide mouth and strong jaw; a composer who performs his own music, wearing colorful suits and hats with feathers in their bands; no jester though he projects genial humor and likes to laugh. His eyes, under brows like ledges and over high cheekbones, appear protected; he can peer directly into those near him as if he has X-ray vision, and sometimes he looks away quickly as if he doesn't want to see too much. Those eyes also may betray sadness and poverty he's known, cruelty, ignorance and rejection of guileless impulses even to extremes of physical violence he has endured.

Ornette is an avant-garde musician – abjuring the conventional, delving into the unknown – whom even Wynton Marsalis, staunch advocate of jazz tradition, reveres for his universality. Marsalis' Jazz at Lincoln Center Orchestra installed Ornette amid its pantheon of masters by performing concerts of his works as arranged by the Orchestra members, but more importantly Marsalis has taken pains to understand, appreciate, absorb and deliver himself to Ornette's realm. He demonstrated that in a 2004 concert at modest Merkin Hall, not far from Lincoln Center but not part of it, stretching to play, *really* play, with a band comprising trombonist Roswell Rudd and multi-instrumentalist Scott Robinson besides New Orleans native, then-Lincoln Center Jazz Orchestra drummer Herlin Riley and Greg Cohen, bass. Ornette's music might serve as a potent tonic against the institutional, social, commercial and conformist pressures someone like Marsalis engages.

People are drawn to Ornette, although his music might disturb or upset before it enriches them. I'm glad to know him, and nearly every day get the happy thought, "I could be spending time with Ornette, or at least slip on a record . . ."

Harmolodic dialogue[1]

Music burst from the loft window of a bare brick building, over a mostly empty parking lot and into windswept, handscrabble streets west of midtown Manhattan.

The music was clangorous and not instantly thrilling; it discharged in fits and starts. Following the sound through an unnumbered doorway and up a creaking wood staircase, I found the air hot and thick, the noise in this unrenovated old factory bouncing off the walls like the roar of a subway in its tunnel.

It was summer, 1978, and 48-year-old Ornette was teaching "harmolodics" – his principles of harmony, motion and melody — to a group of younger men he'd enlisted in a new venture, Prime Time. He was trying to forge music in this loft with these people out of sweat and thought, trial and error, originality and genius.

Genius is a lonesome thing – it doesn't dependably come with age, experience, ambition or accomplishment, its declaration and support by perspicacious philanthropies, the admiration of peers across art forms, critics or the general public. One may shirk or shrink from accusations of genius, accompanied as it is by responsibility, but it's tough to deny it. Genius tends to show up early. It is a singular perspective – a broad overview, maybe, but not in accord with the world as the world thinks it works. It's the lucky genius who finds his or her proper form of self-expression.

Geniuses don't have it easy. Geniuses, like prophets, may be ignored or reviled, and only a genius at finance is expected to be wealthy. The genius might sustain his or her self, though, with the certainty of their view, pitting determination and self-assurance against strength-sapping opposition.

Ornette's musical genius is sweeping and profound. The music he's composed and performed and has composed as well for others to perform is indelibly marked with it. His sound on alto saxophone and other instruments, though commanding and immediately identifiable, is but a sliver of his genius, which includes acute comprehension of sound and its malleability, its reflection of and in society, the use of music as a means of inquiry as well as expression and its potential as a clarion call for people to care for and about each other.

His music isn't universally beloved, as, say, Bach's is – not yet – in part because it is so shockingly different from the Western music that's preceded it, although it finds common cause with musics from non-European and pre-industrialized realms, and touches base with indigenous American elements of blues and jazz. That said, harmolodic music – or what in 2006 Ornette referred to as "sound grammar" – is entirely modern in its assumption of all the world's sophistication besides its fundamental essences. Ornette's music is no throwback, but a brave breakthrough to a future where any and all music is possible, because it reminds people what any music is and where all of it comes from.

Creating harmolodic music involves, for Ornette, restructuring the interplay of aspects of organized sound that in jazz and other genres produce a dynamic tension. Musicians may seize any tone as a harmonic resolution, freed from the tyranny of fixed chord sequences and their closely related substitutions, the requirement of adhering to a schedule for passing through whatever chords and substitutions are prescribed to accompany given melodies. Ornette desires lightning rhythmic

response to the structural realignments that can be inferred from melodic variation. This means each and every member of his ensembles is expected to be listening to each and every *other* member, to be ready to react to what any and everyone is doing melodically and harmonically (the two being horizontal and vertical expressions of the same pitched material) *and* rhythmically, while hewing one's own path through a composition.

It can be demanding intellectual and physical work, and Ornette's meticulous process was being fully documented this afternoon. Two Asian women snapped still photographs around the half-ring of musicians — two drummers, a bassist, two guitarists and Ornette. A long-haired, bare-chested man working for Artists House Records focused a video camera on a tripod set on a makeshift platform to take in the scene. The band played fitfully, a few phrases at a time, while Ornette from his perch on a stool instructed, commented, cajoled and occasionally complimented someone. He cradled his alto in his arms and blew it or his trumpet, or used his violin or an electric guitar to illustrate his points.

Charlie Haden, since the 1950s Ornette's constant bassman, was rehearsing with cotton in his ears to protect himself from advancing tinnitus. Electric bassist Jamaaladeen Tacuma was expected to arrive on the train from his home in Philadelphia shortly. Ornette Denardo Coleman, the composer's son, sat at one drum set and Ronald Shannon Jackson at another; they stood and drifted towards the window while the elder Ornette focused on a point of theory with electric guitarist Charlie Ellerbee. Bern Nix, the other electric guitarist, was attentive while Ellerbee, who was at that moment missing a job with the disco band Trammps at a record company promo party on a boat in the East River, looked worn and bored.

Ornette was preparing Prime Time for a midnight concert at Carnegie Hall, where they were to share a Newport Jazz Festival bill with pianist Cecil Taylor's unit. Cecil is the only other individual in jazz — perhaps in twentieth to twenty-first century music — whose genius encompasses ensemble reorganization on this order. Miles' ensembles, complex, abstracting, collaborative and intuitive though they often were, retained always some element binding them to tonal, harmonic, rhythmic and hierarchical values that Ornette and Cecil ignored, dismissed, departed from, protested. The gig was three days away, and Prime Time's music was just jelling, yet the men (all but Ornette) were getting restless, as though kept after class to complete lessons while a ball game began outside.

Ornette's coaching was aphoristic, hard first to decipher and then to apply. "The rhythm and sound is like a man and a woman," he tried to explain. "They have to get along with one another or else they'll start to fight." With seven musicians presumably of equal status comprising this band, conjugal discord seemed inevitable unless highly sensitive collective collaborations developed. Yet Ornette was not counseling his players to listen to each other, he wanted them to pay attention to *themselves*. "All the disco stuff and everything has a pattern," Ornette chided his

acolytes, "but you don't have to do *that*." His point seemed to be that if they all played honestly, fully and freely, according to what they heard in their musical cores, everything would fall together.

Two decades and more than 20 recordings since Ornette first sold his saxophone playing and songs to Contemporary Records' Lester Koenig, jazz people were still suspicious of him as a musician.[2] It has long frustrated Ornette that his music is considered inappropriate for radio airplay, strange for established musical institutions to program and difficult to sell. He doesn't believe that his musical language and logic are oblique or eccentric; he is troubled when he's treated as if he's putting people on. Such is the fate of the innovator, creator, genius, avant-gardist – to be mistrusted for trying to convey previously unvoiced thoughts. Coleman's verbal syntax is unconventional but he intends it to convey meaning, just like his music.

Resistance to his logic has tainted the innate optimism of the man, who holds two ideas paramount: the inviolability of the individual and the possibility of a perfect world modeled on musical rapport. In some of his attitudes, Ornette exemplifies Swiss Enlightenment philosopher Jean-Jacques Rousseau's belief in humanity's natural goodness; in others, he is crucially American, his beliefs close to those of the nineteenth century New England transcendentalists Amos Bronson Alcott, Ralph Waldo Emerson and Henry David Thoreau and Long Island, New York-born poet/editor Walt Whitman. Ornette's rigor of intent, discipline and iconoclasm are akin to qualities in the music of American composers called, in the early 2000s, mavericks: Charles Ives, Harry Partch and John Cage chief among them.

Of course, those composers were not jazz-bred improvisers. And though jazz has had seminal figures who expressed themselves with unmistakable and expansive personal concepts, few have proposed that civilization functions in accord with the principles they've invoked.

If Ornette's hearing (not to say vision) of the world has validity, free jazz as he posits it could succeed among any music-makers of music, and in fact, already exists. We can all play together and if we play with concentration and freedom from preconception, the musical/social unit will coalesce as it would, naturally, had we never held any preconceptions at all.

Ornette says music should be spontaneous and requires no mediation, only direct engagement, so why is further explanation necessary? Well, why should a man who believes in humble self-reliance and pre-lapsarian community have businessmen protect his interests? Ornette grew up in impoverished circumstances, suffered for his non-aggressive individualism and has suffered physically as well as mentally for his art; he is not naïve. He doubts journalistic attention engages with his *music* and doesn't believe it sells records or tickets to his concerts, either, yet he approves of conversation as mutually stimulating. He has an entrepreneurial spirit, yet has never done well in business; in 1978 he had high hopes for Artists House, trusting devotee John Snyder as a business partner who would not exploit him.

Ornette has his contradictions, like any man who began his career as a self-taught Southwestern gutbucket blues sax soloist and has become an avatar of music without bounds. In '78 he didn't have a touring band on salary, because he had grander ambitions than to work frequently in jazz clubs for club pay. Despite internationally distributed recordings, critical regard, grants and commissions, his symphonic and chamber works had excited little interest in classical concert music quarters. And so: Why not convene a band relating to the pop model? Not that Prime Time would sound like James Brown or the Allman Brothers, not with Ornette applying harmolodic precepts and his personal sound.

I interviewed him five days after Prime Time's well-received Carnegie concert. He had just seen the band depart on a European tour and would follow them the next day. He'd arranged for guitarist James "Blood" Ulmer to replace Ellerbee, who had opted to work in the disco infernos, and acoustic/electric bassist Fred Williams to sub for Tacuma, who had reasserted religious vows that he said prevented him from making music. Our conversation was undistracted. To begin, I sympathized with Ornette's logistical problems.

"That's the way it is, music and other stuff is two different worlds. It costs a lot of money to be free."

Are you interested in performing in New York often now?

"I've been in New York since 1959, and most of my musical repertoire has been written since '59, in the last 20 years – so I'd rather stay in New York, even though I think musicians are treated like a minority here when it comes to survival, professionalism and all the things that make a person comfortable throughout a career. I prefer living in New York because I find it allows me better opportunities, the use of different musicians and also keeps my own instincts active. But it has done everything but assassinate me.

"*Playing* in New York to me has always been very good. I play at least once or twice a year in New York. I played in Carnegie Hall this year. Last year I played at Avery Fisher Hall. The places you play in New York after you become a professional are one thing, and *playing*, as you say, in New York, is another. If I live in New York, I might go and play anywhere. But professionally you only play the places that provide the kind of background you need to have the kind of presentation you want. I haven't played the Metropolitan Opera House but maybe when I get a chance to write more music and get into opera and stuff, maybe I'll play there."

Are you interested in writing for voice?

"All the time. Yeah. I'm writing a new piece now called *The Oldest Language*, for 125 people and what I want to do is use excerpts from as many different kinds of linguistics as I can, all the different tongues, to put them inside of the artistry as a part of the piece."

As a setting for you as an improviser?

"No, it's an orchestra piece. I've written about it in a theory book – I know I've

always said this, but some people have seen excerpts from it. I haven't been able to publish it because I haven't worked with an editor to get all of the grammar and everything[3] . . . I want it to be understood, more than confuse. I want a non-musician reader to be able to understand what a performer will get from reading it."

Does language stand in the way of explaining things?

"Musical things, I think it does. For one reason, I think the English language in America is really the street language. It's not the ancestral language of all the people. I know myself, I don't speak any other language fluently, but there are many English words that you can use that another person wouldn't understand. Also, it's hard to describe something musically just using a noun, more than the *contents* of it."

I was surprised that in rehearsal you gave a lot of verbal directions to the musicians. I wasn't sure if they were getting closer to understanding what you wanted.

"That band I've had with me about three years and it's just that a person plays with you or tries to understand, like this interview. When you ask a question or make a statement it's either that you know the subject that you're talking about or you're trying to express something without the persons you're talking to changing their views of it. You try to make their view of it more clear to them so they can stay more natural, rather than to think that you're just trying to get them to repeat something to make *you* feel more secure or something."

So you try to make sure that people absorb what you're saying –

"– for themselves. More than trying to be at a specific point to give *me* security. I don't think that musical security is useful to the individual. I think that musical security is useful to the person who has responsibility and who likes to play music. But the individual is one who likes to take chances."

This term, "musical security," I assume you are secure in that you can take those chances?

"Musical security refers to a person who enjoys reading music, a person who just wants to play [what's written]. There are lots of guys who really like to read arrangements, there are guys who like to just enjoy that. And most of those guys have really become commercially successful in a certain way. I mean I'm sure the guys on the *Lawrence Welk Show*[4] enjoy what they play. And they might even be listening to some of the people that *we* like. But their security doesn't allow them to take those chances, to let people know that they like someone else."

Their *need* for security?

"Yeah, that's right. But I don't think that has so much to do with music as it has to do with the association of who you enjoy playing with, your peers."

That's interesting. You've been associated with a fairly small group of people with whom you've played directly. And your peers share some of your background in terms of the part of the country you're all from and age. But your guitar players and others in Prime Time are younger than you.

"But I didn't ask them what was their age or anything, I was only interested

in their ability to try and play, and what I could do with them musically. And I'm really very clear and sure that the time I've spent with this band, musically, has made me feel like performing with the band. I guess any person who strives to put something together wants it to be heard. That's why I think *Body Meta* [then about to be released by Artists House] is, for me, a very good insight into the growth of that band."

Beyond *Dancing In Your Head*, which is similar?

"Oh yeah. You see, in *Dancing In Your Head* I was more or less introducing several different kinds of ideas into one form of music. That's why I chose to play only one theme, to get the person listening to understand that what they were listening to was a group program, but at the same time to listen to the *individuals* mixing as a total group. On *Body Meta* I'm playing the same songs I'd play if I was playing with the rhythm quartet I brought up in '59. I'm just orchestrating that same music for the band I have now."[5]

(Compared to the two long "Theme From A Symphony" variations on *Dancing In Your Head*, the five shorter tracks on *Body Meta* initially seemed like works-in-progress, jazz-to-come in evolution, with the master saxophonist more involved in obtaining appropriately original input from his band members than in developing his own sustained statements. But that would be to mistake Ornette's solo as his statement, when it is in fact multi-faceted compositions he's trying to instigate from the cliché-freed involvement of the musicians he chose. It is also to overlook how Ornette's alto sound changed in the midst of Prime Time's harder beat and thicker textures, becoming much steelier and less querulous, though he retained the ability to infuse it with laughs, cries, sobs, wails and occasional offhand if not quite *sotto voce* remarks.

Collective creation of harmolodically multi-faceted ensemble works – chamber music, by the definition "one instrument to a part, no conductor" – in which Ornette is not the lone soloist but one among all, was exactly what he was aiming for in the loft rehearsal I'd witnessed. *Body Meta* has less crunch than *Dancing In Your Head* and less danceability than Jamaaladeen Tacuma eventually injected into Prime Time, but the contrasting guitars of Nix and Ellerbee and the pounded backbeats provided by drummer Ronald Shannon Jackson result in a singular portfolio – as each of Ornette's recordings is.)

"I always tell people I think of myself as a composer that plays. We all know that the saxophone, the trumpet and the piano have been the most dominant instruments in the music I'm supposed to be labeled as playing. But I really have always tried to write all kinds of music, like songs and symphonies and what people call classical music.

"In my experience with learning how to identify something I do that other people will judge as good or bad, it has had more to do with the territory that I'm being included in than with how many people actually like what I do without labeling

any territory. If it's jazz or rock or classical or folk, the person who's writing a rock review or folk review or whatever review is only writing because that's the category he's writing about. He's not writing about *music*.

"I found out after I left my home town and came to the big city that music wasn't the way I believed it to be when my mother told me I could buy my own horn. I picked up my horn and started to playing it the first time because I didn't know you couldn't do that. And then when I found out it's best to be knowing more than how good you are, it just destroyed my illusion of what music meant to people."

You thought that music meant picking up your horn and *being* something?

"Yeah, right, and that would allow you to achieve whatever direction you would go, by how good you got."

Coming from inside, with your natural impulses on any instrument?

"Yeah, yeah, right, and I still believe that."

And you believe that for your other musicians, at the same time?

"Yeah, and I believe that for you, and for every person. I've found out that in a world where reproduction is no more than replacement and there is supply and demand, when your personal expression comes in contact with those two concepts you try to preserve as much of your naturalness as you can – because the more successful you get, the more success seems to pull you towards it, which has nothing to do with money or your name, but has more to do with your *territory*. I think people make money from their territories more than by how good or bad they are."

So if you were to become famous for playing music that wasn't strictly your own, people still would try to get you to play yourself, but only because you'd established a territory that was attractive to others?

"Yeah, but what I mean by territory is that when I was living in Texas, I couldn't go out and play the way I play in New York City. So that's territory. I had to go 2000 miles to do that and have the same problems I was having in Texas."

Then it's both geographic and somewhat mental, too?

"The human concept versus the territorial–racial concept (regardless of what your ancestral background is) has more to do with the placement of how you end up being whatever it is you think you are about (of how you relate to that territory and environment) than you believe it does. I still believe that in order to make things successful in a business arrangement you have to sell something, but in order to be well at what you do you have to *do* something. That's two different worlds.

"I've always tried to be at peace with both those worlds without having to think that I was going to be deprived of something that I would need. For instance, I'd really like to finish my large piece of music and I'd like to have a large orchestra on salary and teach the orchestra musicians how to play compositional music improvising, the way I wrote my *Skies Of America*.[6] I'd like to be successful enough musically to put a group together and go out to play music in that kind of large situation. But my own category that I've been christened with has been used against me – it keeps

me from doing that. So therefore I'd have to take my own money and recreate that environment for myself and sell it, which I haven't been able to do because it's very expensive."

We're talking around the word "jazz." I know you've written about yourself as being a jazz artist. Is that really the categorization that you find keeps you from being able to perform in other contexts?

"Yeah, I think those terms existed before I existed and I can't outdate those terms, but I've outgrown them. I can't spend all my time trying to change that. I have to find out how I can get what I do where I would like to have it done. What do I need to do that? In the Western world your success is based on how many people you reach, and in the music called jazz up to now it's only people who've made money from other levels of music who are allowing people that have a jazz background to integrate, to increase their financial status by mixing with other kinds of music."

So they're co-opting them?

"Yeah, more or less it's getting like that."

Do you feel you're co-opting an audience by having electric guitars there with you?

"Well, I'll tell you this here. When I had Charlie Haden with me, he always played with an amplifier, but no one said he's playing an acoustic instrument with an amplifier. But now, if I had two flamenco guitars that were amplified, would that still be called electric? The only reason it's electric is that you can't *play* those guitars otherwise. They can only be heard by having what they need to be heard. So what you really mean when you call that electric is what some people call a certain kind of music. Barney Kessel plays it, an electric guitar. So did Wes Montgomery, so does George Benson. I'm not talking about the music they're playing, I'm talking about the electricity they're using. It's not the same thing as having an electric band, having two guitars. That's really what I have, two guitars. I don't call it an electric band.

"The terms that people have had to play their music under! Categories and the ways in which the musical world allows musicians to survive usually are much more about the selling and buying than the creating and performing."

What if we didn't have the record business, musicians played exclusively for live audiences and there was not that kind of reproduction that makes for replacement of one's personal preferences with what is being sold to that person? Do you think there would be more individualism among musicians?

"I think there has to be more individualism among human beings, period. I think what you're asking me is if the system of surviving in music wasn't the way it is now, would there be more individuals? I'd say the system doesn't really have anything to do with the individual, as much as it influences the person who thinks he can't be an individual because he has to have so much backing. I mean there are lots of people

who give support to people because they don't like *other* people. If you're paying me because you don't want me to be playing with some soul because you don't like *him*, then that's all I'm really doing. If you are pushing me because you don't like someone else, well, that sort of music chaos has gotten all musicians going batty in their heads, because they all think they're in competition with each other while it's the person who's *not* performing who's making that particular problem exist for them.

"Back to what you said: I don't think that record companies have anything to do with the failure of creative music as much as they tend to use it only for their personal failings. What they want to push to become a bigger record company has more to do with the way people who work for them design how the company is going to grow."

When you say the failure of creative music, do you mean its inability to become popular up to this time, or that the music itself has failed?

"I'll put it this way. If what we're talking about doesn't allow a person that has never seen you or I to one day hear something in his head from something he's doing, and if he doesn't feel that he can go anywhere and express that up until the point where he gets help in order to *keep* developing it, to the point where he's as good as he can get, then that's what I mean. If this interview is *not* going to inspire that person, then that's what we're talking about. The thing I'm talking to you about is the image of all these things keeping a person from wanting to feel like he's an individual."

Is creative music intimidating?

"No, no, that's what I'm saying. When you say creative music—maybe tomorrow or in ten years someone will come along and play some music that neither one of us have heard. So now is it creative music because we haven't heard it? Or because he's been doing it so long we're just now hearing it? I think everyone would be playing creative music if they didn't have to be in competition with their security. What we're talking about shouldn't be the issue. Whatever makes a person want to express something, this conversation should only inspire them to do that."

And that's the kind of directions you're trying to give your band?

"That's the kind of directions I'm trying to give anybody – my band, you, anyone. If you said 'Oh, Ornette, I like your playing music but I have never played. Do you think I could? What instrument?' I think we could get together and find something that *you* could express, that had something to do with *you*, that we could play together, and go out and make a performance as good as anyone else. This is what I believe."

I think I believe that, too.

"Sure, and if that doesn't become more logically understood, then there will be more people who like things only from something they heard before or read. There won't be anything that they took themselves to find out. I mean I used to have guys

who came up to me saying all sorts of bad things about my music, then they'd come back and hug me because they found out something they liked, by themselves. One thing that's really terrible is that expression, in any kind of thing, seems to need some person's approval."

Do you function as a leader in that way?

"Not really. The only time I function as a leader is payment and responsibility."

You do give directions that seem to throw the burden of approval back upon the musician.

"What I'm really trying to do – not what I'm *trying* to do but what I'm actually *doing* – is writing music in the most clear form I can, simple, to get the best results out of the people I'm playing with. I give them what I'm playing and say, 'You take this and you do anything you want to do with it. If you want to take it apart, put it together, put Silly Putty on it, whatever it will do for you, give it back to me that way then I'll interpret it from what I hear.'"

On what basis do you interpret?

"I try always what is called emotion, to emotionally interpret sound, the sounds they feed back to me.

"I once told John Snyder, we were talking about me making a tour of America, doing television things, you know, and I always watch Johnny Carson.[7] I said maybe I'll go on the Carson show and let the band play any thing they want to play and I'll just come out and play with them. And they don't have to tell me anything that they're playing. He said that would be a good idea."

That would be great.

"Not as a gimmick; I mean, I know that that could happen. I know that they would say, 'Ok, tonight you're going to play a number with the *Tonight Show* band and they're not going to tell you nothing they play, just come out and play with them.' 'Gee,' I'll say, 'I'm willing to do that.'"

"Two weeks ago I was out at [anthropologist] Margaret Mead's school, and was teaching some little kids how to play instantly. I asked the question 'How many kids would like to play music and have fun?' And all the little kids raised up their hands. And I asked, 'Well, how do you do that?' And one little girl said, 'You just apply your feelings to sound.' And I said, 'Come and show me.' When she went to the piano to do it she tried to show me, but she had forgotten about what she said. So I tried to show her why all of a sudden all her attention span had to go to another level, and after that she went ahead and did it. But she was right: If you apply your feelings to sound, regardless of what instrument you have, you'll probably make good music."

So when you tell your musicians in rehearsal 'That's not it, try again,' what you're saying is that their level of concentration is . . .

"When you're dealing with an instrument and a melody, if you're playing a melody and you don't have everything in your mind that you can do with that note – what some people call improvising, which I now call the harmolodic theory and

method, which has to do with using the melody, the harmony and the rhythm all equal – I find that it's much easier when a person can take a melody, do what they want to do with the melody, then bring his expression to yours, then combine that for a greater expression. But there are not many people that I've been able to teach how to do that because I haven't been working with a lot of people. But the people who I have worked with, they know how to do that."

Has the exploration of this kind of music, and I don't know whether to say development or discovery of it . . .

"Well, I don't think it is a development or discovery, I think it's just natural."

The practicing of it . . .

"The manipulating of the instrument . . . "

Has it always required such rigor to create it, with the groups you've played with since, say, 1959?

"The largest group I ever used was the London Symphony and I had to write all the parts. I took all the money I had for two sessions of a jazz record, made one session out of it and got a couple of readings. What you're really asking me – that problem has more to do with the experience the person has had with the instrument than what they're expressing, whether they're reading or making up an idea to go along with an arrangement. But I would say to have instrumental discipline, how free is instrumental discipline? The people who are playing every night at the Philharmonic have lots of instrumental discipline. Now, can they take that discipline and come and just play with me, because they have that discipline? No.

"So we're not talking about the same thing then, but we are talking about the same ability of discipline, which means that we're back to what I said. Whatever makes an individual an individual, it is not that individual's goal to only see things one way. He has to have that choice, especially in expression, to explore whatever his instincts tell him. If you limit that, all you're going to have is what you're working *for* to present. In other words, the packaging of reproduction is a disaster for an individual, whoever he is."

You could divorce yourself from reproduction. It's your creation, you've done it and it's behind you, so you could go on to – but that would be bizarre, right? Actually, don't you have to take responsibility for what you've created?

"Right, really, really. We're talking about something that is very human, in the sense that for what reason do you make the choice to want to do what you do? Why do you want to do what you do? *There's* something. And when you get closer to that, what you're going to do is going to bring you more ways of expressing that. Now if it gets to me and gets to other people you will be serving the purpose of how good you can get, and I don't think there's any individual who doesn't want to have that experience, with whoever they're relating to. It's just harder when it has to do with expression.

"Because if you meet a woman or you like a certain thing, the moment you

express something witty and she or it rejects you, you have to deal with something you think is wrong that you're doing, so you analyze that and change that. So the expression is never packaged. The packaging comes from the reproduction of it. Probably making love and doing things we do emotionally are the only repetitions we do that we actually like. At least everybody's getting in bed every night, then getting up and saying, 'That was good. Let's do it again tomorrow.' Whatever, that's why we're here."

That's what we're all doing that we're sure we like.

"Yeah, sure, so that there's nothing on that level of form in a reproduction."

I was wondering about the communication, though, among the members of your early group. You were finding these things out about yourself and the way you need to express yourself. Did you do that at the time or before you started working with those musicians in Los Angeles?

"I'll tell you what I think you're trying to ask me: How did I arrive at knowing the things that I've come to know and do? How did I know that I was on the right track?"

And whether you saw that developing within yourself from the time you became a professional.

"Yeah, that's what I mean.

"In Fort Worth I went out to play music with other bands and found out that they were more advanced than me because I just started playing the horn and I didn't know about certain things you have to know in order to play with other people. When I learned those things they did two things for me: They outdated lots of people, and then they made it possible that I couldn't play with other people. Right? So I was back where I started. It's the same way right now. I have a band, and I can't just go out and get [just] anyone to play with me. Now if I was playing 'How High The Moon' [a standard of the bebop repertoire] I could go play that tonight, with anybody.[8] The difference between playing that with anybody and just playing, going and playing with anyone, period, is just that difference.

"If there's anything that I'm working towards showing as a musician or an individual it is that it is possible to express something that has to do with the way you hear, or feel, or think with another individual, without that person having to give you the information before you do what you want to express. It is possible to be able to do that as precisely as if you were sitting down in the first chair of a symphony reading what anybody writes — because if you use that much skill to do that, you can certainly use that skill to play with somebody, individually, the same way."

When you say as precisly, do you mean in unison?

"It's possible both ways. I'm rehearsing with a band now that John Snyder has. The other day I started playing an idea and John started playing the same idea, and neither one of us knew that we were going to play that particular line. And it was just *incredible*. I mean, this is an experience, something I experienced; it has nothing to

do with 'Well, this *might* happen.' John is constantly busy, he's not rehearsing every day like I am, this just happened. If you heard this band you'd think it was the band I had in '59, because those guys played from their own instinct that way.

"Which brings me in mind to say this: An individual has more expression about the things he has observed, more than you can get restricting him to what you want him to do. Most people hire others on the basis of the instrument they play, rather than the music they play. What I try to do is get the person to think musically, not about the instrument."

You do have requirements, somehow, for your musicians, though.

"You're talking about rules and laws. Rules and laws are only designed in a repetitious way. There are lots of people who can go to the piano and know where to push their fingers down, but that's a rule and a law. But now, there are lots of people who when they do that are doing it for a different reason, because they have music in their head."

I meant to talk about the requirements you have for the band. You want and have a spectrum of sound, it seems.

"I got you. In '72 I went to Morocco. I was told the story of a white guy suffering from cancer. They took him to Morocco to sit in the midst of these musicians who played, and the sound of that music energized those cells so that he walked away healed. Now for some reason, anytime you feel good you are being healed. Whether it's sex, or a sound, or a baseball game, if you have a headache and something makes you laugh, it helps. I really believe if one has something closer to him than what he's losing, he can heal himself. But the emptiness between his brain and intelligence won't let him know there's something there. I'm just talking about psychological medicine, I guess, but back to the story. It's that sound that has something to do with changing the mood of our environment – and the way you use it."

Even of your body.

"Yeah. So therefore there must be sounds yet to be combined that are going to mean, that *will* mean, more beautiful things to people, once individuals spend time developing those combinations. Maybe you have in yourself elements of what that is. If you knew about design and composition, maybe you could come upon those combinations of sound.

"In Texas I was playing[9] in a place for people to gamble as part of the house band, where the Rangers came in to bust people for gambling and they'd dance so they wouldn't get taken to jail. I told my mother after one night when I saw a woman cut a guy that I wasn't going back to play because I thought the music I was playing was making these people cut each other. And she gave me a very good answer: It wasn't about me thinking like that, it was about those people *being* there.

"A combination of sounds – when it's used to have a very good effect on the human body you can never tell how good it's going to be, today or tomorrow. But that's the results of sound."

You don't see it as a social force, as though music can make people feel good together – although that's there, too.

"That's there, too."

But you see it as music changing physiology?

"I think that according to the Bible, they say the word was God. Well, the word had to be a sound. We don't have those words around anymore. If we were speaking those words maybe we wouldn't have any kind of social or political ideology to tell us what we do like and what we don't like. We would *know*."

Always, you seem to believe in the purity of that intuitive self, before it comes into contact . . .

"Yeah, yeah, I know what you're saying. Whatever makes an adult an adult, it is not the same thing as hiding your feelings, or hiding your belief. Whatever that had to do with being an adult, it is not the same thing as being creative, because creativity does not have an age. The only thing is: How can you make a person aware of himself doing something that their own age bracket isn't doing, or that their own environment isn't doing?"

Is that inevitable? We have to become more chronologically adult.

"What I mean by adult: If you get to a certain age you can be drafted into the Army or you can buy liquor. They have a certain number that tells you you have these rights. But when you want to be an individual there's no age for that. There's not anything to tell you [that] you can now do this. At some point you just start realizing it."

It's a positive thing.

"Sure. You started realizing there's a difference in what you're allowed to do because your body is growing to relate to the rules of the game of survival in the sense of masses of people. But what your body has to do to make you realize how you want to *be* in this mass is a totally different process.

"Suppose a guy like Reverend Ike[10] or Billy Graham[11] or the President was playing music on the level of their position. They might be playing a different music than any of *us* might ever imagine."

About the White House jazz concert [in June 1978], it surprised me that President Jimmy Carter ran off to congratulate Cecil Taylor, yet I can understand how someone in that position of responsibility, the complexity of the music might match their level of individuality.

"That's exactly what I think. From my experience of seeing that happen – it was a very human day, as far as going and playing in an environment like that. President Carter was sitting right down in front, and listening to everyone very sincerely. When I started playing, he listened. I saw him looking right into my face.

"When Cecil started playing, the President was moved by something. Whatever moved him, what happened was a beautiful thing. What it meant for a person of that position to be moved by someone from an environment such as Cecil's was only

one thing – there was a human element being translated, and therefore it made a relationship. Now that hasn't made the public like Cecil any more, but it might have brought Cecil more sophisticated prestige, because a person in that position [the President's] liked what he's done.

"That had more to do with the individualism of those two people, than with where they were. That could have happened anywhere. But again, what we're talking of, this whole conversation we're having, has to do with the human form being in the male position, and has to do with how well some of the males in their positions are being what it is they represent."

Is this what you want to talk about?

"I think this is all we're talking about."

Do you think there's something else we can talk about?

"Yeah, I think what we should talk about is the concept of, let me see if I can say it right – the concept of information used in the now, in existence. If we didn't have any information and were starting out as zero, where would we be as males? That's something to talk about. Now you hear all this other stuff, gay this, woman that – it has nothing to do with dying. Does it? No, not really. You don't have to do nothing to die. You're going to do that naturally."

I don't see any way around death being of central concern to all men and women.

"Yeah, but what I'm saying – if everybody knew the exact time they're going to die, how much of this shit would they still be doing?"

I hope a lot less.

"Well, that's what I'm saying. Now we're talking about something. If you say, 'Oh, you're going to die on such and such a date, prepare yourself,' what would you do? One thing that drew me to being a Jehovah Witness for a time is that they say you should do nothing you don't want to do forever. Which makes logical sense, but no one's been able to find out what that is."

But you're doing as close to that as anyone.

"Not really, no. I mean, the only thing I have done is have lots of interviews, lots of press and I've made lots of records and made lots of people money and my own personality has always been out of line with the, shall I say, the way success is done in a mass concept.

"The other night I saw two rockers having their interview on David Susskind [television show], talking about their position in the rock world. They were talking about something that was totally egotistical, from a position to influence people to imitate their own rules.

"I do not want anyone to change what they like, just to like me, or to like what I'm doing. The kind of people I just spoke of feed upon having that relationship to be successful as they are. And that is what I think is missing in what is known as a creative person. Because a creative person don't want you to bow down and all that, just to like him."

You want to be liked if you are heard.

"Yeah, I want to be able to know that I will not be liked because of things that no one wants me to do. I want to know that liking something has more to do with growth of the person themselves. Not me trying to say you got to like this or that.

"When I saw those guys talking about their position in the music business, no one spoke about the laws of something they tried as an individual. They always talked about the position they were in that made them more successful. And I'm sitting here talking about the success of the individual, which I would like to try to stay with by putting myself in the arena of masses, the way I'm trying to do with my music.

"I was telling someone I wish I had a manager like [music attorney] Dee Anthony — look what he did for [rock guitarist] Peter Frampton. And the guy said, 'Yeah, but Peter really worked very hard to get where he got, so they made a combination.' I don't think there are only two people who have that capacity to do that."

I think in that instance they sat down and said the masses like *this*, so we're going to do it. Not only did they communicate well with each other, they have a sense that has more to do with being what the masses expect of you than being what you are.

"In America the combination of peoples who speak different languages and the combination of racial backgrounds are multiple. I think 90 per cent of America is white, and 10 per cent is others.[12] So whoever it is who's trying to design whatever it is that's being accepted, they have to think of it in that vein. But the thing that's so incredible, if we were all in one country where we spoke the same language, would all designs have to be the same? It wouldn't have to be that way. It means the people that are designing things for the 90 per cent that they think are the same are *themselves* not the same. Still there are more people geared to that, trying to pull that cart of people across the line because they have the same appearance or the same reflexes — and even *they* are not doing it for the same reasons.

"I'm saying that at least in my birthright I have grown to see that relationship and I am not trying to imitate that to join them. I just want to find out where I can fit, without having to think the same. Oh, if I want to, I'm going to paint my face and do everything to look like you so I can make you come on my side, and all I want to do this for is to express myself. Well, I can do without it, and leave all that other stuff, and just express myself, see?"

And you'll find your natural audience. But then your career, with all its ups and downs, is like a Horatio Alger story about trying to succeed.

"Sure, but understand the reason *that* exists is that the people who are designing things for the people who all look the same way, it's crazy to be against those design-ers because that's the way it is. I believe that one day in America we should have songs on the charts that won't all be in English, in the same language. Why is it that as many people as there are in America, all songs have to be in the same language to be hit records?"

Because the system makes it such that radio stations that reach the widest audiences tend to downplay minorities?

"What I'm saying, though, is if a Scottish person goes home and hears a folk melody, he's gonna start singing it. If an African person goes into his house and hears African music he's going to go 'Oh, yeah,' but if he turns on his radio and hears another language that he hears on the street he gets tuned into that and says, 'Oh, I'd better start liking that because I'm going to be outdated if I don't.'

"In other words, when you go somewhere else to hear other kinds of music people start telling you, 'Listen to this folk music.' But that's not true. It's just that the song form of music is designed to separate the different languages as far as words. I meet a lot of Japanese people who are very much into American lifestyles. They don't *think* in English, but they like the lifestyle.

"See, actually I don't think we've said anything that you couldn't have wrote if you never talked to me."

Oh, I wouldn't have thought I could think things the way you can.

"I understand that. But the way you are asking the questions, if you had said, 'I'm using Ornette as imaginary; this is what I think he would say,' I think you'd come out pretty close to what I'm saying. Just by what you ask me, I can just tell that.

"There's something like that I'm trying to express, that I don't have the words to make clear. I would say that in order to be successful in America and in this conversation we have – which has something to do with this person being born in a minority situation developing something that people like and trying to make success of it, get rich from it, whatever it is – I would think that in order for more human beings born in that situation, regardless of what color or creed they are, the one thing to avoid is listening to anything that's going to tell you that you have competition. Because there's no such thing. That's what I think."

That's a summation?

"Yeah, that's right. There's no such thing as competition. It's just how well you do what you do."

And the support of good business people like John Snyder and Artists House?

"I've known John since 1976, and my experience with him has brought me a kind of openness that I thought I was having when I first met Nesuhi Ertegun,[13] because he was a person that didn't have to feel insecure and didn't have any reason to exploit me. If he had wanted me to be rich, famous, whatever, he could have said, 'Ok . . . ' [and made it happen]. I feel that experience now, again, with a person in the business [Snyder]. It's probably hard for any person to sell something and have people in the same business treat them as equals just because they're in the same business. The president of another record company might not like the way he [Snyder] is doing it, but really the one thing they have in common is music. I've made records for the most major record companies in America, and all I can see is that they're all in the business of selling music."

Which of the records best realizes what you want to do, in terms of production, too?

"I haven't really created the piece of music or spent time to specifically answer that question, but every record I've ever made I made honestly with where I was, up to the point where I was, and I'm still doing that. But if I was just wealthy and I knew people just loved music and I was just sitting down somewhere spending my time and I could do what you just said, I would say I'm on my way to doing it now, with the things I'm writing. For some reason, if you write a song you're called a composer, but if you're playing jazz you're just called a performer."

You're a composer who plays, right?

"I'm a composer who performs."

And you compose the concept, like the harmolodic concept, and maybe the contexts, too, for you to perform in different contexts so there will be challenges and chances, and you've maintained the individuality of your playing?

"Let's say I've tried to maintain. The one thing I guess I can be grateful for is that the word 'jazz' seems to allow the layman and the educated person to understand something that you're doing which is different from others. It has that connotation and meaning for people, even if they don't like it."

Do you think you've been lucky, in that that has been held against you less than against other jazz musicians?

"I don't think I've been lucky – it's been a disaster. One of the things that is bad is that no one believes you. When I first got my Guggenheim[14] to write my symphony, I had a job in New York and the guy said 'Oh, man, you shouldn't spend your time doing that, why don't you come and play in the club, people like to hear you in that context.'

"In a society where what you do becomes known and you become known as a celebrity, the male has two choices: to be a celebrity or to be able to afford being with celebrities. The people in between only read a lot. But if you're a celebrity then you can afford it – you can call a celebrity up . . . And society doesn't leave too much choice for how you get there. Because the celebrity doesn't want to believe he's there only as that, and the person who's wealthy doesn't want you to like him only because he's wealthy, there must be some reason beyond that. But those two positions make what is known in a Western country as your social life more adaptable to the environment."

Celebrity and wealth? And for women, beauty and accomplishment?

"For women I think it has to do with possession and beauty. Possession of whatever it is, because women are totally in a position to have all the things that make you need something on their side. Love, affection – women are the chargers, we go through them to get relief from somebody putting you down. Maybe the role of the male and female has something to do with what they wish their environment would stand for, more than how they want to affect each other.

141

"My feeling is that I've always wanted to know why people want to have other people in poverty. I would rather see everybody wealthy than to have some wealthy and some poor. But if everybody was wealthy, you would not eliminate a lot of things that people don't want to do. People would just naturally want to do them because they wouldn't think you were using them or that you were putting something over on them. If we were both wealthy and we had something in common you wouldn't have to say, 'How much are you going to give me to do it?' or 'I don't want to do it.' We'd really be doing it because it was something we both wanted to do. Wealth should be the most materialistic thing that has something to do with what you don't have to do, more than what you could actually dedicate your trueness to in making this relationship between the people and the environment. America could be so advanced in everything if people didn't think that some people had to be deprived of using things."

I agree.

"Look at New York. It looks outdated compared to the information that has been developed."

Does the music move in the direction of being what we would have if we started from zero?

"I think it's in a stage of going there. I would say that I am more dedicated to trying to keep what I'm doing in that direction."

The direction of starting from nothing, from what would be natural – the set-up of Prime Time, in a way, its the duplication of instruments, like in your double quartet on *Free Jazz* – says 'We can do this stuff all at once, we can be natural?'

"You've got to understand that when you play music the way music has been designed, tempos have always been provided to go with the wind instruments, and there have been systems designed so people can interpret the basis of what the road would be. So what I'm saying is that you can design your own road, because there's only one road."

And at the same time you can have six people on six different roads because they're all leading the same way, like being parallel?

"Yeah, and they're all going to cross each other at the same point. That's what I mean when I say an individual. I don't mean an individual because of having a name or because of having a talent, but because I'm not you and you're not me – that's what I mean. Not who are you and what do you have. Those are things you achieve by what you learn. But the individuals *are*. You are you and I am me. That's what I mean. And the more you become close to knowing that, the more we're going to appreciate each other."

Circle of improvisers

Ornette's musical world has been populated by individuals who have appreciated him as well as each other. Their stories illuminate the sometimes obscure processes by which his avowedly transparent but obviously complicated (if not difficult) music came about. Their personal efforts not only contributed to the realization of Ornette's endeavor, but stand on their own. Those personal efforts, though, have irrefutably partaken of Ornette's initiative, and indicate the diversity of music that their subscription to free jazz, harmolodics or sound grammar has wrought.

When Don Cherry came floating down a street in New York's East Village, where he was wont to hang out, graceful though gaunt, wood flute at his lips, tooting a tune, he seemed like pure music spirit, kin to the Pied Piper, Pan and Orpheus. On stage and off, he effused harmony through melody and rhythm. How Cherry tilted his head, made a face, showed his hand, bent his body and gave voice – or played piano, melodica, the African hunter's harp douss'n guni and the world's most famous pocket trumpet – sang volumes.[1]

Ornette is a unique genius, but Cherry (who died October 19, 1995 of liver failure caused by hepatitis) was in many respects his equal, a brilliant composer and improviser who maintained his own productive career as well as shadowing,

Don Cherry, 1984, New York ©1984 Lona Foote.

responding, counterpoising and quipping with Ornette from the day in 1957 they met in Los Angeles at least through the 1987 recording of *In All Languages,* their last together (which also featured Prime Time) and some attendant concerts promoting the album. Cherry subscribed to Ornette's theory of harmolodics, maybe even served as its chief proponent, as not even Ornette enjoyed more diverse, fruitful collaborations than Cherry.

Cherry, in his colorful, sociable, easy-going way ranged over and beyond jazz genres and expanded from its traditions to work in contexts that might be marketed as r&b, rock, pure pop or world music. He experimented with interactive electronics (recording *Human Music* with Dartmouth-based composer Jon Appleton in 1970) and briefly co-led the New Eternal Rhythms Orchestra with Krysztof Penderecki, collaborating over the course of his career with musicians of many styles and temperaments from North, Central and South America, the Caribbean, the UK and Scandinavia, especially, but throughout Northern Europe as well as Turkey, Africa, India and the Middle East. By the time Cherry died, both his stepdaughter Neneh and his son Eagle Eye had launched successful careers as singer–songwriters personalizing hip-hop and rap formulas.

Cherry was born in 1936 to a musically active part-Choctaw Indian family of Oklahoma City. He took up the trumpet in his early teens, after they'd relocated to the Los Angeles neighborhood Watts. He sat in with West Coast tenor saxists Dexter Gordon, Wardell Gray and Harold Land at the Plantation Club, where his father tended bar; he played piano with trumpeter Art Farmer's group, idolized trumpeter Fats Navarro and was mentored by trumpeter Clifford Brown. His own first band was The Jazz Messiahs with drummer Billy Higgins, and his first front-line partner was Dallas, Texas-born tenor saxist James Clay (they recorded *Art Deco* in 1986). Cherry said, "Clay can play a ballad to make you cry," and he knew from personal experience, having collaborated with most of the formative saxophonists of the 1960s – Albert Ayler, Gato Barbieri, John Coltrane, Eric Dolphy, John Gilmore, Steve Lacy, Jim Pepper, Dewey Redman, Sonny Rollins, Pharoah Sanders, Archie Shepp and John Tchicai, to name a few – in orchestral settings, intimate acoustic groups and non-standard combos.

But his epochal meetings were in quartet with Ornette and drummers Billy Higgins or Edward Blackwell and bassist Charlie Haden.[2] If you haven't heard their records, stop reading immediately and listen to anything you can find from Ornette's '58 debut *Something Else!!!!* through his early '60s Atlantic dates (reissued in total on *Beauty Is A Rare Thing,* a six-CD box set from Rhino Records).

Beyond being a most attentive, fluid and flexible sideman, Cherry was a terrific bandleader, as demonstrated by the international group he organized (with Blackwell, Argentine Barbieri and bassist Henry Grimes) to record four tuneful, syncopated suites released as *Complete Communion* in 1965 and the even richer *Symphony For Improvisers* (adding French bassist J.-F. Jenny Clarke, German vibist-

pianist Karl Berger and Pharoah Sanders, notably on piccolo) in September '66. Both albums and a third, *Where Is Brooklyn?*, from November '66, spotlit group interplay wherein ardent personal statements were balanced by ensemble cohesion. Cherry's melodies were, like Ornette's, based on emotional resonance rather than technically virtuosic display, but seemed to hew to more conventional harmonic values (without being forced there) than Ornette's sometimes atonal explications. The two albums of suites also segued through their themes – four per LP side, eight to a record – noticeably different but subtly cross-referential.

"Those records," Cherry recalled one afternoon in fall '89, idling on a Manhattan park bench, "were the first I composed out of my concept that we live in a time where we have the knowledge, like remote control, to change from station to station. It's like life: You go around a corner and there's another life beginning, another whole environment. In fact, there are only beginnings, there is never an end. Music never stops. It's you who is stopping it. It's you who is ending.

"The form of jazz where you had the composition, then the sax solo, trumpet solo, piano solo, drum solo, then trade fours – that concept doesn't open up for surprises. And surprise is, to me, one of the most important things in life, for inspiration. I would write compositions so I could change those compositions. Or I'd have one artist solo in one piece and out of that piece we'd go to another, maybe never going back to what we started with."

Despite or in addition to Cherry's innovative proclivities, he was a populist, his music inviting and accessible, his additions to recordings by rock–pop musicians including Lou Reed, Ian Dury and Steve Hillage always appropriate, usually self-effacing. He was, like Ornette, comfortable with and attractive to the American counterculture that sprang up in the late '60s, and maybe if those two had been more traditionally ambitious they could have gained higher public profile than they enjoyed in the rarified domain of jazz. Unlike certain of their colleagues, though, Cherry was content to be a creative gypsy, a bohemian globetrotter, fancy free. He was musically secure in that he understood his lineage as an instrumentalist; as a youth he listened avidly to Harry "Sweets" Edison, Chet Baker and Miles. These three all employed the dry, vibratoless tone Cherry favored, and expressed quietude, fragility, vulnerability more often than ballsy brashness.

Whatever influence Miles exerted on Cherry, though, eventually bounced back. In an interview Miles sneered, "Anyone can tell that guy's not a trumpet player – it's just notes that come out, and every note he plays he looks serious about, and people will go for that, especially white people." But when the Miles sat in with Ornette's quartet at the Five Spot, according to Cherry, "He wanted to try the pocket trumpet and he played practically all night . . . After I played, Miles said, 'You're the only mother I know who stops his solo right at the bridge.' Then he tried it." Miles' inclusion in his ensembles after *In A Silent Way* of tablas, sitars and ethnic percussion instruments may have been coincidental or an example of parallel

development. But Cherry's multi-culti interests seemed more organic; he sought those musics out first hand, loved them first and for themselves, rather than what he could take from them.

"It's important to me to be a part of world music, to meet and make music with the musical masters," Cherry explained more than once, no doubt. "I feel free to play whatever I want to play, whether it's different styles of music, or classical, folk or devotional musics, or music that has aspects of all those three things – which I believe can co-exist – along with educational components.

"I also want to be free to improvise forms – not only to improvise on the changes but to be creative enough to improvise new forms while spontaneously composing. But if you want to do that, it's important to play with other musicians who can do that, too."

Cherry had found just such musicians in Ornette's circle and though he said, "I feel like a student trying to learn more about the harmolodic concept; I'm looking forward to the book Ornette's working on about harmolodics, because it's an endless study," he was one of that theory's most lucid professors. He lectured on it in a semi-free associative way that seemed, itself, harmolodic.

"Ornette's system is one of the profound systems of Western music," Cherry eased into the topic, "where you can have notated music and it sounds improvised. And the pureness of the intervals is what makes the brilliance of it swing.

"To me, the word 'swing' in music is the sound. You know, we're all playing the same notes, but it's the *sound* that gives a special swing to it. Bird [Charlie Parker] had that. And Coleman Hawkins [masterful tenor saxophonist whose career stretched from the 1920s through to 1969], when you hear him – every note he plays swings.

"It's the attitude, too. Because in our system we have 12 notes. Now if I play, for instance, the C-natural, and I have in my mind that the C-natural is the tonic, the 'doh' [of doh-re-mi] – I don't like the word 'doh', I'd rather use 'sah,' because the 'ah' has more positiveness in sound – but if I think when I'm playing that C that it's the number one degree of the scale, I approach it a certain way. Now, if I take that same C and have it in my mind that it's, say, a minor third – but still, it's the same note – well, with my mind and feeling and knowing intervals and what it is, it's another sound. Even though it's the same note.

"I take that same note and started thinking of it as a major seventh, the one that always resolves [returns to the key pitch]. What I'm saying is that every one sound has 12 sounds in it. And once you realize that, then you have control of the sound, getting it to be what you want it to be.

"With Ornette's concepts of harmolodics and harmolodic unison it's sort of like that. You can be playing in one key and I'm playing in another key, and it comes out unison because even though my doh, or one degree, is another note, it's still playing

146

the part of doh. Each degree of the melody is relative in another key. They're both playing the same part even though they're different notes.

"Same like that thing of swing being the sound; that's really incredible. When I was in Africa I realized Blackwell has that in his playing. How he tunes his drums is how the real master drummer playing a Western trap set will tune his drums. Blackwell tunes so each drum is independent and has a part to play about intonation, pitch. When he's playing he can sound like ten drummers because each drum as it's tuned can sound like a different person. In Africa you have ten drummers, each with their own drum, and playing together they make the rhythm. Each of Blackwell's drums plays a part in relation to the whole sound of the rhythm. Africa is where that idea comes from.[3]

"Me myself, I'd rather play the conch than the trumpet, even though you generally can have only one tone on the conch, you know. The physics of the conch makes it something that absorbs sound and gives sound out at the same time. You can have a pneumatic drill playing and you play the conch shell next to it, and the conch will absorb that sound, drown it out at certain points.

"And the conch is one of the natural instruments using the embouchure. The embouchure is the real instrument within itself. You get different textures of it with horns like the elephant tusk trumpets they use in Africa. That sound is something special to me. What I'm really into is just the horn itself, without the valves, the rotary of the trumpet. There's a way that the trumpet can be brought out in intervals, like you have in bugle calls. I'm very much interested in all that.

"I realize all these things, but I realize most of all that the trumpet to me is an amplifier of the voice. That's the way I want to approach it. Also, I think of it as a form of nature, or dance and movement. Where I'm playing phrases, or maybe something chromatic, I'm not trying to show technique as a virtuoso, I'm thinking in relation to movement or maybe nature and wind, how the trees are blowing. In terms of dance, because dance is always an important part of music. Dance and movement and the sound of the voice are very important, no matter what type of music I'm playing. It's all really an extension of those things for me."

Cherry continued, speaking of the piano keyboard's ability give voice to complex harmonies, of exotic instruments and his studies of ethnic musics, before returning to the nagging point of stereotypical classification.

"As far as us – Ornette, Dewey, Charlie, Blackwell, Albert Ayler and Cecil Taylor – being classified as free jazz, avant-garde musicians," he said, "everybody thinks we don't have any training, don't know about chords, can't play standards and just play anything, whatever we feel. But that's not true. Ornette's music has been notated music. We all know the standard repertoire of jam sessions, the standard forms, 'I Got Rhythm', 12-bar blues, songs like 'All The Things You Are', 'Take The "A" Train', Count Basie's approach, Monk's tunes. These are the foundations of jazz music.

"But you've got to realize that in bebop, Charlie Parker, Dizzy Gillespie, Bud Powell and Fats Navarro all had a concept of playing sevenths that swung; that was their thing. Thelonious, he was more what harmolodic is. He had his own approach, and it wasn't about technique. It was more about pureness of sound.

"In the Western system of music some people get into where the technique is the main thing, and audiences, that's what they applaud. It's like some people confuse technique with professionalism. I hate professionalism. I've been a professional musician long enough and have shown I can do it. But professionalism becomes a religion in certain quarters, and to me, there's more to religion than that.

"Anyway, Ornette, he has that, too – phenomenal technique. We used to play 'Donna Lee' like wheeeee! [very fast] and it would swing, because we had control of technique. To me, when you play something fast, you should think slow, and when you're playing something slow, you think fast. But I don't put people down for having technique, because it's important. The discipline of practicing, always practicing, and bettering, having control with the technique –that's important, too.

"I practice. I practice compositions. I've studied Turkish music, which is very technical, and forros, Brazilian songs of a certain form; I practice what I found in them. The jazz compositions I used to know, Charlie Parker's things, I go back over them again, because I haven't played them in a long time. I practice Ornette's compositions; learning one of his is always good for technique.

"And long tones – in relation to the trumpet, you have to keep that. If you lose it, man, if you start taking music for granted, or take *playing* music for granted, you take away from yourself. I've seen that happen. It's like they say in India: 'A life is not long enough to learn music.' "

More literally than most other saxophonists, Dewey Redman (who died September 2, 2006) spoke through his music. Vocalization was a distinctive characteristic of his sound; he like to approximate muezzin calls with his throaty sax phrases, and he perfected adding growls, groans, mutters to notes from the bell of his sax, as Rahsaan Roland Kirk had learned to hum and talk through his flute.

What Redman had to say issued from his own personal experiences – as a shy yet eager young saxophonist at Fort Worth and Dallas jam sessions, as a leader of his own bands, as a collaborator with Ornette (from the same hometown, and only a year his senior) and with Cherry, Haden and Blackwell in their Old and New Dreams cooperative, with pianist Keith Jarrett and guitarist Pat Metheny, among his most celebrated associations. Redman always trusted his playing, rather than his public personality, to advance his reputation, feeling that music speaks for itself to those who can hear it, and beyond that little of value could be written, read or said. But he liked to talk, too.[4]

"The word on Dewey Redman is he has a big mouth!" grinned the saxist in 1987, in his apartment a few blocks off Flatbush Avenue in the heart of Brooklyn, on the top floor of a rundown tenement building. "When I talk, I say what I think."

"I first got hip to critics when I was traveling with Ornette, reading them night after night," Redman shrugged. "The same phrase was repeated endlessly: 'Redman is a perfect foil to Ornette.' I was always 'the perfect foil.' At least they could have used different words: 'Redman's style seems highly compatible with Coleman's . . . ' Something like that."

"I'd heard Ornette play before I ever started playing. He had a high school band called the Jam Jivers – Prince Lasha was in it, and Charles Moffett, the drummer. They played jump tunes, songs by Louis Jordan. Then Ornette went up to L.A., and he just blossomed. He was playing all that bebop, that Bird [Charlie Parker] shit, and he could play Bird just like Bird, always could. I've never heard anybody get Bird down so well.

"In fact, a few years ago I was with Ornette at the Montreux festival and saxophonists Dexter Gordon and Sonny Stitt were in the dressing room next door. They were thick with each other, but didn't mix much with Ornette. But they were cool. So they have their strong thing, and Ornette knows they're over there. He puts his alto together and starts blowing this Bird shit through the walls. I was cracking up – I had to go next door and see what they were doing. Well, they felt the draft, I know they did; they just up and cleared out. It got kind of quiet in their room, and then they were gone.

"See, one thing [conventional jazz musicians and critics] always forget about Ornette is he always had a swingin' drummer. Like Blackwell. Always. Ornette came out of Forth Worth, just like I did, and there were plenty of others in Fort Worth, and another whole scene with great players in Dallas just 40 miles away, and Houston. I tried L.A. to see what I could do after Ornette had gone up there, but it was very hard. L.A. is cliquish; I couldn't even sit in at jam sessions. I took a chance to go up to San Francisco for a couple weeks, and I ended up staying seven years.

"After a while though . . . you know, you've got to try New York. I hadn't but moved here and I was playing with Ornette. When I came to New York in '67, Ornette was in a hiatus. He's like that, he has these periods where he doesn't play. So he was in that stage. But I knew him, I'd seen him before I came to New York, and he'd said, 'When you get here, come on over.' He had the loft on Prince Street, and I went over. He said, 'Bring your horn, man,' so I brought my horn. I'd be fiddling around with it and he'd say, 'Well, you're here.' So he'd write out a tune. I'd go over it. I've always been tuned into Ornette's music, even when I was in California and Texas, I always followed it. Anyway, I started going over tunes with Ornette, we'd go over them together, and I guess he decided to come out of his period of whatever that thing was that he goes through, and the first gig I had was with him and Denardo and David Izenzon.

"I didn't really have my stuff together with his music for at least a year, and already I'd recorded two albums with him, Jimmy Garrison and Elvin Jones. I couldn't believe it when I went into the studio with them. I was scared shitless. These were some giants. Here I was, not knowing what I was doing. But the records [*New York*

Is Now! and *Love Call* with bassist Garrison and drummer Jones, lately of Coltrane's quartet] didn't come out badly, those things considered.

"Later Blackwell came back into the band, and then Charlie. Don made some records with us together, and a couple of times Don played concerts with us, but for all intents and purposes he wasn't in the band. For one thing, he was living in Europe then.

"Usually saxophone players don't hire other saxophone players, like trumpeters don't hire other trumpet players. So I thought Ornette was really bold for doing that, and it was a very nice compliment. But we'd go to a gig and Ornette always likes to solo first, so he'd play his stuff, do it every way, take it all apart, put it back together inside out, upside down, really blow – then it would be my turn. And I wouldn't know what I was going to do to follow that.

"It was intimidating to play with Ornette then. Blackwell had been with him 15 years, and they had a special thing, like Trane [Coltrane] and Elvin did – something uncanny. Blackwell would play Ornette right around a corner and beat him there – he knew just where he was going.

"I was with Ornette three years, and I don't understand the harmolodic theory more than anyone else, not to explain it to you. It isn't because I haven't tried to understand it; I've asked Ornette all sorts of questions. The thing with his music is it's approximate. You see the note on the page – that note is for reference in Ornette's music. You don't play that note; you just have to know how Ornette is going to play it. When I was learning his music I'd watch the notes on the page, but I'd also study Ornette, listening to how he'd phrase it. Looking and listening.

"And the things I've heard Ornette say! Once we went into the studio for Impulse! [Records] with the producer Ed Michel, and the first thing Ornette said was 'Take the treble off the bass and put it on the bottom.' I knew we were going to have a serious time. But as long as I've known Ornette, I've never doubted his sincerity. He just sees things differently from anyone else, that's all. And he believes in what he's doing. He's even stubborn about it. I mean, he hasn't been so terribly successful yet with the electric band [Prime Time] but he sticks to it. He wants to do what he wants to do, and you've got to respect the man for that. Whatever they tell Ornette he can't do, he just does it.

"I mean, in 1971 he went to the New York Philharmonic and said 'Look, I've got this piece, *Skies Of America,* will you play it?' A country boy from Texas, man. How dare he ask the New York Philharmonic to play this? But they did it. Then he got the London Symphony Orchestra to record it! How did he do that? That country boy from Texas, who didn't study at Juilliard or the Curtis Institute or in Europe under any master. How did he do that?

"Don Cherry used to tell me that when Ornette first came to New York in '59 fights would break out every night at the Five Spot [where his quartet was performing]. Cats would be sitting at the table, Ornette would start playing, and

cats would start arguing about his music and would fall out, every night. They'd be fighting about whether this was jazz, and/or whether it was even music. But Leonard Bernstein went down there one night, jumped up on the stage and hugged Ornette. That was creditable.

"And look now: He's writing music for Italian chamber orchestras! He opened for the Grateful Dead? But that's the reverse of what it should be — *they* should open for *him*. I mean, I heard Prime Time recently and it just blew me away. It's in there. It's not really that complicated. You don't like it? Ok, you don't like it — but you're either pro or con. Ornette makes you think about music. When you listen to Prime Time you think about a whole lot of things. And if you go back to listen to those records Ornette made prior to coming to New York — *Something Else!!!!* — it sounds so tame! Why were all these fights breaking out? Why were these established musicians putting Ornette down? You know, they did the same thing to Bird.

"Now, Old and New Dreams is a good thing; we've got no personality problems, and we get some good work — not enough, of course, and everybody wants to do their own thing first — but we could really clean up if Ornette came out with us. Forget Old and New Dreams; if Ornette said, 'I want to play with Blackwell again, with Charlie Haden, with Cherry,' there are people out there who want to hear us, and would pay a good price. We could work all we want. There's a joke Charlie tells in the band: Old and New Dreams, with special guest artist Ornette Coleman. The guest who isn't there."

Redman had begun playing clarinet at age 13, advanced in local sessions as an alto saxophonist in thrall of Johnny Hodges, Earl Bostic and Charlie Parker, then took on the tenor, influenced initially by Stan Getz, Dexter Gordon and especially Gene Ammons ("He had a *sound*; everybody I loved always had their own sound.") He admired John Coltrane, too. Self-taught and a relatively late starter, recording his debut album *Look To The Black Star* at age 35, Redman was documented only sporadically throughout his career, compiling a discography as leader of just 16 albums.

He wanted more; he was disappointed that in the late 1960s and early '70s while he was prominent in Ornette's and Jarrett's bands, two of the most acclaimed worldwide, his Impulse! albums *Ear Of The Behearer* and *Coincide* met with indifference. He didn't understand how or why this had happened, but as a muscular black man who articulated strong, intelligent opinions and harnessed extended saxophone techniques — including aggressive high energy — to his own compressed, sometimes fragmented themes and angular motifs, Redman maybe appeared too harsh and threatening (though he was in actuality kind and self-critical) to fit in.

Regrettably, the underestimation has persisted: Neither *Ear Of The Behearer* nor *Coincide* is mentioned in Redman entries in the Leonard Feather/Ira Gitler *Biographical Encyclopedia Of Jazz*, the *New Grove Dictionary Of Jazz*, or the *Penguin Guide To Recorded Jazz* (first edition). The *All Music Guide To Jazz* does better, awarding both

albums (reissued in '98 on one CD, though with only the first of Robert Palmer's two informative liner notes) four stars. But *Music Hound Jazz, The Essential Album Guide*, calls *Coincide* a "what to avoid." Annotator James Eason warns that the music "features so much sustained dissonance that only the most avant of avant-garde fans will enjoy it."

Maybe that means us – anyway, count me in. *Coincide* and *Ear* are complete expressions, rigorously composed to examine and exploit a broad but distinct field of timbres that is rich with extremes of sound – super-harsh overtones, intentionally close-but-wrong voicings (cf. Thelonious Monk's dictum, "Wrong is right") – resulting from intentionally disjunct and thorny ensemble passages. These albums were an anomaly when produced for Impulse! in June '73 and September '74 – tolerance among the larger jazz labels for the avant-garde was fading fast – but they are brilliantly engineered, which is important because Redman's instrumental dynamics were challenging and the overall sound picture was rendered clear and close. The two albums are complementary, but contrasting: *Ear* is about the group, *Coincide* has more of Redman's uninhibited blowing. Throughout 11 focused tracks Redman plays alto and tenor saxes, a double-reed North African musette and zither, with Ted Daniels credited with Moroccan bugle besides trumpet, cellist Jane Robertson, bassist Sirone (aka Norris Jones), San Francisco-based drummer Eddie Moore also playing gong, saw and tympani; one piece features AACM violinist Leroy Jenkins and percussionist Danny Johnson is on three tracks.

Redman's compositions here are more confrontationally dissonant than Ornette's tend to be; the instruments rip, roar and howl in a fierce rush of rough textures and unsettling harmonies, which detail an explicit sonic world. The pair of recordings add up to an uncompromising statement, searing as Amiri Baraka's plays when he was Leroi Jones, potent as Muhammad Ali's punch, yet as tender as a ballad by Ben Webster. Redman was capable of playfulness and was always bluesy, too.

He was somewhat insecure about having long played by ear rather than with the studied grounding in conventional harmony he assumed was necessary for the running of chord changes. He scoffed at compliments to his facility, saying, "There are only so many notes!" True enough, but he was wrong to denigrate his exceptional ability to hear them in unique relation to each other, or deprecate his fast-fingering, long lines and singular twists of phrase. His doubts were odd for a musician in Ornette's harmolodic camp, but demonstrated Redman's desire to fulfill all prerequisites to being taken seriously, and his ambivalence towards the vaunted harmolodic theory.

"I've known Ornette since high school, we've always been sort of friends," he said. "I also consider myself as having gone to the University of Coleman, because I learned so much every night about everything, just from being around him. I learned about space. Phrasing. How not to be caught up in conventional things, but to appreciate them, too. Like chord changes – ok, but not to be limited by chord

changes. And not to be limited in my scope, or critical of other musicians, like saying 'He's too *out* for me,' or whatever. I learned to listen before I critique. As a matter of fact, I never critique anybody any more. What you do is what you do.

"I learned from Ornette. He'll take a piece of music and turn it upside down and read that. Ok? Music is open. It's just open. Music is in the ear of the behearer, know what I mean?

"I remember one time I was rehearsing with Ornette, and I said, 'This sounds like a tune that I know. These sound like changes that I know. This sounds familiar.' This was one of his original tunes. I said, 'Does this tune have changes with it?' He says, 'Yeah, give me it.' I gave him my piece of paper, and Ornette wrote and wrote. I didn't know what the hell he was writing, but he gave it back to me and he had written a change above every note. The eighth notes, the 16th notes – he'd written a change over *every* note.

"I looked at this piece of paper, and the tune was something like this [snapping a fast tempo], and there was a change above every one of those notes. I looked at Ornette, I looked at the paper, I looked at Ornette – and by this time he was doing something else. He's a prolific writer; he can write ten tunes in ten minutes; it takes me ten months to write *one* tune. I said to myself, 'I wonder if he really thinks I can work this out.' But I said, 'Ok, Ornette, ok.' I never ask him about changes any more. That was the last time I ever asked him about changes."

I proposed to Redman: "Cherry told me about what he thinks harmolodics is, how the unisons work, how he thinks of it as the Western tempered system having 12 tones in it, and he can make any of those 12 tones serve the purpose of a minor third, or whatever purpose it needs to have in a performance."

"That's in the right direction, but it's more than that," he replied. "The only person that can really explain harmolodics to you is Ornette. He's explained it to me at least ten times, and it's complex. I wouldn't even attempt to explain it to you. He tells me that I play it. But hell, I don't know. I mean, Ornette, he has his own musical system. That doesn't mean he doesn't know the Western musical system, but he has his own musical system. For example, not long ago Ornette told me that when you are playing a phrase, if you don't play it in sequence, then you don't have to modulate. I'm still trying to figure that out.

"When I first started playing with Keith [Jarrett], I was still playing with Ornette, sort of – because he was about to go into a hiatus again. So one week I would have a gig with Ornette, and the next week I would have a gig with Keith and the next week I would have a gig with my band. That went on for eight or nine months. It drove me crazy. Because I couldn't play the same way with Keith that I could play with Ornette, I had to make an adjustment. I couldn't play with the same sound, even. It's completely different. But that was one of the most exciting periods of my life, those eight or nine months," Redman said, with considerable satisfaction.

Left to right: Howard Mandel, Charlie Haden, Dewey Redman, Branford Marsalis; benefit concert for Edward Blackwell, 1990, New York © 1990 Enid Farber.

Ornette and Charlie Haden are an apposite pair. They have their differences, but the soft-spoken visionary and the scrambling realist, the unapologetic iconoclast and his staunch anchor, the prophet of individuality and the outspoken politico also share a bond. Cowboy Charlie, as Haden was called when a child singing old timey folk songs that he calls "hillbilly music" with his family's band on its radio show out of Shenandoah, Iowa, has been Ornette's most faithful supporter for four decades.

"Ornette Coleman is my master plan," Haden told me in 1991.[5] "My main plan. Going through my mind like a common tone in music, constantly, is 'How do I play with Ornette again?' Sometimes I don't sleep, thinking about it. It's like a compulsion, it's something that's in my blood, and it longs to be fulfilled.

"It's a priority. The minute that I leave for the airport from L.A. to come to New York I call Ornette and tell him I'm coming to New York. The minute I get to town I call him. What ideally I would like to do with Ornette is take two months off – and it's so hard for me because for survival, I gotta keep working in order to pay the bills. But I'm trying to figure out a way that I can take a month off and just play with him every day. He wants to do that, too."

Haden has over the course of 40 years honed his survival skills – he's had to, having supported a consuming drug habit early in his career[6] and, having gotten straight after a residency at the Synanon rehabilitation institute, supporting a family including a son and triplet daughters (all his children have become pop–rock musicians). When a bout of childhood polio had ruined Cowboy Charlie's singing voice, he had picked up the bass from his older brother Jim, who played professionally

in Las Vegas, and at 17 enrolled in Westlake College of Music in L.A. He was soon gigging with saxophonist Art Pepper, pianists Hampton Hawes, Sonny Clark, Elmo Hope – all distinctive stylists — and Paul Bley (whose own 50-year career in the avant-garde demands and would reward reappraisal, his '60s solo and trio music anticipating much of the pianism of Herbie Hancock, Chick Corea and particularly Keith Jarrett). When Haden heard Ornette play briefly at a jam session one night, it was love at first sight.

"I thought, 'Finally!' We all really felt the same way about music," Haden re-called of those days, "in that we were hearing other ways of playing on the song, not just on the chord structure, and I'd never played with any other musicians who felt that way before. I'd always felt like that myself, before I met Ornette. And I feel pretty much like Blackwell felt at home as soon as he came into the quartet, because he knew Ornette's music. Cherry and I were already geared into it – Blackwell was really *intuitive* about Ornette's music."

Regardless of such devotion, Ornette was never financially stable enough to guar-antee any of his musicians a living wage, so Haden has freelanced assiduously since the late '60s, wracking up impressive credits with pianists Geri Allen, Kenny Barron, Alice Coltrane, Gonzalo Rubalcaba and Denny Zeitlin, Keith Jarrett (in the quartet with Redman and drummer Paul Motian), the Jazz Composers Orchestra, saxo-phonists Jane Ira Bloom, Michael Brecker, Joe Henderson, Dave Liebman, David Sanborn, guitarists John McLaughlin, Pat Metheny and John Scofield, among many others. He also has led the Liberation Music Orchestra (for which Carla Bley ar-ranged "We Shall Overcome" in 1969, on the first of its three albums, to represent the police vs. yippies riot that took place at the '68 Chicago Democratic National Convention) and Quartet West, typically a mellow, classy and – though sometimes noir – conventional ensemble, besides instituting special projects such as the duet records *Closeness*, *The Golden Number* and *Soapsuds, Soapsuds*, on the latter striking an extraordinarily close, gratifying balance with Ornette (playing tenor sax).

Their link is exemplified by that album's opener, a rendition of the mock seri-ous theme of the *Mary Hartman, Mary Hartman* television soap opera spoof. After their initial statement, they deepen the song by infusing it with empathy for all comically plagued human beings. Ornette fleshes out "Mary" with easy-swinging rhythm, lucidity and an oblique tonal perspective, ending with a little-kid-looking-for-mom cry. Haden plucks his counterpoint sensitively, answering Ornette's cry by strumming a cluster of bass strings. As the album continues, Ornette and Haden swirl about each other like a double helix, the saxophonist getting looser and blow-ing with a true-ringing tone, the bassist producing heart-felt patterns and subtle touches. The track "Sex Spy," for instance, evokes an unutterable sadness that could believably issue from a betrayal of intimacy.

These duets stand with the best in jazz, such as Duke Ellington's with Jimmy Blanton; Ornette and Haden's mutuality is a compelling example of musical

companionship. But whenever Haden spoke about the foundation of Ornette's music, he always spoke of Ornette's drummer, as he did when in New York City to attend a weekend of performances raising funds for medical treatments of Edward Blackwell, who suffered from diabetes.

"One of the great qualities of Blackwell's playing is that he plays in contrast," Haden explained. "He doesn't play in parallels. I hear music like that, too – I play contrasts, that's why I feel so close to Blackwell's playing. We both heard to go in the opposite direction than Ornette was going in, and still enhance what was happening. That way we'd get feedback from Ornette and he'd get feedback from us and we'd both give to each other and the thing that happened usually was that it ended up being a new language, man. It's unlike any other improvising I've ever done in my life.

"It's hard to think about Ornette's music in terms of bar lines, because it's a new language. Of course, what he writes out has bar lines, but the way it's improvised on is way beyond bar lines. Now, Blackwell could follow Ornette in a way where everything made sense and came out perfect, even if it was 13 bars to a particular chorus instead of 12. That gave me a lot of security, because I never had to worry about the time – it was *there*. So whenever someone comes up to me after a concert with Ornette and Blackwell and says how great I sound I say, 'You better thank Mr. Blackwell, because he's the one who allows it to happen.' It's almost like I don't really have to play. He plays everything.

"Most people see the drums visually as just rhythmic, they don't think of drums as being a musical instrument, but Blackwell approaches his drums as if they were a harp, or piano, or saxophone or bass violin. He tunes them, and gets all kinds of chords, intervals and sounds like an orchestra, as far as I'm concerned. He gets these sounds that really evoke the feeling of New Orleans, too. Every time I go to New Orleans it reminds me of the beauty of Edward Blackwell, because that's where he came from, and the feeling of jazz, the feeling about music in New Orleans, the feeling that that's where it all began.

"The art form really evolved from there, and it evolved in a magical, very human and family way, from the people, kind of like folk tales and folklore. You feel it very strongly there that the art form began there, and they had no one, nothing else to pattern themselves on. They were the ones who were doing it. That's the beauty of playing with Blackwell and Ornette and Dewey and Don Cherry and Billy Higgins. It's that they feel that way about music, as if it's just being born for the first time, and that they've never heard music before.

"When I play with Ornette," Haden continued, "this desperate feeling hits me to create something that's never been before and will never be again. It's about the moment right then, and if you capture it, great; if you don't, you're in trouble. Sometimes it's recorded, and we've made some great records. But it's the act of the moment when you're playing with Ornette that's so magical and rewarding and

fulfilling. It's the only time I've ever been close to being fulfilled at the time I'm playing. All my shortcomings and frailties as a musician and human being go by the wayside. Everything is encompassed in the music and it's really a beautiful feeling and very rewarding and makes me feel very glad and thankful to be a musician and also to be able to play with Ornette Coleman."

In 1974 Ornette received his second grant from the John Simon Guggenheim Foundation, and toured Europe with a quartet featuring electric guitarist James "Blood" Ulmer. Ulmer had grown up in South Carolina immersed in his family's favorite gospel music and come to New York as a refugee from conventional mid-west-based soul–jazz organ combos. His debut as a leader, the scabrous *Tales Of Captain Black*, featured Ornette, Denardo and electric bassist Jamaaladeen Tacuma, was released by Artists House in 1978 and served as a sneak preview, if not proto-type, for the amplified, rhythmically heavy, rock and funk-tinged phase of harmo-lodics Ornette created with Prime Time from 1978 through 1998.

There were essentially two editions of the Prime Time ensemble. The first with guitarists Bern Nix and Charlie Ellerbee and bassist Jamaaladeen Tacuma, recorded *Dancing In Your Head* and *Body Meta* in 1975 and continued, with occasional per-sonnel changes or substitutions (once Denardo took over from Ronald Shannon Jackson, usually in the position of second drummer) through early 1988; it is also represented on the albums *Of Human Feelings* (Antilles, 1979), *Opening The Caravan Of Dreams* (Caravan of Dreams, 1983), *In All Languages* (Caravan of Dreams, 1987) and *Virgin Beauty* (CBS Portrait, 1988). The second Prime Time included guitarists Chris Rosenberg and Kenny Wessel, tabla player Badal Roy, pianist David Bryant, bassists Chris Walker, Albert MacDowell (a holdover from the earlier team) and Brad Jones, too. That band's only authorized recording is *Tone Dialing* (Harmolodic/Verve, 1997).

After five years at Berklee School of Music in Boston, Bern Nix had a degree in guitar education and more than enough information in hand. "I had so many ways of playing a dominant seventh chord, if I tried to think of it all when I was trying to solo by the time I got it figured out my 32 bars were over," he said with a disbeliev-ing shake of his head, sitting for an interview in an apartment in New York's East Village in 1984.[7] He found the plethora of choices paralyzing.

But he had no immediate prospects of employment, so he hung around Boston, picking up occasional local gigs, and was introduced to Nichiren Shoshu Buddhism, which advises that repeating a few simple syllables may help one attain one's goal, be it energy, inner peace, personal betterment or remunerative work.

"It was dawning on me I wasn't going to be a music educator. Most music edu-cators just forget about playing, anyway, and learn to wheel and deal among the administrators and bureaucrats. But I was at loose ends, my money was running

out; I was in personal turmoil, in a hole and getting deeper, and the religion had the ultimate grabber: chant and you'll be happy.

"I was skeptical, but I started chanting 'Nam Myoho Renge Kyo.' And one night I came home from a chanting meeting and found a message: 'Call your father in New York – urgent.' I was afraid something terrible had happened, but I called and my father said, 'I just found out Ornette's putting together a new band, and he's looking for a guitar player. Why don't you call him? Here's his number.' Now I was scared shitless, but I called Ornette and we talked and he said, 'Come down to New York.' Ok, but this was stepping into the great beyond, past anything I'd dealt with. I'd never played with anyone of his stature. I'd listened to him during my hipster period, but now I really immersed myself in his music, because I didn't know what he wanted, and this is how Berklee students prepare for auditions.

"Nobody had ever heard of any guitar player working with Ornette – nobody knew about him and Blood Ulmer. People asked me, 'Why would Ornette want a guitar player he's never heard?' Some of them were thinking: 'Especially you?' And they'd say, 'Well, if he needs a trumpet player, give me a call.'

"I went to Ornette's loft on Prince St. He wasn't there. I waited a couple hours. This little guy comes in – I was expecting somebody my size. He started talking about people he knew in Boston, and writing music – when Ornette writes music for the band he doesn't use bar lines or key signatures, and in some ways it's easier to read that way and in some ways it's harder. But it wasn't like playing melodic rhythms or anything I'd learned at Berklee. I just tried to play whatever I could. And after a while, he said, 'We have another rehearsal next week, so I'll see you then.'

"And I said, 'Oh, yeah.' I was so excited I was sick, and I figured I'd have to practice a lot more.

"But the thing about playing with Ornette is he gets you back in contact with why you wanted to play music in the first place," Nix said. "Because it felt good and it seemed like fun. Somewhere along the line you got into all these rules and regulations until it became a discipline. Plus, you want to make a statement of your own. And there's the interaction with other musicians in something that's larger than music – especially when it starts getting good, you're caught up in something that's bigger than you are. See, Ornette is one of the few musicians you can play with who whenever you play with him you learn something."

Nix was there with drummer Ronald Shannon Jackson (a fellow Buddhist) when Ornette convened Prime Time in 1975. The harmolodician-in-chief had not yet discovered McDaniels/Tacuma and Charlie Ellerbee, both Philadelphians; he was asking guitarist Reggie Lucas and bassist Michael Henderson, who'd just been touring with Miles, if they were interested in his concept of everyone soloing while staying out of each other's way. The answer in both cases was no, but Lucas, also a Philadelphian, recommended Tacuma – a much more restless bassist than Henderson, who had earned his keep with Miles by holding down repetitive figures

for the lengths of sets, whereas Tacuma was hyperactive, unreeling a multitude of bass figures tumbling one after another. So the complementary and contrasting elements of Prime Time – not unlike the matched pairings of instruments on *Free Jazz* – began to assemble, and, surprisingly enough, to generate a larger movement.

Just two months before Ornette prepared Prime Time for its 1978 Carnegie Hall debut, Shannon Jackson had recorded atonal, acoustic music on *The Cecil Taylor Unit* (also featuring bassist Sirone, who had done the '74 European tour with Ornette and Blood Ulmer) for New World Records, a not-for-profit label funded by the Ford Foundation, and Jackson performed with Cecil's Unit on the JVC Jazz Festival Carnegie Hall concert it split with Prime Time. But in 1980 Jackson established his Decoding Society with their Ornettish debut *Eye On You*; in it were reeds players, Byard Lancaster and Charles Brackeen, both Ornette-influenced; Nix and guitarist Vernon Reid, who had played with Defunkt, a hard-rocking black band led by trombonist Joseph Bowie (brother of the Art Ensemble of Chicago's trumpeter Lester Bowie) and who went on to co-found the black rock quartet Living Color and the Black Rock Coalition musicians' cooperative, and electric bassist Melvin Gibbs.

Jackson and drummer G. Calvin Weston, another Philadelphian who sometimes appeared in Prime Time, also performed with Ulmer on his masterful *Are You Glad To Be In America*, which featured saxophonists David Murray and Oliver Lake, and brass player Olu Dara – the avant-gutbucketeers. Ulmer, Jackson, Murray and electric bassist Amin Ali recorded *No Wave* as the Music Revelation Society; Ulmer signed to Columbia Records (after appearing on alto saxophonist Arthur Blythe's *Lenox Avenue Breakdown*), and recorded *Free Lancing*, again featuring Murray, Lake, Dara, Ali and Weston (plus vocalists). Murray and Lake were also in the World Saxophone Quartet; Lake organized his reggae-funk-jazz band Jump Up! (alto sax leading multiple electric guitarists and electric bassists). David Murray's Octet asserted gutsy, polyphonic, harmonically unhampered improvisations from a basis of singable melodies and forceful (but only occasionally rock-accented) rhythms.

Members of these groups were creatively eclectic and promiscuous, finding common cause with downtown improvisers such as John Zorn, Elliott Sharp, Wayne Horvitz, Bill Frisell, Lawrence Douglas "Butch" Morris – musicians as interested in confounding genre classifications as Ornette was.

With mostly white punk–jazz groups like James White and the Blacks (or the Contortions), the dilettantish Lounge Lizards, drummer Anton Fier's Golden Paliminos (whose first record featured Tacuma, electric bassist Bill Laswell and renegade reedist John Zorn, among others), auteurist Kip Hanrahan's specially assembled projects, second wave British punk bands such as the pseudo-nihilistic Public Image Ltd. (Johnny Rotten's more musically attuned successor to the Sex Pistols), the politically engaged The Clash and even America's folk–pop–punk-rockers Talking Heads (with their 1980 album *Remain In Light*) coming at jazz–rock–soul–funk–world music from an ironic or otherwise attitudinal, but nonetheless

admiring, perspective, a rampant free jazz-influenced soul–pop hybrid seemed to be loose in the land. At least so it seemed in New York City, where bands of this milieu appeared at rock–pop venues such as the Peppermint Lounge, Danceteria, the Ritz, Squat Theater, Tramps, the Lone Star Café and the concert hall of Joseph Papp's Public Theater.

This is not to suggest that a taste for musical freedom (that is, the investigation and pursuit of alternatives to musical conventions) and funk (a "dirtying" of sound characterized by black Baptist church fervor, urban ghetto slang, electronic distortions, emphatic backbeats and complex polyrhythms, outside-the-box, often over-the-top, improvisation and an uninhibited embrace of confrontational subject matter) began with Ornette, or Miles either. Black pop music by the mid-'70s was rife with stars, bands and wannabes who sought to expand their palettes beyond the crossover-appropriate songs of romance and upwardly mobile social ambitions that had been the staple of Motown Records. Even Motown acts – the Temptations, Marvin Gaye and Stevie Wonder – had decided to broaden in their scope with songs including, respectively, "Ball Of Confusion" and "What's Goin' On" and the album *Talking Book*.

In the mid- to late '70s George Clinton's Parliament-Funkadelic combine offered flamboyant goofiness and instrumental jams as loose as anything the Grateful Dead propounded; raunchy singer–guitarist Rick James flaunted sex-and-drugs freakiness (and the emerging artist known as Prince took those topics a step or two farther), bands such as Earth, Wind & Fire and Osibisa brought elements of world music – African- and Caribbean-derived rhythms, instruments and song forms – into the mix. Jamaican reggae, exemplified by singer–songwriter–bandleader Bob Marley, advanced these developments on an international level.

The popularity of these groups far outdistanced Ornette's, though Miles had achieved global recognition. What both Ornette and Miles did was break new ground using the aforementioned pop elements and more, push daringly into what was still unknown territory and, as avant-gardists, chart new terrain that intrigued less innovative musicians, though they might still strike casual music listeners as discomfortingly extreme.

The guitar style of Bern Nix, which can be discerned as maturing from Ornette's *Dancing In Your Head* and *Body Meta* of 1975 through *Of Human Feelings* (recorded in 1979), *Opening Of Caravan Of Dreams* (from 1983) to *In All Languages* (from early 1987), is one of the alternatives, if not by itself an extreme. Nix's sound is not that of the bodacious guitar-slinger, a slash-and-pulverize superhero; it is often thin and quavery, self-effacing if not tentative, legato and diffidently uninflected, reaching out to make connections while phrasing in such a way as to work with what everyone else is doing, played by a deliberately accommodating person, a psychologist turned diplomat.

In rehearsal, Ornette requested self-conscious originality – he frequently asked

Nix, "Why are you playing those notes that way?" expecting an answer, and Nix's conclusive rejoinder would be to make sure that "that way" was how *he* sounded, unlike anyone else. The squiggle he let loose over a Bo Diddley beat on "Voice Poetry" to kick off *Body Meta* is one exhibit of his deferential tone, which might seem unfocused or lost in ensembles where a single guitarist was expected to carry the basic line of a tune. But in Prime Time – working with and against Ellerbee's crunchy rhythm guitar chords and Tacuma's fast-shifting bass parts, embellishing Ornette's fervor – Nix, the offhand yet not aloof commentator, had an enriching role to play.

Jamaaladeen Tacuma had the exactly opposite musical personality, as an unrepentant extrovert, impeccably snappy dresser and irrepressibly lively presence onstage. "I'm a family man with a wife, four children and another on the way, and I live in Philadelphia so I'm sort of removed from the New York scene," Tacuma, age 26, said,[8] "but I'm very eager to play all the time. Ornette Coleman has created a monster."

The monster's hands were long, his fingers deft at picking animated patterns from his streamlined Steinberger electric basses – black graphite four- and five-string instruments that had long necks sticking out of small, solid bodies. He used those hands on those basses to produce pulsating bottom lines that moved the ground under the entire Prime Time ensemble. The monster's love of Motown music, Philadelphia-based songwriter–producers Kenny Gamble and Leon Huff and Jimi Hendrix informed the strut he provided to Ornette's harmolodic band. But for all Prime Time's dissonant iconoclasm, Tacuma claimed to be after a "classy, laid-back sound."

"The closest example of the feeling I'm talking about is played by Anthony Jackson, who works with everybody from Steely Dan to Chaka Khan to Al Di Meola," he enthused (he was always enthusing). "He's *smooth*, like Willie Weeks used to be with Donny Hathaway, like Ronnie Baker used to get with Gamble and Huff – that Philly sound."

Tacuma's bass sounded fat and unforced like that, but he wasn't content in the background, where the bass usually resides; he played with nearly manic dynamism, often outfront and always audible underneath. Since childhood he'd been showy – he admitted to "getting dressed up just to watch American Bandstand on television," and said he sang in a doo-wop group while still in elementary school.

"I'd go to the Uptown Theater, which was like New York's Apollo, for shows, and I'd be screaming to see the soul groups," he related. "I'd look at the Fender basses, look at the musicians playing them, see a relationship between the way they moved and their instruments. I lied to get into my first band – I told this guy that I had all sorts of equipment, when I really didn't." Later, Tacuma was fired by jazz organist Charles Earland because he was getting too much attention from the audience. But Ornette encouraged him as a "naturally harmolodic" player.

"I was reading this music sort of slow, and Ornette was playing a certain phrase a certain way," Tacuma recalled of an early Prime Time rehearsal. "He started saying, ' That's right! That's right!' I knew it wasn't right, from what I knew about music then. Now I can look back on that and see what he meant – sometimes the notes themselves can create certain phrases. You don't have to know this in advance – certain notes can just be written out, and you can phrase them any way you want to and they'll sound fine. When we [Prime Time musicians] read Ornette's music we have his notes, but we listen for his phrases and phrase the way he wants to. I can take the same melody, then, and phrase it like I want to, and those notes will determine the phrasing, the rhythm, the harmony – all of that.

"In Prime Time we all act as soloists, which is not a very conventional way of playing but which is what we do," Tacuma declared. "Sometimes I just sit and pick out melodies, thinking of a sequence or patterns, and these melodies come back-to-back, they just keep coming to me. There's a certain harmonic structure that we've formed, or that we approach, and we just pluck the melodies out of it. The way we're doing this doesn't have anything to do with emotion, or how something affects you. The music is just there. What Ornette is doing on sax, what Blood is doing on guitar, what Denardo is doing on drums, I'm learning how to do on my bass. And I'm loving it!"

Of Human Feelings is the most persuasive recording of the first Prime Time, giving the essential harmolodic multiplicity of dimensions a party spin. Ornette's melodies for eight songs are concise and catchy; his improvisations (on alto sax only) are laser sharp, with no meandering. The drum team – Denardo and Calvin Weston – is busy and brisk; guitarists Bern and Ellerbee also play well simultaneously without trying to harmonize (blend) or play "together"; they play their own parts that co-exist, and can be heard as belonging to very different orders of music, not just different songs but different sessions under different guidelines; they expand the field rather than defining it by intersecting. Tacuma seems to be everywhere at once, leading and lifting everyone while also establishing a gravitational field of his own.

The mix is excellent – clean and present, without fuss (on *In All Languages*, recorded eight years later, production glitz including reverb and electronic drum effects detract from the band's immediacy). The sonic confluence in *Of Human Feelings* takes place mainly in the middle frequency range, dynamics are compressed (there are no extremely loud or extremely soft passages) and the tracks are short – all this would suggest it was designed with hopes of radio play.

However, this is riotous music, encouraging sonic diversity and its accompanying internal tensions, which are resolved only with listeners actively participating by holding conflicting ideas in mind at the same time, for all the surface consistency that would put it in the pop sphere. Furthermore, *Of Human Feelings* does not suggest the diaphanous eroticism of Miles' *In A Silent Way*, is not as darkly grandiose as *Bitches Brew* or as compellingly nasty as *On The Corner*. It is snappy, unpretentious and

inordinately upbeat – rather like a tight rhythm 'n' blues band, James Brown's JBs with contrary complications or Louis Jordan's Tympani Five of the late '40s gone berserk.

The domination of the ensemble by Ornette's sax – which he would deny is inherent, but seems unavoidable in all his recordings – also puts me mind of King Curtis Ousley's yakety-sax hits of the '50s and early '60s. Ousley was a Texas tenor, alto and soprano player born and raised in Fort Worth, four years Ornette's junior, who struck it rich through studio session work and leadership of Aretha Franklin's band – according to Ornette biographer John Litweiler, when Ornette arrived in New York City in 1959 Ousley "met him in a Rolls-Royce." Recalling the raunchy honkin' and hollerin' style King Curtis deployed in boogie-woogie contexts leads me to wonder how the lesser bands Ornette had served in during his Fort Worth teens might have sounded, their players intonationally challenged and rhythmically limp.

Would maladroit music by "Silas Green from New Orleans," the ancient min-strel troupe which had been Ornette's ticket to ride out of Fort Worth in 1950, have given him a refracted glimmer of inspiration, like Charles Ives hearing two marching bands approaching his New England town square from different direc-tions? A.B. Spellman reported that Ornette remembered leading a recording ses-sion for Imperial Records in Natchez after leaving the Silas Green group, the results of which have never been discovered and were probably never released. Until this

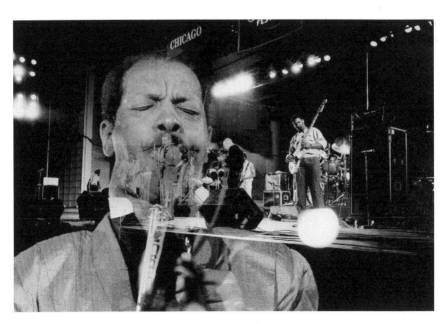

Ornette and Prime Time, 1982, Chicago, double exposure ©1982 Lauren Deutsch.

grail appears, listeners can only speculate about the origins of Ornette's hard-rocking harmolodic endeavors.

Of Human Feelings (originally titled *Fashion Faces*) was released on the Antilles label, a no-longer-operative division of Island Records, a boutique-like independent firm that had thrived on reggae music. The LP is out of print and has never been issued in the U.S. on CD, a situation that is likely to remain so. *In All Languages* is a good second choice – especially as it presents both Prime Time and Ornette's "original quartet" with Cherry, Haden and Higgins performing the same songs for comparison's sake. *Virgin Beauty* is tricked up with Grateful Dead guitarist Jerry Garcia's unnecessary overdubs on three tracks; Tacuma is replaced by Chris Walker, and the bloom is off the concept. Maybe you want to search out *Opening The Caravan Of Dreams*.

Following the dissolution in late 1982 of a business agreement between Ornette and Sid Bernstein Associates, a high-powered management and production firm that had most famously brought the Beatles to Shea Stadium, Ornette and Denardo decided to put together their own record company. Ornette had also been contacted by Kathelin "Honey" Hoffman, artistic director of the nascent Caravan of Dreams, a multi-purpose performance space in Fort Worth, Texas, Ornette's hometown.

Caravan of Dreams was[9] a half-block square nightclub with 400 seat dining room, 212-seat theater, rooftop bar, geodesic Cactus Research dome, two dance studios, Aikido dojo and 24-track recording studio with two-track digital capabilities. It was built at a cost of $5.5 million by Edward P. Bass, the second of four sons of an oil-rich Fort Worth family and an actor in Hoffman's Theatre of All Possibilities; he resided in one of two apartments in the four-floor, red-brown mock-adobe structure, situated in "downtown" Forth Worth, an area subsequently redeveloped as Sundance Square.

In 1983 this district comprised a couple of bars and lunchrooms, a luxury hotel, a shopping complex bearing the name of the Fort Worth brand Tandy (owners of Radio Shack), the Tarrant County Convention Center and auditorium and a bus depot. An upscale retail-and-restaurant Sundance Center remained of a '70s redevelopment initiative financed in part by the Basses, but there was no evening entertainment facility other than Caravan. That Center's twin 30-story office towers cast shadows over the modest frame homes on streets where Ornette had grown up.

The old neighborhood of Fort Worth's black community was on the wrong side of the railroad tracks that had brought livestock to the slaughterhouses of Cowtown, a section of the city that in the '80s was a country and western-themed tourist attraction, anchored by the enormous club Billy Bob's. Ironically, central Fort Worth had been a wide-open vice district called "Hell's Half-Acre" or "the bloody Third Ward" into the 1950s, but its Wild West ways ended with the death of fabled Fort Worth mayor Amon Carter.

"We wanted to do something artistically historic to open the Caravan," Honey Hoffman, a Beat-generation and hippie-inspired dramaturge with global connections, explained in an interview held the week Caravan opened for business.[10] "Ornette's the major influence in the music world that we represent artistically, just as William Burroughs is in the writing world. I asked Ornette, 'In your wildest imagination, what's the best thing you'd like to do in your hometown after being gone since the '50s?' And he answered, *Skies Of America*. I called John Giordano [conductor of the Fort Worth Symphony] –not knowing he'd played saxophone with Ornette when he was younger – and he said, 'Great, we'd love to do it.' So here's a black composer who lived on the other side of the tracks, who wasn't really allowed downtown during his youth, returning as a composer for the symphony orchestra, also bringing Prime Time and a string quartet to provide the full spectrum of his music. It was kind of mythic, and there was a lot of astonishment."

She put it mildly. The local reaction to the opening of Caravan – including the black tie-or-costume-requested performance of Ornette's sweeping and sometimes sagging symphony, Prime Time's two nights of performance in Caravan's main space, the premiere of Ornette's "Prme Time/Prime Design" for string quartet and Denardo playing electric drums in the Cactus Dome, a staged shootout in the downtown streets at high noon and rigmarole attending the attempt by filmmaker Shirley Clarke to finish a movie on Ornette she'd started 20 years before – wavered between bemusement and outrage.

"Coleman was sent packing years ago with his horn and his head's strange harmonies, unable to sound a chord Cowtown music lovers could readily recognize," sniffed a front-page article in the *Fort Worth Star-Telegram*.

It further implied that Caravan's staff was an invasionary force of avant-garde dilettantes. Hoffman was undeterred.

"One thing I like about Fort Worth is that just because people here don't understand something, and they're scratching their heads about it, it doesn't mean to them it's not worthy," she believed. "It just means they don't understand it."

If Ornette's sax style had gotten him run out of town in the '50s, his magnum opus for the 96-piece orchestra and jazz band (Prime Time, of course) posed an even greater challenge. *Skies Of America* is Ornette's aesthetic writ large. The score, notated in detail, instructed the classically trained musicians to play their parts in the octaves of their choice, and a few measures asked for volunteers willing to improvise. Eight themes explicated in massive movements (though with little counterpoint) and unnotated variations were to be played in alternation by the orchestra and Prime Time, forces that merged only in the work's final moments. Nonetheless the elite of Fort Worth turned out for the event.

In the performance Prime Time – Ellerbee and Nix, bassist guitarists Tacuma and Albert MacDowell, drummers Denardo and Kamau Sabir, and Ornette on alto, trumpet and violin – restrained its volume to match the orchestra's unamplified

dynamic. Riffs familiar from Prime Time's three recordings emerged from the symphony's brass, string and woodwind sections, often starting as dense storm warnings, then diffusing like wafting clouds. Giordano led his sections firmly, creating a more compelling version of *Skies* than that recorded by the London Symphony Orchestra under David Measham's baton in 1972 (which was half the Fort Worth rendition's length, with Ornette alone, no improvising ensemble). Still – perhaps inevitably, given the work's duration – the symphony's momentum flagged.

Little matter – Fort Worth was in self-congratulatory mode, and after the concert the gaily clad audience traipsed across the street to explore Caravan of Dreams, sample its free cuisine, drink its generously poured libations and hear Dallas-born tenor saxophonist James Clay, Don Cherry's old bandmate, lead a quintet. The next day's newspaper reviews of *Skies* were unanimously respectful, as Hoffman had anticipated, if not necessarily insightful. Fort Worth's attitude *had* changed, even unto revisionism. For instance, a hefty, white-haired music storeowner was overheard addressing a regular customer who'd been mystified by the concert while Denardo, unrecognized, shopped for drumsticks.

"I used to be the only redneck peckerhead in those dives, but I just had to play drums with Ornette before he left town," the man remembered (how accurately I can't say). "I'll tell ya, that free-form stuff he got into, it's lost on me. Thing is, it's got no structure. But I'll say this: I know Ornette well enough to believe he's sincere about everything he does."

Sincerity was Ornette's middle name, to judge by the humble pleasure he took in responding to the swirl of activity around him. During rehearsals and soundchecks he had willingly allowed Shirley Clarke's crew to poke cameras inches from his players' faces. Greetings from the Mayor, a plaque from Ornette's high school graduating class of 1948, fans in from Austin, Denton and Lubbock, Texas as well as music journalists from Berlin, Paris and Manhattan made this prime time to party.

So Prime Time played four get-down sets over two nights while Caravan's staff of 90 ironed out its service routines. Murals covering the dining room walls purported to show Forth Worth's history of interracial festivity, with Ornette and his original quartet sketched in one corner – not completely inaccurately, as besides Ornette, Dewey Redman, Ronald Shannon Jackson, Charles Moffett and John Carter hailed from here. Afterwards, Hoffman was bubbling about the hours of live music Prime Time had recorded. From them came *Opening The Caravan Of Dreams*, and *Prime Design* was also released on LP; Clarke's *Ornette: Made In America* enjoyed some screenings, though not a full commercial release.

And Caravan of Dreams made good on much of its promise to Forth Worth. It sponsored readings by Burroughs, Brion Gyson, Soviet poet Yevgeni Yevteshenko, and cyberpunk writers William Gibson and Bruce Sterling; staged Alfred Jarry's Ubu plays, Noel Coward's *Private Lives*, and Brecht's *The Good Person Of Szechuan*; booked dancer Molissa Fenley, the Living Theater, Dizzy Gillespie, Herbie Hancock,

Sun Ra and T-Bone Burnett, and employed Texas-born jazz players including saxophonists Kirk Whalum and David "Fathead" Newman and guitarist Cornell Dupree. It sparked a downtown renaissance.

"It's become the most important jazz venue between the East and West Coasts," Mike Price, entertainment editor of the *Fort Worth Star-Telegram*, opined three years after the opening. "Their program might be a bit advanced for this community, but I'm glad to have them around." By that time Caravan of Dreams Productions, the recordings arm of the center, had become a major purveyor of mature harmolodics, having released *In All Languages*, albums by James "Blood" Ulmer, the African electronic musicians Twins Seven Seven and two by Ronald Shannon Jackson and the Decoding Society. *My Way*, a gospel tribute to Dr. Martin Luther King, Jr. sung by Eartha Kitt with the 100-voice choir led by Rodina Preston in association with the Dallas-based Junior Black Academy of Arts and Letters was being readied; videos and audio books were announced as in the works.

Suspicion abounded, however, that Caravan's achievement, and Ornette's rising profile, had been fueled solely by Ed Bass, who was characterized as a profligate patron of far out arts. *Fort Worth Star-Telegram* reporter Sam Hudson chortled when he told me, "Ed Bass is an eccentric, rich, and flaky person, supporting some eccentric, poor, talented people. The Caravan folks are screwy, but hell, Ornette's seen stranger. He was ready to emerge anyway, and he would have found some way to do it. After all, real artists are intensely practical people – how else would they get their work done?"

Denardo disputed the charges of patronage. "Even though Caravan has that association [with Bass], that's not how it works," he said. "They wanted to do some recordings in their club; we had a lot of masters in the can that we were planning to release, because in terms of Ornette's output, even in the times when he wasn't on a label he was recording one or two records a year. We decided to combine our efforts. I got involved on the business side of it, trying to get a record company up and running. It's a business, just like any other record company."

Kathelin Hoffman – who Ornette had commemorated with a beautiful ballad "Kathelin Gray" on *Song X*, his 1986 collaboration with guitarist Pat Metheny – explained, "Caravan of Dreams is a for-profit organization. Our architecture is well endowed, that's the primary investment. We're set up for investors but on a cost effective basis, so this type of operation could be set up somewhere else. We don't have a subsidy; we have to make it, and the record company is already making back its money after just six months of operation."

Even if Bass had funded Caravan and Ornette directly – so what? More significant charges concerning Ed Bass and the Caravan of Dreams troupe were published by Gayle Reaves of the *Fort Worth Star-Telegram* on April 7, 1985. According to Reaves, whose principal source was Carol Line, an ex-Caravan of Dreams staff member charged with the theft of $25,000 from the facility, Caravan was one of the dreams

of John Polk Allen, a charismatic proponent of what Reaves called "a belief system that mixes Gurdieffian discipline and Sufi philosophical touches with avant-garde theater and vague ideas about ecology and technology." He'd been a board member, director, or consultant to several of the odd enterprises linked to Bass's money, including "two ranches in Australia, a forest preserve and research station in Puerto Rico, a conference center and farm in southern France, an art gallery in London, a hotel in Nepal, a conference center in Arizona, several related theater troupes, and a 'ferro-cement Chinese junk' sailing the oceans."

The *Star-Telegram* quoted informants on several other allegations relating to Allen, which were categorically denied and eventually recanted by their sources. Felony charges against Carol Line were dropped, and she returned briefly to work at the performance center. "This is a dead issue," Kathelin Hoffman said firmly and correctly. "Ornette is the major artist of Caravan of Dreams Productions, but we're not his patron. It would be patronage if we were subsidizing him, but this is art to go on the market. Ornette is responsible for his own successes – he's never before had anyone backing him so he can really do what he wants. We have a good creative relationship with Denardo, as well, but Ornette speaks often of the inspiration we've given him – that we're here, trying to do the same thing as him."

"As far as what Caravan has done for me and with me, I'm not displeased at all," Ornette said in 1987. "I feel more comfortable about their interest in what I'm capable of doing. Their relationship to me is that they respect what I do and what I've gone through to get where I am, so they're just trying to say 'We want to record you, but we're not trying to exploit you, make lots of money and do all that.'

"But I'm trying to get them to think that way, you know. I haven't had a major campaign to bring me to millions of people, like if I was Bruce Springsteen, and with . . ." The major label was left unnamed, and Ornette shrugged. "Because sound is all people hear in their ears, whether it's Bruce Springsteen or me or whoever. It's who's behind me that has to do with success."

Trouble with those behind those behind him – Allen and Bass – arose again in the early 1990s regarding the Biosphere 2, a three-acre structure in Oracle, Arizona that purported to be an artificially enclosed ecological system, constructed for scientific research on potential problems and solutions for human colonization in outer space. When it was discovered that oxygen had been pumped into the presumably closed system, and suspected that other infractions on the experiment had been hidden, its scientific integrity suffered. Bass, who had launched the endeavor with $200,000, accused Allen of mismanagement; experiments faltered over a range of personnel problems, and ownership of the site was transferred in 1995 to Columbia University, which eventually curtailed all involvement; the Biosphere and its 1600 surrounding acres have been offered for sale, and is currently being considered as a site for a planned community. An article in the *Village Voice* denounced Allen as leader of an authoritarian personality cult.

Ornette wouldn't comment about what Fort Worth reporter Hudson had described as Caravan's "hidden agenda," but he had said he liked "that Sufi stuff." In the late '80s he composed and performed a work for chamber ensemble and trumpet entitled, "The Mind of Johnny Dolphin." Johnny Dolphin was the pen name Allen used for his novel *Thirty-nine Blows On A Gone Trumpet*, published in 1987 by Synergetic Press, based in Santa Fe, which also, among its audio books (*Uncommon Quotes* by Burroughs, recorded live at Caravan) and video tapes, distributes Clarke's film on Ornette.[11]

Coleman family business

Ornette to the contrary, it would take more than a talented, trusted manager and a committed record company to disseminate his music to the public he believed was awaiting it. But a talented and trusted manager certainly helped. In 1987 he released three records within six months; had a JVC Jazz Festival concert at Town Hall in June featuring both the original quartet and Prime Time as on *In All Languages*, had two nights of his chamber music performed at Weill Recital Hall (attached to Carnegie Hall), and the presentation in Verona, Italy of *Skies Of America*, as revised and conducted by John Giordano of the Fort Worth Symphony Orchestra. He attracted mainstream media attention, too, enjoying notice from the magazines *People*, *Esquire* and *Horizon* as well as major coverage in the *Village Voice*, *The Wire* and on National Public Radio, thanks largely to Denardo having accepted responsibility for a range of harmolodic business dealings.

"After observing how people through the years had worked to handle his affairs, I knew I could do a job that wasn't any worse in terms of what he felt he was getting out of it," explained Ornette's then 31-year-old son, a graduate of City College of New York with a political science degree who had been making music with his dad since he was ten. "So I said, 'Let me handle and manage everything.'

"Now people think Ornette's just getting active, but he's continually spinning," he insisted, downplaying his effectiveness. "When the public notices there's a lot going on, Ornette's already in mid-motion, in the fast lane. That's how it's been all along."

Ornette acknowledged Denardo's involvement as "about 90 per cent" of the reason he'd become so active, but maintained "I've always been interested," in reaching the largest possible audience. His commercial ups and mostly downs may have been caused by his own naive and/or idealistic dealings with a profit-oriented music industry or the idiosyncrasy of his music, but Ornette believed he'd often been victimized, and he was wary and weary but no less determined after 28 years of experience with Contemporary, Atlantic, ESP, Blue Note, Impulse!, Flying Dutchman, Columbia, A&M Horizon, Artists House, Caravan of Dreams and Antilles Records.

"I haven't seen one book that has to do with the history of American music

where somebody wasn't talking about something I was doing," he complained. "If this is true, why do the people that I go around to at the record companies try to disillusion me? In the early '80s when I was trying to find a manager I found these two guys that just raped me terribly, and then I went to a record company that tried to finish me off."

Things could be different and Ornette's time had come, according to Denardo, because the intimations of harmolodics had proved true. "You can do things in a really foreign way in terms of music theory, and yet the ears can get the same sense of resolution and order," he asserted. "That's what harmolodics is, and that can be applied to anything. Ornette's a living example of that.

"One thing about working with Ornette is being organized," continued Denardo, who was learning his "more-than-overtime job" from scratch, and claimed that "in the past four years, Ornette's made more money than in all the years up to then combined."

"Once you're organized and people know you're doing things, those people who've always wanted to do something with you feel, 'Ok, this is a situation I can work with.' By virtue of my centralizing everything, and having repaired a reputation that people felt they didn't want to deal with, now they're confident things will be done right," he said with quiet pride.

Others who believed in Ornette had rallied around Denardo's efforts, among them oboist and double-reed specialist Joseph Celli, formerly director of the presenting organization Real Art Ways in Hartford, Connecticut, who arranged a week-long Ornette Coleman Festival, including the gift of a key to that city and gala outdoor performances by Prime Time on the statehouse lawn in summer of 1985. Celli also commissioned chamber works from Ornette – "In Praise of NASA" and "Planetary Soloists" that he performed with the Kronos String Quartet at Weill.

"I think some of Ornette's chamber music pieces are of great significance in terms of the evolution of music," Celli proposed. "There are special kinds of problems associated with them because Ornette's music is very special. It is not just music notated on the score that's then sent around to anyone and can be performed in any context. The printed page is an outline, you might say, for what the realization of the music in fact might be. The notes are a sketch or guideline for you as an individual artist to bring to life with your personality. This has to do with Ornette's strong belief in individuality – the individual and the individual realization of music. Any of his pieces, if they're getting really good performances, will sound quite different in each performance and will have a tremendous individual character to them, just as his improvised ensembles do.

"There is now a group of people who have committed a significant amount of their time to understanding philosophically and conceptually what he's doing, his theories concerning harmolodic theory, individuality, the relationship between improvisation and written parts and so forth, and I think those players can generally

get a notated score from Ornette and realize it quite well, as Malcolm Goldstein does, for instance, in the world premier of Ornette's violin piece 'Trinity.' I think if ten violinists were to play it it would sound radically different as a solo piece, but it would always be recognizable as Ornette's piece. And that's some of the beauty of that music.

"Some of these pieces should be in the permanent chamber music repertoire. I think the string quartet "Prime Time/Prime Design" for amplified string quartet and electric drums is a major string quartet, I would say a major piece of the past decades, right up there with important string quartets by Elliot Carter and other people like that.

"The work that Ornette wrote for Kronos and myself is in several very contrasting movements, each with an identity of their own. It was very interesting to observe Ornette working with Kronos, preparing them for it, because here you have tremendously gifted players who can play just about anything that's written on the page, but Ornette sets up the expectation of their being able to bring more to the page than there were notes to the page. It was beautiful to watch, as he gave them more and more freedom, in terms of developing the expressive possibilities within the piece.

"There are sections, for instance, where the mukta vena, an Indian double-reed instrument I'm playing, has a cadenza, but the string players have a number of variable relationships that they can set up which kick off sets of unexpected things to occur. Those unexpected things tend to keep the music alive, because the

Ornette plays his violin, left-handed, 1982, Chicago ©1982 Lauren Deutsch.

171

performers have to be responsible for that. We don't come to it with a sense of absolutely knowing what's going to happen in each situation. And that of course is part of Ornette's whole philosophy, how he's approached music.

"My mukta vena is a folk instrument, most often played in outdoor settings and usually in ensembles of six to eight such instruments. They're very, very loud. This is, to my knowledge, the first time it's ever been used in this kind of a context. It works tremendously well with strings, though, because it has such incredible resonance. Ornette understood the instrument in a very short time after I showed it to him; he wrote specifically for it, as he did for all the instruments. He doesn't write the same melody for a violin or viola or cello or mukta vena; he really gets into the gestalt of a particular instrument, the essence of that instrument, and when he's writing he writes with that in mind.

"He is in many ways like Charles Ives," mused Celli of the American maverick composer who spent most of his adult life as an insurance company executive in Hartford, and whose symphonies were rescued from oblivion by Leonard Bernstein.[1] "Like Ives, he has not had the opportunity of having a lot of performers dedicated to doing good performances of his works, and that's how composers learn, you know. They rewrite things. They have things performed and then they go back and revise."

Ornette, from the outset of his career, had considered himself a composer. "As I always tell everyone who books me to play, I consider myself a composer that performs," he told me in '87. "When I got my first Guggenheim grant I had written [in the application essay] that I wanted to write music; I've always really wanted to be a writer. The reason I've ended up being a performer is that when I wrote things in California they [Lester Koenig, Contemporary Records' owner and producer] couldn't find anyone who could understand the things I was writing.[2] They said, 'Oh, we can't play it.' And [Koenig] said, 'Can *you* play it?' I said yes, I took my horn and auditioned for him and that's how I got my first record date. After that I became known as a saxophone player in the public mind. But I've always basically wanted to be just as consistent as a composer.

"Now, this is a true story: Back in '62 I took all my life savings and went and rented Town Hall, and wrote a string quartet, hired a rhythm and blues group, and had David Izenzon, Charlie Moffett and myself [scheduled to perform]. I'll never forget, it was 1962, December 21, and that night there was a subway strike, a newspaper strike, a taxi strike, I mean everything was strike, even a match strike, know what I mean? Not only that, I hired a guy to record it for me, and [later] he committed suicide. I could tell you lots of tragedies that happened. But that was called [as released by ESP Records] *Ornette At Town Hall*.

"What I'm trying to say is that I started [writing chamber music] when I was getting such a bad relationship with the critics and the musicians because I wasn't playing the standard jazz, and they didn't want to support me. Club owners didn't

want to pay me, and I didn't want to get paranoid and evil, so I said, 'Maybe everyone just don't understand what I'm trying to do as a player, so I'll retreat and just start writing music.' I started writing *Skies Of America* at that time, and my first string quartet – well, I had performed it in '62 so I must have written it in '61, or something like that.

"Another thing that happened, I was with a licensing company that licenses your music for performances – I won't mention which one – but they told me I wasn't getting any loggings, nobody was listening to my music. And I was broke and starving. So I said, 'Well, how can I get someone to listen to my music?' And they said, 'Well, if you were in another category, like classical, maybe that would help.' I said, 'Oh, really?'

"I have always thought that music was the same; anyway, I never have classified music as being in different categories, so I went and started writing music that consisted of violins and stuff like that. And I went back to them and they said, 'Oh no, you can't change your category, you've got to stay in the jazz category.' So I left that [organization] and went to another one. But that didn't help too much, neither.

"I think most people classify you by what you do when they see you perform. In the context of drums and things like that, everybody calls that either a band, or jazz. When they see a violin or a French horn, they call that classical music.

"I really believe that any instrument can become the soloist's instrument in any kind of context, and maybe one day when we get tired of using categories and use names instead, and let that name be whatever is playing – like Europeans do their classical performers – I think we'll have even better performers and composers. Because right now, you know everybody might think that the reason I have Prime Time is to become more popular, but that isn't the reason. My reason was I just got tired of using saxes and drums in the regular setup, you know. I've been constantly trying to perfect my writing and share it with those that want to play instruments."

"Have you enjoyed working with these musicians who have so-called classical backgrounds?" I asked. "Do you find they have different interests in the music than the performers who come from the so-called jazz background?"

"Yeah, well," he answered, "what I find is that the musicians that you call classical are really thirsty to expand their musical expressions. It's less ego, and more musical interest. Whereas in jazz you have the person that's only interested in the solo image, and, you know, jazz is a kind of masculine image, where the classical music is more feminine *and* masculine. You see lots of ladies playing in classical, and if you close your eyes you can't tell which sex is which. But in other music, like jazz, that's not true. It's more like a masculine kind of setting. But I really believe that sound has no gender, so therefore, it works for me to be able to share what I'm writing with whoever wants to play it."

The jazz audience that was maturing in the 1980s had come to venerate Ornette, and one of their leading representatives among commercially viable musicians was guitarist Pat Metheny. Born in 1954 in Lee's Summit, Missouri – not far from Charlie Haden's hometown of Shenandoah, Iowa – Metheny had been a prodigy. When he dropped out of the University of Miami as a freshman, he was offered a job teaching there; he joined vibist Gary Burton's group when he was 21, and in 1976 released his first album on ECM Records, the label he helped prosper as a key sideman with diverse leaders as well as with his quartet, the Pat Metheny Group.

A long-haired white boy with a quick and clean, light-gauge guitar-string sound and an apparent preference for pastel colorations and pastoral themes, Metheny was initially looked upon as irrelevant if not mendacious by devotees of the black avant-garde – but he found an enormous and keen audience traveling by van across the U.S. with his Group, playing colleges and coffee houses where the black avant-garde had few fans. Metheny, however, was more multi-faceted than his early critics appreciated. His very first recording (in 1974) had been with pianist Paul Bley's quartet (also featuring electric bassist Jaco Pastorius, Metheny's roommate who would become famous in Joe Zawinul and Wayne Shorter's Weather Report); his 1978 ECM album *New Chautauqua* was a solo involving his overdubbing of multiple parts.

His reappraisal in the minds of jazz purists, though, started with the release of *80/81*, a two-LP quintet album with paired tenor saxophonists Dewey Redman and Michael Brecker, bassist Charlie Haden and drummer Jack DeJohnette. By December 1985, when Metheny made his label debut on splashy new Geffen Records with *Song X*, a full collaboration with Ornette also featuring Haden, DeJohnette and Denardo, the guitarist had stretched out considerably. Besides tinkering with his basic sound by experimenting with a guitar-synthesizer that offered an infinite array of timbres, he now counted among his musical associates the alto saxophonists Anthony Braxton and Lee Konitz, tenor saxophonists Sonny Rollins and Jimmy Heath, pianist Chick Corea, bassist Miroslav Vitous, Brazilian percussionist Nana Vasconcelos (who had collaborated with Don Cherry) and drummer Billy Higgins.

Song X[3] is from its first measures great fun to listen to and no compromise of Ornette's concept, but an unforeseen extension of it. The title track that opens the album in its original sequence is a characteristically acrobatic Ornette line, and after two unison-unisons – actually the same notes played at the same time by both Ornette and Metheny! – the two lead musicians launch simultaneous improvisations that hold their own side by side, and enlarge each other, too. When Ornette pauses, the intricate interplay of DeJohnette and Denardo can be perceived; when Ornette returns, Metheny ratchets up his game, which had begun at a high level of inspiration anyway. Just like Prime Time, this ensemble demonstrates a preternatural sense of ending, coming to a peak and phrasing in conclusion by invisible cue.

Haden, who had a hand in bringing Ornette and Metheny to the project, is a better-than-dependable anchor; as he walks steady quarter notes on "Mob Job" and

Metheny chords gently, Ornette is swayed to lighten his tone, and even slips out an intriguing violin passage (he had not used violin on his Prime Time recordings). But the album presents many dispositions: "Endangered Species" is a ferocious 13 minute rave-up, graced with Denardo's electronic ping-pongs and Haden's audible "Whew!" as well as full-out playing from Metheny (including a synth adventure) and definitive, completely unleashed Ornette. There is nothing Ornette craves so much as to be accepted and admired; the fervor with which Metheny – and DeJohnette! – imbibe his song and embrace harmolodics in this performance must have given him great joy, as he seems to give himself over to the rip-roar, then exultantly blows to stay with and rise above it. If the title of "Endangered Species" is meant as a warning, the music rather promotes self-immolation as flat-out exciting.

"Video Games" gives Metheny another opportunity to synthesize his guitar sound, but he knows when to lay out and let Ornette revel in the drummers' fury. "Kathelin Gray," like "Endangered Species" and "Trigonometry" (with more impeccable drumming) is attributed to Ornette and Metheny as co-composers, and is an exceptionally warm and relaxed ballad, a melody that would seem ripe for inclusion into the standard jazz repertoire.

One freedom that on superficial listening might seem absent from *Song X* – indeed, from most everything Ornette had recorded after *Science Fiction* – is the license to add a measure or drop one at whim, which he'd indulged while Blackwell or Higgins were his drummers. The orderliness of the rhythmic forms of this program (excepting "Endangered Species") is not a bad thing, but merits mention. The double-drumming Denardo and someone else usually provided in Prime Time may have been necessitated by Denardo's still-developing time-keeping skills or desired for the flexibility it allowed Tacuma, among others, to determine where the first beat of a measure fell.

On *Song X* there's little sense of measure lengths inhibiting or releasing the frontline soloists – certainly due to DeJohnette's expertise as well as Denardo's. The propulsion and pulse are palpable, but like framework might be taken for granted. Then, on the concluding "Long Time No See," Ornette rushes the beat, intermittently breaks it or rears back, pulling up. With Metheny laying out (or in, but decorously staying out of Ornette's way) he addresses himself as freely as he could care to, unspooling at irregular lengths ideas full of quirks and kinks, and plunging into a final recapitulation faster than ever. It's a wrap – of music that leaps without impulse-denying self-consciousness, as if it just happened to occur to the entire ensemble.

Song X is a kick from start to finish, and not least of all for Metheny, who plays neither placidly nor ethereally, nor does he brood. The guitarist brings princely talent and the abandon of a garage-rocker to his chosen task of coping with Ornette's sound – not just his concept – the better to enhance his own by discarding mannerisms and attaining an unmediated musical state.

As Ornette encouraged Denardo at ages ten and 12 to regard his untrained

thumping as legitimate expression, so he validates Metheny's eagerness to set aside preconceptions and let his fingers fly on intuition. The six tracks withheld from the original album due to space limitations but included on the *Song X – Twentieth Anniversary* reissue are extra pleasures – "Police People," "The Good Life," "The Veil" and "Compute" are first rate Ornette tunes that appear on other albums with different titles. Maybe the inclusion of "Word From Bird," with its wickedly difficult post-bop head opening into a jam free-for-all indicates the esteem Ornette had for Metheny and his delight with this project overall.

Throughout his career Ornette had demonstrated little interest in revisiting his past, maybe because memories of his origins were painful or because he was busy with his present. After his brief early '70s tenure at Columbia Records, he mostly financed his recordings (including those on Artists House and *Of Human Feelings*) himself, which may have been a cost-prohibitive proposition. From 1979 (*Of Human Feelings*) to 1985 (*Song X*, which was *not* self-financed), he recorded only two tracks in the studio, both in '84, one each for Jamaaladeen Tacuma's albums *Renaissance Man* and *So Tranquilizin'* on the independent Gramavision label.[4] *Opening The Caravan Of Dreams*, from '83, was an album from Prime Time's live performances, of course. In '86 Ornette played on one track of Jayne Cortez's jazz and poetry album *Maintain Control* (issued on her own Bola Press label, with Bern Nix, Albert MacDowell, Denardo and Charles Moffett Jr. playing tenor sax in her Firespitters band).

Jazz at large was undergoing a crisis of retrospection, initiated largely by the rise of Wynton Marsalis as a spokesman of the "young lions" who urged a reaffirmation of jazz before the incursions of funk, rock and electricity, a return to the jazz values of the 1950s and early '60s represented by Art Blakey's Jazz Messengers and Miles' music before the advent of electric pianos. A re-evaluation of that period might have spotlit the "change of the century" Ornette had claimed to have ushered in with Don Cherry, Charlie Haden, Billy Higgins and Edward Blackwell, and Ornette could have raked in substantial fees during the mid-'80s by recording and touring with Old and New Dreams, rather than Prime Time. But dwelling on the past held little interest for Ornette, and rather than glance back he tried to pull that past into the future by celebrating the thirtieth anniversary of his musical meeting with Cherry, Haden and Higgins and Prime Time as well on *In All Languages*, both groups playing the same set of new compositions on two separate LPs released by Caravan Of Dreams Productions as a double album.

"No one gets an acoustical sound with me but them," Ornette kvelled about the members of his "old quartet" in an interview over lunch at a downtown New York eatery; he drank Campari and soda and ate vegetarian pasta.[5] "The particular way that everybody played was like the way we were playing when we first started getting together. If they were playing with me consistently, we would reach the level of Prime Time."

Denardo Coleman amplified on the reason for the reunion. "Prime Time's been such an effort," he said, "and even though there's been a lot of interest in Ornette getting back together with the quartet, he only wants to do something when there's really something creative going on. He just decided it was a good time for audiences to hear his music in both contexts. Now the quartet has one sound, and Prime Time has another, but they really connect. It wasn't like the quartet got together for a couple of days to make a record, playing the same old thing. He really pushed them, like he does when Prime Time rehearses."

Getting the two bands together seemed to be a large part of Ornette's motivation. "I wrote a song called 'DNA meets $E = MC^2$,'" he effused. "We played it together in Boston — un-*believable*! We're not going to do it often, because it takes about an hour and a half. I wrote a theme for everybody; I let them each play on their own theme, then we mix and it's something else. It really is 'DNA meets $E = MC^2$,' believe me."

That composition isn't on *In All Languages*; the two bands didn't perform together on record nor in their 1987 JVC Jazz Festival concert at Town Hall, a festive and well-received event. After that gig Ornette took Prime Time to the Verona Jazz Festival, where it performed *Skies Of America* with the Sinfonica dell' Arena di Verona, conducted by John Giordano. Although Jamaaladeen Tacuma is on *In All Languages* and performed at Town Hall, he didn't make that trip; Chris Walker played bass (along with Albert MacDowell) in his stead, and remained with Prime Time for the recording of *Virgin Beauty* from late '87 and early '88.

The path to that album on Columbia Record's Portrait imprint and featuring guitarist Jerry Garcia of the Grateful Dead on three of the uniformly short tracks (suitable for radio play, though few radio stations of any format programmed harmolodic jazz), remains to be discovered. *Virgin Beauty* was well-reviewed when released (as was *In All Languages*). The rock world's interest was piqued by Garcia's contributions, though in fact he had not been in the studio with Prime Time, and Ornette's performance with the Dead at the Oakland Coliseum in February 1993 (as documented by bootleg tapes) was considerably more organic.

Regardless: Something had changed in Prime Time. Maybe the band's exposure to the "old quartet" had rendered it, too, old in Ornette's mind. By June, when the East German Broadcast Company recorded Prime Time's set at the Jazzbuehne Berlin '88, only Ornette, Denardo and Walker remained from the familiar cast; the rest of the personnel were brand new.

Prime Time remained a band of improvisers negotiating unpredictably accented, forward-rushing, pulsating rhythms and Ornette's melodies.[6] Their individual voices still tended to bunch up, snarl and then disperse like traffic on roads converging at a roundabout then splitting off in diverse routes to a common destination. Their harmonic palette regarded dissonance as an attribute of the larger, cosmic unison, and they still employed state-of-the-art gadgetry for modernistic purposes. They

were aficionados' darlings, booked into high profile engagements (the New Music America festival in Miami in December 1988, which among many performances across genres included the Kronos Quartet debut of Steve Reich's "Different Trains"; the New Orleans Jazz and Heritage Festival in 1990, at the Riverboat Hallelujah Ballroom). They won *Down Beat*'s 1990 critics' poll as "best electric jazz band."

But now conservatory-trained Chris Rosenberg and Kenny Wessel were the electric guitarists. David Bryant played multiple electronic keyboards, and self-taught Indian tablist Badal Roy sat on a rug stage front, maybe to maintain eye contact with Ornette. MacDowell was the lone bassist most of the time and Denardo played electric traps and drum-triggered samples ("When samplers were introduced they were for keyboards, so I adapted keyboard technology to percussion," he said.) According to Bryant, as well as Ornette, the band recognized no instrumental hierarchy.

"Ornette says he's getting rid of the accompanist," the keyboardist reported in a telephone interview, "by elevating the role to the soloists' height."

It also seemed to most fans that Prime Time's appearances had become rare.

"Well, for my father it's the quality of the presentation that's important," Denardo asserted. "When an offer's on the right level, we'll be there." Ornette had often asked for high performance fees, and at this point wanted concerts to be special occasions. Scarce as their gigs were in the States, Prime Time had two European concerts and performed *Skies Of America* twice in Italy during 1990.

"All our engagements are first-rate," guitarist Rosenberg said. "Ornette doesn't like to work in smoky bars."

"Unlike most musicians, he doesn't have the burning desire to connect with his public at any cost," Bryant concurred. "If Ornette could have us on retainer, available to rehearse day or night, he'd do that. Rehearsal is his favorite. He hates to commit himself to the public performance of a piece. It's like he wants to say, 'Yeah, ok, this is what we did this time, but you've got to realize it could sound like this, too.'"

Denardo explained that his father's rehearsals were "laboratory sessions where we test and get ideas. Everybody in the band's secure in their own voice, eager to add to the total sound. Of the new guys, Chris' and Ken's knowledge and command of their instruments is good, they're in harmony with each other and they're enthusiastic. David's been studying with my father quite a while, so he worked in naturally. The music's still opening up to him, but he had the vibe."

Bryant, who had been corresponding, phoning and visiting Ornette since 1982, and had first been invited to rehearsals in March '89, demurred. "I wasn't sure Prime Time had a place for me, but I figured someday he'd hire a keyboard player. One thing keeping that from happening was that nobody ever asked Ornette what he'd want to hear from keyboards. I thought he didn't use them for the same reasons I was frustrated with keyboard instruments – their equal temperament and

problems they'd create for him because of how keyboard players tend to phrase. There are advantages and limits to using keyboards."

To fit in with Prime Time, Bryant said, he'd developed a piano vocabulary of "split tones and slurs," and restrained his ten-finger abilities. On the road, he carried a Korg sampling grand piano with 88 weighted keys – "It samples electric piano sounds and other sounds too" – plus an Oberheim Matrix 6 synth "for ballads; it can replicate sustained strings and other ethereal things," sounds that Ornette had never previously had in any of his bands. In Bryant's analysis, "A lot of what Ornette freed up with his acoustic quartet was about soloing with chord changes. With Prime Time he's applying the techniques for soloing without changes for orchestral purposes."

"Ornette hadn't used keyboards since '59,"[7] said Rosenberg, "but he seemed to feel sufficient time had passed. He said with the introduction of synthesizers, 'The piano grew up.' David broadens our horizons, our timbral and pitch possibilities."

Rosenberg was recommended to Ornette in '88 and after unusual auditions (during one he improvised with Ornette on a Bach cello suite) suggested his duet partner Wessel for the "funk-bebop guitar chair." Both guitarists had advanced degrees from the Manhattan School of Music; prior to Prime Time both were mid-level freelancers, Rosenberg arranging for music-theater actors (such as his wife), Wessel touring with Athur Prysock's organ trio.

"Ornette gets you beyond licks and bags, to play yourself," Wessel said in a phone interview. "It's been good for me – I have more of my own voice than I did a couple years ago." He'd won his gains, he said, through struggle.

"Ornette likes the background of information and density. With seven people improvising spontaneously, you get some very exciting peaks, and also the opposite. It's a challenge to play, as well as to listen to. You can't predict the next thing, but if you open yourself up it takes you where you've never been in a concert before."

Badal Roy, the resolutely non-traditional tablaist who had broken into jazz with Miles in the early '70s (also playing on Mahavishnu John McLaughlin's *My Goal's Beyond* and in saxophonist Dave Liebman's underrated '73 album *Lookout Farm*) had changed his approach for Prime Time, though not his equipment: "I use at least five right hand drums, which are called tabla, tuned C-D-G-F and A-flat – Ornette plays in A-flat a lot – and two bayan, left hand, bass drums, which I don't tune to pitches, but should give a bass sound that touches my heart," he explained.

As for what Prime Time required of him: "With Miles it was: 'Start now, play one line, groove. Hold that one line on tabla,'" said Roy. "Ornette wants me to never play the same thing more than four times. I can get a groove going, but he says, 'I'm always changing; keep playing so I can keep playing around you.' For Ornette, 30 seconds of the same thing is too long."

Maybe Ornette didn't believe there was any such thing as "the same thing," and thought that repetition wasn't very harmolodic. Despite years of trying to explain his music, Ornette still felt it was misunderstood.

"Every time I read a review of my records," he mentioned during lunch, "it says I'm the only one soloing. That's incredible, because that's *all* Prime Time is doing. *I'm* the one that's stuck – *they're* the ones that are free. People hear the horn standing out in front and they think that I am doing the soloing, but that's just the sound of the instruments. When you hear my band, you know that everybody is soloing, harmolodically. Here I am with a band based upon everyone creating an instant melody – a composition – from what people used to call improvising, and no one has been able to figure out that that's what's going on. All my disappointment about it just makes me realize how advanced the music really is."

He tried once more: "In Prime Time the melody can be the bass line, the modulation line, the melody, or the second and third part. That's how I see harmolodics. That you can take any melody and use it as a bass line. Or as a second part, or as a lead. Or as a rhythm. I do that in all the music that I play."

Thirty-year-old bassist MacDowell, who Ornette had snatched out of high school in 1975, thought he got it: "Harmolodics is music before it's orchestrated. Jazz is live composing on the spot; harmolodics is that, but even with a melody it's not what you can play according to somebody else. If Ornette plays a C, he may be in C major, but maybe C minor or F, and he might be playing any of three clefs. Harmolodics is my interpretation of what his playing possibilities are."

In 1995 Ornette, wearing a snap-brimmed cap, mis-buttoned Andean vest, loose slacks, unfussy shoes and with a sprout of whiskers under his lower lip, sat in the midtown Manhattan skyscraper office of a vacationing Polygram Records executive, at once quite at ease and totally incongruous. Though emphatically more an artist than a company man, he was now at the helm with Denardo of Harmolodic Records, an imprint of international Polygram (to be precise, under Polygram's subsidiary French Verve) devoted to issuing his new works and back catalog. *Tone Dialing*, the first Harmolodic release, featured Prime Time, and stood out as one of the most delightful, musically abundant and fated to be under-valued albums of the '90s, reflecting both the decade and what music had become through Ornette's efforts.

Again, in the course of 16 tracks, he'd turned conventions, associations and expectations upside-out. The music was rooted in blithe melody, unbridled instrumental blends or juxtapositions and complex/compound rhythm (motion). He felt it exemplified the still-unpublished precepts of harmolodics, his unified field theory purportedly for all creative (not just musical) expression.

As applied to Prime Time, Ornette's idea was that all parts were created equal and functioned in a context of voluntarily democratic improvisation (as distinct from chaos or anarchy). In terms of how the music sounded, the premise was challenged by the pre-eminence of Ornette's own alto sax, trumpet or violin, which

were almost inevitably discerned as the music's focal point. Listeners tuned into Ornette even as Avenda "Khadijah" Ali and Moishe Naim declaimed the gnomic rap of "Search for Life" or guitarist Chris Rosenberg performed "Bach Prelude" to the tinkling bells, occasional rattles, off-beat tabla accents and processed drum sounds of Badal Roy and Denardo.

Actually, *Tone Dialing* (produced by Denardo) unusually spotlit each of Prime Time's players — Bryant in a full two-minute chorus opening "Kathelin Gray," Wessel on "Local Instinct," "La Capella" and "Miguel's Fortune," Badal Roy on the eponymous "Badal," bassist Brad Jones with a Hadenesque intro to "When Will I See You Again." It is also possible to listen to any one or any set of the musicians throughout, or the ensemble as a whole, and discover coherent interpretations of/perspectives on Ornette's durable themes. Though Ornette is commanding on trumpet and violin as well as alto (additional parts underlie his sax at points) this Prime Time does cohere as a unit, making Tone Dialing as much of an ensemble triumph as *Science Fiction*. Bryant, both guitarists, both bassists, both percussionists and the guests on "Search For Life" (Chris Walker is credited with bass and keyboards on it) make essential contributions. This album, mixed with transparency to reveal its sonic depths but also bearing an attractive surface sheen, glints from within, diamond-like, however it comes to the ear or mind.

Besides covering Bach and revisiting his own compositions, Ornette draws on energies associated with hip-hop, Central American music, rock, musique concrete and blues throughout *Tone Dialing*, for an album that seems pan-idiomatic. For all Denardo's fast, propulsive drumming, Badal Roy's tonal percussive work and a myriad of percussion details, the music is not as rhythmically invigorating as *Of Human Feelings*; it seems more deliberate and self-consciously elaborate, making a unique place for itself in Ornette's catalog, monumental and cross-disciplinary in a manner *Science Fiction* foreshadowed. It aspires to be a truly universalist tract, demonstrating by all it subsumes how far-flung traditions manifest a single inherently human culture.

But the album is irrevocably '90s, too. It's flush with the hustle and chatter of healthy commerce; it's as multi-racial and omni-ethnic as a parade of representatives to the United Nations; it's so high tech that every tune leaps into cyberspace, and so funky — the opposite of ethereal, pristine — that no sound slips its ties to earth. The 66-minute program is also radically optimistic and forward-looking, although the music also has a core of vulnerability, inevitably, as it relates to the expending of energy and the exhalation of breath.

Ornette here seeks to validate through music each individual's and all peoples' perceptions and abilities, insisting that we all have unplumbed capacities for comprehension, compassion and maybe activism. With its title evoking the worldwide-web of communications that emerged contemporaneously, *Tone Dialing* promotes

the belief that our being in touch with each other does not in any way diminish each person's individuality, but rather provides us with infinite resources and exponentially increasing viewpoints. An "ethnical civilization of all world citizens" is Ornette's rainbow prophecy, and as this happy music projects it, we open our minds.

In an attempt to awaken audiences to his convictions and the untapped resources of the mind, Ornette didn't rely only on Prime Time; he had begun to concertize with more than one of his bands, as well as dancers, mimes, acrobats, contortionists, slide-shows and videographers in attendance. At the San Francisco Jazz Festival in November 1994 camera-operators swooped around the stage of the Masonic Auditorium as he played with his New Quartet, featuring acoustic pianist Geri Allen. After that opening set, just as the band left the stage and before people exited for the intermission, three people strode out to the floor in front of the stage. Spots picked them up, as at least one – a local shaman named Fakir Mustapha – doffed his shirt, and his associates began to penetrate the skin on his face, chest and back with skewers, in a previously unannounced demonstration of body piercing.

Cries of shock rang out from throughout the theater – to watch this event was no less excruciating because the subject of the piercings was a volunteer for an evidently ritualistic and bloodless act. I shivered to see it, as if my own body experienced some kind of empathetic somatic response. Some ticket holders rushed for the lobby, or the washrooms, retching. Others sat still, stunned.

Then a small, white-haired black man announced as Vincent Harding came onstage, and as the auditorium quieted out of some automatic sense of respect, he began to orate in the measured, clear voice of a practiced preacher. Dr. Harding had been associated with the Reverend Dr. Martin Luther King, and was a professor of "religion and social transformation" at Illiff School of Theology in Denver, Colorado. He calmed the crowd with a poem that referred from the start to "tone dialing" – a meaningless phrase to us, as this was before the album was released, and no one knew it was Ornette's title.

> We dial and we wait.
> Wait for the tone.
> Wait for it to come from somewhere.
> Wait for it to come,
> familiar,
> reassuring,
> letting us know that it's time to call.
> But even as we wait, as we wonder, as we listen,
> as we watch, as we feel,
> even as we tremble in wonder,
> something tells us that

we are the tone,
we are the dialing.
It is shaping, rising, whispering,
screaming even as we wait.
It is coming from deep down inside of us.
We are the tone.

As Harding developed his theme, he called for unity and understanding.

In all our colors and our histories,
in all our female and maleness
in all our brokenness and wholeness
in all our piercing and healing,
we are the tone.

At his mention of the piercing, there was laughter — the laughter of tension released. He won over everyone listening as he declared,

There is no tone unless we are prepared to hear the
shouts and screams and all the deep silences within ourselves
and within the other instruments of the great human
humanizing force.

He compared tone dialing to people spinning with the planet and leaping toward the stars. He told the assembly:

It is time to call.
To call ourselves.
To call each other.

He acknowledged that such dialing might transpire with "fear and trembling," but prophesized that those who dialed would

. . . open from within like a lotus in a sea of fire —
saxophone fire, drum fire, bass fire, piano fire,
guitar fire, tabla fire, soul fire, dancing fire, fire dancing.

We'd hear unfamiliar tones from Asia, Africa, Latin America, Europe, he told us, and also suggested, "We are yearning for the opening-up tone," and that this was "the new dialing . . . the new tone . . . the new nation." He encouraged those waiting to call on the saints —

> Like St. Carmen McRae and
> St. John Coltrane,
> St. Martin Luther King,
> St. Malcolm X,
> St. Dorothy Day . . .

and he accepted a suggestion from someone in the audience to sanctify Sun Ra. He lectured that

> The new nation has already begun to arrive.
> It will not be held back, not by hundreds of propositions,
> not by millions of dollars . . .
> We will never turn back
> and we'll take our most endangered children with us.
> . . .
> Can we hear it? Can we feel it? Can we *be* it?

It was a most effective use of rhetoric. He concluded:

> The saints say yes!
> And if the saints say yes —

— his voice rising triumphantly, to express a sentiment first penned, to my knowledge, by Ira Gershwin[8] —

Who can ask for anything more?

Harding's appeal to atomized concert-goers to consider themselves a unified community, his notes of hope and optimism, swayed an audience that only moments before had been infuriated, had felt violated and would likely have turned against Ornette, whom they'd correctly assumed had invited the body piercers to their festival outing. But the next minutes proved Ornette was not entirely wrong to do so.

The taboo the audience had seen broken had shaken it out of complacency and into demand of answers about why such an apparent outrage had been perpetrated. We felt wounded, as if the piercing had been of ourselves, and so were ready to reach out to each other, or at least accept a stranger's poem as a balm. When Harding ended his speech there was tremendous applause, and then Prime Time played its set.

Seldom had I seen an audience so suddenly attuned and eager to absorb whatever would be presented. Dissonance was not now irksome, or even registered as dissonance — conventional harmony, conventional music would not have been enough

to satisfy, much less sooth, those who'd been distressed. Now the audience saw the players onstage as people like themselves, individuals making music with care, working together towards desired ends. We felt rapport as people do after a shared experience of real meaning, whether tragic or victorious – maybe because we wanted or needed that connection with others, maybe because we had been encouraged in that desire, even pushed to have it.

I don't recommend that other bands use body piercing as a ploy to sensitize listeners, but Ornette's gamble paid off for everyone who stayed through the concert's second half. We'd experienced more than a concert – we'd been delivered a harmolodic revelation. He had reached us – maybe unfairly, as music should be able to shake up listeners without resorting to spectacle or tricks. But Americans in the late twentieth century, as now, were constantly inundated with spectacle by commercial and political forces, and could easily be victimized by media tricks. In terms of tone dialing, Ornette had our number. If it took body piercers, fire-eaters, those who walk on glass or those who improvise music freely to awake people to the wonder around them, so be it, he seemed to say. Better to see and to feel than to sit dully, cozened, in a smug and self-absorbed state.

"I have always understood I have not stopped thinking of pop music like the Rodgers and Hart and the George Gershwin styles," Ornette said from his borrowed seat in the PolyGram offices. "I think they're very fantastic composers, but I also realize that the word 'composer' don't necessarily mean you're advancing. You have to be an expressionist. I call myself a composer, but I don't stop thinking I can advance in what's being played.

"In fact, one of the problems I've seen in Western culture is that most composers don't improvise their music as strong as a jazz person could, taking something that's Tin Pan Alley. The way jazz music has benefited American music by addressing the composer's form with greater expression has made jazz have two different faces. Basically, a jazz musician hasn't had to be a composer to improvise. Which makes me realize more and more that when a person says, 'You don't play changes, you don't play chords', what they're really saying is, 'You're not writing in the traditional form or the American song form'. Am I right?

"I'm doing what I'm doing in the same quality of form. It's just that instead of me writing the melody using the same changes, the changes are different and the melody is different. The form is the same. Now, rap music is putting some energy into the improvised music and composed music in today's society," he postulated, "Because it's the real street opera. We have a rap song ["Search For Life"] on *Tone Dialing*. You realize it's my band, we're playing the same, and I'm not playing any different than I do on any other song.

"Most rap songs are just a voice and a rhythm. It doesn't have complicated movements and stuff – that doesn't mean it can't, it just hasn't. There's an art form there.

Like jazz has grown, it's going to grow. It's going to take more composers to analyze it for that to happen. But we [the harmolodic "we"] will not allow any prejudice to be in the way of the energy of the expression that can be shared, which we call removing the caste system from sound." Caste systems and such imposed hierarchies, he believes, work against love and equality.

"Basically," Ornette declared, "what we experience from things that have social and human value is something that makes us feel good. Makes us appreciate it, or whatever. That really starts with love. If you find someone you love, regardless of which they are or what sex they are, if you love them, you love them. That doesn't mean everyone is going to appreciate you doing that," he knew quite well, "because of *their* relationship to what *they're* doing."

Ornette's comments veer to the speculative, metaphysical and, yes, sometimes unfathomable; his music does the same. He wants listeners to peer beyond the accepted superficiality, the common assumption – or at least consider that quest.

"All information has something to do with changing its form, its appearance, to have a wider relationship to those that can use it," he suggested. "Look at John Cage. He went to the point of having four people read from a book with a generator playing,[9] and that was advanced information that had to do with music being in the form of words. That transformation of information is something I understood when I was four years old. I remember trying to do something I saw my mother and sister doing, and they like to beat me to death. They said, 'No, you can't do that, you're a little boy.' I said, 'But you're doing it, and you're laughing.' Ever since then I've been aware that human beings do things that translate into other things you can do that might not have the same shape and form you find when they were originally done. To me, harmolodic music encompasses all those things.

"I think of communication as a form of energy that allows everyone to have the same equal time or position, and I call it harmolodics, a noun. Harmolodics is like a color that has sound, alphabets; it has a gravity in it that works the same way that thinking is to talking, or the five senses are to presence.

"If you think of the five senses in a harmolodic way, smell is presence, taste is clarity, hearing is receiving, touch is action and sight is territories [these equations are printed as part of the liner notes of the CD *Tone Dialing*]. In harmolodics, those five things each also have five different things, as in music the four basic voices that have to do with sound – soprano, bass, alto and tenor – each has the same four sounds. The alto has a soprano, the alto has a bass, the alto has a tenor and an alto." He spoke of the instruments' octave ranges, the spread of their registers.

"When I was working on bebop music, and found out that the piano was more from the treble clef more than from the voices, I discovered what makes every musician unique is when they line up those voices into sound. Some people call it chords, some call it changes, some call it modulations, some call it melody, but that's really what it is. It's like that *Time* magazine cover where they had taken photos

of people of several races and made one face – the person looked like they were Filipino – and said, 'This is what it would look like if everyone was mixed.' Well, isn't it amazing that there's someone already like that who didn't have to be mixed? You know what I'm saying? That's harmolodics."

He took a breath and looked squarely at me.

"I've had hundreds of interviews, and I don't think any of them have helped me do anything yet. What I mean by helped me – someone says, 'I read that interview, but I can't do nothing for you.' I get a lot of mail but it's never from something that I've said, it's always from something someone has heard that they liked that I'm doing. Am I defeating myself by having interviews?"

The interest I was showing must have eased his mind on that account – at least he kept talking.

"I want to say this: in 1960 someone at Atlantic named the record I had called *Free Jazz* and all that music was written out, except for the fact that when you write a song, even a pop song, a jazz song, after the people play the melody, you improvise, right? Well, in 1960 in America that was like the most fantastic concept of improvised music that had ever been heard on the planet, because a person that didn't know no music at all picked up an instrument and played how he felt, without relating to anything!"

Ornette shook his head, bemused. "Everyone thought I was doing that, but I had already done that when I first picked up the horn. Then I realized I had to play with others, and I started analyzing what I was doing so that I would be able to do it better. By the time I had gotten to the point of making that record [*Free Jazz*] I had already gone through that hue, four times – maybe ten times – shading. What was called free, for me, was no more than me having a full stomach. I was already complete. I had started playing like that in the '40s.

"Did I ever tell you how I got to write 'Lonely Woman'? I was working in Bullocks' department store in Los Angeles as a stock boy, in 1952 or '54, and I went down on my lunch period and came on a gallery. There was this white lady in a picture with the most shattering expression you could see on her face. In the background there was everything you could imagine that was wealthy – all in her background – but she was so sad.

"And I said, 'Oh my goodness. I understand this feeling. I have not experienced this wealth, but I understand the feeling.' I went home and wrote 'Lonely Woman' and I said, 'From here on I'm going to support artists no matter what they do – because that artist sent a signal out. That's not just a painting. It's a condition.' I related the condition to myself, wrote this song, and ever since it has grown and grown and grown.

"Now, I don't have the same relationship to that as to the word 'jazz'," he went on, "which had to come from an advertising person. Like I had the record *The Shape Of Jazz To Come* - every time I look up I see 'The Shape Of Something'. It's just a

thing people catch on to. Someone said '*Free Jazz*' and everyone figured, 'Oh yeah, I know what that is: just take your horn and play.'

"I was already being a person that was exposed to taking that burden on myself, so someone put that stamp on me and said, 'Go out there and represent this.' When I heard guys playing what was free, I would go, 'Oh, this is really something.' And then I would sometimes play with them, and I would play to try to make it sound like not only was it free, but they don't have to worry about making a mistake.

"When you hear *Tone Dialing*, you won't believe this but the melodies and the improvising all sound equal, totally equal. Everyone is playing to the fullest of their ability to relate to the overall feeling and information you hear. Whether you want to believe this or not, the only reason other music doesn't have those same outlets is because the style of language limits that.

"You know what's really interesting to me? For the last 25 years I've always wanted to be known as a composer, but I've been mostly classified as a saxophone player. One reason I know is because as a minority and being labeled playing jazz . . . Well, I never told anybody that I was black, they could see that I am. I never told anybody that I play jazz, neither, but that's something that has been identified with me on stage, like blues, or whatever. I'm talking about conditions, right? But one thing that I am sure of: When I say something about something I've done musically, it speaks for itself.

"When I was looking to change my band, form the second Prime Time band, I went looking for a classical guitarist, for a lead guitarist, for an Indian tabla player. When I found Chris Rosenberg I said, 'What is your favorite classical piece?' And he said, 'Oh, I just love this Bach prelude.' I said, 'Play it for me', and he played it. And I said, 'Ok, I'm going to take my horn and interpret that piece harmolodically; don't tell me nothing about it, the key, the changes, nothing.' I did that and when I got through he said, 'I'm going to join your band. How did you do that?'

"I started explaining to him some things I'd found out about music. What I expressed to him was that my own melodies, anyone's melodies, anyone's harmonics, are just some information that's labeled something at the moment for you to be able to absorb what you want to do with it at the moment. Even in my first Prime Time band I was never thinking about having an electric band, or a rock band, or a jazz band – I just wanted to have the largest composing sound. I still do. That's why what I'm most concerned about now is the idea of using any instrument to make some musical information from, whether it's a violin or French horn. In fact, I saw a Scottish guy playing the bagpipes and he was playing some advanced bebop, though he was probably thinking it was Scottish.

"The point I'm trying to make is that classifications of music limit what you can appreciate. And, being a player, I decided I was never going to just think about the caste system in music.

This caste thing bothers Ornette big time.

"The one thing I have done more than trying to get my jobs playing music is find an environment that had a belief in something that didn't have to depreciate what a person was, what a person does, what a person has and what a person wishes to be," he emphasized. "I've always been trying to find that environment. It usually appears under the heading of philosophy and religion.

"Every time I hear about something that has to do with an individual being natural but at the same time sharing what they believe, I want to go and join them, because I think that's the healthiest way to feel normal about who you are and what you believe. Whereas in the business of what we are doing now, me having this conversation with you about – you came to interview me about what?"

Music and your activities.

"That's a little different topic. Let's stick to music. Regardless of what your nature provides you with in relationship to people, everyone's nature in relationship to music gives you the impression they're getting the same quality from it. Not in the sense of their behavior, but in the sense of why they're using it or why they like it, why they enjoy it.

"Now, think of jazz music: The improvising qualities that Louis Armstrong brought to tempered notes someone labeled jazz, and they realized that he was improvising. But improvising in the classical field is not the same thing as improvising in the jazz field, though the word means the same. Is it a racist word, in the sense that it means one thing to you and another to me, but we're doing the same thing? If a classical person improvises and a person is improvising in jazz, they're both improvising, so how can they be different?"

Your work shows they're not different.

"That's my point. Since we're starting to put out a label and have a relationship with people that write and sing and compose music, I've been working to approach that concept without thinking of a casteing relationship to it. In other words, to remove the caste system from all forms of expression, to remove our caste system from all information. I have been practicing that in sound as well as in humanism."

More rueful than bemused, he says, "It's something that your environment decreases who you are. A person figures if you're around in mud and I'm around in mud, you must be just like me. And that's not true. I mean, I have never changed from who I am. I don't even know that I've changed. I've always been this way. For instance, I got a scholarship to go to college in the South, and I grew up with all these little black kids, their asses hanging out, they're starving and on welfare and all, but when I got to the college, they all acted like they're Einstein, like they'd never been hungry, like their asses was never out – and I said, 'Oh, I don't want this influence. I'm leaving this. I want to teach myself whatever it is to become an adult. If I'm wrong, I'll find out I'm wrong.' And I never went back to that.

"I think any human being that has had an experience with another human being

that made them feel that they didn't have any identity of their own turns it into so many things – that's what makes people racists and all the other stuff. They have been hurt from something that they couldn't do nothing about, and now they're passing it on to you, regardless of what race they are. That concept comes from a caste system, and if religion can't erase that caste system, maybe human beings can.

"It would be really good if the true concept of being what is called a human being was that you didn't have to worry about what group you should be with and what you should be doing, but that you have something to say and all you want to do is find the environment where you can say it in the clearest manner. Then people of all energies could come and share the information.

"What I'm really talking about is how the twenty-first century could really become something for all the people who existed before, who made it possible for us to have these kinds of insights. That would really be a very advanced civilization. Because love is not going to go away because you get smarter. It's going to get more and more freer, right?

"The ultimate goal for human beings, obviously, is for everyone to find the Garden in themselves, without any prejudice. The people who've started on that journey have got a head start, but that doesn't mean that everybody's behind.

"I'm no different than anyone else," he avowed. "I'm no better and no worse. I've just been born in America and come to understand that the one thing that's true about human beings is that there's something everyone's inspired to do and to become, and there's so many choices as to how you can get there. Because obviously the graveyard is not the graveyard. It can't be. Something existed before that, so where's that? Isn't that true? Something existed before the graveyard, so where is that? It's not real estate."

In July 1997 the totality of Ornette's world view became the focus of New York City's annual summer Lincoln Center Festival, a cross-genic international celebration of music, dance and theater, with the presentation of four nights of the composer–performer's art under the umbrella title *?Civilization*. The centerpiece of the prestigious events was meant to be the collaboration of Ornette and Prime Time with conductor Kurt Masur and the New York Philharmonic on two full performances of *Skies Of America*, an hour and a half work of daunting contrasts and challenges.

At every turn of the score of the symphony (more properly, concerto grosso) the traditional Western orchestra and the self-contained commando corps of improvisers faced their differences in aesthetics, fundamental structures and approaches to harmony, melody and rhythm. The first of the two concerts was imbued with stately grandeur and an air of daring, the second more assured and streamlined. In both, the Philharmonic and Prime Time alternated in frank opposition – though not

necessarily enmity – with infrequent simultaneous activity, and eventually adopted a policy of mutual tolerance in lieu of merger or resolution.

In its 1972 recording, produced by Ornette's cousin James Jordan, *Skies* was altered from its composer's original plan. Due to British musicians' union restrictions, Ornette alone, without his touring band, was juxtaposed with the London Symphony Orchestra, and this reduction poses the work as a struggle of one man against a multitude. The Columbia recording of *Skies* (issued for the first time on CD in 2000), comprises 21 movements with titles including "Native Americans," "The Artist In America," "The New Anthem" (complete with allusions to "The Star-Spangled Banner"), "The Men Who Live In The White House," "The Military" and "Love Life." Though at moments this rendition recalls the grandiosity of a 1950s soundtrack for a movie epic, Ornette's blowing is tart, and its 41-minute length does not seem to eliminate anything essential to the point. Although unauthorized tapes of John Giordano's re-orchestration as performed in Fort Worth in '84 and in Verona in '87 circulate, the only other recording of *Skies Of America* issued has been the 11-minute and 30-second opening segment of Prime Time and the Verona orchestra, as a supplement to the Italian periodical *Musica Jazz* in June, 1996.

The Lincoln Center festival's scheduling of *Skies*, plus a following night of Ornette in small group settings with old and new associates and a concluding evening of Prime Time in full regalia, was intended to elevate the reputation of the Einstein of harmolodics. "We hope . . . we can do our part in establishing his artistry in the mainstream of American music," festival director John Rockwell, a former cultural reporter for the *New York Times* (to which he would return) wrote of Ornette in program notes. He'd been on the Ornette beat for at least two decades. Thirteen years before he had attended the opening of Caravan of Dreams and raised one of Ornette's harmolodic dictums for explanation during a breakfast interview the night after John Giordano conducted the Fort Worth Symphony in *Skies*.

"You said something about there being as many unisons as there are stars in the sky," Rockwell reminded him. "Does that mean that the way your ear hears what some people might think of as dissonance, you hear as a unison in some way? In other words, you hear almost any combination of notes as valid in itself?"

"That's right," Ornette answered. "Not only that, but when you hear something that irritates you, it's the placement of that irritation into your own environment that makes you realize it has no meaning to how it's being used. In relationship to an idea – whatever causes you to think or feel – that irritation is not programmed because it is safe or secure, but to get things done."

"Let me ask another question," Rockwell requested. "Is harmolodics basically what you instinctually feel, and now you've got a system to explain what you instinctually believe?"

"That's right," Ornette responded, then told the story of Miles sitting in with him at the Five Spot in the late '50s, and afterwards telling the press that Ornette

was "all screwed up." Ornette interpreted this comment as Miles' rejection of the language he had developed with Cherry, Haden and Blackwell. He appended his understanding of the story of Babel: "In the Bible they say once everybody was speaking the same language, and God said, 'You can't get to heaven with the same language.'"

"Is harmolodics trying to get back to talking about the same subject but in several different languages?" I interjected.

"I think everybody's saying the same thing," Ornette replied, "they're just at a different place."

"What you're saying is that harmolodics is a system that's so universal that it allows each individual to do what they instinctively feel, and it fits into the whole?" Rockwell wanted to know.

"Exactly," Ornette approved. "You know what I want to do is get a harmolodic orchestra together. People who read music don't get an opportunity to improvise, but there's such a thing as improvised reading, which means you have the right to change the octave at any place. The only reason orchestras need conductors is that every person has a tendency to phrase something differently than any other person, so the conductor keeps them all together. But that's not really necessary, because if they go home and play their part, they're going to play it that way whether the conductor's there or not."

From left: John Rockwell, Howard Mandel, Ornette, 1982, Fort Worth ©1982 Lona Foote.

"The conductor is the guy who destroys all the different unisons by making all the individual members play one way?" Rockwell proposed.

"That's exactly right," Ornette repeated. "And that's what I was trying to get John Giordano to try – which he did, but we didn't have enough time to really do it." Rockwell must have at least been curious about Ornette's harmolodic initiative to have helped him get another try.

As music director of the Philharmonic, the 70-year-old Masur, a native of Brieg, Silesia,[10] programmed Aaron Copland's "Fanfare for the Common Man" to precede *Skies* at the Lincoln Center concerts. Ornette had chosen excerpts from the writings of Martha Graham, Puritan preacher Jonathan Edwards and poets Walt Whitman, Langston Hughes and Joy Harjo for a program handout to foreshadow the deliberate density, drama and primordial dissonance of his 25-year-old *magnum opus*.

Upon Masur's downbeat *Skies* initial orchestral theme unfurled, voiced principally by the strings over an unsettling kettledrum tattoo, rolling in like thunderheads. The theme was darkened by low brass and woodwinds; it twisted suddenly, severely, into a peak, then returned to its elegant pace on the backs of a cluster of walking basses. After a breath-length pause, Prime Time was ushered in by Ornette's beseeching alto sax.

Kurt Masur conducting the New York Philharmonic, and Ornette, 1997, New York City © *Jack Vartoogian/FrontRowPhotos.*

193

The juxtaposition was sharp: gone was a stark, modernist American symphonic vocabulary John Giordano had extrapolated or Ornette maybe cribbed from earlier twentieth century composers (Ives, Copland, Roy Harris, William Grant Still), replaced by the harmolodic re-envisioning of ensemble dynamics, interactions and reflections practiced by Denardo on traps, Badal Roy, Al MacDowell, Brad Jones, Chris Rosenberg, Kenny Wessel and David Bryant with boldly-clad Ornette (who has a suit of eye-catching fabric specially tailored for each of his performances) at their lead.

Mixing Prime Time was always a trial for sound engineers and the concert venue, hangar-like Avery Fisher Hall, did not afford the amplified instruments clarity or timbral parity with the orchestra. But Prime Time repays active listening, and on this occasion attempts to penetrate its sonic tangle were rewarded by intriguing combinations of sounds – harmolodic unisons – and the disclosure of a multitude of melodic details. Audience applause after each of Prime Time's bust-outs emphasized *Skies*' blocky structure, interrupting the flow Masur and Coleman might otherwise have sought for it – still, the globally renowned Maestro was undeterred. Masur guided, cajoled, danced and eventually *willed* the Philharmonic through Ornette's unfamiliar rhythms, striking angularities, passages of raucous polyphony and even lighthearted tunes like the Moroccan-inspired motif that was the basis of *Dancing In Your Head*.

Other pieces Ornette's followers recognized from his repertoire emerged, including "What Reason Could I Give"; Ornette also alluded briefly to "The Star-Spangled Banner." Though powerful, *Skies* remained problematic: later movements seemed to repeat and impede, rather than advance, its progress. But by then the ensembles had warmed up and Masur had gained a firmer grip on when to cue in the orchestral passages. Engaging with *Skies*' insistently idiosyncratic elements by exerting a personal stretch, the conductor rendered the entire piece as imposing, polished and mostly vibrant. Few of the orchestra's individual members stepped forth to contribute personal cadenzas, a feature of the Fort Worth version, and episodes scored for small groupings from within the Philharmonic did not stand out as prominently as in Giordano's Verona version, but both New York performances were well-received by the audience, full of Ornette's loyalists if not New York Philharmonic subscribers or Masur fans.

For many loyalists, the first half of *?Civilization*'s nominally "acoustic jazz" concert, on the mini-fest's third night, was incomparably more gratifying. Ornette perched on a stool with his alto, trumpet and violin, buffered by no intervening form or content, in free play with bassist Charlie Haden and drummer Billy Higgins. The three master improvisers communed with what registered as effortless spontaneity, sublime taste and unpretentious, life-affirming profundity, in perfect balance, to distill the beauty of every moment. It seemed like a glimpse of harmolodic heaven, like sunlight illuminating meadows of cumulus clouds spreading forth eternally – leading

anywhere but the graveyard. The house mix was viable: the quietest comments from Coleman's ravishing, earthy saxophone could be heard, as he voiced beautiful ideas, conceded his vulnerabilities, shared intimacies and certainties, chuckling, moaning, confessin' the blues and offering its consolations in upward-yearning phrases and songs all humans might understand.

Though self-effacement ruled – Ornette never let slip one gratuitous honk or superfluous trill – he was the apex of the triangle completed by Haden's solid tone and immaculate time, and ineffably joyous, swinging Higgins. The drummer was still healing from his recent liver transplant, but applied his sticks, mallets and brushes to cymbals and drumheads with graceful economy. No tune titles were announced; Ornette extemporized in his personal idiom, offering a wealth of characteristic motifs, hiccup-hops, bluesy wails and hypnotic, wending lines.

After the intermission, trumpeter Wallace Roney tried to contend with the legacy of Don Cherry, who had died two years previously, capturing some of the much-missed pocket trumpeter's signature phrases, if not his playful invention. Pianist Kenny Barron delivered the single-note fleetness of late '40s piano innovator Bud Powell to Ornette's more open concepts of harmony and equilateral group improv. Ornette demonstrated his fondness of late Billy Eckstine-era roadhouse blues crooning by introducing a smooth male balladeer, and his interest in Ellingtonian chamber jazz/art songs via a woman vocalist with classical diction and pin-point intonation. The two singers indulged a sugary love lyric and the instrumental quintet

Ornette and Prime Time, 1997, New York City © *Jack Vartoogian/FrontRowPhotos.*

ended with Ornette's 40-year-old blues "The Turnaround" – a set some steps short of heaven.

After the apotheosis of Ornette's reunion trio and pretensions of *Skies, ?Civilization*'s fourth night, a bacchanal billed as "Tone Dialing," was dizzying. Prime Time dove eagerly into its repertoire. The band's rhythms, on the surface relaxed, were at core hot and grinding; its ostensibly simple themes perpetrated a labyrinth of possibilities; its at-first-contact convoluted arrangements, upon a few minutes' attentions, revealed themselves transparent and lucid.

The band played without losing focus as dancers swirled around them, jumping on broken glass and remaining unhurt, and fire-eaters came out from the wings. A film montage of world-ranging curiosities and atrocities was projected on a scrim. Lou Reed, bad-boy singer–songwriter long ago of Andy Warhol's Velvet Underground and performance artist Laurie Anderson joined the band in guest appearances; her voice-processing synth-speech was a better match than his street-punk ruminations for Ornette's exploratory sensibility.

All these added attractions were hard to bear, and did nothing to enhance the essence of Ornette. Much of his music throughout *?Civilization* was breathtaking, simultaneously provocative and a balm. At his best and at his most ambitious, Ornette had been guileless and transporting, acutely perceptive and compassionate about where humans stand, how we communicate, what we long for – the shapes, tones and colors of our vistas, what we look for from the skies.

Honors

In 1996 Ornette issued two CDs titled *Sound Museum* on his Verve/Harmolodic imprint, one designated *Hidden Man* and the other *Three Women*, both comprising performances of the same titles[1] with an acoustic quartet featuring pianist Geri Allen, bassist Charnett Moffett and Denardo. The quartet had debuted shortly before their appearance at the 1994 San Francisco Jazz Festival. Ornette also played two duets with Allen on her '97 release *Eyes . . . In The Back of Your Head* (Blue Note), which on other tracks featured her husband Wallace Roney and Brazilian percussionist Cyro Baptista. In '96 he recorded a full program of duets at a concert in Dresden with pianist Joachim Kuhn, and it was released on Verve/Harmolodic as *Colors*.

Earlier in his career Ornette was famous for shunning keyboards as tempered, chord-capable instruments that restricted his freedom of modulation (shifts from one key to another, which he liked to do at whim within a solo) and movement (as pianists were used to asserting the changes of chords underlying melody lines in regular cycles, and Ornette wanted to liberate his lines from such predeterminations). In the course of 40 years, though, pianists had developed new maneuvers compatible with new options and objectives. To some extent this was directly due to Ornette's revolt against harmonic fixity, but Cecil Taylor's influence on pianists of

the era cannot be overestimated, and the contributions of Muhal Richard Abrams, Paul Bley, Jaki Byard, Chick Corea, Marilyn Crispell, Herbie Hancock, Andrew Hill, Keith Jarrett, Don Pullen, Lennie Tristano and Joe Zawinul, among some others, should not be overlooked.

Allen and Kuhn, in their recordings with Ornette, exhibit very different ways of relating to their instruments. In brief: Allen uses fascinatingly lyrical ambiguity and elusiveness; Kuhn deploys a bounty of technique to fulfill his impressionistic inclinations. In neither case do the pianists dominate the music's content or flow; they are full partners, however. The measure of Ornette's mastery with both of them is his ease in creating unisons. To do so he draws on a wealth of emotional empathy and original, imaginative melodic ideas, instantaneous speed of response, sensitivity to the weight and space of information and alto sax instrumental ability on par with, if not beyond, the immortal Charlie Parker's. Ornette sounds only like himself, but he seldom plays the same thing twice (there being no "same thing," no same river to step in even once). He never coasts; he's always in the moment. He doesn't race or compete with his collaborators, ego contests being of little interest to him. He wants to make music collectively – not alone.

But the company he chose to keep changed again. In summer of 1997, ?Civilization was booked into the Perugia Jazz Festival in Umbria, Italy, but without a performance of Skies. There Ornette played with Indian classical musicians convened by Badal Roy, and besides leading Prime Time, participated in a once-only quartet with Haden, Higgins and one of the few altoists capable of going head-to-head and not making it a battle: Lee Konitz, three years Ornette's senior, who had recorded "Intuition" and "Digression" – often cited as the first examples of unpremeditated improvisation – with Lennie Tristano in 1949.

Perugia might have been the swan song of Prime Time; maybe the effort of leading an octet or the sheer wind Ornette required to play so he could hear himself amid its maelstrom had become too much. He's comfortable in acoustic settings such as Allen and Kuhn provided, and a smaller ensemble is less expensive to travel with. Audiences are also pleased to hear Ornette at lower volumes, without extraneous trappings. In 2003, at a Carnegie Hall concert during the JVC Jazz Festival New York, he introduced a new quartet with Denardo on drums and bassists Tony Falaga (out of the Orchestra of St. Luke's) and Greg Cohen (best known as a member of alto saxophonist and composer John Zorn's Masada Quartet).

Sound Grammar, this quartet's first recording, live from a 2005 concert in Germany, appeared on a new label[2] run by Ornette and James Jordan, also called Sound Grammar; "sound grammar" has become his preferred term for what he used to call harmolodics. The album is a beauty, with eight tracks clocking just under 58 minutes (there is also a 75-second introduction by Jordan, who is credited as the recording's producer). It presents Ornette in a context at once typical and confounding. The fullness of his alto (also his trumpet and violin) is captured with

fidelity; Denardo is somewhat underrecorded – his bass drum is seldom felt or heard, and he seems distant — but the bassists interact brilliantly with Ornette and with each other, in the manner introduced as far back as *Free Jazz*, when Charlie Haden's forthright pizzicato offset Scott LaFaro's frequent use of a bow.

Here Falanga plays arco, shadowing or crossing Ornette's lines with his own, while Cohen maintains the steady plucking, though often with frantic eighth notes rather than Haden's usual quarter-note stride. David Izenzon had both bowed and plucked for Ornette in the mid- and late '60s; Jamaaladeen Tacuma had produced bass-countermelodies for Ornette while Al MacDowell had played less flashy but steady time in the first Prime Time, and MacDowell had been somewhat liberated from marking time when Brad Jones held the second bass position (on an upright instrument) in the second Prime Time.[3] Falanga's consistent bowing lends some of the performance an aspect usually associated with chamber music, but nothing in the chamber music repertoire contends with Ornette's natural and unshackled phraseology.

A more interesting conundrum is posed by the album's promotion, which stipulated that other than "Turnaround" and "Song X," all the compositions are new. Pursuant to harmolodic or sound grammar dictums, each performance will be new, and as Ornette had stipulated during our breakfast in Fort Worth in '84, "I think melody itself has a different content depending on what instrument is playing it," so why shouldn't each arrangement for different instrumentation bear a different title? But the titles "Jordan," "Sleep Talking" and Matador" were affixed to melodies that had previous iterations – "Matador," for instance, as "Latin Genetics" on *In All Languages*.

Little matter: *Sound Grammar* won Ornette the Pulitzer Prize (with a cash award of $10,000). It was only the second Pulitzer ever given to a musician for a jazz-related project.[4] At the same time, John Coltrane, who had died in 1967, was awarded a special citation "for his masterful improvisation, supreme musicianship and iconic centrality to the history of jazz." Ornette had been befriended by Coltrane when he'd come to New York in the late '50s, had played with his quartet (Albert Ayler's quartet performed, too) at Coltrane's funeral and wrote string quartet parts for *Universal Consciousness*, a 1971 recording by Coltrane's widow Alice Coltrane.

The Pulitzer is a fitting cap to Ornette's prodigious career. Though the monetary gift is not as large as some he had been given, Pulitzer winners receive more attention (in the U.S., at least) than recipients of other honors, since they concentrate on recognition of journalistic excellence and are supervised by a 19-member board of editors and "news executives."[5] Ornette was elated, telling the *New York Times*, "I'm tearing and I'm surprised and happy – and I'm glad I'm an American. And I'm glad to be a human being who's a part of making American qualities more eternal." But he had had occasion to offer similarly heartfelt thanks before; since the mid-1990s, especially, honors for Ornette had been rolling in.

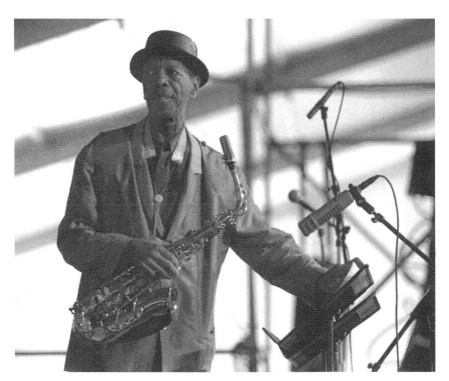

Ornette, 1990, Chicago ©*1990 Marc PoKempner.*

In 1994 he was given a five-year fellowship of $500,000 by the John D. and Catherine T. MacArthur Foundation (commonly called "a genius grant"). He used the funds, in part, to open Harmolodic Studios in an office building in Harlem, equipped with state-of-the-art recording facilities and his multi-media archive.[6] In 1997 he was inducted as an officer ("chevalier") in the French Order of Arts and Letters, a ministerial honor seldom awarded to non-French artists (though that year Lee Konitz, pianist Randy Weston and jazz producer George Wein were also recipients), and also inducted into the American Academy of Arts and Letters. In June 1998 he was recognized by voters of the Jazz Journalists Association in the 1998 Jazz Awards, but that was not unusual, as he has often been recognized in polls of the jazz press since 1959. In 1999 he was presented with the New York Governor's Arts Award, an honorary title without attached stipend.

In 2001 Ornette was given the Japan Art Association's Praemium Imperiale award, valued at about $140,000. He received the Dorothy and Lillian Gish Award, with a cash prize of approximately $250,000 (and a silver medal) in 2004. In 2007 he was the recipient of a Grammy for lifetime achievement from the National Academy of Recording Arts and Sciences, and a Texas Medal of Arts Award.

Speaking about such recognition in '97, Ornette was gracious but candid.

"I'm really tired," he said, "of being sold as a product for being who I am, but not for what I really *do*. I'm tired of being juried by people who don't know what I'm doing." That had not been the case with the Pulitzer; the committee that advanced him for the prize (reputedly foregoing 240 nominations in which he had not figured) was chaired by composer Yehudi Wyner, a professor of music at Brandeis University and past winner of the music prize, and comprised David Baker, professor of music and chair of the jazz department at Indiana University; Ingrid Monson, Quincy Jones Professor of African-American Music at Harvard University; John Schaefer, advocate of contemporary composition and host of "Soundcheck," a daily afternoon radio program on New York City's station WNYC-FM and retired *New York Times* critic and arts section editor John Rockwell.

After 40 years as a recording artist, Ornette had reservations regarding that industry too. "The record companies make a profit off your past, but they say they're not interested in what you're doing *now*. The music industry is mostly interested in my past, never in my future. But I believe that kind of thinking hasn't brought us any closer to each other. Art is not for the special person, it is for *anybody*. It's like the past coming back to the future, you know?"

He made these remarks ten years before receiving his Grammy, but they were prophetic: the award for Lifetime Achievement didn't mention *Sound Grammar*, which had been released six months previously, and though Ornette appeared on the Grammy's heavily hyped international television broadcast, he did so as a presenter (of Best New Artist to pop–country singer Carrie Marie Underwood, who had emerged from the television talent show *American Idol*) and was not invited to perform.

It's also notable that when Ornette and Denardo ran Harmolodic Records through Verve/Polygram in the mid- to late 1990s, former *Down Beat* editor Chuck Mitchell was president of Verve Records worldwide, and jazz aficionado Jean-Philippe Allard was a high-ranking executive at French Verve. The Sound Grammar label has no connection with Verve/Polygram; it is another Coleman family business, and independently distributed. At the time of this writing, the next Sound Grammar release was intended to feature Ornette, Denardo and three basses – Charnett Moffett on an electric instrument joining Falanga and Cohen.

The vagaries of the record business notwithstanding, Ornette's music is securely documented. And though fellowships, grants and similar honors may seem like consolation prizes in commercial culture – if this artist is so great, why ain't he rich? – they do serve to redress the unjust system of financial compensation that artists of obvious long-term merit may suffer under corporate capitalism. The frequency of Ornette's name on honor rolls of creators in the late twentieth and early twenty-first centuries may insure that people in even the distant future will give him a listen. Some of them are sure to be impressed. Or so those of us believe who find wisdom and poetic logic in his utterances, even when they seem at first as oblique as the

juxtaposition of lamenting moans and glinting bleats that mark the lines of his many memorable songs.

Suppose the past *inevitably* comes back to the future. Say that art isn't *only* or *necessarily* alive in the past, but just might live – certainly its creators hope it does – in the present. Take it that if art *is* alive, it's for everybody – not just people who buy *certain* kinds of music rather than *other* kinds, or look at certain kinds of art (like TV) over other kinds (like maybe strikingly original music). If the record companies with whom Ornette has voluntarily contracted to manufacture, distribute and promote reproductions of his living music supported what's *now* rather than *past*, following Ornette's formulation, they *might* bring people closer together. And that will be true in the future as it could be now, because his music lives. Ornette has developed an evocation of the human sound that's more than imitative vocalization; it is, instead, an audible equivalent to the hum of one's internal monologue, whether that involves a roar of pleasure, a cry of pain, a whisper of tenderness or a question to the cosmos.

That's his goal, by the way: to heal people like a doctor of science and raise the conscious health of all society by turning us back to our own powers, having helped us to hear ourselves. Towards that goal, Ornette lives by the earnest questions he asks, based on his personal experience. He has little interest in conventional guardedness or reserve. "Why are people so scared to be who they are?" is typical of his queries. "There are little kids who know fear more than they know love. It's like there's something on this planet that makes everyone a killer."

Ornette's clarity is tempered by his sense of compassion – as is audible in such of his compositions as, most famously, "Lonely Woman." His music sings plainly of many hues of human feelings; celebration and sadness mix in his sound from his very first recordings, maybe because joy and sorrow are opposite sides of the coin of the human condition, never far from each other, and one can never be experienced without acknowledgement of the other.

Likewise, the past is tied to the future, and the future always connects to the past. I asked Ornette, when we were talking about honors he'd been given, how his career – starting in Southwestern tent shows and honky tonks and taking him as far as the mystic mountains of Morocco – had informed him.

"I know more about what I'm doing now," he replied without hesitation. "I want to compose *music* – not *style* – *music*. I'm trying to eliminate the word 'style.' I would like to preach about instrumental music being the next 'vocal' music – that is, with 'instrumental' covering 'vocal.' Instrumental music having the effects people get now from vocal music. We have to start going after a universal understanding that 'instrumental' music means *tones*.

"You could say that we're 'styling' music to have acceptance," he continues, "but that's actually what we're fighting. If you go to a store, you go to buy 'style.' But music is an idea, more than a style. And anyone can enjoy the energy of creativity. It can also *come* from anyone.

"I was born during the time of racial segregation," Ornette explains. "What I'm doing now I knew I wanted to do then. I find that same quality I saw *then* hidden now in everything. Now I want to ask you something: Is there anything natural that the baby and the adult acquires at the same time?"

Everything, I answer.

"Yes," says Ornette. "I think so, too. And we need to have more contact with that quality. So I think art must be love, and love must be art. And why couldn't you or somebody else write something just as powerful as I play?"

He was not satisfied; he wanted answers, and he had more questions. "People always talk about how much I've done," Ornette said, grateful and sincere. "I always hope I can do so much *more*."

CECIL TAYLOR, GRAND PASSIONS

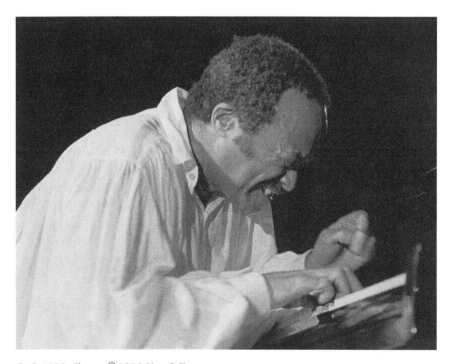

Cecil, 1982, Chicago ©1982 Marc PoKempner.

The Great Unknown

I've met Cecil Taylor but can't say I know him. I've listened to his music assiduously for 40 years but I'm still not quite sure I've really heard it. In fact, I know for sure there's more to it, much more, than I've yet come close to absorbing.

I've interviewed him at some length – twice in his home, once at a restaurant of his choice, with two musicians of his working trio he'd invited along. I've shaken his

hand at the Jazz Journalists Association Jazz Awards, presenting him with a lifetime achievement honor.[1] I've heard Cecil expound on American presidential politics late into the night in a hotel room in Istanbul (he didn't strike me as any more perceptive than the average contrarian, but he was fully fascinated by his own opinions and a circle of young male Turks were enraptured just to sit near him). I've heard him recite his poetry – dense texts, replete with arcane references, archaic words and phonetic utterances less communicative than scat-sung syllables – and seen him perform "Tetra Stomp: Eatin' Rain in Space" with ballet dancers Mikhail Baryshnikov and Heather Watts leaping and falling pointedly as sleet on the stage of Chicago's Opera House.

I've attended to Cecil's music with awe and astonishment in concert halls, school auditoriums and nightclubs in Chicago, New York, San Francisco, Washington D.C., Istanbul, as well as on recordings every place I've lived since high school and many places I've visited. It has befuddled, beguiled, provoked, overwhelmed and moved me deeply many times, relaxed me into a state of meditation and inspired me to try huge projects. I've written about a few of his still-increasing inventory of albums and a handful of his performances and have discussed them at length with many other practiced listeners. I've introduced Cecil's music to classes at New York University and lectured on it to conservatory students in Yerevan, Armenia and Kiev, Ukraine.

I've spoken with Cecil during chance meetings on the streets of New York City – one morning, after dropping my daughter at her grade school I encountered him on an East Village corner, bleary-eyed and seemingly blown out from an after-hours party that had just ended; he spoke for just a moment about having to trudge home to Brooklyn, some five miles, and I didn't think he'd make it. I've rushed backstage to enthuse over one of his performances, and seen him drained from the feat he'd just finished, yet rally to be cordial, even charming. I've only fleetingly encountered the person behind the performer, and I still grope for understanding of his music, though he does not try to hide or disguise what he does.

So why should you keep reading? My experience is not unlike that of others who have confronted or been confronted by Cecil's music or the man himself, except, maybe, that I've pursued them for the discombobulation, stimulation and resolution they provide each time. And as Cecil's music is not going away but has rather through his perseverance and determination opened up musical territory that dares others to enter and will remain ripe for exploration even long after they do, to ignore him and his music is like pretending there are fewer continents than actually exist or to assume that we've heard everything there is to hear in this life, though his music obviously proves otherwise.

Bafflement edged with effrontery is one frequent reaction to Cecil's music: What is this, and how dare he? It is not the only first response, but some large percentage of new listeners find his piano performances initially surprising, then impenetrable;

repetitious (however fantastic) yet also structurally indecipherable; self-aggrandizing, annoying, loud, patience-testing and maybe deeply disturbing of assumptions concerning what music is supposed to be. Those who react so may grow uncomfortable, embarrassed and restless within the first minutes of one of his performances, which have often been a dramatic torrent lasting an uninterrupted hour or more.

(Such stamina as he demonstrates is only superficial certification of his capabilities, but scoffers who say, "My child can do that" are as philistine as any proposing that babies' splatters compare to Jackson Pollack's. A quick check of YouTube.com in 2007 found a posting titled "Claudia jams on the piano Cecil Taylor style" but the cute 15-month-old discovering keyboard clusters only lasted 15 seconds. On the other hand, there *is* something infantile and tantrum-like about Cecil's ferocity at the keyboard. His disregard for conventional melody, song forms and metric demarcations resembles an innocent's, too – but he reclaimed that innocence after formal piano education starting at age five that culminated in studies at New England Conservatory in Boston.)

In casual surroundings, the disenchanted listener may start to chat with companions despite the attentions the music seems to demand. They may talk on, or fall silent, abashed; they may be shushed, or not – they may very likely get so ill at ease as to suffer in uncomfortable silence, or get up and out.

This last is acceptable conduct, I think, though those who would know music need to bring patience as well as perceptual skills and gut reactions to their contemplation of new configurations of sound. However, if you can't take something from an experience, whatever its attributes, there's little to do except let it wash over you or exit without fuss. The latter option clears you as an obstacle to the full enjoyment of those who are more interested in the phenomena that repels you. You don't want it, need it, aren't ready. No problem. But others may be loving what they hear.

How, you might ask, did any listeners get to loving such sound? Does it naturally make sense to them, or have they somehow prepared for it? What preparation is possible? And could it possibly be worth the effort? Isn't music supposed to just be lovely?

Says who? And who's to say what lovely is? What form of endeavor – movies, books, sports, politics – is not better appreciated the more we know about it, the more we who watch or listen understand of its complexities, depths and stakes? In Ken Burn's video documentary *Jazz*, Branford Marsalis spurns Cecil's recommendation that his audiences prepare for his concerts by saying that he, Branford, likes baseball, but doesn't spend an hour fielding grounders before going to a game. Ok, but the prerequisite of enjoying baseball is knowing the rules of the game, and engaged fans have a lot of information in mind about the players and their capacities, the teams and their standings, when they sit down for a nine-inning, three-hour joust; fans' preparations for an the next World Series begin on a season's opening day.

If music is used simply as background – in a restaurant, bar, elevator – you may not want anything more from it than that it fill in the silence that falls between people who are not especially comfortable with each other and that serves to emphasize just how uncomfortable they are. If we expect anything else from music – if we go to it expecting plot, performance, information and insight with the flux of people in action, as we do from theater, film and dance (art forms no one expects to be mere background, but instead are spectacles awaiting our full attentions for their completion) – don't we want as much from that music as the musicians can deliver?

The shock of anything new is most often overcome on second exposure to it; those who reel upon first contact yet who opt to try again must have been hooked by some snare of the demonstration. Curiosity paired with calm fortitude and a bit of trust (aka, suspension of disbelief) may elicit understanding if not appreciation of what was initially off-putting. There are enough listeners, though – sophisticates among them – who leave Cecil's performances unaffected by his music and mystified by his legend, and yet are so influential in the certification of culture in the U.S., that a conspiracy of disregard for his work is plausible, despite his receipt of such prestigious awards as a 1973 Guggenheim and 1991 MacArthur "genius" grant.

Cecil's personal demeanor, which is easy to interpret as remote or arrogant, his outspoken opinions and flaunting of taboos have not endeared him to the conventional and/or commercial music worlds, or to most arts supporters or academia, either. He can be haughty, demanding, irresponsible about keeping appointments and unwilling to collaborate as has been expected. No one involved with jazz who behaves thusly encourages the world's interest in engaging with unique – difficult, iconoclastic, idiosyncratic, perverse, subversive, confrontational – accomplishments, although divas (of either gender) in opera and rock–pop–soul stars have been known to get away with such manners and worse.

Jazz presenters, record companies and philanthropies may have as much or more financial profit to gain from working with lesser musicians who promote themselves as having attained what Cecil has, although they may be sustaining a shared delusion that those lesser musicians have done what they claim. It's scary to face the truly avant-garde. Cecil's self-regard, in and of itself, can put the well-intentioned supporter off; the mere possibility of his scorn can be withering.

But the production of fear is not what Cecil thrives on; audience bafflement is not due to his failings, nor is obscurity his intent. Though he has resisted a life of explaining himself to others, having little need of self-justification and obtaining dubious results when he has tried to articulate his points, he has in fact participated in two filmed documentaries, *Burning Poles* (1991) and *All The Notes* (2004). In the latter he speaks as well as performs, opening his home to a see-all camera, confiding deeply personal thoughts and also clearly outlining his music-making process to filmmaker Christopher Felver.

"You practice so you can invent. Discipline? No – the joy of practicing leads you to the celebration of the creation," he says, looking straight into the lens. A few scenes later he succinctly reveals his method.

"When I was at the conservatory I discovered how to make up my own scales. Hit one note that you like then find another note that you like in combination with that. That's how you begin to make your own music. The scale is linear. Harmony is the vertical [expression of the same pitches].

"So," Cecil hits a chord, "I practice *this*," which he demonstrates by striking in quick succession the root note of the chord, then the second and third notes of it simultaneously, and then the root note but an octave higher, and arpeggiating these pitches up the keyboard. "This is an inversion," he continues, demonstrating the same pitches again with his right hand, voiced differently by re-organizing their sequence over two octaves. "The right hand has a second inversion, while the left hand has the original inversion." He plays that, too – suddenly a motif recognizable from any of his performances since the '80s. "And so I would say to students, I am not here to give you rules, I'm here to help you find your own language."

The reputation of incomprehensibility that clings to Cecil doesn't emanate from his serious auditors as if they were taking pride in their attachment to some rare fetish. My own uncertainty about what I've experienced in his performances stems not from any doubt about his premises but from being overwhelmed by the logarithmically multiplying complexities of his music. In its density and dynamism, its velocity and subtlety, its tempests and longueurs, its breadths and particularities, an hour or so of his music can present just too much to fully absorb. I gasp at how he launches so many compact, thorny, technically demanding motifs, juggles them spontaneously with enormous concentration and brio, sustains suspense and springs surprises, strings together threads through unremittingly shifting episodes and ties every nuance finally together, after tumultuous keyboard acrobatics, into a marvelous whole. And he can do that no matter what size ensemble he's engaged to accompany him, little differently with a large band that he's had limited rehearsal with, like Italy's Instabile Orchestra (on *The Owner Of The Riverbank*, a recording on Enja from 2000) than with his handpicked trio mates or duet partners, or alone.

"At first glance Taylor's method of working certainly appears to be muddled and irrational, and his rehearsals can be quite grueling," reported Marcello Lorrai in liner notes to the Instabile project, which he watched come together over three days.

> Wouldn't it be better to have, right from the start, a score with all the desired pitches and rhythms ready and notated, so as to be able to proceed immediately with rehearsal of how the notes should be interpreted and played, adjusting what works and what doesn't, working steadily but surely towards the musical product which Taylor himself wishes to hear? It's difficult to resist the

temptation of thinking that it's all just a waste of time. However, as the rehearsals proceed, it becomes increasingly evident that Taylor is not interested in the performance of a pre-defined product, but is interested in a process which gradually grows, which is fed by the feedback of the musicians' reactions to his input, a process which moves towards a sort of extemporary composition created in stages. And then, what exactly is the word "time" supposed to indicate? Perhaps Taylor's non-object orientated use of his time with the musicians is deliberately aimed at introducing the musicians to a different concept of time, which in turn profoundly influences the musicians' concepts about the music they have to play.

A different concept of time? Cecil projects his music as a modernist mission, on the scale of *Moby Dick* (pianist–composer Anthony Coleman, a friend and vastly under-acknowledged figure in New York jazz and beyond, has argued this case in detail from a downtown, postmodern perspective) or some other meganovel by Joyce, Cervantes, Pynchon, but this "concept of time" comment proposes he wants to take on the least understood realm of physics, too. The urge to avow the magnitude of Cecil's mission threatens to infect all those who write about him.

In actuality, Cecil's music, from beginning to end, is *as music* more demanding than what's asked from auditors of most movies, plays, dance and certainly the tangible visual arts. The music requires submission not just of simple audio attention but full body presence, yes, over an extended time period. To hear it live, especially, is to be convinced that Cecil moves a lot of air – literally, soundwaves – that have an impact on one's skin, torso, bones, not for a mere moment but for so long you may feel you've been massaged (or pummeled). Alone or with combos or large, freely sweating ensembles, he bestirs grand passions, evokes a sweep of life ranging from intense beauty – sometimes very briefly, so fast can you catch it? – to insistent offensive railing against convention, without aversion to showing off, doing better than what he rails against.

Such endeavor drips hubris. He drives to make history by being as large –no, larger! – than anyone comparable; grasping as much music as he can to include everything: all ideas, all perception, all experience, the irony-dripping opposites of them, too. He seeks to make of his music, if not himself, an elemental force, sucking in all the room's air and all his auditors' awareness, vanquishing rivals, belittling others' paltry efforts. His insults can be catty and vainglorious, but are usually not unfounded. And after he has encompassed, digested and exceeded all that's gone before, what does he hope to give out? Something bigger than we could or would imagine left to our own devices, yet not so big as to escape us, if we try to follow along. We make heroes of those who construct edifices of such grandeur, don't we? Sometimes not until after they're gone.

If making such art is so demanding, is it worth the effort? If they're so smart, their work so complex, why aren't master artists curing disease, ending war, reduc-

ing poverty? King Saul first summoned the shepherd and king-to-be David just to play harp for him to ward off evil demons[2] – why can't musicians be content in that diverting role? Why not settle for embellishing jazz as it has been, rather than declaring there's more out beyond the precincts it came from?

Hasn't the genre, as initiated by Jelly Roll, Satchmo, the Duke, the Count and Bird enough possibilities to satisfy a musician (and audiences) for a lifetime without requiring the *sturm* and *drang* of revolution and transformation? Why expand upon jazz? Isn't an attempt to go beyond its accepted practices disrespectful of the parameters and accomplishments of the revered elders – to say nothing of the preferences of audiences, made plain by their attachments to time-tested devices, their obvious pleasure in what's been established, their return to, say, African-American born blues, swing, gospel and ballads (with maybe Latin rhythms adding spice) for comfort and other psychic balms?

These are the questions Cecil and all avant-gardists have faced when they embark on their outward-bound ventures. There may be no logical answers – the artists may be responding to personal internal pressures, more than anything else. Is the struggle worth the effort? That can only be an artist's decision.

Why would anyone not be satisfied with jazz as it is or has been? Cecil may well be so satisfied, in fact; he is a musician with high regard for those on whose shoulders he's arrived, but he hears something else – why should he reject it? Maybe he (and Ornette, and Miles) rejected something else, as Greg Tate puts forward in *The Future Of Jazz* (A Cappella Press, 2002):

> Since the agreed-upon forefathers of this revolution in sound . . . all began recording in the mid to late 1950s and are therefore contemporaries of the post-bop figures responsible for developing said mainstream, the avant-garde . . . represents less a breaking away from than a group of artists who derived a wholly Other set of directions from the inspiration of classic bop. This revolution, as it were, now seems to have been more opposed to the conservative tendencies of their own generation than a rejection of the past.

By Tate's lights, a conservative conformity was the enemy the jazz avant-garde railed against from the get-go – an interesting point, even more interesting in its hint that jazz (as derived from that recent avant-garde movement, bebop) was being adopted in the '50s as a generic convention, and so required opposition by those attracted to the jazz life from the start for its promise to them of career-long outsider status or, at least, acceptance of their innate individuality. If jazz, in part due to its roots in black America, inherently was an avant-garde project, we ask again: didn't jazz as a genre offer possibilities enough for Cecil (or Ornette or Miles) to flaunt their singularity?

Well, yeah – and those possibilities are what Cecil (Ornette, Miles, *et al.*) had understood and pursued, captured and pursued again as they saw them slipping

away over the ever-receding horizon. Inherent in jazz is the treatment of base musical elements – melody, harmony, rhythm, timbre, tonality, dynamics – any way the musician sees fit. Going beyond what's been established is no more disrespectful than ignoring what may yet be gained by exploring the possibilities. Who do we believe has more alertness to art's potential satisfactions, anyway: the audiences who receive art, the critics who want to explain it, the institutions that would codify and teach it or the still-seeking artists who make it?

Do avant-gardists' answers and actions diminish those artists who don't accept iconoclasm or innovation as tasks for themselves? Not necessarily: Classicists, preservationists, embellishers have their honorable roles. An institution such as Jazz at Lincoln Center in New York City is a valuable asset for American culture, providing a venue for the performance of enduring repertory, the education of young musicians and the enticement of audiences who are not necessarily expert or conversant with the cultural heritage it upholds.

As Jazz at Lincoln Center has in Wynton Marsalis a brilliant instrumentalist with proven leadership skills (drawing other high level instrumentalists into his orbit), charisma that is handy for fundraising and promotion (allying social, political and commercial powers with the greater musical mission), the will to mount performance series and the ambitions to compose works that extend the established vocabulary of jazz to modern dance,[3] popular film,[4] choral and classical ensembles,[5] there is little argument that the institution extends the reach as well as supports the existence of jazz. Other arts organizations of the late twentieth and early twenty-first centuries such as the Thelonious Monk Institute of Jazz, the International Association for Jazz Education, the National Endowment for the Arts (through its Jazz Masters program) and the Doris Duke Jazz Ensembles Project (administered through Chamber Music America) also provide training, competitions, career advancement counseling and commissioning opportunities and sometimes funds to musicians in the jazz field.

But if such organizations do not specifically orient their activities to artists whose efforts critically examine, explore and maybe even reject what they've determined to fit within their operative definitions, they align themselves with the status quo if not the past, and certainly not the present – because they can't halt changes over time and are by their operative definitions instituting resistances to change. Such organizations and the musicians who submit to their seemingly reasonable constraints will not have a hand in determining the future, but will always be reactive, adapting to what's just gone down instead of proposing their own ideas of what may yet become.

And for such organizations to dictate or impose their definitions and standards upon musicians who have different ideas, maybe born of different experiences or different perspectives on and perceptions of those experiences, is pretentious and stultifying. This is why there has been discontent among jazz avantists for years.

They have argued that Jazz at Lincoln Center has resisted presenting music beyond Marsalis' purview, whether or not such music was associated with the avant-garde.

Pretensions can be borne; stultification must be resisted. This is why there was glee among some avant-garde supporters when Cecil's AHA Trio was finally scheduled to perform in spring 2007 at the thousand-seat Rose Hall of Jazz at Lincoln Center, on a bill with John Zorn's Masada Quartet.

(Not, as it turned out, that Cecil and his players – bassist Henry Grimes and drummer Pheeroan ak Laff – or Zorn's foursome featuring trumpeter Dave Douglas, bassist Greg Cohen and drummer Joey Baron, proved any superiority of their music to more conventional projects that particular night. Masada performed its well-polished repertoire of original themes borrowing from Middle Eastern and Mitteleuropean modalities with brio; the most avant-garde elements of their pieces were Zorn's inclusion of rude burps, honks and splats in his solos, which were otherwise embedded in the improvisatory format Ornette introduced with Don Cherry, Charlie Haden and Ed Blackwell in 1959. Cecil's set was hampered first by problems originating at the hall's mixing board, and secondly by his sidemen; Grimes bowed violin as well as bass, obscuring the frequencies of the lower octaves of the piano, while ak Laff played so loudly and self-referentially as to cover Cecil's right hand – not an easy thing to do, but heightened by the drummer's persistent overuse of cymbals which dominated all upper register frequencies.

Yes, mistakes and misjudgments can occur in free improvisation, too. Regardless of the results of a particular performance, to exercise my brain, hone my perceptual skills and test my assumptions – again – I'll turn to Cecil, because he always pushes himself, among others, and therefore offers the possibility of surprise.)

The act of listening to Cecil's music is, for me, the act of trying to follow it, and of each time being returned to examine my own ways of comprehending music. In the examination I discover how much more there is in music, as well as in *his* music, to contemplate, and in the contemplation question, learn, question more, grow.

At each listening, first I pledge to myself to concentrate fully on the initial motif the pianist plays, and the second – but already he's onto the third and fourth – and so on, and what he is doing with his hands, flinging them at high and low ends of the keyboard, hammering out ascents and descents with dart-like fingers or quietly pressing exceedingly strange chords and clusters. He is not simply tossing off random handfuls of notes; he is laying out the pieces from which he'll construct something huge in real time. To get from the start of his performance to its conclusion, we might think of the bridges he studies. He has interest, for instance, in the work of architect Santiago Calatrava; consider how Calatrava's bridges are anchored, how they rise, arch, function, extend end-to-end and endure.

This may not be precisely how jazz pianists have thought or played before Cecil, but it is not so different, either. Jelly Roll Morton, James P. Johnson, Earl Hines, Ellington, Waller, Art Tatum, Mary Lou Williams, Teddy Wilson, Nat Cole, Monk,

Bud Powell, Tristano, Brubeck, Oscar Peterson, Horace Silver, Erroll Garner, Bill Evans, Herbie Hancock — all kept their hands on the ivories, typically chording mostly with the left and planting harmonic pins in the bottom registers, in the right making pretty or smart or robust figures usually with single-note runs. Sometimes they stretched their fingers to span an octave or more, tinkled grace notes way up top, struck chords in both hands and moved them in blocky parallel, created counterpoint or contrary motion or intricately close harmonies within the narrow confines of the black and white keys.

This is not what Cecil does — or rather, he does those things and more. However, those pianists in their performances, like Cecil in his, plant musical ideas in gestures as firm as a bridge's foundation, raise their variations on sturdy struts, reinforce their extensions with supplemental braces, adorn otherwise functional elements with decorative — and sometimes distracting — diversions, keep sight of their essential themes, and, having transversed some lapse of time, come to resolution on the other side of its passage.

Having grasped what the rough structure of Cecil's activity might be, and having fixed on the materials he'll employ in the construction at hand, again I'll set my concentration on his motions, listening for whether the notes run up and down, if they're the same notes or merely similar ones, how they differ — by touch, by pitch, by sequence — what pattern is plaited in his alternation of strands, whether anything predictive or obvious connects one flourish to the next. My attempts to discern these patterns are ongoing, sometimes succeeding for a moment in grasping their shapes, sometimes becoming more desperate as I become lost or my concentration fails (Cecil's doesn't).

My process may be complicated by other elements that Cecil brings to a concert: his costume, his sidemen, the way he comes onstage, sometimes approaching the piano as a dancer creeping up on a prop, sometimes as a hunter stalking dangerous game. But whatever the attendant details of performance or recording, I have thought pretty much the same way about his music since my first revelation regarding Taylor's *Unit Structures* in the mid-'60s, shortly after it was recorded and issued on Blue Note Records.

I've written already about a favorite cut-out bin in a record store in downtown Evanston, Illinois, where as a teenager I found promotional copies of new jazz and blues LPs at a discount price. *Unit Structures* was a prize from there. The album's cover was, like most Blue Note covers designed by Reid Miles, arresting: a grid of repeated three-quarter portraits of Taylor from his chest up to his hairline, his mouth set firmly and his eyes shaded in sunglasses. Each square photo was tinted differently, like an Andy Warhol lithograph but more aggressive. The colors were weird: pink, yellow-green, purple, black-green, blue, purple-red, red-yellow, and one solarized so the light parts of the original negative turned orange, the dark parts — including Taylor's shades — a bloody mustard.

Cecil approaches the piano, 1982, Chicago ©1982 Lauren Deutsch.

The liner notes were equally distinctive, but even more arcane. Written by Taylor himself and titled "Sound Structure of Subculture Becoming Major Breath/Naked Fire Gesture," they began, "The first level or statement of three an opening field of question, how large it ought or ought not to be. From Anacrusis[6] to Plain patterns and possibility converge, mountain sides to dry rock beds, a fountain spread before prairies, form is possibility; content, quality and change grow in addition to direction found." I've already admitted to the fascination that Ornette's atypical use of language holds for me, and you might suppose that Cecil's was likewise compelling. It wasn't. I couldn't get through the sentences, and still can't.

Cecil's writing actually kept me from buying the record. It went on for approximately 2000 words, with references to the compositions within that didn't appear to clarify anything ("Enter Evening's anacrusis consist of four separate lines, unequal in length; statements with changing consecutives. Unit Structure's anacrusis isolates amplitude in note freezing sound: in attitude, the mobile phrase grouping piano attack happening across Structure's TPT"). There were phrases, though, that caught my eye: "As gesture Jazz became: Billie's right arm bent at breast moving as light touch." And: "Rush on Bantu Zulu with eagle nuts spread wise eyes acknowledge skin recently dyed."

I was, as I've also mentioned elsewhere, a pretentious and precocious brat, and considered myself devoted to artistic experimentation – that is, to consuming it. I read William Burroughs, Donald Barthelme, Ishmael Reed. Why not Cecil? It came to me that these words were some private verbiage which the artist allowed to be

made public, though he might doubt that anyone would understand it (nor were they necessarily meant to); still he would privilege us with access to these musings. Despite their obtuseness, they might be erudite if I stuck with them – as my teachers claimed Ezra Pound could be deciphered if one knew as much as he did. At the end of Cecil's missive, at least, an expressive cry emerged: "Where are you Bud? . . . Lightning . . . now a lone rain falling thru doors empty of room - Jazz Naked Fire Gesture, Dancing protoplasm Absorbs."

Whatever that meant, it was vivid, and maybe meant or suggested many things that could be said or suggested no other way. What did it have to do with the music? Maybe nothing, or maybe the music was the key to the code. After staring at it repeatedly on return visits to my record store, for $1.98 I brought the album home.

How does one describe music one has never heard before? We have no vocabulary for what we have never previously experienced. There is precious little musical vocabulary commonly held by amateurs that accurately and lucidly depicts what's occurring in any given moment of ensemble sound. Loud, soft, sweet, sour, smooth, harsh, rhythmic, dreamy, tuneful, eerie – the usual adjectives don't make it; they may allude to one bit of sound, one horizontal strain or vertical slice, but not to concurrent occurrences each on a time frame and course of their own.

At first spin, I couldn't realize anything about *Unit Structures* except that it wasn't like any other album I'd ever heard. The band didn't sound like any other so-called jazz ensemble. It was larger than most, and had a remarkable collective sound, in that the members were obviously *not* trying to play in tight unison. They played odd, fragmentary gestures, each seemingly on his own wavelength, together creating what I initially heard as undifferentiated cacophony.

The overall sound was surprisingly transparent, though. I did not hear it as propelled by a single forceful movement heading somewhere, but instead as spread out, so that when I tried again I could hear lines in layers, each set off from the other, without being able to figure what lines belonged to whom. Was that the oboe? Or the two basses (not that I could separate them from each other)? The compositions didn't have a crisp melody, or what I would have thought of as introductions, verses and choruses. They weren't blues, I didn't think, though they had the blues' snaky, emotive quality.

More like modern classical music? Describing his 1952 "Sonata for Flute, Oboe and Harpsichord" in the liner notes of a Nonesuch record I owned, Elliot Carter used the phrase "fluid changeable continuity." But this wasn't like any compositions from the conservatory world that I'd ever heard; they would have been much stricter in cadence and not with anything resembling this group's texture and dynamic.

Okay, maybe it wasn't music I liked. It sure was novel, though. Thrown together to be weird? Put it away, try it again someday.

And so I did. I don't know how I came to listen again and again. I've sometimes joked it was to bug my mother that I'd slip it on the record player in our living

room during afternoons when I was sitting there doing homework, but actually I kept listening because it was an odd wall of sound that I could use to block out most everything else or anyone else. My mother didn't mind (a couple of years later she happily accompanied me to an epic performance by Sun Ra's Arkestra at the hard-core jazz club Slug's in New York's then-crime-ridden Alphabet City). She simply continued housework or her Sisyphean task of maintaining our family business's accounts.

One day, though, as I lounged on a sofa and she was rifling through invoices and shipping notices on the nearby dining room table, *Unit Structures* suddenly – unexpectedly – miraculously? – irrevocably – clicked. I was listening to "Steps," just two minutes and 56 seconds in.

Out of a series of what I'd nearly come to hear as disjunctly phrased thematic statements from the various bandmembers, staggered but overlapping like terraced fields or geometric planes or a handful of ribbons, and a frenzied, squealing juggernaut of sax blowing, came an urgent repetition of one pitch in dramatically different timbres. One note – the same pitch, but with wildly different inflections – leapt in quick and urgent succession from one to another of several saxophones, maybe around a circle of three or four, maybe twice, straight out at me. I'd later learn this technique of passed notes is called hocket, and frequently employed by the Pygmy people of central Africa's rainforests; I would also realize, but only much later and with better listening skills, that the passage wasn't hocket at all, but merely an intense moment in a solo by Jimmy Lyons.

Nevertheless, at the instant I heard it I was struck as if by lighting with the fact that Cecil's music was not whatsoever random, thrown carelessly together or chaotic, whatever I'd thought up until then. Shocked, I picked up the phonograph needle and listened again to how at the repetition of that sax tone all the gears spinning on their own in the music locked up in sync. This collective improvisation suddenly appeared to me as comprising structural elements so specific and deliberate as to prepare space to open up for the crystallization of simple yet profound – cogent, verifiable, fundamental – ideas about units organized yet individuated.

Players, it seemed, could stand alone even while remaining vital parts of larger ensembles; equally, entire ensembles could turn or climax on the motion of a single link. Bits of things swinging freely and at a wild pace yet somehow set up to successfully, in combination, activate huge machinery entered my teenage ears to work a twist on my mind. Units could operate independently yet within some undisclosed structure and meld to form greater units, structures supplanting the structures that I had taken for granted as immutable, the way things were instead of the way things only might, and so also might not, be.

I have never recovered from this revelation. I took it then as a jolt and it feels that way still, like a concept beyond or existing simultaneously with ones I'd assumed right along. Why I should have been surprised to actually learn something, to learn

that I didn't understand how the world's layers interact, only speaks of my vanity. That I could be so shaken indicates I was vulnerable to humility, too. The specifically musical context of this epiphany reinforced most concretely the aim of musical composition: to design sound for the delivery of predetermined effects. Yet there was no way Lyons could have read a score to reach that juncture, so the music also carried the birthmark of jazz: that each player added something of his or her own to the event, something only partially predetermined, also unpredictable, and capable of being modified by will or through whim.

In this composition, the individuals contributed firmly personal, and not merely idiomatic statements, but the ensemble sound had to be directed by someone. Cecil was that one, I guessed. Correctly, but at that stage it was just my guess.

"Steps" overflows with incident. It begins with an oddly staggered ensemble introduction that breaks on piano cues, at the ten-second and 21-second mark. Cecil's piano feeds a moment's worth of notion to the group, and each group member responds in kind but not in lockstep. Saxes follow in not-quite-unison, their phrases seeming to bear some call and response relation to the piano and drums – which bear some call and response relation to each other. The instruments do not phrase as if the "melody" hangs together, leading conventionally from a natural (because at least semi-familiar) phrase to the next. Instead, the phrases that seem very deliberately formed – man-made, yet of some organic shape – grow out of each other as a tree trunk splits into limbs that branch to sprout thinner limbs, then twigs. One of the basses seems to be bowing, and perhaps one plucks, but who can hear the basses?

There is no explicitly demarcated time, though a time frame exists – the musicians are not engaged in subjective rubato, the way a regular pulse is sometimes suspended to let featured players dramatize a statement, *out* of time. Drummer Andrew Cyrille strikes components of his kit (snare, tom-tom, cymbals) with sharp intent, lending accents and color instead of keeping the beat, although a beat underlies everything. At the start he does not use the drum kit's components in combination, though he moves from one to the next deliberately, to construct percussive phrases. His movements are most closely linked to Cecil's, but do not accompany or copy Cecil's movements either; the drums and piano are complementary but not static – they spur each other on, separately but together giving propulsion to the horns.

At 1:58 Lyons begins his "solo" statement – but Cecil is not comping mildly, he is in full flurry, matching (or leading) the sax in energy though not in pitch or phrase length. At 4:21 Ken McIntyre, the other saxophonist takes over – Cecil and Cyrille don't pause or reduce the level of intensity to which they've built; they roar on. A bowed bass is evident at 6:11, and the drums roll over it, as all else pauses. Then Cecil and Cyrille toss phrases back and forth for 30 seconds, picking up momentum as their energies combine.

At intervals there's plucked bass – Henry Grimes; at other moments, trebly bowed bass – Alan Silva. Non-stop, Cecil sheds countless notes, flinging them off as though he has an infinite supply. At nine minutes and 39 seconds the piano seems to have had its say; the drums hit an emphatic downbeat. One of the saxes returns, momentarily, repeating a phrase twice, three times; bowed bass and drums clatter on until the piano concludes, definitely, and there's a hint of aftertone ringing for the merest moment. There's been no apparent recapitulation.

"Enter, Evening (Soft Line Structure)" continues the unfolding of motif with eerie timbres; McIntyre's oboe against Lyon's alto sax and Eddie Gale Stevens Jr.'s muted trumpet; a bass bowed deeply, as if underwater; the piano filtering through, and no drums; a bell is struck as the second minute approaches, and the ensemble seems to open into improvisation at 2:40. The piano weaves in, around, over and between trumpet and bass bowed even more high in pitch than before. All these sounds are discontinuous, but somehow connected; when the piano absents itself, brushes on cymbals are asserted; when the piano returns, the oboe returns, too. All the sounds are wrapped so closely any one sound is impossible to determine; the applicable image might be of separate strands of vines twisting into a ropey length. When Lyons' alto sax enters, the other horns are gone, but the bowed bass's timbre is close to the alto's and the piano becomes more active. This is a strangely lyrical piece, all based on timbral relations and complicated design, which concludes with a genuinely through-composed ensemble episode, or at least an episode so deliberately detailed as to mimic through-composition. Again, it has abjured recapitulation. Why play the same thing twice?

After *Unit Structures* grabbed me, Cecil's album *Conquistador* was a must-have. Recorded five months after *Unit Structures*, and also at the Englewood Cliffs, New Jersey studio of brilliant sound engineer Rudy Van Gelder, this music is easier to deal with than *Unit Structures*, but no less gratifying. Trumpeter Bill Dixon makes a difference in this ensemble; his horn has a penetrating dark tone, a clarion call akin in power, if not timbre, to Miles', and it seems to force space into the Unit's sphere. Lyons again plays sax, but with less frenzy; Cyrille drums and the two bassists are present. There was only one track to a side of the LP – precedent to Miles' *In A Silent Way*, but timbrally very different, due to the acoustic instrumentation. *Conquistador* is deliciously haunting, in a way all its own.

As are many other examples of Cecil's work with impressive collaborators in his bands. I'll leave it for you to discover the distinctions and pleasures in the best documentation of his music, only recommending as among the most sublime his *Nuits de la Fondation Maeght* (from 1969, also released as *The Great Concert Of Cecil Taylor*) with Sam Rivers on tenor and soprano saxes joining Cecil, Lyons and Cyrille (no bass at all!); *The Cecil Taylor Unit* and *Three Phasis*, both recorded in April 1978 for non-profit New World Records with a sextet including Lyons, Raphe Malik on

trumpet, Ramsey Ameen on violin, Sirone on bass and drummer Ronald Shannon Jackson, and *Momentum Space*, from August 1999, featuring Cecil in various combinations with tenor saxophonist Dewey Redman and drummer Elvin Jones.

These recommendations scratch the surface of a truly imposing catalog. Cecil's music takes on infinitely different shades depending upon the personalities and temperaments of his collaborators. Lyons and Cyrille are among his most important co-figures, but Cecil's late '80s ensemble with reedist Carlos Ward, violinist Leroy Jenkins, bassist William Parker and Thurman Barker on drums and marimba is outstanding, as documented on *Tzotzil Mummers Tzotzil* (Leo Records). *Nailed*, his 1990 summit meeting with British soprano and tenor saxophone master Evan Parker, bassist Barry Guy and drummer Tony Oxley (issued by the German label FMP) is magnificent and cathartic. Immersion in such unrelentingly high-energy music does indeed require preparation, at the very least a comfortable chair and uninterrupted time (*Nailed* encompasses 78 minutes, the track "First" accounting for 52 of them, the track "Last" only half that length). The most formidable collection of Cecil teamed with others is the 11-CD boxed set *Cecil Taylor In Berlin '88*, from FMP (Free Music Production), a gloriously detailed documentation of the pianist's meetings with the cream of European free improvisers, mostly in duets but also a big band setting.

Another of Cecil's most unusual collaborations is his 1990 studio meeting with the Art Ensemble of Chicago for a program entitled *Thelonious Sphere Monk: Dreaming Of The Masters*. The Art Ensemble – trumpeter Lester Bowie, saxophonists Roscoe Mitchell and Joseph Jarman, bassist Malachi Favors and drummer Famadou Don Moyé – is a flag-bearer of principled freedoms propounded by Chicago's Association for the Advancement of Creative Musicians (AACM). An internationally celebrated pan-stylistic band, the Art Ensemble announced itself as performing "Great Black Music – Ancient to the Future," an umbrella phrase covering its sources in jazz, martial airs, circus, folk and soul musics, spontaneous composition (aka improvisation), intuitive research and absurdist theater. Its 1973 album *Fanfare For The Warriors* included participation by pianist Muhal Richard Abrams, an AACM co-founder, but otherwise nothing in the band's oeuvre incorporated a pianist.

"Cecil Taylor, along with Ornette Coleman, inspired us in the '60s to extend the music, to try a different reality," Bowie once explained to me[7]. "We'd thought of a Monk album for our *Dreaming Of The Masters* series – and the only one we'd have join us was Cecil Taylor.

"Of course, Cecil doesn't play tunes established by someone else; he didn't think he could play 'Round Midnight' and 'Nutty' better than Monk himself did. And we didn't press him," said Bowie. "This album wasn't intended as a Monk tribute so much as a 'thank you' for what we learned from Monk about being innovative. We believe Cecil Taylor is the next step after Monk, and significantly, he developed his own music while experiencing Monk at his peak."

"It's meaningless to repeat what one of the masters has done, note for note," Jarman concurred. "We are not as good as the Master was by repeating his notes . . . We need to play our own music and incorporate the master's ideas, but show they're an influence, not an infliction."

The Art Ensemble sans Cecil deconstructed 'Round Midnight' and 'Nutty' to undertake the challenge of personal expansion on enduring themes. With Cecil, it attempted to forge music wholly new. The track "Intro to Fifteen" begins with a fleet, simple, catchy melody, then develops on Cecil's distorted vocalization of his poetry, couched in the Art Ensemble's clatter of small percussion instruments and electronic atmospherics (from Jarman's synthesizer/sampler). A plucking of a grand piano's taut wires echoes through Cecil's line, "the link to all that was beautiful and morally impressive." Beware, though, literal explanation: according to Cecil, satisfaction unto delight was not in analyzing his words ("dialog becoming a mumbo-jumbo, mumbo-jumbo, mumbo-jumbo," he recited) but in regarding the piece as audio collage, entertaining in its not-literal dimensions ("logic being the lowest form of magic"). "Wade in the water" is Taylor's concluding directive, with which I think he means to say, each time I hear him say it, "First of all, *feel*."

"One thing to remember about Mr. Taylor's performance concept and his musical legacy is he's not handicapped by specific concepts of time," Jarman mentioned. "To us a ballad may last five minutes; once Mr. Taylor starts, he could go on forever, until the music resolves." A complete rendition of a work like "Intro to Fifteen," which was developed in the studio over three eight-hour days, might last two hours, as the Art Ensemble had discovered during its Paris concerts with Taylor in 1984.

"Excerpt from Fifteen Part 3A" represents Cecil's comprehension of the Art Ensemble as "a special vehicle," according to Jarman. "He enjoyed the individuals as individuals and as individuals in a group, as a group or groups. He'd direct a solo or a trio, and one layer would come forward as another faded into the background but remained, like a color wash behind the figures of a large Romare Beardon painting."

The most unique result of their collaboration, though, is "Caseworks," an example of what Jarman describes as Cecil's "structural formula." It opens with paired flutes, then trumpet and bowed bass repeat the elegant line upon which the piano expands.

"Mr. Taylor's compositional process is to give you the pitches; you internalize the rhythm after he plays it several times, and he tells you he wants you in *this* section but not *this* one," Jarman explained. "Bounds and parameters are not defined by time, but by feeling, idea and awareness of his personality. Roscoe and I chose the flutes, which startled him but made a huge difference; it would have sounded like something else entirely if we'd played saxophones. The light dancing flutes are a beautiful complement to what Mr. Taylor writes."

That said, and the magnificence of his large ensemble works admitted, probably

the best way to first approach Cecil's music is through his solo piano performances. Of several superb recorded examples, I suggest *Air Above Mountains*, a 75-minute concert on the occasion of his first encounter with a Bosendorfer grand piano that was amended with eight extra bass notes. Cecil seems to be falling in love with the instrument as he elicits sumptuously rich chords from it, unhurriedly, tenderly and repeatedly. His spontaneous composition challenges the vaunted reputation of composer La Monte Young's *Well-Tuned Piano*, an improvisational work investigating at length (more than five hours, in the five-CD version released by Gramavision Records in 1987) just intonation, the tuning system in place prior to eighteenth century developments in keyboard technology that ushered in equal temperament (today's standard, which many musical scholars believe is inferior).

Fly! Fly! Fly! Fly! Fly! is an instructive alternative, also presenting Cecil in sonic fidelity, seated at a well-tempered Bosendorfer piano. Musing softly as though to himself, Cecil establishes a full-voiced, marvelously detailed theme within the 53 seconds of the track "T (Beautiful Young'un)." The rest of the 48-minute performance extrapolates from "T," but is handily broken up into seven more separate tracks, each with their own title, lasting from two and a half to ten minutes. Unfortunately this LP, originally released on the German label MPS and issued in the United States on the hard-to-find Pausa imprint, has not, at the time of this writing, been reissued on CD.

Other alternatives abound; starting in July 1968 with his just short of 80 minute Italian concert called *Praxis* (issued by the Greek Praxis label), through his 68-minute concert in Willisau, Switzerland in September 2000 (issued by Swiss Intakt), Cecil has recorded 17 solo programs. All of these are worthwhile, and each offers its own nuances.

To characterize a couple of them: On *Silent Tongues*, recorded in Montreux in July 1974 and excerpted in a British anthology entitled *A Tribute To Duke Ellington* (in reference to his then-recent death), Cecil highlights the linear aspect of his keyboard approach, rather than vertical clusters (though dense clusters appear here, too). *Garden*, recorded in Basel in 1981, strikes me as among his more stately outpourings. On *Chinampas*, recorded in two studio sessions in London in November 1987, Cecil plays no piano at all, but recites his recondite poetry amid an intricate construct of tympani, bells and small percussion instruments he deploys himself, with overdubbing. In *The Willisau Concert* he is somewhat lighter-fingered, and arguably more reflective, than elsewhere. This CD also displays Cecil's way of responding to audience demands for encores: he will return to the piano after he has concluded his performance to add brief afterthoughts, here clocking in at 1:24, 1:47 and 1:15.

It should be emphasized that Cecil's solo performances are distillations, not reductions, of his concepts; in each he has motifs pivoting against each other, and uses both the melodies (horizontal motion) and harmonies (vertical stacking of the same

pitches he uses linearly) of *all* the motifs he introduces as warp and woof of a musical tapestry, to be pulled or primped, cut up, reversed, reconfigured on impulse.

It should also be stressed that this is not his parlor trick, this is his music, meant not to impress but to express himself and perhaps enrapture others. How effectively he enraptures depends upon the receptivity of those others. But I treasure the memory of an evening in the '80s when my buddy Don Palmer and I sat in my living room drinking Scotch, switching between two sound sources hooked up to one set of speakers. We intercut Cecil's *Air Above Mountains* with *Otis Spann Has The Blues*, a mostly solo session by Muddy Waters' heart-wrenching pianist recorded in 1960, and the juxtaposition, despite their obvious stylistic differences, contributed to a pure, rich, compelling sense of continuity.

Such is not always the case when Cecil's music is compared to another pianist's. In 1984, producer George Wein – himself a pianist, who had introduced Cecil's quartet with Steve Lacy to general audiences and important critics (see Whitney Balliett's *New Yorker* review) at the Newport Jazz Festival in 1956 – booked Cecil and Oscar Peterson, the reigning virtuoso pianist of mainstream jazz, into Carnegie Hall for a Kool Jazz Festival concert. Pre-event speculation, rampant though unfounded, centered on the question of whether they would duet, as Peterson had done with Herbie Hancock and Cecil did with Mary Lou Williams. They didn't, and neither did their musics suggest any continuity or continuum. Their separate fan bases, though integrated in the hall's seats, exhibited no catholicity of taste; instead they seemed at hostile odds with each other. The event served to show just how far from "jazz" Cecil was still regarded as being.

Peterson played first, with bassist Niels-Henning Ørsted Pedersen and drummer Martin Drew. Massive in a plaid tuxedo jacket, the 59-year-old Peterson spun forth a jazz piano vocabulary that paid homage to his inspiration Art Tatum, the blind improviser who from the mid-1930s to his death in 1956 was regarded by other pianists – even the great Fats Waller – as "God."

Peterson's piano technique was impeccable, as was his presence; he easily reeled off speedy, intricate but evenly articulated single note runs, and showed enviable independence of his right and left hands, producing counterpoint that would have seemed to require four hands, not just two. He performed his original, classically-tinged "Balade" with considerable tenderness, swung hard throughout a medley of themes associated with Count Basie, and was so expert at controlling the piano's volume that he could comp under Ørsted Pedersen's bass solos busily but without overwhelming the upright bass.

Limitations of Peterson's musicality only applied to his aesthetic choices, such as an interpretation of Billy Strayhorn's composition "Lush Life" that made more of the song's superficial glitter than underlying melancholy. He gave the Ellington–Juan Tizol warhorse "Caravan" an anachronistic two-beat treatment, and introduced

another of his own pieces, "On Danish Shore" with a fast boogie-woogie bass figure. His chops finessed ideas derived from Swing Era pianist Teddy Wilson and bebop prince Bud Powell as well as Tatum, but after a while his dazzling finger work became predictable, and the effects clichéd. His skills were prodigious, even astonishing – but his imagination was less involving.

Cecil's music, while maybe an acquired taste, was delivered with equal but completely different virtuosity. It was as if he used his variety of attacks to re-sequence the pitches of a scale, and used clusters or simultaneously struck adjacent keys to create new notes belonging to no known scale. He drove his rhythms as hard as Peterson had – harder, viciously – and he didn't swing so much as pound. He was elegant and exotic, too, coming out to the piano from the wings with darting moves and ghostly cries, clad in silk pajamas and a headdress.

Within minutes of Cecil's opening statement, Peterson's admirers were leaving their seats and streaming for the hall's exits, noisily – as they wouldn't dare do during any typical Carnegie concert. In defense of their hero, Cecil's adherents grew loudly appreciative, clapping in time and cheering his most intense passages. This was as rude as leaving the place to anyone who wanted to actually listen to Cecil play, but he continued unaffected. The concert included no duet, no duel and no acknowledgement of mutual respect, either. The two master pianists acted like they'd never heard of, much less heard, each other.

Peterson's finger-work set a high standard to match, and such pianists as Bill Charlap, Chick Corea, Michel Camilo and Chucho Valdés have developed their chops with him as a model. Cecil's influence is less pronounced on pianists, due both to the absence of a precedent for how he plays (not even the great Tatum used his hands as Cecil does) and because he encourages personal investigations over imitation, however sincere. Still, there are pianists who have recognized his sway on their thinking. Marilyn Crispell, a soft-spoken woman who emerged from the Creative Music Studio run by Karl Berger in the 1970s and '80s to tour and record with saxophonist Anthony Braxton's quartet and eventually establish herself as a leader in the early 2000s through a series of trio albums on ECM, regarded Cecil as a beau ideal.

"In the late '60s and early '70s I was making a living improvising on themes of Hindemith, Brahms, Bartok, Bach and fourth chords for modern dance classes," she said in a *Down Beat* interview. "What I played had to be very simple for the dancers to follow, I couldn't clutter it up. Typically I'd just use a theme and embellish a little bit on top of it.

"Some of my other friends who played for dance classes were jazz musicians, and I'd say to them, 'If I was going to improvise in a jazz setting I'd do this kind of stuff but nobody would ever listen – they'd think I was crazy.' And they'd tell me, 'No, you should go ahead and play.' It wasn't until somebody played me a Cecil Taylor record that I got the courage to play the fusion between classical and jazz that I heard in my head. I probably wouldn't have gone out on my own, or added drums

to my music, without having heard Cecil. We're really very different, but some of our aesthetic sensibility is the same.

"I met Cecil at Creative Music Studio in summer of '77. I really wanted to play for him, but was too shy to ask him to listen, so when I saw him playing ping-pong I went into a practice room right outside the ping-pong place, and started playing my heart out. When I came out, he was right there and said, 'You can really play, you know?' I think Cecil is one of the major influences, innovators and geniuses of the century; there's definitely a school that comes out of his music, and I definitely consider myself a part of it."

Crispell's music sounds very little like Cecil's, though. "My playing gets even more romantic than what Cecil would do. I used to play clusters and things similar to what he does, but I've tried very hard to be true to what I want to do and not be a clone of him. What I want to hear is very fast bebop, very fast time, or maybe a free feeling moving behind very fast lines, punched out rhythmically, not in clusters but in single notes. I'm working on given them more rhythmic punch by playing with two fingers – I work with the shape of the phrase, as you would playing a line with one hand, but I feel I can't get the power for what I hear with one hand. This came out of my playing a Wurlitzer spinet," she said of the instrument most readily available in the rural New York village she calls home, "on which the notes stuck all the time."

Late tea, early winter and my dinner with Cecil

I went to Cecil's townhouse in Fort Greene, Brooklyn, to interview him for *Down Beat* in November 1984. The night before he'd performed two sets with his Unit at Irving Plaza, a modest-sized rock 'n' roll hall. We had a 5:30 p.m. appointment, but he didn't answer his doorbell, and after walking off and returning a couple of times, I called his agent, who lived across the street. She went to his home and soon reported back that he was sitting in his living room, facing the television with the radio on but fast asleep.

At 7:30 he was ready to see me, but only just. He looked small and distant, not as if he'd been thinking about our appointment. His receding hair was pulled back, in dreadlocks; the skin of his face was thin, showing veins; he wore a shirt under a sweatshirt, yellow sweatpants, white socks and soft shoes. A hush was suggested by his presence, as if he was a high priest or had a splitting hangover, and could only be approached with extreme propriety. I anticipated I would ask questions, and have to work for, or with, the answers. I doubted any wisdom would be simply proffered.

The second floor sitting room, above a ground level bedroom and bath, had little furniture, just a library desk from which he wiped away with a sponge evidence of recent partying, a settee, some blankets and pillows, and a stiff chair. A piano had a sun parlor to itself; there were photos and sketches of him and fellow musicians on the wall near some stairs. Books including a volume on Bruchen bridges and Coptic

history were on the mantle of a decorative fireplace. Cecil sat himself on cushions on the floor and motioned me to do likewise, then collected himself silently. A kitten only weeks old frolicked around him. I ventured an innocuous comment about the piano he'd played at Irving Plaza, not a first class concert hall.

"The whole thing about this is that no one ever said it was going to be easy," he answered wearily. "Andrew Cyrille said this wonderful thing to me last night: 'But it is part of your job.' When I thought about that, I said to myself, 'Well, that's Andrew. He does not say he accepts it, but he *realizes* it.'

I thought I'd heard portions of "This Nearly Was Mine" creep into his improvisation; he hasn't obviously performed any such standards, compositions by other performers, or even announced titles of his own since the early 1960s. This elicited a shrug.

"The material perhaps was handled differently, condensed, but there was finally the remembrance, the tonal association, of similar activity," Cecil allowed. "To reach the level where you have mastered the devices inherent to the process of creation, you have to consciously be on top of the manipulation of those participles that go into creating the form that you're working with." I assumed he meant particular intervals, maybe rhythmic syllables or harmonic turning points.

"So the favorite song could be the rope that hangs your development," he went on, meaning maybe that to get hung up playing a song would be to hold oneself back from refinements or discoveries resulting from the pursuit, examination and recombination of those deconstructed smallest units, or essential building blocks. "Because given the fact that it seems to me there is the wonderful balance of how one formulates – i.e. how one consciously organizes material which is determined by how you train your senses to respond to something, i.e., intellectual manipulation – and what makes you feel good, which is passion, well, it *is*."

His accentuation suggested the balance exists – and perhaps resides in the cellular level, the particular basics, of a given song. But Cecil seemed to dismiss the question of basic material as being not of much matter.

"It seems to me that with the artists who were most important to my own development, you felt and then learned what made you feel. But you felt *first*," he said.

He meant without worrying whether what made one *feel* was a particular song?

"The music that was nice, was interesting, I might after a first listen go to a score to find out how it was put together, but never listen to it again. But music that continues to make me want to dance and sing – the structural unities that make up its particular architecture are what make my body want to do something beyond passive acceptance.

"What I find very wonderful now is that each playing experience is giving one plenty to think about in terms of what I perceive to be the essential differences between this music and its organizational principles, and probably inherent in dealing with that is musicians who create individual worlds out of unique applications of their own sensory thought apparatus."

In other words, he was identifying the participation of skilled, sensitive musicians as full collaborators as bedrock to the music he performed, and so, maybe, to jazz?

"As Ellington makes very clear, you construct a sound universe that allows these individual players to enrich the framework that they agree to participate in . . . There is a whole field of activity, a whole thrust of this communal explosion which comes, and you see yourself in that, and you then have to devise anchoring points that chart the direction . . . In a sense, that's really what I'm working on."

Wouldn't that be composition?

"They call it collective improvisation; they call it jazz. I don't know whether jazz is a noun, adjective or a term of political science. It certainly doesn't have any inherent defining process. Inherent in the word, it seems to me, is the tie-up with the particular socio-economic-historical situation of Americans of African and Indian descent. There's nothing in the word that gives very much insight into the spiritual–religious–musical process that makes it. There have been very few explanations of what is *inherent* in that process."

So there would lay an enlightening path for exploration? I didn't have to ask, Cecil had worked up his own momentum, and forged ahead.

"Mr. Miles Davis shows a compromise mishmash of musical stands which he calls fusion, which essentially did not aid in the development," he floated out, " . . . and finally if one participates in the diminishing necessity of accommodation" – as I gathered he felt Miles had done – "what happens is that the quality of the experience becomes devalued, because you are no longer able to grapple with the most surprising element – that which you don't know is happening when it happens."

Why that would be so? I wondered but I didn't ask.

"The thing I like about Ornette is the uniqueness of his syntactical structure when he's speaking," he continued, as if mindreading me. "When Ornette says harmolodic, he says it means, obviously, a combination of harmony and melody being a singular act. And I like that.

"I was once in a situation where we thought it would be a good idea for me to play with the Prime Time group. He thought it would be good and I thought it would be an interesting idea, because I've really had many hours of pleasure listening to what's called rhythm and blues, and since in Ornette there is what I always call a non-urban aspect, I thought it would be interesting to work in a context where New York City opposed the world."

I wasn't clear whether he meant he stood opposite Ornette and Prime Time in this formulation, or with team Ornette/Prime Time and Cecil vs. All Others.

"What happened was he gave me the music, a wonderful piece he wrote, and I worked on it for three or four days, although you know he's not going to really play it the way it as it is, and he said to me, he was a perfect gentleman, he said, 'Only triads.' I said, 'Well . . .'" – in a spirit of reluctance but acceptance of the instruction.

"He was very patient, and we worked on it for an hour and a half, and then he

started playing – and I really learned something. Because we'd worked on the music enough so that when he started playing I heard exactly what he was doing. And you know, Jackie McLean – if one is to forget about the relationship one has enjoyed with Jimmy Lyons for so many years – Jackie McLean was one saxophonist whose attitude I was more attuned to, until that day when with Ornette I felt I was getting inside it.

"So I commenced to playing triads, until I thought I would share with him the glories I have learned from Marvin Gaye's marvelous Fender bass player"[1] –presumably by adding emphatic bass lines – "at which point Ornette came over and said, very gently, 'Much too much left hand.' Well, I guess that's when the project ended." Cecil had received more than enough instruction, he felt, to continue.

"I do remember he talked about it philosophically, and I said to myself, 'Well, this is wonderful, there's a man who is writing and organizing, approximating the functional involvement of sound, where other people have used political slogans to define the thrust of the body of social content of this music.'"

That is to say, Cecil recognized in harmolodics a system that tries to institute the precepts of an ideal democracy, one without hierarchies or "caste systems," as Ornette calls them. "You know that to play this music [jazz, improvised music, what he, Cecil plays, and Ornette perhaps plays, too] is in itself a cultural statement that transcends the immediacy of political statement. Plus, you never make any money."

I mentioned one musician they'd both recorded with, Ronald Shannon Jackson – "Whom I imagine," I said, "let himself serve each of your designs."

"Yes, he did, but one also learned he had designs of his own."

The hint of disdain he seemed to imply gave me an opening to ask one of the crucial questions about "free improvisation," the format he and Ornette, among a few others, could be identified as fostering. I didn't know how to put it, but he understood my thrust.

"I heard *Unit Structures* before I really heard Ornette's Golden Circle trio," I led off, "and I didn't know what I was listening to, but after numerous listenings some things became clear to me. I became astounded and curious as to how this music that you and other musicians are engaged in offers so many freedoms? And what are the limits of those freedoms? When do they stop? Do they stop at the personal level – that is, at the level of your decree – even when 'freedom' is subsidiary to all the other skills you've developed, indeed all the *freedom* you've developed to allow so many musicians to find a place in your music – next to your music – or to find a way yourself to include them in?

"How far can the freedoms of a musician go to play however they want to, and why do those freedoms stop at certain point? Are the freedoms allowed purely dependent, say, on Ornette's conception of where he wants to be in the mix? In the anecdote you tell about improvising with him but being told not to go into bass

lines, for instance – can't he give up that extra amount of space that allows someone else to reshape a part of the universe also?"

Cecil laughed. "You'd have to ask *him*. I do surrender to the majesty of anyone's art if it touches me, and I think that I'm civilized enough to expect that they at least recognize the possibility that there's certain magic that may happen in the world of music that they're not into " – i.e., *his* world – "that is very powerful.

"When I say that the music is a ritual, I mean: Is it entertaining? I hope it is entertaining, but it is also, I think, the most holy thing that I can do.

"I understand that legend has it I'm a morose person, but actually I don't give a fuck what they think, because I'm happy much of the time, because I'm doing what I want to do, and one of the things you discover finally is that no one else takes the responsibility for you wanting to do the shit that you want to do. If you want to do it, yeah, you want to do it. Are you sure? Yes? You'd better be – because if it makes you feel so good to, then you're going pay for it. You accept the consequences of it?

"Part of reality is that I don't live in Egypt a thousand years ago, or in Sumeria 8000 years ago, so if one investigates it helps one to understand how civilizations pass, and how the greatness of civilizations past continues. Materialism or Communism are political forces that determine reality under which poets, i.e. artists, have to find margins of activity that do not chip upon the political reality. Those who are shaping the political destiny of the culture, one may make comments about – but one is not capable, obviously, of transcending [the destiny they shape]."

We'd gotten far afield. I went with him: Does recorded music have a chance of transcending political destiny?

"[Making records] is an attempt to deal with the death that happens in the re-cording studio," he scoffed. "I don't listen to my records after I've made them. I haven't heard the Max Roach record, or the tapes[2] – and I'm not particularly in any hurry to be going to. Nor my solo tapes. It's all about cutting through the desire to make one version of museum pieces that are enshrined.

"However, there are a group of pieces that have emerged in the last four years that I think I want to play as long as I live. It's taken me four years to decide that. And sometimes it becomes frightening. I think I'm really onto something, then it's, ah, I think it's become a little bit too easy now, but then – and this has happened before, too – when you're working on something, everything mushrooms, and you have to make your own communication system, because the ideas come so fast you have to find something that will communicate those ideas. 'Beautiful Young'un,'[3] that piece really turned me on to certain things at a certain point, that's one of those favorite songs. And it's gotten so I can't write ideas down fast enough."

When he performs, is he responsive to his audiences?

"The audience, yes, they're participants. At first I was being very nervous, and a lot of things that being nervous does not really cover, but I'm very aware of the

audience now, I play with the audience, I play *to* the audience, and I'm feeling that I've gotten over my own shyness as an individual to be able to do that now. That's also great. It has enhanced the pleasure.

"An entertainer," he said he understood, "the good ones, the great ones, specifically gear [themselves to do] what they imagine is acceptable to people. As I become older it has become increasingly clear that we are enclosed by the culture we live in. It is vital to understand that, just so you can find the space to do as much as you can of what you want to do.

"When you spoke before of freedom," he continued, "there is no such thing as freedom, only preparation. Because the only beings that are free are those people who don't have to worry about where their next money is coming from. You work at this. The term freedom, much like the term jazz, doesn't have any meaning, because you can't communicate certain things to functioning people once they decide to become part of your community, and not have a language that they understand. And if they understand, it means it has to have been worked upon; and if it's worked upon, it's not a manifestation of freedom, it's a manifestation of a particular dedication and training. Freedom became a cuss word the beboppers applied to us. I'm not free of them. They're very much part of my development.

"What I have worked very hard to become 'free' of is the interpersonal intimidation that goes on. I'm getting less out of that, which is why I may curtail some of my

Cecil in his home, 1984, Brooklyn ©*1984 Lona Foote.*

activities. But I don't want to make this an ivory tower," he muttered, evidently as much to himself as to me. He looked up then. "Maybe a Japanese tea room."

"I think I'd better go to bed," he apologized, bringing our talk to a close for the moment, and I let him.

In 1994, ten years later: Cecil Taylor at 65 has the air of a lion in early winter. Onstage at a solo concert he had produced for himself at Lincoln Center's Alice Tully Hall – as no one else had stepped up to schedule him into the auditorium that was home to Wynton Marsalis' Jazz at Lincoln Center – he was robed in splendor and mesmerizing in performance. He demonstrated so many ways to approach, press, caress and pummel the piano's keys, so many methods of chasing an idea through music's labyrinths, so deep an understanding of his (and our) moment and its celebratory potential that one dared hope this is what aging is about: mastery and the courage to deny it in the push ever onward.

That's what Taylor had achieved in his musical life then spanning some 40 years and more than 50 recordings. The amazing technique he had constructed was never intended to be an end in itself, anyway. His lightning speed, revolutionary finger work, utter control over vast dynamics and unique vocabulary involving myriad echoes, cross-references and reflections on musical history, including but not limited to the heritage of jazz piano, had proved to be at the service of an all-consuming quest.

His musical energy – though it may sometimes have seemed self-aggrandizing – had focused on intellectual, aesthetic, philosophical, spiritual, mystical and mythological investigations at the core of all enduring artistic endeavors. Cecil had, since his first, self-produced recording *Jazz Advance* of 1956 made enemies of standard operating procedures, received opinions and discouraging words. In the process he had gained many fascinated followers, wherever avant-garde music had an audience.

He had spent the last six months living in New York, the longest period he had stayed in the city in eight years. For much of that time he had been living and performing in Europe and Asia, having received a grant from the German government in 1990 to stay, compose and perform in the country for a year, and in 1992 an invitation to perform in Japan with dancer Min Tanaka, as well as concertize on his own. A few months after that he'd taken his band to perform at the Miro Museum on the island of Mallorca. Cecil had met painter Juan Miro at the Fondation Maeght in 1969; the artist gave each member of Cecil's group at that time – Jimmy Lyons, Sam Rivers and Andrew Cyrille – an original lithograph ("Same design but different colors for each," he explains) and left it in his will that the pianist should be the first to play at the museum when it was completed.

"We've had a very interesting artistic career outside of this country," says Cecil. Is it the kind of career he envisioned for himself?

"You never know. You just try to prepare yourself, and there are political or economic signs in any culture or civilization that give you a clue as to where you're going to be placed in that milieu. You just do the work, then the opportunities come about that allow you to see what you have achieved in your time.

"You know, when you see a really great artist, all time stops. The largesse of their spirit lights you inside, your inner sensibilities, so you recognize this is a vision, a spiritual presence, that can only further your own development as an artist. Empires fall, but the highest achievements of empires are really what the artists create within them. Some art work transcends the dominance of empires.

"When you attempt to build through composition — and when I use that word I mean a kind of architecture by using sonorities to create the three dimensions — there is a commitment, and the commitment comes from sources you're not even aware of. Since it is not intellectually accountable, then it must be a repository of one of the greatest forces of nature that come to realization within oneself. Since we are, after all, human beings who are co-existing with plants and animals, mountains and rivers and streams, perhaps one of the purposes of our life is to achieve the nobility of that moment through transcendence in which we return to the point of our beginnings.

"So poets who perhaps attempt to levitate — the process to achieve that, the thing that all poets have in common, the internal material — is the development of the senses to respond to the particular media you're working in. And since that kind of work has no basis in commercial reality, then the activity must be about developing those monuments to the flowering of the senses. When you're talking about dealing with that, the next level would be the transcendent one, which, if it is achieved, is the purpose for one's living. And it has ramifications in terms of one's humanity.

"Of course, I can only speak for myself, but music, which in many ways saved my life, led me to literature, to dance, to architecture, finally to people. So if you make a commitment to one, you begin to see there is no single art, and if you get into different kinds of art they nurture you. If you're fortunate, they lead to an expansion of your knowledge. And it's like a river or an ocean, it continues to move. So that one's life is more rewarding as one is allowed to get older. There is a deeper joy, and because of the joy there is an understanding."

Is that what he tries to communicate to audiences?

"There are two things we start to realize when we get older: that there is a duty to serve — the inner self, but also to serve those who would be listening — and that the reason one serves is because one wants to express the joy of living, and so it becomes a celebration of life. The parameters of that go beyond the viability of that which is commercial."

Even disregarding the question of commercial viability, some people are unprepared to confront the complexities and possibilities in Cecil's music. How does he respond to this?

"There are generations of listeners who know the music that they know, and they are quite cognizant of all the levels of music that they're into. Indeed, I've found many times friends who I've known over the years had a very interesting perception of music which always fascinated me because they weren't musicians but it seemed to me they grasped in their own way a fullness of the dynamics within the sound structures that was always appealing and enchanting because it was arrived at through their love, and that love furnished them with insight that could not be denied. On many occasions I've found myself reacting to a poignant sound the same way they did."

Are there limits to his musical interests?

"I'm interested in only one thing: music that is good. Definitions of music should perhaps be left to those who really love it. That doesn't necessarily mean musicians. I mean, Stevie Wonder wrote incredible music at one time. Aretha Franklin was an incredible musician and did extraordinary work, and then we get to men like James Brown and Marvin Gaye, who certainly were without peers, for me at least, in that division of the music. All of the music that I love, there are common touchstones to it, you see."

And is he part of that musical continuum?

"Oh, I don't question that."

Many of Cecil's works, particularly the mid-'60s albums *Unit Structures* and *Conquistador*, seem to be related somehow to geometric planes, or ideas from architecture.

"I find I get more gratification out of looking at an architectural drawing than I do most musical scores. The point being that for me there is not much mystery in looking at a musical score, because the process becomes pretty much the same. If you look at one, you know the procedures.

"The point is really: Does music exist as a note, or does it take its point of beginning, its genesis, from someplace else? One of the distractions has been this idea of written music. It divides the senses, though some people might say it increases the options. But I mean if you look at a piece of music – notes – that means your eye must be directed outside the body.

"There's always been this wildly inaccurate way of describing people who play by ear. What other way is there to play? One can add things to it. But there seems to be a bit of misconception about what constitutes musical literature. What is this mythology about composition? What is the body supposed to be doing while one is performing?"

Does he have a rigorous practice routine?

"I don't know if I'd call it rigorous. There are certain procedures one must exhibit, and it's a matter of preparation. One gets up in the morning, then one must work at developing the mind. There are certain things one must study in order to write words, then there is usually at least an hour spent doing various exercises for

the body. Then the most glorious meal of the day, for me, which is breakfast. I might mop floors. See what the telly is saying. And then one composes, one practices and one has achieved a state of highness. That's the way I enrich my life."

How often does he practice?

"Every day is different. This is a very intense time because I'm preparing for something specific. But after all, it is my life's work. It's a heightened time now, a time of spiritual intake. I practice to be able to perform."

Cecil is an avid consumer of the performing arts. What has he seen recently that has excited him?

"In the last two or three months? I went to see the originator of the Bhuta dance at the Japan Society, a very interesting gentleman, 87 years old, who was incredible. About two weeks ago I went to see Abbey Lincoln at the Blue Note. There are many riches one can take part in, and that is a nurturing experience, too.

"I like the voice. The voice was either the first or the second instrument. Certainly Lena [he has a photograph of singer Lena Horne on his living room wall] is a very interesting performer. I first saw her in the stage when I was 12; she had just done *Cabin In The Sky* and *Stormy Weather*, and remembering how Lena looked in Hollywood films! But to see her on stage, it was amazing. I can still remember when she came out the audience gasped. See, there are no margins when you're really dealing with something so close to perfection. Certainly Marvin Gaye was a man who fully transcended boundaries, in terms of his continuous development. I have many favorites."

Cecil's favorites among his immediate constituency of music that has developed out of what was considered black free jazz during the 1960s include Bill Dixon, Sunny Murray, Don Cherry, Butch Morris, Reggie Workman, William Parker and Charles Gayle. Would he comment on them?

"These people are all extraordinary. It would be interesting if the corporate moguls who determine who attains visibility were clever enough to be open to the expansion of their economic field

"But I think that those who determine what is commercially viable are on a different plane. That's not what I'm interested in, and when one realizes finally the nature of the ingredients that go into that kind of mentality, you realize what it is that has given you the most joy, and you continue to do that. And that brings development in your own mind and feeling. When one realizes that, that's when generation begins. The important thing is to realize that no matter where you live, the world is available."

He refers to those musicians who had an early, long and/or profound influence on his work as "my nurturers," and cites pianist and arranger Mary Lou Williams, arranger Gil Evans and percussionist Max Roach among them. He calls Roach "one of the finest percussionists the world has ever known." Did he absorb specific rhythmic impulses from working with Roach?

"I think the manifestation of rhythm is the reason that life begins. Rhythm never stops. It is perhaps – at least – one of the most vital aspects and one of the compositional grids that shapes the nature of a culture's music."

What about melody?

"There are different kinds of melody. If you hear Coptic or mbouti [pygmy] melody, or kabuki, you realize it's unbounded. Same with harmony. The organization of vertical structures is in ongoing change."

Would he like to have an influence on younger musicians?

"I don't have any aspirations there. For those who would be interested, if I can assist them in any way . . . The first obligation is to the music, and the hopeful development therein, and that is part of the personal legacy that goes into the continuum. The thing that has shaped my particular attitude is people like Duke Ellington, Fats Waller and certainly Billie Holiday. That which has saved us – we are responsible to it and we cannot defame it by doing less than we feel is our all."

And what of those who don't walk it like they talk it?

"As one grows older one becomes more understanding of it all, and then one understands it is not easy, but it is so worthwhile and brings so much joy. One can only hope that those who are not understanding will eventually see that if it is not a noble pursuit, then it is not worthy of human effort."

Does he ever get frustrated about the quality of documentation of his work, or the lack of it?

"No. No . . . One of the things you realize is you just do the work, and you prepare for the most beneficial events in relation to the things that happen. For instance, those CDs that I did with Jost Gebers of FMP – what is that popular song, 'The Best Is Yet To Come'? One becomes aware of good fortune, that spirits have been kind enough to endow you with the ability to continue working, and the personal sense of fulfillment, and the want to continue. It is enough. That which is external to that perhaps could be Machiavellian. What is important is that when light is thrust out, it has no parameters. And when the time is right, when it is to happen, these things *do* happen."

It seems I've caught Cecil in a mellow mood.

"I'm under the spirituality of all this work I'm doing. I'm very excited by it; I try not to think too much about it. Now I'll get up, make a soothing tea, and get back into it again."

Does he still get stage nerves?

"The most difficult time for me will be in the limousine going to the concert. Of the beneficial things that spirituality has given me, the concept of ritual – which is very much a part of my performance – is the one which takes the effervescence out of the stomach."

Cecil in 2000, at age 71 – still confronting Western music, literature and dance as an outlaw jazz genius living large in New York and the world – also has a sociable side. "I want to get together with some musicians *I* think are important," Cecil stipulated on the phone from his Brooklyn home. A few nights later, I joined bassist Dominic Duval, drummer Jackson Krall and Cecil at an East Village bistro called Pangaea for sophisticated fare: risotto, salad, cigarettes, drinks and an outpouring of uninhibited opinion ranging over everyone and everything that's happened in music among other arts and sciences since a bit before World War II.

He had retained a level of physical energy that would be the envy of an athlete of 20 and he still delighted in pitching himself into battle against the hugest musical challenges he could conceive. It seemed he enjoyed battling the musicians with whom he collaborated, as well. Dominic Duval, a self-described "musician who plays bass" who first encountered Taylor at the Knitting Factory in 1996, put it differently: "Cecil's sounds always subsume but also bend to those of the people around him. He fits what he does to what others do. But few have played Cecil's music without paying him their due.

"What his music about? It's a love song. I think. Even the stuff that seems fast and furious – it's a song about what he feels that day. He practices maybe ten to 12 hours daily, when he has concerts coming up. Not to play better; rather, he's figuring out what comes together as songs, with fast and slow sections and all of his

Cecil with large ensemble, Dominic Duval, bass; Knitting Factory, 2000, New York City © Jack Vartoogian/FrontRowPhotos.

colorations. When he goes on the bandstand, he's got it all figured out, starting with maybe three motifs and an organic process he wants to get across.

"He doesn't go back in any single performance to the same rhythmic materials, and he wants the tonality he's dealing with to change all the time. His music is like a collage – happy, sad, violent, inclusive of all the colors. He's developed a way of playing that's like a dancer, so I've tried to learn to play my instrument that way, too, foregoing standard techniques to develop my own fingerings, double stops, arpeggios, guitaristic things and chord sequences."

Cecil typically influences his fellow players in such a manner. When we met, Duval and Krall had recently performed with him in Minneapolis, after a lengthy layoff. They'd recorded *Qu'a* and *Qu'a Yuba: Live at the Iridium* volumes one and two in quartet with Cecil and soprano saxophonist Harri Sjostrom in March '98.

"But I hadn't played with Cecil for a year," said Krall, as we awaited the pianist's arrival. "Dominic hadn't played with him for a year and a half. We were supposed to play with him in Chicago, but were snowed out, so he performed solo. In Minneapolis we just hit – no rehearsal. And the music was miraculous, amazing. We picked up right where we had left off, and I reached a point in my own playing I'd never reached before."

In the past year Cecil had created galvanizing music in duets with Elvin Jones (at New York City's Blue Note Club, following the release of *Momentum Space*, their underrated trio recording with Dewey Redman), Amiri Baraka (in a night of profane and arcane readings at St. Mark's Poetry Project) and the amelodic British guitar anti-star Derek Bailey at Tonic, an alternative music venue on a bleak street of Manhattan's Lower East Side. Also, in a free-to-the-public concert produced for the Bell Atlantic Jazz Festival by Knit Media, Cecil had collaborated with drummer Max Roach for a historic third time, an event that seemed likely to become a legend.

"I don't mind the legends," Cecil announced upon finally arriving at our table. "Give me more!" He wore a sweater and slacks the same tan shade as the restaurant's walls; a dark, soft hat, which he didn't remove; a light mustache, glasses, heavy bracelets on his right wrist and a silver Zuni necklace with dangling totems. The stories he proceeded to tell didn't particularly follow one from the next, but spiraled around, turning back on themselves, sometimes dribbling off inconclusively and most often turning on a nuance of inflection, a lifted eyebrow, a grimace or flash of teeth. Duval, Krall and I sat for four hours, filling in the blanks for ourselves and infrequently chiming in as Cecil smoked half a pack of cigarettes, left the arugula he'd ordered untouched and drank half a dozen champagnes. It was a treat to meet him on his own terms, whether or not I caught all his references and narrative connections. He began without ado, launching into memories of New York City in the '50s.

" . . . with Allen Ginsberg, I had a wonderful time, talking to Chet [Baker] – I

was there when he first played with Gerry Mulligan, who asked would I consider giving his wife piano lessons? Well, you know the answer to *that!*"

[Obviously: "No!"]

"Chet was striking looking. That was the era of James Dean, remember. When I came off the bandstand, Chet wanted me to talk to someone who had just come in. 'I'm the greatest writer in America,' this fellow told me. And I was a big 23, so I said, 'I'm the greatest pianist in America." Then I went up again to play, and when I came off, Jack Kerouac said, 'Well, you are!' And he gave me a manuscript and a wonderful walking stick.

"We were at the Cedar Bar [a Village hangout of the abstract expressionist painters and Beats during the '50s]. Allen says, 'This is my poem "Howl." I'd like you to do the music.' Well, I'm not going to do this. Then Leroi [Jones, aka Amiri Baraka] says, 'Allen, jazz musicians are not literate!' Leroi, the most controversial poet in America. You think 'Howl' was something? Well, [African-American poet] Bob Kaufman is the one who started the Beat movement. Allen, Peter [Orlovsky], Roi and Bob Kaufman had an apartment together, you know . . ."

Then, switching gears: "Dominic, I've got some music for you. But sometimes you have to wait."

Duval: "I've been studying that tape you gave me. I need your help."

Cecil: "We can help each other. You've got four strings; the double and triple stops I wrote are merely range areas. It will be interesting to see how they're interpreted. You know, it's a wonderful thing about the piano — if you love Ellington, you end up writing orchestrally anyway . . ."

Duval: "We need to talk about the dynamics of the music."

Cecil: "Perhaps you can imagine [bebop pianist] Mr. Al Haig's reaction [upon hearing me] around 1955. Haig left; he wasn't happy. As opposed to Zoot Sims [a swing-styled but post-World War II era saxophonist], who came to a loft session where I was involved. Zoot just listened, which is all you can ask of anyone. Ira Sullivan was playing trumpet, Pee Wee Russell was there . . . Now Mr. Sims may seem several steps removed, but these people were, in some ways, one's ancestors. We had a wonderful conversation . . .

"You remember [trumpeter] Benny Bailey? He was the first guy who asked me, 'What are you doing?' That was very nice. This was in Europe, in Nimes; he was playing with Lionel Hampton's big band and had said Hamp had gotten salty with the band, soloing for three hours, permitting no one else to solo. Benny asked me, 'What's your sign?' I said, 'Aries,' and he said, 'Oh, just like Hampton,' and left the table. Whereupon one of the great geniuses of American music [Hampton himself] came and sat down . . .

"Hamp said, 'I was born in Whittier, California, where ex-president Nixon was born.' This was probably '75 or '76. Hamp said he'd been promised houses in Harlem if the GOP won the upcoming election. Well, they built the houses, but

when he was playing in front of them people rioted and they stopped the music. That was one of only three [jazz or black music] performances I'd seen broadcast on the morning *Today* show. They'd had to give it up to Hamp, and also to Little Richard . . ."

Krall: "You know, a book on Mary Lou Williams has been published."

Cecil: "Besides being one of the great musicians, she was so beautiful. I was so honored she picked me [to have an interest in]. You know, I heard 'The Zodiac Suite' [one of her major compositions] when I was 12, with all these strings and harps . . . it made quite an impression. And back when Benny Goodman was mistakenly called the King of Swing, *the* piece for us was her composition 'Roll 'Em.' You know Andy Cyrille's first gig was with Mary Lou? I met her the first time at the Cookery, and she told me that when Art Blakey was 18, she'd said to him, 'If you don't get to New York, I'll kill you.'

"Another one of my favorite pianists is Fats Waller. I was coming up in the time of Art Tatum, Bud Powell and Teddy Wilson, but I always preferred Fats. Listen to him on the Esquire All-Star records: Fats Waller was one of the finest technicians the piano has ever had. Every note he plays is distinct, with a space between them. And he was also famous as a theater organ player. His son was at school with me . . . "

Krall: "But Fats died at age 39. . ."

Cecil: "Yes, and Bird died at age 35 in '55 . . . I myself had two marvelous meals today, and drank a lot of fruit juice, and water. You should read what [jazz journalist, author and commentator on the U.S. constitution] Nat Hentoff wrote about [Charlie] Parker. I met Hentoff when I was 16; he was an interesting cat. He had a radio show on WBUR in Boston, on which he played all Ellington. Then in '47 or '48 he won a Guggenheim fellowship, and when he returned from his year in Paris, he had Lee Konitz and Charlie Parker as his guests. We corresponded. He became editor of *Down Beat*, didn't he?"

Cecil's conversation continued to skitter from name to name. He'd talk about Eubie Blake (" . . . the only chance I had to converse with him, in East St. Louis – he had enormous fingers . . . ") and naturally segue to a discussion of Blake's writing partner Noble Sissle ("They revolutionized the musical with *Shuffle Along* ") then to the comic Bert Williams ("a light skinned black man they put blackface on for his stage act . . .") and to W.C. Fields ("who I prefer to Chaplin as I prefer Keaton to Chaplin; Fields called Williams 'the funniest and saddest man I've ever seen' "), Mae West ("a tough babe"), Marilyn Monroe, Kim Novak and Sammy Davis, Jr.

More names came up: Amadou Diallo, an African immigrant to New York who had recently been killed by overzealous plainclothes policemen, though he was unarmed and innocent of any crime; Al Sharpton, the controversial black community activist ("He says, correctly, 'Don't emulate the police' "), poet James Merrill, Franklin Delano Roosevelt ("A bastard, but our bastard") and Eleanor Roosevelt ("She went to Tuskagee University, to say 'Yes, they [African-Americans] can fly airplanes") . . .

"There's a smothering of the great American spirits," Cecil maintained. "Look what happened to Frances Farmer, Lennie Bruce, Orson Welles, Paul Robeson. Oh, they're going to get you . . .

"When James Brown was put in jail [convicted on several charges relating to erratic and threatening behavior] I went into the kitchen at the Village Vanguard [the musicians' gathering place in that nightclub] to talk about this, and a guy there says, 'Well, he's a criminal.' I said, 'When Jean Genet [French writer/thief] was put in jail [writers] Sartre, de Beauvoir and Camus went to Andre Malraux [France's cultural minister] and Genet walked. When James Brown is in jail, where is Aretha? Where is Michael Jackson?' What the oppressors do to you in your community, you adopt that behavior. You adopt the attitude of your oppressors.

"You know about when the [jazz] musicians [in the '60s went on television as a guerilla theater protest] and stopped the shows? We went to [talk show host] Dick Cavett, who said, 'Where's Jesse Jackson?' Jesse [civil rights leader and politician] was the commercial hook, but he was not going to be there. I said, 'Where are the dressing rooms?' And we were each given one.

"Before we went on to perform, [Cavett's bandleader] Bobby Rosengarden played 'It Don't Mean A Thing (If It Ain't Got That Swing).' Cavett said, 'You're not on television because you're the avant-garde.' I said, 'But you've never had Duke Ellington's band on this show, either,' and Cavett said, 'We had him as a pianist.' Well, Steve Allen sits down to play piano on these shows, too. I told him, 'Yes, alright, you've had Duke Ellington, but these musicians are talking about their livelihoods. You're talking about manners!'

"In those days, a corporation would have one black guy around to represent it. Nothing has changed, except for Quincy [Jones]. Max [Roach] asked me what I was doing on New Year's Eve – he said, 'I was at the White House. And the president was very affable.' But then I watch Brian Gumble [host of television's *The Today Show*] who has Quincy as a guest, and it turns out Q was responsible for all the entertainment at the White House that night . . . Well, politics is the lifeblood of the nation."

"I think art is the lifeblood of the nation," I blurted.

Cecil: "Well, yes, I couldn't agree with you more. But it really depends whom you know, and where you are. Bill Evans, being called the pianist of my generation! Really! Now, Don Pullen – talk about an interesting pianist. Or John Lewis. The Modern Jazz Quartet was magisterial. It was genius of Monte Kay [nightclub owner and jazz artists' manager] to put them in tuxes. To me, the MJQ was always about Milt [Jackson, vibist], he was always beautiful. But if you listen to the delicate thing John Lewis [pianist] is playing behind him . . .

"When I met Matt Shipp [a young pianist of the '90s avant-garde], he talked about Lennie Tristano. Well, yes, Lennie Tristano. But you say Horace Silver can't

play? I said, 'Young man, even if you're the greatest pianist who ever lived, I wouldn't have to see you!'

"You know what's sad? The most interesting musician in McCoy [Tyner]'s band has been [bassist] Avery Sharp. All the joy is gone, it seems. McCoy has worked steadily since John [Coltrane] died, and yet nothing has changed.

"Andrew Hill [pianist and composer, roughly Cecil's contemporary]? He's an interesting guy. He's written some interesting music. Mal [Waldron, pianist and one-time accompanist to Billie Holiday] wrote some interesting music. I must mention Randy Weston. Lowell Davidson [an obscure pianist of the '60s] — he had an idea but, well, he died. Delmar Brown [a younger pianist, promoting his band as a "World Pop Experience"] — he just makes rhythmical sounds, but because of his personality, they make an impression.

"I'll say that Jaki Byard [pianist with Charles Mingus, among others] knew as much about the piano as any man in the world. What I choose to remember of him is when I heard him at age 17 . . . Also, Oscar Dennard. Richard Twardzik. Eddie Costa. Great pianists, so many of them, died before they were 30.

"Oh, all these basements you play in: The music transforms them into temples. But it takes, what, 30 years? You have to keep steppin'. I mean, at one point [pianist] Hilton Ruiz was number one, playing at Bradley's. And one night, [Michel] Petrucciani [a French-born pianist] was here. Well, Hilton gave us 'The Star-Spangled Banner' like Horowitz banging it out. Petrucciani lit a cigarette, put that cigarette in his mouth, in his nostrils, in his ears [as a sign of disdain for what Ruiz was playing] . . . You know 'Isn't She Lovely,' Stevie (Wonder)'s tune? Hilton made that tune happen!"

"One must consider drummers, too," Cecil continued. "Max Roach is a virtuoso but [Art] Blakey had the heart. Elvin [Jones] has that. It's passion. Of course, when I think of what Max did at the Beehive [with Clifford Brown], he's clearly a mf.

"And if you don't know Sunny Murray, or Milford Graves or Tony Oxley [all drummers], well [you ought to] . . . [Dutch drummer] Han Bennink, his sense of comedy is not mine. But Sunny Murray's a mf, he can play those drums. Tony [Williams] — yes; Max, yes, and Blakey — but Sunny!

"In '63, we played two weeks opposite Sonny Rollins at the Vanguard. There was a matinee on Sunday, and Newk [Rollins] came to me and said, 'Don't ever let them stop you from doing that!' When Max Gordon [longtime owner of the Village Vanguard] died, he had still not really heard [come to appreciate] Sonny [Murray]. But he'd heard Andrew [Cyrille]. Andrew was there [performing at the Vanguard].

"Ah, the way Andrew Cyrille played! Once, at Ronnie Scott's [London jazz club], Monk was backstage. My other master. He said to Andrew, "What was that? You can't play that fast!" And then to me: 'Just keep that drummer hot!'

"You know, I wanted [trumpeter] Ted Curson on *Coltrane Time* [Cecil's 1958

recording session, also known as *Hard Driving Jazz*] but they [the producers] wouldn't let me have him. It had to be Kenny Dorham. Well, first thing we played was a blues, and Kenny Dorham wasn't happy. Then 'Caravan.' Well, Kenny Dorham was so unhappy he went after Louis Hayes, the drummer, and the bass player, Chuck Israels. Trane said to Kenny, trying to turn him around about me, 'He's a young Monk.'

"Then Trane said [to Cecil], 'What do you want to play?' And I said, ' "All Or Nothing At All" ', and Trane said ok, but Kenny Dorham said no. After that recording Kenny Dorham decided to study harmony at New York University, and one day he ran into me in Washington Square Park – and he said, 'I want to talk to you.' But that was too little, too late. He died soon after."

This recollection of a reputable jazz musician, at first angry to be cast with Cecil, but later seeking his guidance, gave us all pause. It was a somewhat awkward moment, until we realized we were the last ones in the restaurant; the waiters were waiting for us to leave. Duval and Krall and I headed for our respective homes. Outside, Cecil hailed a cab to take him to an after-hours club.

Speaking of drummers

British critic and photographer Valerie Wilmer wrote in *As Serious As Your Life* (1980) that Cecil played the piano as if it was "88 tuned drums."

"Cecil does play with a percussive technique, and he plays more rhythmically than does any other pianist I know of," drummer Edward Blackwell said when I had him listen to an obscure track featuring Cecil with drummer Tony Williams for a 1980 *Down Beat* Blindfold Test.

The test – originally devised for *Metronome* magazine by jazz critic Leonard Feather – asks a musician to comment on recordings without benefit of knowing in advance who the performers are. Blackwell was best known for his partnership with Ornette Coleman and membership in Old and New Dreams with Don Cherry, Dewey Redman and Charlie Haden – all of whom he worked with in other situations, too. Williams was still celebrated for his explosive playing in the 1960s with Miles Davis, although he'd changed his style since then. "Morgan's Motion" was the only piece pairing Williams and Cecil from *The Joy Of Flying*, the drummer's 1979 album for Columbia that otherwise contained fusion and hard rock collaborations. Blackwell spoke while the record spun.

"Is that Max [Roach]? I know they were scheduled to do a thing. This is not so much together as playing individually. Cecil is playing, and the drummer is playing, but they're almost playing individually, it seems like. Here they seem to be making an exchange, but before . . . Here it sounds like they're really coming together, after a while. That drummer I can't recognize. You stumped me.

"I played with Cecil quite a bit when I moved to New York,"[1] Blackwell said. That was news to me; they'd never recorded. "I know Cecil well, and it's a challenge

to play with him, but after playing with Ornette for so long it was easy for me to understand what he was doing.

"With Ornette I got to the point where instead of anticipating where the one [the first down beat of a measure] would be, I'd listen to him for where *he* would put it. And the same way with Cecil. You can't just go ahead and say one is one; it's going to be *here*, or it's going to be *there*. Sometimes it's going to be somewhere else.

"What I do to fill it out is play on the rhythm of the notes Ornette plays. I follow him and playing exactly on the notes and the speed and the rhythms that he plays, it puts me right up with him. Otherwise I would be one place and he would be somewhere else. And sometimes I'll do a phrase before him, and he'll pick it right up. That didn't happen so much with Cecil."

"I've been a fan, a devotee, of Cecil's from the first time I heard him, about the same time we did our *Freedom Now!* suite,"[2] drummer Max Roach told me, seated at his apartment on Central Park West in 2001. Their most recent collaboration had been a year before. "I associated him with the revolution that was going on artistically, politically and all that. It had always been in the back of my mind to work with Cecil. And I was doing an interview at WKCR [Columbia University's radio station], talking about the duets I had done with Archie Shepp and with Anthony Braxton, and I was asked what I would like to do next, and I said, 'Cecil Taylor.' So they sponsored a concert at Columbia for Cecil and me to do our session together.

"That was a really interesting experience. I began to get close to him. He'd always come by [venues where Roach was playing] and we'd wave at each other, but we'd never sat down and talked about anything. So when we sat down to plan the concert at Columbia, to talk about what we might do, we talked about everything except the session. We talked politics, we talked visual arts . . . He had a studio on the top floor of a building on Chambers Street then, and had a dog and a cat that were always trying to ball each other. I didn't want to be disconcerted by that, I just thought it must be one of Cecil's things . . .

"And his record collection fascinated me. He had everything there. He was dealing with the ancient, the contemporary, everything musical. We talked and talked, and the next thing we knew we were on the stage together. It was totally improvised, but I knew from the first time we talked that it would work. His warmth and friendliness and what he clearly appreciated about where I was in my music, and what I appreciated about where he was in his — our collaboration happened without our having to say anything in advance about it.

"It was strange," Roach conceded about the stylistic conflict that was assumed to exist between the two musicians. "Prior to and during and after the concert there were two camps there, Cecil's, which asked incredulously, 'You're playing with this bebopper?' and my camp, which said, 'You worked with Bud Powell, and

now you're working with Cecil Taylor? What's happening?' My whole thing about Cecil was that he was more like Bud Powell than an imitator of Bud Powell, because Bud went away from what everybody was doing, and people who do that are always heavily criticized, just like Cecil was.

"So I said, 'Why not Cecil? Cecil to me is more like Bud than a person who imitates Bud, just as Anthony Braxton is more like Charlie Parker than a person who imitates Charlie Parker.' Cecil is adventurous, and creative, and he decided to be on his own, to go his own way.

"And besides, for me to work as a percussionist with Cecil – just like working with, say Bud and Anthony and Charlie Parker – it gave me the impetus to find something different myself. It helped me grow. After we did the concert at Columbia we did several concerts in Europe, and they always involved some of the most thrilling and challenging musical moments I've had. Cecil is one of the most challenging musicians I've ever worked with. To put it in lay terms, it's like being in the ring with Joe Louis, Jack Johnson or Mike Tyson. It's like being on a battlefield, but it's warm music. You really have to be at the top of your game to hang with Cecil up there on that stage, because he takes everything his own way; but in doing that he lets you go *your* own way, if you know what that is.

"For me, he brings out the best. People look at it as freedom, but the kind of discipline you have to deal with – with your instrument, your own ideas, your own creativity – it's monumental with Cecil. I went to hear his solo concert at Alice Tully Hall, which I thought was just fantastic. I always think it's fantastic, what he does. He exemplifies something original. He embodies something of his own.

"You know, I worked with Lester Young after he left Count Basie's band. We were at one of the joints in the Village. I just assumed that if I played like the great drummer Papa Jo Jones who worked with Count Basie, that would be the way to play with Lester Young. In those days you worked for six weeks in a club, so you got a chance to really develop something that works, you think, with a person like Lester Young. Well, one night, when I thought I had everything down, I said, 'Ok, Lester, that was a good night.'

"And Lester looked at me and said, 'You can't join the throng 'til you write your own song.' He sang that to me. And he said, 'Do you dig the tones?'

"What I'm saying is Cecil exemplifies that. It's not a matter of doing something somebody else has done. To be a creative artist you have to come up with something that's unique to yourself, and you have to hang with it no matter what barbs are flung and which of your critics and your peers understand you or not.

"Cecil's technique is personal and I don't know anybody else who can sustain that kind of energy and power, and ideas just keep coming. It's so personal to Cecil, and even though he's always expanding and moving out, it's the same direction he has persisted in all his musical career, that I know of. I've heard some of the early things he did, when he first came out of New England Conservatory; he can play

so-called straightahead as well. I just love him as an artist and as a person, and the fact that he gives you the freedom – he doesn't say 'Ok, now I'm doing it this way or that way.'

"I remember that time in his loft on Chamber Street, prior to our first Columbia concert, I said, 'Cecil, we've talked about a lot of things, but is there anything you feel you'd like to hear from me?' And he said, 'Yes, come to think of it. Most people don't know when I'm playing a ballad.' I said, 'Ok, why don't you give me some ideas.' So he went to the piano and played himself, Cecil Taylor. It was beautiful, but it was still Cecil. It was still in that complex range where I could play out on it, or bash on it, or lay out, or do something every simple. It just *worked*. He looked at me, went right into his thing, and it sounded like Cecil. And I said to myself, 'Well, that means whatever you think is alright with him.' That's one of the things I like about him. Cecil depends on you to use your imagination, your skills, and if you can't keep up, you just get lost in the shuffle."

Does he take your ideas, too? I asked.

"I think he does, yeah," Roach said. "When we did that first concert many of the writers were saying that Cecil was percussive and I was melodic. But it's a funny thing: Cecil used to play drums when he was young, he started out playing drums, that's what he was telling me when we had our conversation, and that can explain why he uses his hands the way he uses them. And I started out in music playing piano.

"He's the kind of person who, though through and through he's a complex person, he's also very simple, easy to get, accessible. He's as accessible as Dizzy Gillespie was. You know, Dizzy was everybody's friend. I feel Cecil's like that."

Did you see him collaborate with Mary Lou Williams?

"No, but I heard about it. There were various opinions. Some people thought Cecil was too powerful for her, but I said, 'Nah, that's not what it was about. Cecil was just playing, the same way *she* played.' The way Cecil played and the way Mary Lou played, I thought it would work together perfectly. Because Cecil plays *with* you, but he doesn't play *like* you. He's Cecil, just like everybody else should be themselves."

Roach had seen jazz in rapid development at several junctures; he'd been the house drummer at Monroe's Uptown, where bebop was forged in after-hours sessions, starting around 1942. He knew what conservatism meant, in jazz terms.

"The minute you say 'jazz,' it's like saying 'classic jazz,'" he said, "and people expect a certain sound and certain attitude. If you say 'jazz,' they're looking for a saxophonist or a trumpeter, like if you say 'ragtime,' they're looking for a pianist. What Cecil is doing is using his vision of sound, and whether anybody else picks it up or not doesn't make any difference. Sometimes an artist may never be picked up on. To prevent that, musicians often come to the point where they leans towards what they think the public is going to appreciate them doing.

"God bless Cecil, because he goes beyond that. He stands his ground. He's not looking out to see if anybody's listening or not, or whatever. He's *there*. What he does makes sense, and it's not easy to do. I think a lot of people are not dealing with Cecil, because his music is difficult. Many people are not dealing with Charlie Parker honestly, either, because he's difficult, too, in pure form. These kinds of people would rather deal with hybrids, watered down versions. That makes it easier. There are some people out here who will always do that. There are writers like that, too.

"Let me say this: Cecil and I want to do some more things together; that's in the talking stage. He's won a MacArthur, I've won a MacArthur, and we look at each other and smile, because we can afford to think of new things to do. We're toying with new ideas.

A MacArthur Fellows Band? I suggested.

"How about that?" Max Roach shot back.

Cecil's solo performances are extraordinary – he doesn't need another person to complicate or inspire his always far-flung and multi-dimensional extrapolations. Yet his duets are legendary, too. His final one with Max Roach occurred in 2000 – Roach's MacArthur Fellows band never happened – in the central quadrangle of Columbia University, before some 6000 awestruck listeners, as part of a music festival produced by Bell Atlantic, then New York City's telephone company.

I saw some people in the crowd with hand-held tape recorders, capturing the music for posterity. But there was no authorized recording of this fourth Taylor–Roach encounter. According to producer Michael Dorf, "They said they didn't want it recorded" – a shame, because the pianist and the drummer were gorgeously lit, brilliantly mixed and seriously inspired, mesmerizing for an hour and a half, like sorcerers in deadly combat.

Upon taking their places without belabored introduction, Cecil and Roach – respectively at a grand piano and low slung, tipped in traps with a tympani like add-on – wrestled with all their mights. Cecil was unimaginably articulate all over the ivories, almost stripping off the keys with his hyperfast fingerwork. Roach cut him no slack – he knew exactly what to lay down as guideposts for Cecil's full roar, and he often laid a course Cecil had no choice but to follow. After about an hour of the most intense improv., Cecil stood away from the piano, and Roach soloed muscularly for about eight minutes. Then he stood to announce that the rest of the concert was dedicated to New York Latino music timbales player and bandleader Tito Puente.

Roach and Cecil then resumed their titanic dialog for another 15 or 20 minutes. Their combined sound was orchestral; they leapt upon each other's moves gleefully, as if pleased to know they were creating grandeur that would be forever gone,

irretrievable, the instant after its impulse. Together, Cecil and Roach pounded out an impassioned cry – "I *am*" – against anything (including that in each other) that might protest, "But you're *not*."

Most of the audience sat on blankets on the lawn of the quad, deeply absorbed in their music, or on the steps of the library, Sproul Hall – but many stood stock-still, ears wide open, transfixed by the duet's sound. The stage was set up against neo-classical pillars of the building housing Columbia University's English department, a few yards from the school's Miller Theatre, which had been McMillin Theatre, site of the pianist and drummer's first collaboration on December 15, 1979. That event was preserved on *Historic Concerts*, on Italian Soul Note Records. Their second public performance was in Bologna, and third at Town Hall in New York City, both in 1989. Private tapes from their fourth date must exist. I want one.

In late November 2001 Cecil and another drummer, Elvin Jones, came to the stage of the Blue Note in Greenwich Village as titans, not for an athletic event or anything competitive, but to make music together. They had already recorded *Momentum Space*, two years before. They had scheduled three consecutive midweek nights to perform publicly, for the first time; they would repeat the experience annually, until Jones died in May 2004. They were greeted by respectful, anticipatory applause. The pianist held some loose sheets of staff paper in hand, the drummer carried just a pair of heavy-headed mallets.

They also brought, each of them, some 50 years of night-after-night experience with the most relentlessly unconventional musicians of the improvisatory arts – and over the course of that time they had evolved from explorers to prophets to visionaries. Jones, age 74, was well known as a wickedly powerful rhythmist, able to heat simple time into boiling pools of polyrhythms; he still moved with panther-like grace. Cecil, age 72, had become an eminence grise. Both were icons of unbending authenticity, incomparably free of self-consciousness when sitting at their instruments, applying themselves to the totality of the moment, responding to everything they're conscious of by producing unchartable fathoms of sound.

This kind of a concert may not be everyone's tea: there were no landmarks for the uninitiated, no song forms, jaunty motifs or comfortably measurable, pre-harmonized patterns. However, all its elements were transparent, exposed.

Jones started with a soft but firm two-handed tattoo across his tom-toms and continued to hammer at them with dauntless curiosity from many angles, staying away from his snare drum and spraying a slap across one of his two sizzle cymbals infrequently, as an accent. Cecil's first gesture was to swipe his keyboard's entire length once, as lightly as if dusting it – but with perfect articulation of the self-designed scale he'd plumb and plunder for the next 70 minutes, non-stop. It took Cecil perhaps 30 seconds to introduce his lighting-bolt bass notes, hurricane of

dissonant clusters and angular figures splayed, fragmented, extended and inverted across octaves. From then on he juggled these balls in the air in such rapid and un-predictable sequence that they could more likely have been played by an octopus.

Both men were models of focused energy, yet both were relaxed enough to let the other breathe. There was no forced mutuality – each assumed his individual concept was large enough to encompass the other's. And so they were. Cecil was freed of any responsibility to a driving beat, and sometimes interspersed his earthy, lyrical phrases with silences, as for reflection. Jones was attuned to issues of volume, complementing and contrasting the pianist's array of touches with his own nu-ances of attack, pronounced or underplayed as they occurred in his own train of thought.

Of course, Jones honed his duet skills in the John Coltrane Quartet – some of whose greatest moments (as in "Alabama," videotaped for critic Ralph Gleason's *Jazz Casuals* television program) were when McCoy Tyner and Jimmy Garrison dropped out to let the saxophonist soar over the drummer's battery. As for Cecil, whether directing an unruly orchestra, leading bristling Units or engaged in duets, he's always extended a tentacle to each collaborator directly, as well as encircling them all.

Jones had seldom been able to assemble a band of his own that balanced his impassioned physicality with any element equally compelling. Together, though, darting, incisive Cecil and vital, implacable Jones made music bigger than either of them alone, music that emerged without conditions or niceties out of some elemental human impulse, ceaseless, uproarious, serene, mysterious, immediate, epic and unrepeatable.

If there's a *sine qua non* for any art that dares greatness, it's the artist's commitment to his or her endeavor. Artists may be infamous bastards, vainglorious megalomani-acs, hopelessly self-absorbed, willfully arrogant, spacey, druggy, sullen or scary. But little, if anything, of lasting value comes from half heartedness, hypocrisy or genuine cynicism about one's own work.

Which is one reason pianist Cecil looms so hugely as an uncompromising American artist, mostly musical in impact and of the jazz world by choice, consensus and default. At age 74 in 2003 he intended every public performance, such as those with his 3 AHA trio during two nights at the Blue Note in Manhattan, to further amplify his career of achievement, besides work in and of itself.

Cecil is no hit-maker. He doesn't care about involving himself with any vernacu-lar other than what he's concocted from his own resources, with which he means to turn the world his way. He has devised and continuously developed a personal style that sets an incomparable standard of speed and density for a ten-fingered improviser. But he doesn't use that style to give his listeners repeatedly digestible tidbits within familiar structures backed by a winning smile. It's not a style that he

has, as much as a unique way of playing that functions inseparably from its content, arriving at an indisputably original form.

Forget about the pianists who tout pseudo-funky ostinatos and painfully wrought flights of tuneful preciosity, flash-of-the-hands' frothiness or sublimely polished, utterly conventional retreads of tradition — Cecil will have none of that. To him, it's just showiness which promises but seldom realizes anything substantially and heroically new. Listen instead to what he's stirred up, he'd urge if he deigned to urge.

Instead, he growls, groans, moans, shouts letters of the alphabet as poetry and whines like a Mongolian throat-singer, then throws himself into engagement with his keyboard – and expects us to devote attention just as engaged, informed, immediate and virtuosic as his own to the task of listening to him.

It's no small demand, yet he has followers who swear listening to him is a tonic for the mind. Despite his fearsome technique, as he's gotten older he's typically begun his uninterrupted hour-long sets more quietly, reflectively, laying out a few notes as if they will be a theme to focus in on and explore.

Just as their echo is dying, he starts to roll out rippling figures and plunging bass posts, harmonically distant yet evocative chords, and disturbing angular figures that seem completely unrelated to what he'd begun before. These continue to come tumbling out after each other in faster succession if not predictable sequence, muddying the passage of time so as to seem simultaneous. They accumulate as waves of action, and become oceanic as crosscurrents and contrapuntal crests, sometimes – infrequently – calming so, in the lull, he can set forth another languorous, luminous and starkly haunting line. Is it what he started with ageless minutes ago? Or just a similarly bejeweled strand of pitches, suspended in the suddenly hushed (yet in our ears, still ringing) air?

Meanwhile, Cecil's collaborators contribute parallel swells of activity. At the Blue Note his 3 AHA percussionist Jackson Krall balanced the resounding piano well with powerful but seldom clangorous drums and cymbals attacks, and didn't try to anticipate or emulate the pianist's idiosyncratic phrasing, breathing, so much as respond with equal spontaneity and gravitas. Albey Balgochian, who played a standup, apparently hollow-bodied electric bass, had a gluey tone that wasn't immediately appealing; he held on gamely to the overall arc and vibe Taylor created, without quite establishing a persuasive sound sphere of his own.

It can't be easy playing in Cecil's ensembles. It looks to be like trying to grapple with a partner who's out of reach: There's nothing to hold onto. You end up wrestling yourself. As that's the task Taylor sets for his audiences, I imagine his fellow players enjoy it even more.

He has impressed and inspired a legion of them since first emerging from Boston in the mid-'50s. By 2007 he stands as our era's Beethoven. That's a big claim, yes, and one that some audience members scoffed at when they read it in my program notes to a solo concert in 2006 at Merkin Hall, then afterwards conceded it might

indeed be valid. He is a musician of torrent and torment and the lyricism buried within, delivered with comparable noise, angst, power and glory.

I could be wrong. Civilization to come might decide his sound and fury signifies nothing. Unlike Miles, unlike Ornette, unlike Monk and Bird and Trane and many other revolutionaries, Cecil's never been embraced wholeheartedly by the jazz powers-that-be. That's understandable. Fifty years since his debut, he still defies categorization, and would rather be a prickly iconoclast than an elder statesman accepting his due.

I applaud that, though the only regard Cecil Taylor cares about is that people hear him, as best they can, when he appears. I go over and over, trying to apprehend what he's done, and leave each time somewhat awed, a little less mystified by the how, what and why of his latest art, and ever more caught up in its all. If his 3 AHA Trio left something to be desired as a unit, and his New AHA trio with drummer Pheeroan ak Laff and bassist Henry Grimes in its performance at Jazz at Lincoln Center was disappointingly inaudible and flummoxed by misjudged collaborative efforts, I will remember the first time I heard him play with ak Laff and Grimes at the Times Square basement club Iridium, early in 2006.

That had been a splendid set, well-miked and, perhaps because they were just breaking into being in his trio, ak Laff and Grimes had played with considerable sensitivity. Cecil was obviously pleased. As he came to the end of his long uninterrupted performance he did something he seldom does, quoted a work by another musician. It was a surprise, but unmistakable. Just as he reached a glorious climax, seeming full of his own spirit, ebullient and fulfilled, his fingers flew into the transcendently joyous theme from the fifth movement of Olivier Messiaen's *Turangalîla-Symphonie*. This was a remarkable allusion to a highly regarded masterpiece, but atypical of any repertoire, jazz or Western symphonic literature alike, and unlikely to be recognized by general audiences.

Messiaen, the French composer, conservatory professor and church organist had an extraordinarily broad grasp of the world's music, with an interest in Javanese gamelan, ancient Greek and Hindu rhythms, twentieth century serialism and birdsong, too. Most of his works have religious themes – he was a devout Roman Catholic, quoted as making music about "the marvelous aspects of the faith" – but he described *Turangalîla-Symphonie* as "a love song" inspired by the romantic legend of Tristan and Isolde, and frank in its reference to sexual union. Its title comes from two Sanskrit words; according to the composer, they combine to mean "love song, hymn to joy, time, movement, rhythm, life and death."[3]

When the work, commissioned by Serge Koussevitzky for the Boston Symphony Orchestra, was premiered by conductor Leonard Bernstein in 1949, Messiaen's second wife, Yvonne Loriod was the piano soloist. The fifth movement of ten, titled "Joy Of The Blood Of The Stars," turns on the theme Cecil quoted. As Messiaen wrote, "The cadenza that ends the fifth movement is so vehement it even manages

to exceed the shattering orchestral tutti that precedes it. The solo piano is part of the gamelan. It also makes birdsongs heard."

Throughout it sparkles with ultra-trebly notes produced by the electronic instrument Ondes-Martinot, sounding like tinkly tuned bells, or as Messiaen described them, the "metallic resonance of a gong . . . surround[ed] with a halo of harmonics. Strange, mysterious and unreal when they are soft, or cruel, lacerating and terrifying when forceful, these metallized sounds are certainly the most beautiful the instrument can produce."

Cecil elicited all that on his 88 tuned drums.

FURTHERMORE: THE ONCE AND FUTURE AVANT-GARDE

What is the avant-garde?

Seattle jazz journalist Paul deBarros, in a lively discussion we had on the way to the Portland Jazz Festival in early 2007 to hear a weekend full of musicians who recorded for the ECM label – including vibist Gary Burton with pianist Chick Corea, saxophonist Charles Lloyd's quartet with pianist Geri Allen, and a 12-piece ensemble of Norwegian musicians performing a lengthy, subdued, through-composed work by young clarinetist Trygve Seim – sagely suggested it is art that "shifts the paradigm," providing a concept that requires us to reconceive or at least review everything, with fresh awareness if not necessarily more truth or greater clarity than we had before.

Poet Jayne Cortez, who I ran into walking out of a drug store on Bleeker Street in Greenwich Village near my office, when I mentioned the topic of jazz beyond jazz immediately offered that "the avant-garde is that in art which didn't exist before. It's always hard to introduce, because the avant-garde has to make a place for itself where there wasn't one, where there wasn't anything." This left the image of the avant-garde in the shape of a wedge – maybe with a single, driven artist at its point – forcing open obdurate culture, widening its incursion as its broader base pushes forward, shattering a placid plane as an earthquake breaks the ground.

Composer and orchestra leader Maria Schneider, at the end of an interview she submitted to in spring 2007 for *Down Beat*, was maybe too quick to agree with my assessment that her music, while beautiful, isn't "avant-garde." In her most recent recording, *Sky Blue*, which Schneider had previewed for me, her orchestra members created a forest of birdcalls using only vocalisms and little toy instruments. She told me she'd heard conductor Marin Alsop in a National Public Radio broadcast say that new music can require human brains to rewire themselves, which was why the audience rioted at the premiere of Stravinsky's "The Rite Of Spring."

Some people I spoke of this book to shook their heads sadly, or with dismay – seldom with glee – announcing "there is no avant-garde anymore," though I think the truth is there are many artists innovating in every medium, and the problem in

what we've called jazz is that the audience base has deteriorated so dramatically that most of those on the commercial end of exploiting it are trying to hold on through consolidation, rather than turning attention to what's usefully refreshing or jarringly new.

Musical avant-gardists who have emerged in the wake of Miles, Ornette and Cecil, for instance, are as daring as ever – I am thinking of AACM musicians Muhal Richard Abrams, George Lewis and Roscoe Mitchell, whose all-improvised album *Streaming* (2006, Pi Records) projects a cinematic excursion through improvisations, casting motifs produced on piano, trombone, saxophone, computer programs and percussion instruments together so as to excite a reconsideration of the basic ways we organize sounds into music. Their work encourages us to abandon questions of what pitches harmonize and how different rhythms intersect for matters relating to sonic scale, to foreground and field, to the conjunction of non-associative elements and the role listeners play in pulling disparate noise into meaningful music.

Now those three musicians aren't brand new – nor are their AACM compatriots Anthony Braxton, Wadada Leo Smith, Henry Threadgill and Fred Anderson. That's right, the avant-garde currently includes notorious elders: big band leader and soloist Sam Rivers and composer–theorist George Russell, both age 84, and saxophonist Yusef Lateef, age 87, as well as youngsters like psychedelic microtonal guitarist Gabriel Marin, 20-something, of the "ethno-fusion" band Consider the Source – a Hendrix-like trio that sends Middle Eastern-derived riffs way over the top – and drummer Tyshawn Sorey, also in his early 20s, breaking up a blues shuffle into Elvin Jones-like polyrhythms. And no one, known or unknown, owns the sole direction the avant-garde takes today. There must be thousands of musicians trying to find personal ways to awaken us to life through sound.

I think of pianist Myra Melford with trumpeter Cuong Vu in her band Be Bread, combining impassioned melodic lyricism with spikey timbres and adept use of space; or electric guitarist Nels Cline who re-arranged the innovative, elusive compositions of pianist Andrew Hill for an ensemble with post bop trumpeter Bobby Bradford – one of Ornette's associates from the '50s – and klezmer-informed clarinetist Ben Goldberg, improvising accordionist Andrea Parkins, plus a slamming team on bass (Devon Hoff) and drums (Scott Amendola).

I think of John Zorn blowing raw alto sax over and through the ocean-bottom basslines of Bill Laswell and Afrological drums of Hamid Drake, of Elliott Sharp raising brilliant, bristly musical thickets and New Yorkizing the blues, of keyboardists Anthony Coleman, Wayne Horvitz and Annie Gosfeld, saxophonist–storyteller Roy Nathanson with the Jazz Passengers, among other figures of serious fun. Of Butch Morris, creating orchestral timbres and movements by asking any number of improvising players, using any variety of instruments, to interpret his unique set of hand gestures by their own lights. And pianist Gonzalo Rubalcaba, filtering his Cuban born-and-bred romantic sensibility through gorgeous touch and profound understanding of modern harmony to conjure music of classical sublimity.

These are just some of my favorites, and maybe not giants on the order of Miles, Ornette and Cecil, but devoted to getting to the jazz beyond jazz – breaking ground rather than solidifying it. Oh, they'd like what they do to take root, too – they hope as much or more, though, to sow what's *not* been sown before, something new that not only promises insight and/or efficacy, but makes good on the promise by sprouting forth and disseminating more life. What's avant-garde almost certainly evolves out of what we bring with us – it's our rearrangement, adaptation, expansion or emendation of what we've known before, or some combination of those processes – as there is nothing completely new under the sun, but *only* recipes blending different proportions and emphasis of timeless elements.

There will always be an avant-garde waiting to spring at us or waiting for us to delve into it, as long as humans have the life to walk around a new corner or turn a new page, though the means of support of avant-garde activists may currently be at risk. As Tuli Kupferberg, self-described "Jew peddler, anti-capitalist anarchist-pacifist" and co-leader of The Fugs, a notorious folk–rock–agitprop band dating from the mid-'60s, mentioned in a 2005 interview, "An avant-garde depends on cheap rents," and in New York City, among several other municipalities in the United States, real estate has gotten too pricey to allow a concentration of low-income artists to live or work within close proximity, where ideas can be quickly shared, debated and tested. But the warp-speed and global reach of communications now available through the Internet may mitigate that condition, even as the multi-media capacities of the 'net promote the avant-garde impulse to new, previously unsuspected forms of art, leaving real-time improvised musical collaboration an activity of the past.

Concepts can be lost, examples forgotten, but the germs of ideas, once born, have all the strength they need to remain in this world. Consider how impossible it has proved for people of great goodwill to banish even the most nefarious theories. Ideas stick, and the ideas that artists arrive at, however they do so, pass from their works to their audiences, who convey them, however consciously or unconsciously, however diluted or corrupted, until the ideas are so fully assimilated as to be assumed as a priori fundamentals, present since the inception and incapable of being overturned.

Then, of course, those ideas gain a new status, not as the avant-garde any longer but as the established order of things, which must be questioned, examined and rebelled against – expanded upon even if the adventurer who takes on that task speeds off in the opposite direction than the original idea set forth. Opposite ends of a spectrum are still poles of a single spectrum, after all. Fanatic control by a composer over every musical element formerly improvised by an ensemble of improvisers taking advantage of exorbitant freedoms might stretch the bounds of music – what we hear and how we hear it – to encircle the same entirety.

Because there is, after all, only one entirety, only one same river in time and place, beginning to end. We are all in this together, extreme conservatives and

unrepentant avant-gardists, those vociferously adhering to the legacy of the past and those forging, however heedlessly, paths into the future. A greater unity, much fuller comprehension, the contemplation and embrace of everything must be the ultimate goal of even the most disparate and fractious avant-garde.

Jazz may get us there. But even if jazz – that is, *jazz*-jazz – and the jazz *beyond* jazz become cultural artifacts, the notions Miles, Ornette and Cecil (among many others) made manifest will not die. Once an idea is proposed and propagated, it remains in the air; there is no stuffing it back into Pandora's box and forgetting about it, no way to contain its dominion if people find it attractive or efficacious, even if the gods chain its chief proponents – poor Prometheus! – to rocks and send birds to eat their livers every day.

What's called avant-garde may be mysterious, daring, even threatening as it challenges functional customs. The initial expression or realization of this avant-garde idea or substance may burst open the door to a world beyond it, changing how we view ordinary matters by introducing the perspective of he/she who created whatever's avant-garde and making it so persuasive, appealing and/or useful that it is taken up wholeheartedly. Or it may have no effect: the proposed new perspective may be too radical (or inherently flawed) to be deemed appealing or efficacious upon its introduction *or* later.

Indeed, people may be put off by what's avant-garde completely. But maybe not everyone. Maybe a few people will be intrigued and try it on for themselves. Maybe they will identify with it, re-craft it to their own uses or disseminate it even in adapted, diluted or errant form. Maybe they will come to worship it as it is or misunderstand and misrepresent the original intent of its proponents or its true import. Yet they will keep it alive. Maybe, eventually, a constituency will accumulate for this avant-garde.

That is what has happened around some of the most ostensibly improbable works of Miles, Ornette and Cecil. Against high odds, the three remain potent beyond the scope of music, bearing significantly on fashion, film and video, dance, painting, poetry and other arts. Throughout their careers they've triumphed over random heedlessness and pointed hostility by drawing on resources of swing and bebop, yes, also of rhythm 'n' blues and the latest advances in equipment and processes, African retentions, Western European classical heritage and American experimentalism – besides their own on-the-job/in-the-ear training, insights and resolves.

In unforgettable performances and recorded oeuvre, Miles, Ornette and Cecil cast off assumptions that traditionalists cling to like security blankets in favor of perhaps starker or more ungainly yet defiantly beautiful evocations of music as they've conceived it, before the rest of us have. They've brought this music to us. Their concepts and crystallizations seem destined to remain vital, controversial, alive, for decades and perhaps centuries to come.

NOTES

MILES DAVIS, DIRECTIONS

Me and Miles

1 Originally published in slightly different form in *Jazz* magazine, Switzerland, 1987.

New directions

1 Miles' eventual guitarists John McLaughlin, John Scofield, Pete Cosey, Reggie Johnson, Dominique Gaumont, Mike Stern and Foley McCreary represent no cave in to rock 'n' roll (which anyway was the genre promoting the most dazzling guitar playing of the period). Instead, the roles Miles assigned them allowed rock 'n' roll-originated post-Hendrix guitar to attain its apotheosis of genuine musical innovation/creativity. Electric bassist Jaco Pastorius, who didn't record with Miles (though is honored by a Miles title) also represents that strain of musicianship – maybe keyboardist Joe Zawinul does, too, considering that in the rock world keyboards were mostly downplayed in favor of guitars. His keyboard contemporaries in rock and pop were Al Kooper (playing with Bob Dylan, Mike Bloomfield, Eric Clapton and founding Blood Sweat and Tears), Pigpen and Tom Constantine (of the Grateful Dead), Garth Hudson (The Band), Keith Emerson (The Nice, Emerson Lake and Palmer), Jack Nitzsche (Neil Young, the Rolling Stones), Billy Preston (the Beatles, Zappa's Mothers of Invention), Ray Manzarek (The Doors), Nicky Hopkins (Quicksilver Messenger Service, Jeff Beck Band), and Elton John. None of them were Zawinul's match as a technician, innovator or composer, though cases can be made for Ray Charles and Stevie Wonder.

Talkin', playin', BSn'

1 Originally published in slightly different form in *Down Beat*, December 1984

255

ORNETTE COLEMAN, QUESTIONS AND CONJECTURES

Ornette I've met

1 "He blew a hand-carved ivory alto saxophone with a four and a half reed and the sound was like nothing any of them had heard before . . . 'He plays all the notes Bird missed,' somebody whispered . . ."

2 Baker was always the most serious musician of any of my friends, and since 2000 has become increasingly better known as a figure in Chicago's avant underground, releasing a solo album *More Questions Than Answers* on the Delmark label in 2005.

3 Asha Puthli was then in her early 20s, and had come to New York from her native Bombay (India) to dance in Martha Graham's company. She was sent to audition for Ornette by Columbia Records producer John Hammond after having worked with the Boston-based Peter Ivers Blues Band, had never seen the songs she sang on *Science Fiction* until then, and recorded them in one or two takes, for which she received high praise from Robert Palmer in the *New York Times* and top placement in the year's *Down Beat* critics' poll. Then, however, she seemed to disappear, returning in 1987 to record one track with reedist–composer Henry Threadgill, and disappear again. In her first absence from the U.S. she had recorded several albums released in Europe which yielded disco hits that have been sampled by hip-hop artists including The Notorious B.I.G. She performed in New York City in 2006; her repertoire included Ellington's "Single Petal On A Rose," a Joni Mitchell song, Gnarls Barkley's hit of the season, "Crazy" and several original songs. During a subsequent interview with the author she said, "I'm not really an avant-garde jazz artist, not solely. I love every kind of music. I'd love to sing with Pygmies in the rain forest. Anything, really, if it's music."

4 Ms. Okuba, a stunningly beautiful Japanese woman with a sensational, silvery high register, occasionally sang one or two songs with Prime Time backing during the band's concerts in the '80s, but no examples have yet been released on record.

Harmolodic dialogue

1 Originally published in somewhat different form in *Down Beat*, October 1978.

2 This statement remains true 30 years after I first wrote it: In 2007 Ornette was awarded a Lifetime Achievement Award from NARAS, the National Association of Recording Arts and Sciences, and presented an award to another winner on television, but did not perform at the event. Despite his numerous honors, recordings and historic per-formances (including one broadcast over National Public Radio in summer 1978 from the White House lawn, featuring a rare vocal performance by President Jimmy Carter of Dizzy Gillespie's "Salt Peanuts"), Ornette remained a cipher to the vast audience of mostly high school and college music students and teachers attending his interview by Greg Osby, sponsored by *Down Beat*, at the International Association for Jazz Education conference in January, 2007.

3 In 2007, Ornette's cousin, occasional producer and longtime advisor James Jordan,

retired director of the music program of the New York State Council on the Arts, had taken on editorial efforts regarding the manuscript.

4 A television program, produced from 1951 until 1982 and eternally re-run, hosted by Welk, an Alsatian-accented accordionist whose cover versions of mainstream hit songs epitomized squareness and banality.

5 *Dancing In Your Head*'s "Theme" variations and all tracks on *Body Meta* were recorded with the same personnel on December 28, 1975; "European Echoes" on *Body Meta*, was also recorded by Ornette's trio with Izenzon and Moffett in December 1965, as heard on *At The Golden Circle, Volume One*.

6 *Skies Of America*, which Ornette completed composing in 1971 and recorded with the London Symphony Orchestra conducted by David Measham in April 1972, offers conductor, symphony musicians and guest specialists alike significant latitude regarding note choices and episodes of improvisation.

7 Host of NBC television's *Tonight Show* featuring celebrity guests from 1962–92.

8 George Gershwin's "Embraceable You" is the only "standard" Ornette has recorded, in 1960, issued on *This Is Our Music* in 1961. He ventures far from the original melody, interspersing Gershwin's phrases irregularly among his own spin-offs throughout the nearly five-minute performance.

9 Circa 1946–49.

10 Formally the Right Reverend Dr. Frederick J. Eikerenkoetter II, founder and pastor of the Christ United Church, a media-savvy black American evangelist based in Harlem, preaching a doctrine of salvation and prosperity through positive thinking and self-love.

11 White mainstream American evangelical minister.

12 According to U.S. census figures from 1980, self-described "whites" accounted for 83.1 percent of the total population, "blacks" 11.7 percent, others 5.2 percent.

13 Principal, with his brother Ahmet, of Atlantic Records, which recorded nine albums by Ornette from May 1959–March 1961.

14 In 1967, the first awarded for jazz composition.

Circle of improvisers

1 This portrayal of Don Cherry is adapted from an article originally published in *The Wire*, in December 1995, and an interview with the author from 1987.

2 Ornette, Cherry, Haden and Higgins first performed under the auspices of pianist Paul Bley, whose recordings of them show he often laid out to let their solos proceed unhampered by chordal strictures.

3 Blackwell said, backstage at a benefit in 1989 to raise funds for his health care, "My drums are tuned, like a family. You know, the father, mother, daughter, son and so on . . . That's the way they're set up, that's the way they're played . . . The cymbals are incidental. The drums are the main object."

4 This appreciation of Dewey Redman contains material from articles that first appeared in *Down Beat* and *Signal2Noise*, in winter 2006–2007, from interviews held with the author in 1987 and '91.

5 Some of Charlie Haden's comments here first appeared in an article published by *The Wire* in 1992.

6 Cherry and Higgins also used heroin while working in Ornette's band, though Ornette didn't.

7 Bern Nix was interviewed by the author originally for an article in *Guitar World*, 1983.

8 Tacuma was interviewed by the author for an article in *Guitar World*, November 1982.

9 Caravan of Dreams is reported on the website www.geocities.com/bluesdfw/News2001. htm to have closed in 2001, "18 years to the day" after Ornette opened it.

10 Material that follows was originally published in different form in *Musician* magazine, February 1984, and the *Village Voice Jazz Supplement*, late spring 1987.

11 There are two other intersections of the careers of Ornette and William Burroughs. In 1965 Ornette recorded *Chappaqua Suite* for French CBS Records; it is an ambitious two-LP work for his trio and an 11 piece orchestra including tenor saxophonist Pharoah Sanders, originally commissioned as a soundtrack for a film by Conrad Rooks (who used a soundtrack by Ravi Shankar instead). Ornette appears briefly in the film, a surreal depiction of drug addiction in which Burroughs has a featured role. In 1991 Ornette performed on alto saxophone over the London Philharmonic Orchestra, and with bassist Barre Phillips and Denardo, in Howard Shore's score for the David Cronenberg movie *Naked Lunch*, inspired by Burrough's novel of the same name, another surreal depiction of drug addiction.

Coleman family business

1 Bernstein conducted the New York Philharmonic in the world premiere of Ives' *Symphony No. 2* in 1951; Ives had written it between 1897 and 1901; Bernstein recorded it and other Ives' works including *Symphony No. 3* ("The Camp Meeting") and "The Unanswered Question," a chamber work featuring trumpet, not unlike Ornette's "The Mind of Johnny Dolphin."

2 According to Litweiler, Koenig "had been a friend of Arnold Schoenberg," the Austrian-born architect of early twentieth century avant-garde atonal music.

3 Reissued in 2006 by Nonesuch Records, remixed and with six previously unreleased compositions credited to Ornette, including a 15-second "All Of Us").

4 Gramavision, founded by Jonathan F.P. Rose who would later sit on the board of Jazz at Lincoln Center and chair the building committee responsible for the construction of its five-floor headquarters at Columbus Circle in Manhattan, also released albums during this period by John Scofield and Oliver Lake's Jump Up!

5 Some material from this section was published by *Down Beat* in an article titled "The Colors of Music," 1987.

6 Material in this section was published by *Down Beat* in an article titled ?Civilization November 1990.

7 Pianist Cedar Walton recorded two tracks with Ornette, guitarist Jim Hall, vocalist Webster Armstrong, Redman, Haden, Blackwell and unidentified woodwind quintet, in September 1972 for Columbia, but these pieces remained unreleased until 1982,

then issued as on *Broken Shadows*, and remained obscure until inclusion in 2000 on *The Complete Science Fiction Sessions*.

8 In "Nice Work If You Can Get It".

9 Ornette may have been referring to the performance of any of a number of Cage's compositions with indeterminate directions.

10 An area claimed over centuries by Poland, Prussia, the Czech Republic and East Germany.

Honors

1 *Three Women* has one composition, "Don't You Know By Now?" not on *Hidden Man*, as well as Lauren Kinhan and Chris Walker (a Prime Time bassist at the end of the '80s) adding vocals on one track.

2 Ornette's affiliation with Verve/Polygram ended in 2005.

3 MacDowell added his electric bass to the two uprights in Ornette's 2005 Carnegie Hall JVC Jazz Festival concert, but the problematic Carnegie acoustics had hampered that listening experience, rending all three muddy.

4 Wynton Marsalis was the first jazz musician to receive a Pulitzer, in 1997 for his oratorio *Blood On The Fields*; nominee Duke Ellington was denied a Pulitzer in 1965.

5 As described by Sig Gissler, administrator of the Pulitzer Prizes, in 2007.

6 This installation was closed in 2002.

CECIL TAYLOR, GRAND PASSIONS

The Great Unknown

1 Twice: having received the Award for his own career in 2004, he deigned to accept the Award on behalf of pianist Hank Jones in 2005, and spoke elegantly on that occasion of the encouragement Hank's late brother Thad had given him early in his career, as well as the drumming Elvin, Hank's late brother, had shared with him in the previous five years.

2 As the Reverend Milton C. Williams, Jr. cited at pianist Andrew Hill's Episcopalian funeral on April 27, 2007.

3 As practiced by Garth Fagan Dance in "Griot New York" and the New York City Ballet company directed by Peter Martins, also a constituent of Lincoln Center, in "Them Twos."

4 Marsalis wrote, performed and recorded the effective jazz soundtrack for *Tune In Tomorrow*, a comic romance released in 1990, adapted from novelist Mario Vargas Llosa's *Aunt Julia And The Scriptwriter*, transplanted from its original setting in Peru to New Orleans.

5 Works such as Marsalis' 1997 Pulitzer Prize-winning oratorio *Blood On The Fields* and *All Rise*, commissioned in 1999 by Kurt Masur for the New York Philharmonic – another Lincoln Center constituent organization – recorded in 2002 by Esa-Pekka Salonen

conducting the Los Angeles Philharmonic Orchestra, the Paul Smith Singers/The Northridge Singers of CSUN and the Morgan State University Choir.

6 In poetry, unstressed syllables preceding the metric count of one; similarly in music, notes preceding the downbeat, "pickup" notes before the beat's start.

7 These quotations are included in my liner notes for *Thelonious Sphere Monk: Dreaming Of The Masters* (Columbia/DIW Records, released in 1991).

Late tea, early winter and my dinner with Cecil

1 Singer Gaye employed a plethora of bassists in his classic Motown hits and later recordings; on "What's Goin' On" three are credited: James Jamerson, Bob Babbitt and Jax Janowski; elsewhere the Crusader's Wilton Felder, Gordon Banks, studio session guitarist Chuck Rainey, Ron Brown and Henry Davis are credited.

2 Also known as "T," it opens Cecil's solo album *Fly!Fly!Fly!Fly!Fly!,* recorded in Villigen, Germany in 1981.

Speaking of drummers

1 1959.

2 1959.

3 From Paul Griffiths' translation of Messiaen's notes for the 1990 Deutsche Grammophon recording.

ACKNOWLEDGMENTS

Thank you, thank you, thank you, thank you – Larry Birnbaum, for suggesting this book topic; Richard Carlin for commissioning it. Kitty Brazelton for sharing so much of the composer–performer's processes with me. Rosie Mandel for being such a tonic when the cognitive dissonance gets to be just too much. Joe Petrucelli for research assistance and enthusiastic but critical reading; Matt Miller for scut work and fresh perspectives. At Routledge, Constance Ditzel for patience, Denny Tek for attentions. At Prepress Projects Ltd, Andrew R. Davidson, Helen MacDonald and Eilidh McGregor. Susan Katz for relentless encouragement, JA Kawell for professional assistance and much, much more.

Jim Baker, Charlie Doherty, John Litweiler, James Hale, Neil Tesser, Tim Schneckloth, Bill Milkowski, Don Palmer, Greg Tate, Jim Macnie, Steve Ganis, David Adler, Paul deBarros and Kevin Whitehead, Sy Johnson, among many playing and non-playing members of the Critics Band, including all my friends in the Jazz Journalists Association, especially Susan Fox, Forrest Dylan Bryant, Fred Jung, Francis Davis, Gary Giddins, Dan Morgenstern, Willard Jenkins and W. Royal Stokes. Jim deJong, Marc PoKempner, Karen Kuehn, Lauren Deutsch, Jack Vartoogian, Enid Farber, R. Andrew Lepley, Lourdes Delgado and the late Lona Foote for good ears and great eyes. Mike Zwerin, Amiri Baraka, Nat Hentoff, Mitch Myers, Michelle Mercer and Ashley Kahn for jazz writing. Publications editors including Abe Peck, Jack Hafferkamp, Ray Townley, Marv Holman, Chuck Carman, Art Lange, Carol Tuynman, Noe Goldwasser, John Ephland, Suzanne Mikesell, Suzanne McElfresh, Tony Herrington, Pete Gershon, Matti Lapio, Robert Christgau, Rafi Zabor, Larry Blumenfeld, Aaron Cohen and Jason Koransky. Also Thurston Briscoe (now at WBGO) and Tom Cole of National Public Radio and Revenant Records' Dean

*Unless otherwise noted, quoted material throughout the text is from interviews and direct observation by the author. A comprehensive list of the author's interviews and published articles, as well as an annotated discography and videography of works cited in the text is online at www.HowardMandel.com, the author's website.

Blackwood. Some friends: Colleen Growe, Julian and Sofia Trigo, Whit Blauvelt, Steve Singer, Myra Melford and Erwin Helfer.

I'm particularly grateful to all the musicians in the text – especially those who played with Miles, Ornette and Cecil, but really everyone who's talked to me, directly, on the phone or through their instruments – with special acknowledgement of Don Cherry, Dewey Redman, Edward Blackwell, Don Pullen, Leroy Jenkins, Lester Bowie and my good friend Andrew Hill, a man who nudged jazz gently but firmly way beyond jazz. Shout-outs to George Lewis, Martin Mueller, Maria Schneider, Jayne Cortez, Frank Kimbrough, Jason Lindner, Andrew Cyrille, Reggie Workman and Junior Mack.

This book is for my mother, Marjorie K. Mandel, who was tolerant of intense noise in her home when I was a teenager, way beyond what my brothers Larry and David and I stirred up. One afternoon while I was writing this book at my office and listening to *Unit Structures* at full blast she called on the phone and remarked to start, "I like your background music!" Thanks, Mom, not only for that.

PHOTOGRAPHY CREDITS

SELECTED BIBLIOGRAPHY*

Adorno, Theodor. "Perennial Fashion – Jazz" in *Prisms*. Cambridge: MIT Press, 1967.

——, translated by Jamie Owen Daniel. "On Jazz." Discourse 12.1 (Fall–winter 1989–90).

Balliett, Whitney. *Collected Works, A Journal of Jazz 1954 – 2001*. New York: St. Martin's Griffin, 2000, 2002.

Brown, David P. *Noise Orders – Jazz, Improvisation and Architecture*. Minneapolis: University of Minnesota Press, 2006.

Cage, John. *Silence – Lectures and Writings*. Middletown: Wesleyan University Press, 1973.

—— and Richard Kostelanetz. *An Anthology*. New York: Da Capo Press, 1991.

Carr, Ian. *Miles Davis, A Biography*. New York: Quill, 1984.

Chambers, Jack. *Milestones: The Music and Times of Miles Davis*. Boston: Da Capo Press, 1983, 1985.

Cole, Bill. "Caught in the Act – Miles Davis, Wesleyan University, Middletown, Conn." *Down Beat* (April 15, 1971): 28.

Cole, George. *The Last Miles – The Music of Miles Davis 1980–1991*. Ann Arbor: The University of Michigan Press, 2005.

Cook, Richard. *It's About That Time – Miles Davis On And Off Record*. New York: Oxford University Press, 2007.

Coryell, Julie and Laura Friedman. *Jazz-Rock Fusion – The People, The Music*. New York: Dell Publishing Co., Inc., 1978.

Crouch, Stanley. "Play The Right Thing – Miles Davis, the most brilliant sellout in the history of jazz." *The New Republic* (February 12, 1990): 30–37.

—— *Considering Genius – Writings on Jazz*. New York: Basic Civitas Books, 2006.

Daniel, Jamie Owen. "Introduction to Adorno's 'On Jazz'." Discourse 12.1 (Fall–winter 1989–90): 38–69.

Davis, Miles, with Quincy Troupe. *The Autobiography*. New York: Simon and Schuster, 1989.

DeVeaux, Scott. "Constructing the Jazz Tradition: Jazz Historiography." *Black American Literature Forum, Vol. 25, No. 3* (Fall, 1991): 525–559.

Early, Gerald, editor. *Miles Davis And American Culture*. St. Louis: Missouri Historical Society Press, 2001.

—— *One Nation Under A Groove – Motown & American Culture*. Hopewell, NJ: The Ecco Press, 1995.

Fisher, Larry. *Miles Davis And David Liebman – Jazz Connections*. Lewiston: The Edwin Mellen Press, 1996.

Freeman, Philip. *Running The Voodoo Down – The Electric Music Of Miles Davis*. San Francisco: Backbeat Books, 2005.

Gebers, Jost, editor. *Cecil Taylor In Berlin '88*. Berlin: Free Music Production, 1989.

Gordon, Robert. *Can't Be Satisfied – The Life And Times Of Muddy Waters*. London: Pimlico, 2002.

Gracyk, Theodore A. "Adorno, Jazz, and the Aesthetics of Popular Music." *The Musical Quarterly* (76, 1992): 526–542.

Jost, Ekkehard. *Free Jazz – Studies In Jazz Research 4*. New York: Da Capo Press, 1974.

Kahn, Ashley. *Kind Of Blue – The Making Of The Miles Davis Masterpiece*. New York: Da Capo Press, 2000.

Kirchner, Bill, editor. *A Miles Davis Reader*. Washington: Smithsonian Institution Press, 1997.

Kostelanetz, Richard. *A Dictionary Of The Avant-Gardes,* Routledge, New York, 2001.

Lee, David. *The Battle Of The Five Spot – Ornette Coleman And The New York Jazz Field*. Toronto: The Mercury Press, 2006.

Lewis, George E. "Improvised Music After 1950: Afrological and Eurological Perspectives." *Black Music Research Journal, Vol. 16, No. 1* (Spring 1996): 91–119.

Litweiler, John, *The Freedom Principle – Jazz After 1958*. New York: Da Capo Press, 1984.

—— *Ornette Coleman – A Harmolodic Life*. New York: Da Capo Press, 1994.

Mailer, Norman. "The White Negro – Superficial Reflections On The Hipster." *Dissent*, 1957; *Advertisements For Myself*, 1961.

McRae, Barry. *Ornette Coleman*. London: Apollo Press Ltd., 1988.

Mercer, Michelle. *Footprints – The Life And Work Of Wayne Shorter*. New York: Tarcher/Penguin, 2004.

Murphy, Chris. *Miles To Go, The Lost Years*. New York: Thunder's Mouth Press, 2002.

Murray, Albert. *The Omni-Americans Black Experience And American Culture*. New York: Random House, 1970.

Nisenson, Eric. *Round About Midnight: A Portrait Of Miles Davis*. New York: Perseus Publishing, 1982.

Revill, David. *The Roaring Silence – John Cage: A Life*. New York: Arcade, 1992.

Roby, Steven. *Black Gold, The Lost Archives Of Jimi Hendrix*. New York: Billboard Books, 2002

Schuller, Gunther. *Musings: The Musical Worlds Of Gunther Schuller*. New York: Oxford University Press, 1986.

Schönherr, Ulrich. "Adorno And Jazz: Reflections In Failed Encounter." *Telos – A Quarterly Journal Of Critical Thought* (Spring 1997): 85–96.

Shattuck, Roger. *The Banquet Years – The Origins Of The Avant-Garde In France 1895 To World War I*. New York: Anchor/Doubleday, 1961.

Spellman, A.B. *Four Lives In The Bebop Business*. London: MacGibbon & Kee, 1967.

Szwed, John. *So What – The Life Of Miles Davis*. New York: Simon and Schuster, 2002.

Tate, Greg. *Flyboy In The Buttermilk – Essays On Contemporary America*. New York: Simon & Schuster, 1992.

—— *Midnight Lightning – Jimi Hendrix and the Black Experience*, Chicago: Lawrence Hill Books, 2003.

—— "Miles Behind." *Village Voice* (July 6, 1982).

Taylor, Yuval, editor. *The Future Of Jazz*. Chicago: A Cappella, 2002

Tingen, Paul. *Miles Beyond – The Electric Explorations Of Miles Davis, 1967–1991*. New York: Billboard Books, 2001.

Troupe, Quincy. *Miles And Me*. Berkeley: University of California Press, 2000.

Taruskin, Richard. "No Ear For Music." *The New Republic* (March 15, 1993): 26–35.

Wilmer, Valerie. *Jazz People*. Indianapolis: The Bobbs-Merrill Company, Inc., 1970.

—— *As Serious As Your Life*, Westport, CT: Lawrence Hill & Company, 1980.

Wilson, Peter Niklas. *Ornette Coleman – His Life And Music*. Berkeley: Berkeley Hills, 1999.

Online resources

Of several excellent, comprehensive discographies available via the internet, I suggest:

The Miles Davis Discography Project, www.jazzdisco.org/miles, which is organized both by album and by recording session.

Miles Ahead Discographical Details, Peter Losin's Miles Ahead, www.plosin.com/MilesAhead/DiscoDetails.aspx, has images of record covers among its other searchable categories.

Miles Davis Discography, www.jazzdisco.org/miles/dis/c, is organized clearly, chronologically.

The Sound Of Miles Davis, www.jan-lohmann.com, is the website of Jan Lohman, intrepid and insightful Miles researcher.

The Miles List is a daily listserve covering all things Miles. E-mail listserv@nic.surfnet.nl, leaving the subject line blank but writing "subscribe Miles" and your name in the message box to plug into lively ongoing discourse of the world from the perspective of Miles' listeners.

Ornette Coleman's home page is www.ornettecoleman.com

Ornette Coleman Discography Project, www.jazzdisco.org/ornette, can be sorted by sessions or albums. Robert Stuben maintains a useful Ornette Coleman Discography, www.geocities.com/BourbonStreet/Quarter/7055/Ornette/Disco-ornette.htm.

The Ornette Coleman Mailing List, maintained in part by veteran jazz researcher David Wild at www.geocities.com/bourbonstreet/delta/8835/ornettemail.html is a listserve concerning matters relevant to sound grammar, harmolodics and Ornette himself.

Richard Shapiro's *Cecil Taylor Sessionography* is a resource for personnel and titles of recordings from 1956 through 2002, www.efi.group.shef.ac.uk/mtaylors.html

A Cecil Taylor Discography, maintained by Antaios in Japanese as well as English, includes depictions of album covers as well as personnel and recording dates, at http://outbreakin.hp.infoseek.co.jp/ceciltaylor.htm

The Cecil Taylor Research Group can be contacted via http://launch.groups.yahoo.com/group/ CTResearch

The European Free Improvisation Homepage, www.efi.group.shef.ac.uk, hosts extensive postings regarding Cecil Taylor (among other artists), including an interview with him by Chris Funkhouser, a transcript of a panel discussion he participated in at Bennington College in 1964, and a perceptive overview of his recordings by Damon Short.

INDEX

White, James 159
White, Lenny 64, 66, 107
Whitman, Walt 126, 193
Whittier 236
"Who Do You Love?" 54
Who, The 64
Wilburn, Vincent Jr. 10, 24, 83, 90, 97
Wilen, Barney 37
William Paterson College 104
Williams Tony 21, 22, 38, 40, 46, 47, 48, 49,
 52, 56, 60, 61, 73, 75, 87, 105, 116, 239,
 240
Williams, (Thomas Lanier III) "Tennessee" 30
Williams, Burt 237
Williams, Buster 107
Williams, Fred 127
Williams, Hank 32
Williams, Henry "Rubberlegs" 27
Williams, Martin 58, 111
Williams, Mary Lou 14, 211, 221, 232, 237,
 243
Williams, the Reverend Milton C., Jr. 259
"Willie Nelson" 68
Willisau 220
Willisau Concert, The 220
Wilmer, Valerie 111, 240
Wilson, Cassandra 87, 106
Wilson, Gerald 36
Wilson, Philip 42
Wilson, Teddy 211, 222, 237
Wings 76
Wire, The 7, 169, 257, 258
Withers, Bill 76
WKCR-FM 241
WNYC-FM 200
Wolff, Michael 107
Wonder, Stevie 45, 70, 76, 160, 239, 255
Woodlawn Cemetery 82
Woodstock 70
Woodstock festival 63, 98
Woodstock Generation 84

Woodstock movie 64
"Woody 'n' You" 94
"Word From Bird" 176
Workin' 24
Workman, Reggie 232
World Saxophone Quartet 42, 86, 159
World Series 205
World War II 5, 27, 57, 234, 236
Wright, Bernard 97
Wurlitzer electric piano 113
Wyner, Yehudi 200

X, Malcolm 49
Xenakis, Iannis 59

Yellow Jackets, the 103
Yerevan 204
Yevteshenko, Yevgeni 166
Yo Miles! 107
York, Nora 108
You Won't Forget Me 103
You're Under Arrest 25
"young lions" 87, 176
young Turks 27, 204
Young, Gifted And Black 70
Young, La Monte 43, 59, 220
Young, Larry 64, 73,
Young, Lester 3, 27, 42, 94
Young, Neil 69, 76, 255
YouTube.com 205

Zappa, Frank 20, 51, 69, 255
Zawinul, Joe 5, 39, 56, 57, 59, 61, 64, 65, 68,
 73, 87, 92, 98, 174, 197, 255
Zeitlin, Denny 155
Zeno 58
Zenon, Miguel 107
"Zimbabwe" 82
"Zodiac Suite, The" 237
Zollar, James 107
Zorn, John 6, 14–15, 86, 159, 197, 211, 252

An environmentally friendly book printed and bound in England by www.printondemand-worldwide.com